# ISLAND ANCESTORS

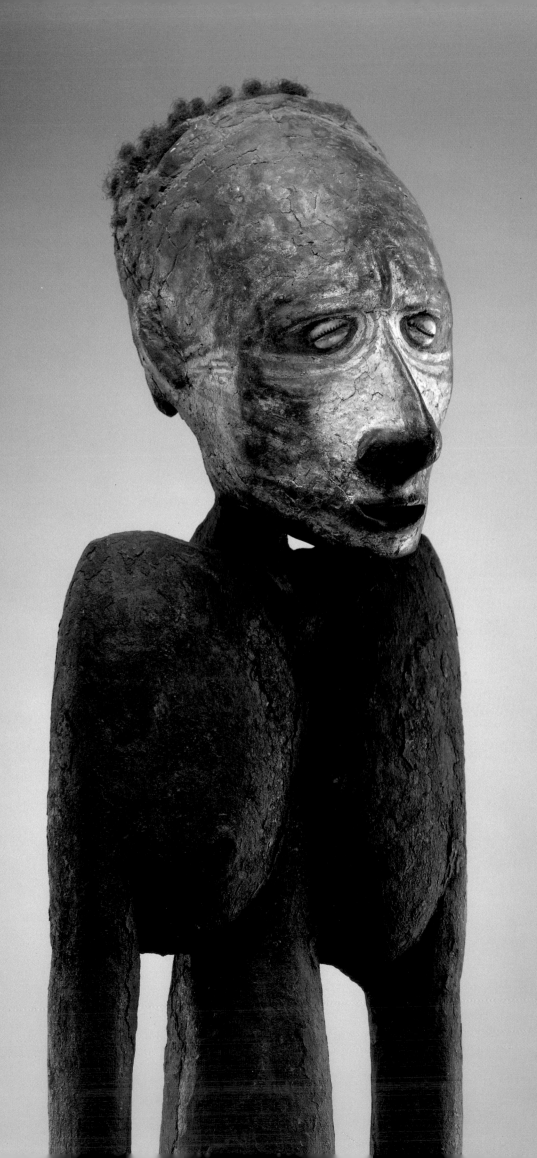

# ISLAND ANCESTORS

## OCEANIC ART FROM THE MASCO COLLECTION

ALLEN WARDWELL

*Photographs by Dirk Bakker*

UNIVERSITY OF WASHINGTON PRESS
IN ASSOCIATION WITH
THE DETROIT INSTITUTE OF ARTS

*The exhibition* Island Ancestors: Oceanic Art from the Masco Collection *was organized by The Detroit Institute of Arts with support from Masco Corporation.*

DATES OF THE EXHIBITION

The Kimbell Museum, Fort Worth, Texas
*September 24–December 4, 1994*

Honolulu Academy of Arts
*February 2–March 26, 1995*

The Detroit Institute of Arts
*June 11–August 6, 1995*

North Carolina Museum of Art, Raleigh
*March 9–May 5, 1996*

PHOTOGRAPHIC DETAILS

*Front Matter*
p. ii: Male Ancestor Figure *(pl. 17)*
p. vi: Male Figure *(pl. 101)*
p. viii: Dance Staff *(pl. 46)*
p. x: Dance Paddle *(pl.103)*
p. xii: Canoe Prow *(pl. 2)*
p.xiv: Hand Drum *(pl. 22)*
p. 2: Carved Bar *(pl. 82)*
p. 14: Male Figure *(pl. 15)*

*Back Matter*
p. 272: Fly Whisk Handle *(pl. 78)*
p. 278: Ancestor Figure *(pl. 7)*

Copyright © 1994 by The Detroit Institute
of Arts Founders Society
98 97 96 95 94 5 4 3 2 1

Printed in Japan by Nissha Printing Company
Photography by Dirk Bakker
Edited by Julia Henshaw
Design by Audrey Meyer
Line art illustrations by Deborah Reade
Composition by Graphic Composition, Inc.

Library of Congress Cataloging-in-Publication Data

Wardwell, Allen.
Island ancestors : Oceanic art from the Masco Collection /
Allen Wardwell.
p.   cm.
Includes bibliographical references.
ISBN 0-295-97329-3 (cl.).—ISBN 0-295-97330-7 (pbk.)
1. Art—Oceania—Exhibitions.   2. Art, Primitive—
Oceania—Exhibitions.   3. Art, Australian (Aboriginal)—
Exhibitions.   4. Masco Corporation—Art collections—
Exhibitions.   5. Art—Private   collections—Michigan—
Taylor—Exhibitions.   I. Title.
N7410.W27   1994
709′.01′1099—dc20                    93-39697    CIP

The paper used in this publication meets the minimum requirements of American National Standard for Information Sciences—Permanence of Paper for Printed Library Materials, ANSI Z39.48-1984.

# Contents

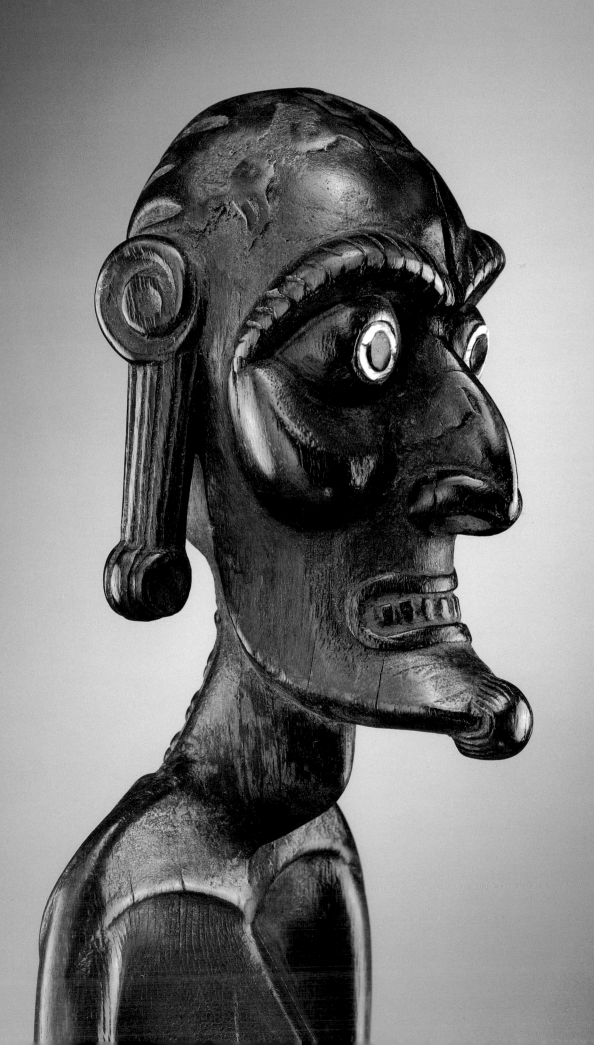

# Foreword

ISLAND ANCESTORS: OCEANIC ART FROM the Masco Collection is an exhibition that has among its many merits two that deserve special recognition. One is the purity and high quality of these unique and incredible objects themselves. They stand as a testimony to Wayne Heathcote, whose collection formed the core of this remarkable group, and to the insight and understanding of Richard Manoogian, who has further enriched the collection by adding extraordinary works at the same level of excellence. Pieces from these cultures are rare to begin with and thus to find a collection of such uniform distinction is rarer still.

Next, looking at these amazing works from the South Pacific, we are reminded of the powerful vision of the peoples who made them and appreciate their vivid depiction of deities and spiritual images beyond our ken. Human fear of the unknown speaks with a universal voice. This exhibition offers an unusual opportunity to become familiar with visions that may seem strange at first, until we realize that the language they speak is ultimately part of everyone's vocabulary. This is not the art of sylvan landscapes and realistic portraits. Only when life becomes less of a moment-to-moment struggle can such artistic renderings occur. This is rather the vocalization of the substance of what exists only in the mind. It is that which we have never "seen" on this earth but which we recognize nonetheless.

In organizing such an exhibition, there are many individuals to thank whose contributions were essential to its success. Richard Manoogian has, as always, contributed his intelligence and unfailing generosity, along with Joan Barnes and others at Masco Corporation. Ellen Taubman, Curator of the Masco Oceanic Collection, has brought her considerable knowledge of the field to enrich our understanding and has been helpful in many ways. Michael Kan, Curator of African, New World, and Oceanic Cultures, has served as a helpful consultant on the collection and as curator of the exhibition. Suzanne Quigley, Head Registrar, and Tara Robinson, Curator of Exhibition Coordination, have been responsible for organizing the exhibition. David Penney, Lisa Roberts, Barbara Heller, and Carol Forsythe, all museum staff members, have contributed essential professional advice.

Allen Wardwell's clear elucidation of the background of the cultures of the South Pacific as well as his explication of the individual pieces make this publication an important contribution to the literature in the field. We are once again grateful for the superb photography of Dirk Bakker, Director of Photography, and the efficient management of the publication by Julia Henshaw, Director of Publications. The commitment of Donald Ellegood, Director of the University of Washington Press, was also essential; Audrey Meyer's handsome design enhances this book. Our thanks go to them all.

SAMUEL SACHS II
*Director*
The Detroit Institute of Arts

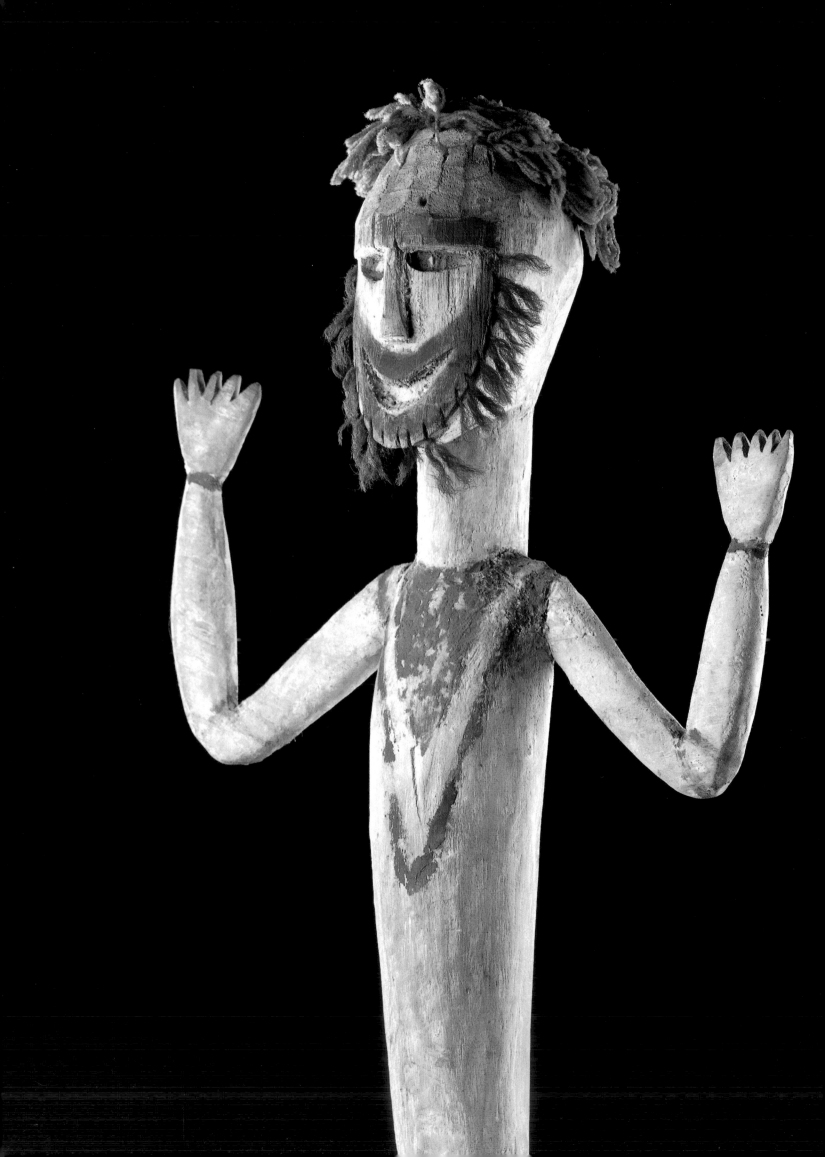

# Preface

THE CURIO CABINETS IN A VICTORIAN gentleman collector's living room were the predecessors of today's collections of ethnographic art. The specimens from what were to these early collectors far-off and mysterious places—Mexico, North and South America, and, most importantly for this exhibition, the South Pacific—created a thrill and excitement each time a new object was discovered. The Masco Collection of Oceanic Art has been the lucky beneficiary of this early interest in the South Pacific. Many of its greatest pieces owe their existence to the western fascination with "primitive" cultures that was the impetus for this collecting tradition.

Collections of Oceanic art are today primarily found in the museums of the former colonial powers active in Oceania, such as France, England, Belgium, and Germany. While the Masco Collection includes American paintings, sculpture, and silver, and American Indian art, this group is one of the few American collections, and certainly the only major private one, dedicated to the art of Oceania. As a result of the unfortunate rarity of Oceanic art, relatively little has been published and few exhibitions have been mounted in comparison with other fields of ethnographic art, for example, the art of Africa. This is one of the primary reasons that I am particularly happy that we have been able to publish this collection and present this exhibition to an American audience that has not had the opportunity to experience directly and in this depth the art of Oceania.

The core of the Masco Collection of Oceanic Art was formed by Wayne Heathcote, the leading dealer in the field of Oceanic art. Wayne first became interested in Oceanic art during a stint as an Australian policeman in New Guinea in the 1960s. With the help of a number of established collectors, such as Bruce Seaman, his knowledge and understanding of the field deepened quickly and his keen eye and focused attention allowed him to become an accomplished specialist. He began retaining certain pieces for his personal collection, many from smaller private holdings disbursed at that time. The 1970s saw the public sale of two outstanding collections, those of James Hooper and George Ortiz, both of whom were recognized for their superior taste and for their holdings of rare and

important pieces. From these auctions, Wayne added the shark teeth weapons (cat. nos. 99a–d) collected by Captain James Cook during his third voyage to the Sandwich Islands (now Hawaii), the Torres Strait canoe prow (cat. no. 37), and a number of others.

In this field, the provenance or history that accompanies a piece can be almost as valuable as the object itself. It enables us to ascertain the origin of a piece, its relative age, and when it was collected. Most, if not all, of the cultures from which these objects originated have not existed for the greater part of at least a century. Thus, an object's provenance can provide a context that is of great importance to the serious collector, particularly since many objects were reproduced and sold to travelers as souvenirs, never having been used as part of an authentic tribal culture, even as early as the middle of the nineteenth century.

In 1987 Wayne decided to sell his private collection in its entirety. Richard Manoogian, chairman of Masco Corporation and already a devoted enthusiast in the fields of American painting and American Indian art, decided to pursue this opportunity for Masco Corporation with the support of Michael Kan, curator at the Detroit Institute of Arts. Shortly thereafter Richard and I were introduced. I was familiar with Wayne's collection since I had known him for many years in my capacity as head of the Tribal Art Department at Sotheby's New York. Richard asked me to become curator of the Masco Collection, and I happily accepted. My task was to improve the collection over time and arrange for its exhibition and publication.

We entered the market at a fertile time and were able to acquire many outstanding objects. From the Carlo Monzino sale in New York we acquired the Mortlock Island mask from the Caroline Islands (cat. no. 104) and the Eastern Highlands headdress (cat. no. 58), the latter shown as part of the "Primitivism" exhibition at the Museum of Modern Art in 1984. From the collection of the famous twentieth-century French writer Tristan Tzara we acquired the Solomon Islands canoe prow (cat. no. 51) and the extremely rare Torres Strait drum (cat. no. 38), which had sat in his Paris studio for many, many years. We were also fortunate to acquire the Solomon

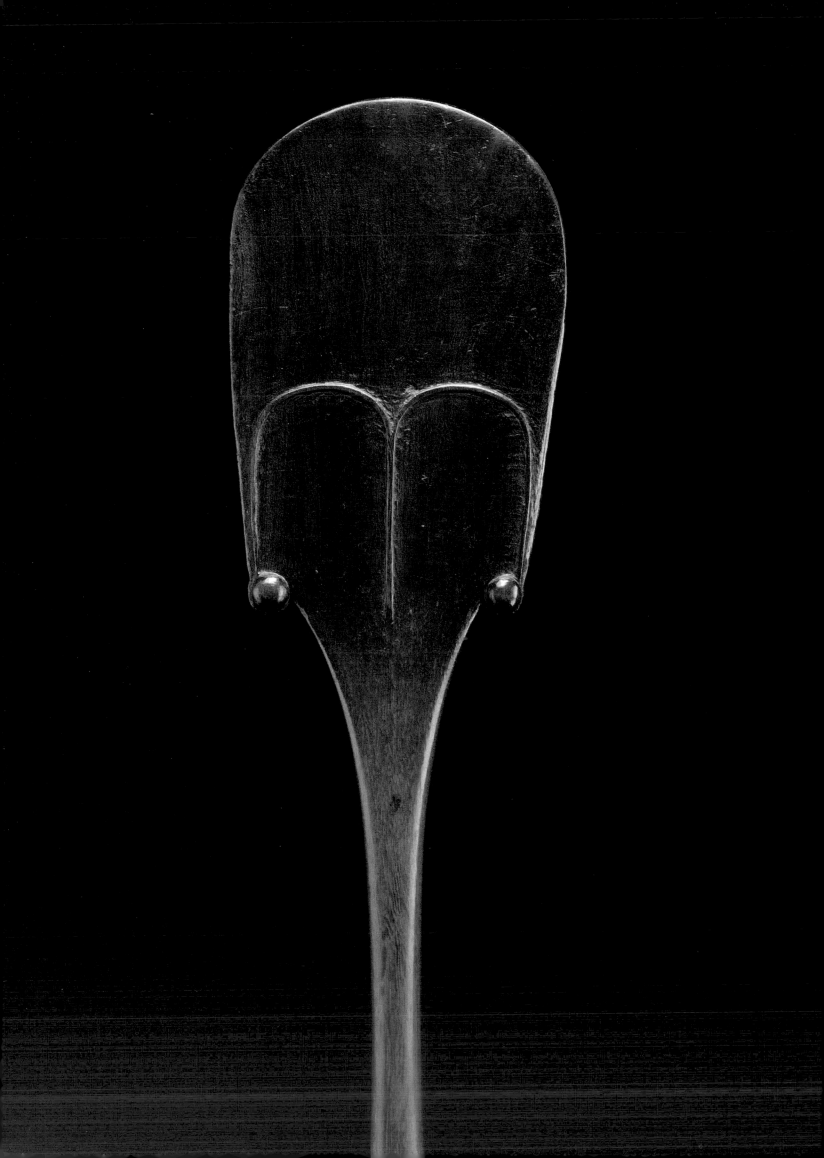

Islands shield (cat. no. 53) from the Museum für Völker-kunde, Dresden, which had traded it and a number of other items to an international art dealer.

Works produced by the peoples from the vast areas of the Pacific are made of a variety of natural materials, such as wood, shell, fiber, feathers, vertebrae, and teeth. Many of these objects used ingenious combinations of elements. Colors were of vital importance, with a wealth of reds, yellows, and blues. Objects of importance, carved for specific rulers, were often made of special materials and created by already acknowledged artists of the tribe. These objects, such as the Maori feeding funnel (cat. no. 85) and the Marquesan shell crown (cat. no. 94), are some of the most refined examples of Oceanic art which still retain the unique qualities of design that gave them their ritual and spiritual importance.

Some of the finest sculptural forms were produced for utilitarian and ritual purposes, such as the Cook Islands sloping chief's stool (cat. no. 77), the large ceremonial poi bowl from Hawaii (cat. no. 100), the Fiji Islands "cannibal fork" (cat. no. 65), and the Tongan Islands curving pillow (cat. no. 70). All of these objects were carved from large pieces of exotic wood, often from a single tree trunk, with little more than stone tools. They are as refined and simple as a contemporary piece of furniture or sculpture. Alternatively, the more visceral works, such as the New Guinea figure with ancestor skulls (cat. no. 35) or the New Ireland "Uli" (cat. no. 42), were often meant to invoke a fearsome reaction and still do so, even though they have been removed from their original context. Examples of both of these types of objects are some of my favorites in the collection.

Masco Corporation is pleased to be able to share this sampling of its Oceanic art collection with the public through both the exhibition and this publication. We hope that you will find this collection as captivating as the Victorian collectors found some of its pieces more than a century ago.

ELLEN NAPIURA TAUBMAN
*Curator, The Masco Collection of Oceanic Art*

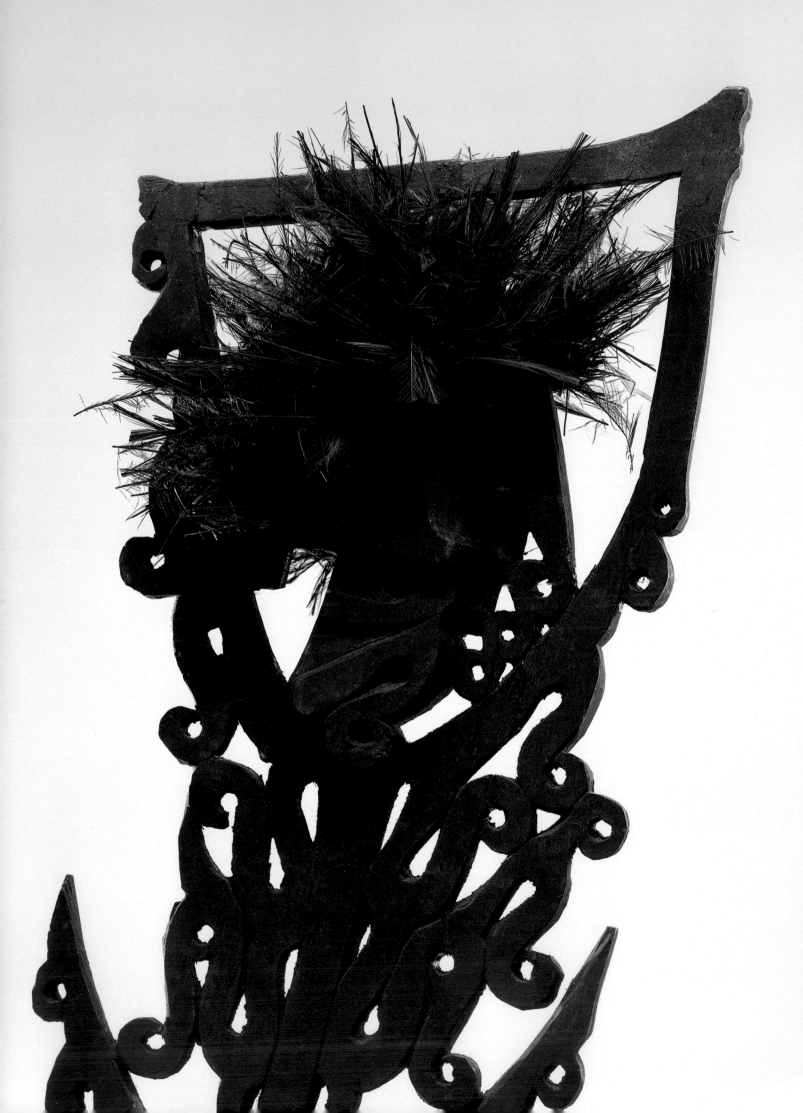

# Acknowledgments

BECAUSE I HAD NOT BEEN ENGAGED IN the research of Oceanic art for more than twenty years, it was an unexpected honor to be asked to write this book. It also became immediately apparent that I would need the help of many others even to begin to cover such a vast subject. I began by appointing Christina Behrmann, a former New York University graduate student of mine, as my research assistant. She had already worked on a small exhibition of Sepik River art and had some familiarity with the general literature. In most cases, I simply asked her to find out as much as she could about specific object types, and she proved to be remarkably adept and efficient at locating information from both obscure and familiar sources. Her thorough research formed the basis for many of the entries here, and her enthusiasm for the subject made our association all the more pleasant and fruitful.

Both of us relied heavily on the resources of the Robert Goldwater Library in the Metropolitan Museum of Art where we were efficiently served by librarian Ross Day and his assistant Peter Blank; Virginia Webb helped with our requests for information from the photographic archives. Ms. Behrmann also worked with Liz Denlinger and Dennis Massie in securing interlibrary loans.

From the inception of our research we were fortunate to have the benefit of documentation from Wayne Heathcote on the objects that had been in his collection. He has been of continuing assistance throughout our work, readily supplying materials, sources, and histories to complete our records. Additional investigations into the Masco Oceanic Collection had also been carried out over a period of years by Terence Barrow, who had written preliminary descriptions of some of the objects and advised on photography. His lifelong involvement with the art of Oceania, particularly Polynesia, provided background for much of the new material that is presented here, and he was always available for consultation.

It is a special pleasure once again to acknowledge the assistance and encouragement I have received from my friend Douglas Newton. The extensive citations in the bibliography suggest only a small part of his great knowledge and familiarity with this art. We discussed the pros and cons of every piece included here, and he was able to lead me to additional sources of information that have added greatly to the completeness of some of the entries. He also read all of the preliminary introductory texts, corrected errors of fact and interpretation, and made numerous helpful suggestions. Any mistakes that may appear are, of course, mine, but the text is considerably improved over what was originally shown to him.

Specific inquiries were also directed to other scholars and collectors who were always willing to share their opinions with us. Among them were Linda Finer, John Friede, Norman Hurst, Carol Ivory, Adrienne Kaeppler, Anne Lavondais, Stephanie Sears, and Raymond Wielgus.

Equally important was the essential support received from various sources in Detroit. Ellen Taubman, who is Richard Manoogian's assistant and curator of the Masco Collection, assiduously saw through the completion of many necessary details including photography, additional questions of provenance, budgeting, and scheduling. She worked closely with me on the selection of objects that were to be included in both the exhibition and the book.

The Detroit Institute of Arts served as the central administration point for the catalogue and the traveling exhibition. Director Samuel Sachs II corresponded with potential participating museums and presided over the various financial, scheduling, and staffing needs. The project was managed by Michael Kan, who is curator of African, Oceanic, and New World Cultures. He oversaw all correspondence relating to the exhibition and, with the assistance of Lynne Spriggs, wrote to previous owners of many of the objects to ascertain their previous history. He also provided excellent liaison with members of Mr. Manoogian's staff and consulted with me as to the nature and content of the exhibition and publication. Michael Kan and I have shared mutual interests in this and other fields for more than thirty years, and I have greatly enjoyed his collaboration in our first joint project.

The superb photographs were made by Dirk Bakker, whose photography is justly renowned. The editing of the catalogue was tactfully supervised by Julia Henshaw and her staff, including intern Matthew Sikora.

Lastly, I wish to thank both Richard Manoogian and Ellen Taubman for offering me the opportunity to study and to elucidate some aspects of this fine collection. Their confidence and support have revitalized my interest in a field from which I had been too long removed.

ALLEN WARDWELL

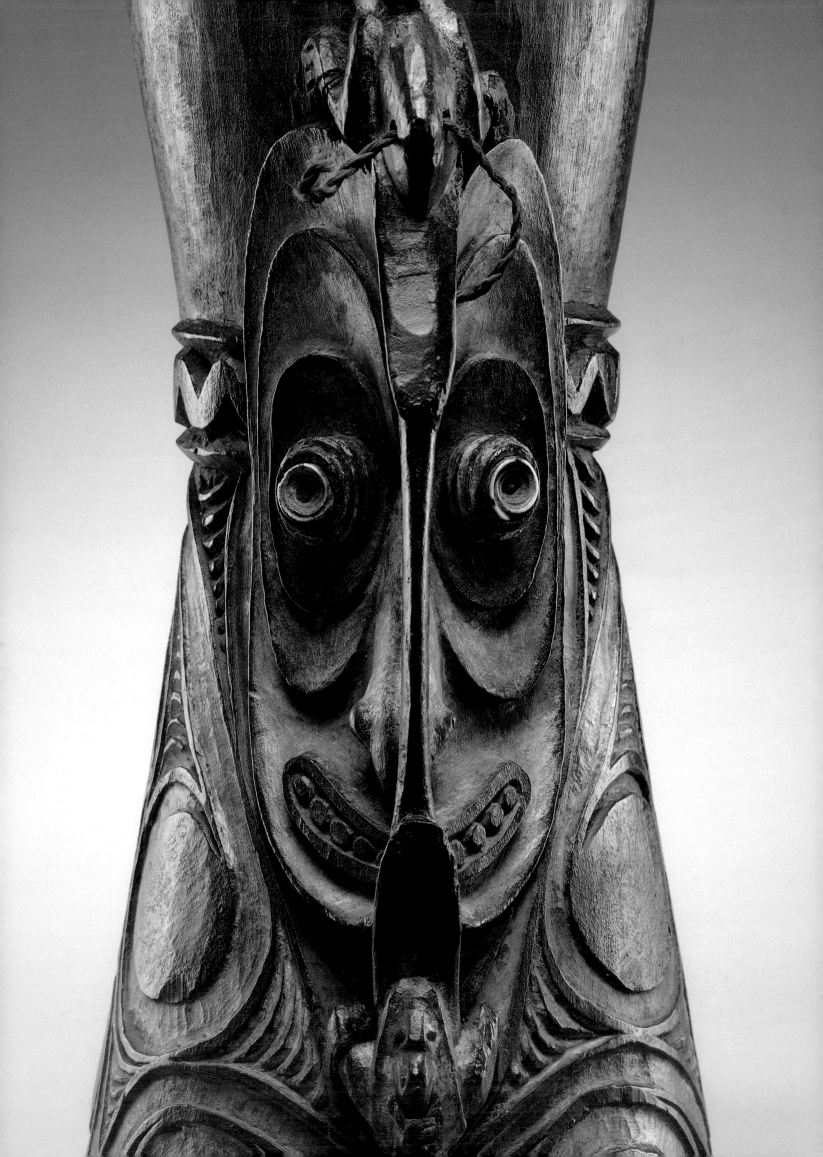

# THE OCEANIC CULTURES

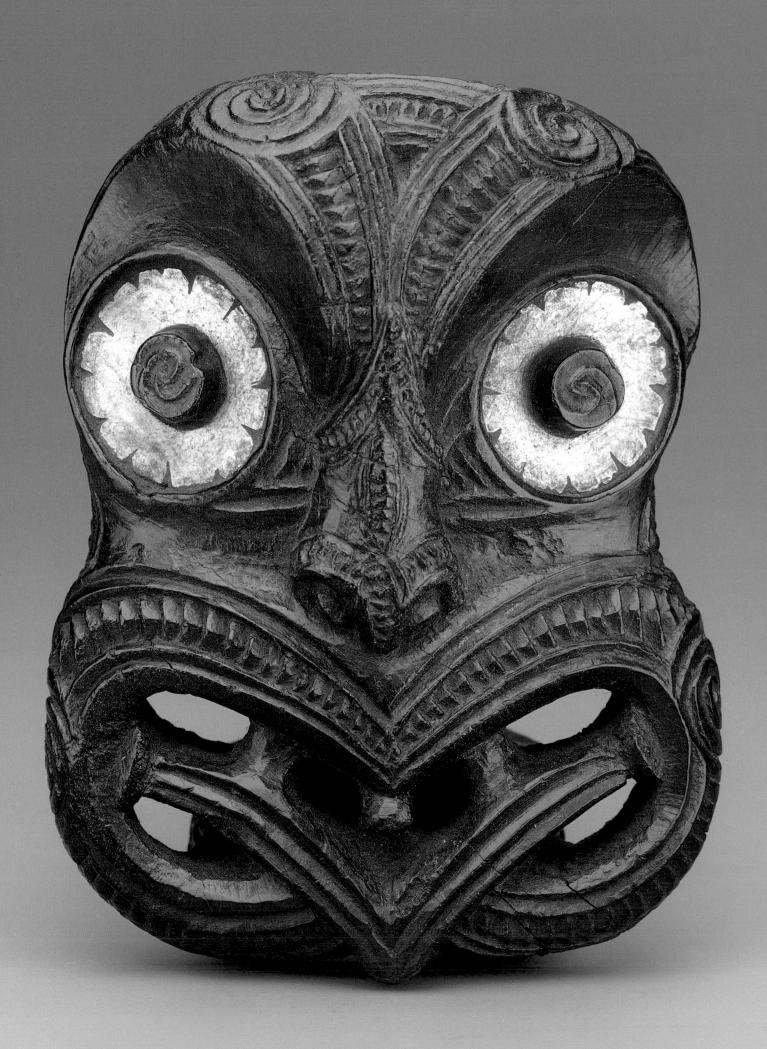

# Introduction

## Early Settlement, Religion, and Art

THE PACIFIC OCEAN COVERS ONE-THIRD of our planet. It is more than twice the size of the Atlantic and washes the shores of five continents and those of the thousands of islands that lie within its boundaries. The island chains of Japan, the Philippines, Indonesia, and Malaysia are among the largest of the geographical features of the Pacific, and each of them has developed its own distinctive culture; the study and illustration of their arts falls outside the scope of this volume. These island cultures to the west have always been closely bound to the traditions and great religions of the Asian mainland and stand distinctly apart from those of the more isolated peoples of what is popularly known as Oceania.

The remaining island groups, Melanesia, Polynesia, and Micronesia, and the continent of Australia produced the sculptures and crafts that form the Masco South Pacific Collection and are the subject of this publication. The three regions are so designated as geographical entities rather than as references to their histories or the way in which they were populated. They encompass a total land mass of about 470,000 square miles, slightly less than three-quarters of which is accounted for by New Guinea, the world's second largest island.

The peoples who inhabit this part of the world have adapted themselves to a larger range of environments than might be expected. Although the legendary South Sea paradise might once have existed on some of the islands of Polynesia, many of the inhabited areas of Oceania are not ideal for human existence. In Micronesia, for example, there are small, low atolls, poor in natural resources, and they are sometimes subject to devastation from powerful typhoons. In Melanesia, there are swampy, flood-prone river lowlands with faunas that include malarial mosquitoes and crocodiles; thick, interior rain forests requiring labor-intensive agriculture; cool, mountainous highlands; and areas of intense vulcanism, all of which support a large part of the human population. These environments have contributed to an underlying belief in the unpredictability and all-pervading power of nature and a philosophy that regards it as a force that must be accommodated rather than modified.

Additional factors account for the threads of continuity that are found among the diverse cultures of the South Pacific. One is obviously the undeniable presence of the sea itself, felt by all of the people except those who live in the high interior of some of the larger islands. Also, because of the moderating influence of the Pacific and the similar latitudes, temperatures do not vary greatly, and most days are hot and humid. Plentiful amounts of rain fall during the wet season, and many islands have a dry season lasting several months. Livelihood is based mainly on agriculture, with a supplementary protein diet supplied from fishing. Meat, always in short supply, is obtained from jungle fowl, chickens, and pigs where they are available.

All of the original peoples of Oceania migrated there from Asia. With the exception of the sweet potato, which came to Polynesia by way of limited contact in prehistoric times with South America, and sago, an indigenous plant in Melanesia, all of the cultivated plants of the Pacific Islands are of Asian origin. The cultures that existed at the time of the coming of the Western world to the Pacific in the late eighteenth century are designated as belonging to the late Stone Age. Agriculture was practiced with the use of the digging stick, and fowl, pigs, and dogs had been domesticated. The adze was employed for woodworking, and advanced methods for making cloth (tapa) from the bark of the paper mulberry tree, and knotting, weaving, and plaiting techniques were developed throughout the Pacific. Except for parts of Micronesia, sculpture is an art form practiced throughout the region.

Although these basic similarities exist, the varying styles and expressions shown by the works in this volume indicate great diversity as well. The original cultural determinants from Asia became less important over the tens of centuries of prehistory and thousands of miles of ocean that ultimately separated the peoples of the Pacific from one another. The distinctive artistic statements and cultural adaptations represented by these objects were produced by indigenous peoples who reacted to their own unique circumstances. To understand something of the nature of their art and its variety, it is necessary to briefly describe the history of how and by whom the Pacific Islands were populated, the religious philosophies of the

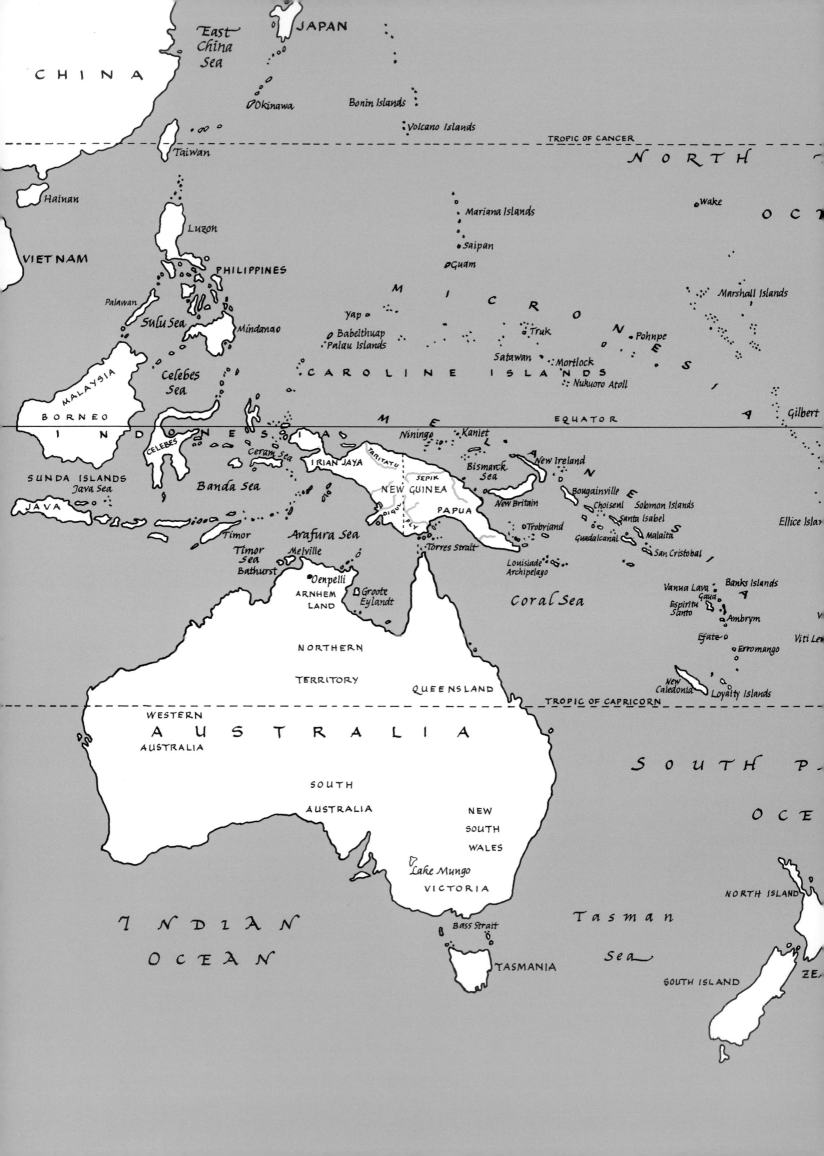

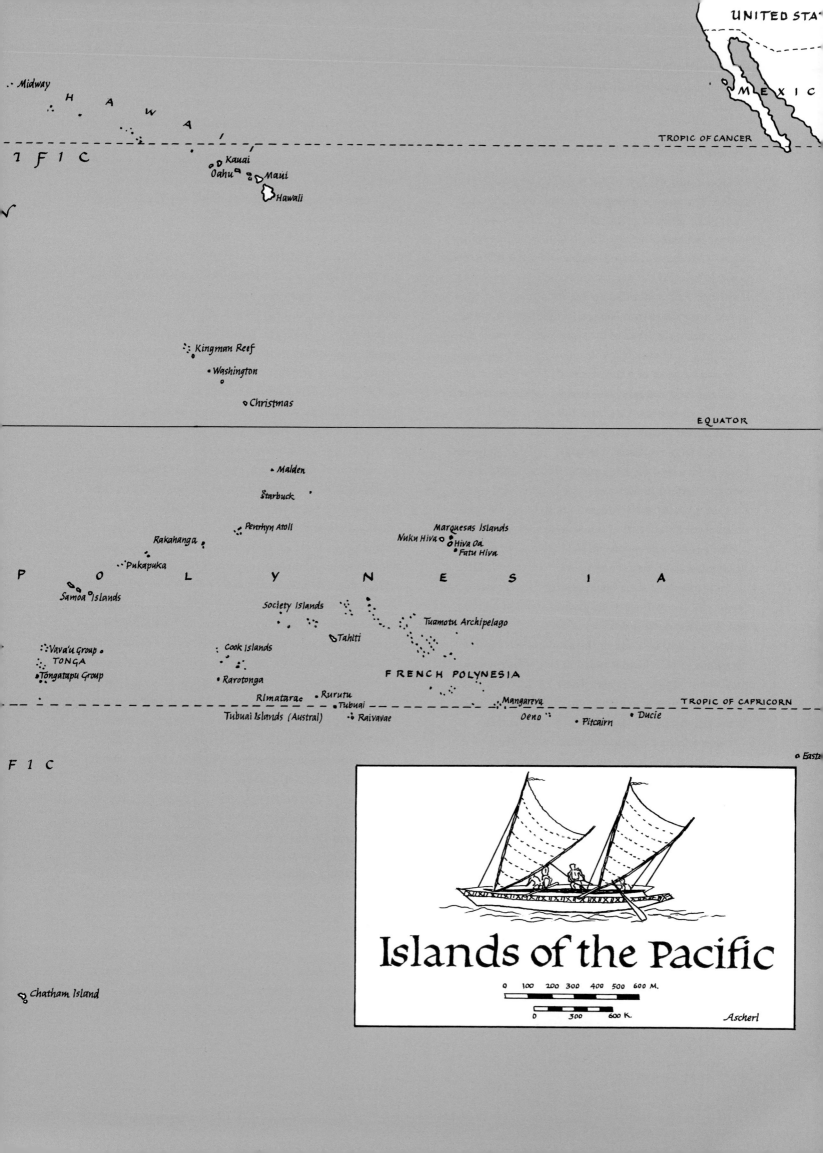

UNITED STA[TES]

MEXICO

TROPIC OF CANCER

Midway

H A W A I

T I F I C

Kauai
Oahu
Maui
Hawaii

Kingman Reef

Washington

Christmas

EQUATOR

Malden

Starbuck

Penrhyn Atoll

Marquesas Islands
Nuku Hiva
Hiva Oa
Fatu Hiva

Rakahanga

P O L Y N E S I A

Pukapuka

Samoa Islands

Society Islands

Tuamotu Archipelago

Tahiti

Vava'u Group
TONGA

Cook Islands

Tongatapu Group

FRENCH POLYNESIA

Rarotonga

Rimatarae
Tubuai

Rurutu

Mangareva

TROPIC OF CAPRICORN

Tubuai Islands (Austral)

Raivavae

Oeno

Ducie

Pitcairn

F I C

Easte[r]

Chatham Island

# Islands of the Pacific

0   100   200   300   400   500   600 M.

0        300        600 K.

Ascherl

people, and the materials they used for the creation of artifacts.

## Melanesia

Melanesia was the first of the three island groups to be settled. The story is a long and complicated one, consisting of a series of Asian migrations, each of which left its own influences behind. The first of these migrations occurred perhaps as early as 50,000 years ago when it was possible to cross the deep water trench that separated Southeast Asia and arrive on the land mass that then joined Australia to New Guinea. At that time, due to glaciation, the water levels of the world were as much as two hundred and seventy feet lower than they are now, and only small bodies of water separated New Guinea from mainland Asia and Australia. Two no-longer extant land masses then existed. One, now known as Sahul, then encompassed today's Tasmania, Australia, New Guinea, and the Malay peninsula. The other, Sunda, comprised Borneo, Java, and the Philippines. Human beings therefore first arrived in Melanesia, specifically New Guinea, on foot, possibly using simple rafts to cross the small channels that were part of this now-sunken land.

The earliest settlements of New Guinea would have been along its shoreline and up its river valleys. Their remains have long since been inundated by the rise in sea levels with the melting of the glaciers about 18,000 years ago. The first datable evidence of homo sapiens in Melanesia is found at a site in the southeastern Papuan highlands of New Guinea called Kosipe which was occupied about 26,000 years ago. These early people were nomadic hunters who used a type of stone blade indented in the center that has its origins in Southeast Asia.

There followed a period of some 12,000 years of slow development which saw the introduction of new tools (including ground stone axes) and the domestication of pigs, all of which had once again been introduced from Southeast Asia. There is evidence in the central highlands of New Guinea that the edible root taro was being cultivated in large, well-tended areas by 9000 B.C. At this time, the sea waters had risen again so that the settlement of the outer Melanesian islands could not be accomplished without the aid of considerable maritime capabilities. However, these skills were apparently available to the people by at least 6000 B.C. when New Ireland, the Solomon Islands, and New Caledonia were all populated. Among the archaeological finds from this period, the presence of a hoelike adze and heavy adze blades with roughly honed edges suggests the practice of some form of rudimentary agriculture and the clearing of forests. Labor-intensive cultivation had also developed in the western highlands of New Guinea by 4000 B.C.

Through linguistic studies, it has been found that around 3000 B.C. a group of people who spoke the Austronesian language began to establish themselves in small communities along the coasts of New Guinea and on some of its offshore islands. Because the interior and the more habitable coastal areas were already occupied, the Austronesians seem to have had little impact on the cultures of New Guinea, where the earlier well-established traditions continued to develop in their own ways, largely undisturbed by these new influences. Groups of Austronesians soon spread to the outlying Melanesian islands, using sea-going outrigger canoes. More efficient means of navigation than had been available previously, including knowledge of ocean current patterns and stellar observations, were probably also employed.

Prior to the Austronesian migration, there is scant evidence of the creation of art. The presence of ocher and white clay in burials and ancient village sites indicates that body painting was practiced from very early times. In addition, although they are not as yet dated, there are a series of stone carvings in the form of mortars with pestles of bird and animal forms from highland areas of New Guinea that may have been made just before the coming of the first Austronesians. Some of them present intriguing similarities to later New Guinea wood sculptures of birds and combinations of human and animal forms.

However, it was not until the coming of the next wave of Austronesian peoples that evidence of a clearly defined art style began to appear. This migration was of far-reaching influence and forms the basis of much of what we now see in many of the art expressions of Oceania. The incursion is known as the Lapita culture, after the name of a site on New Caledonia. Apparently this culture originated in Southeast Asia or the Philippines during the third millennium B.C. and had definitely established itself in New Britain, Santa Cruz, Vanuatu, and New Caledonia during the thousand years between 1600 and 600 B.C. The Lapitas greatly improved the cultivation of root and tree crops and raised chickens and pigs.

## Polynesia

The Lapitas were also great sailors and reached Fiji, Tonga, and Samoa by at least 1100 B.C., if not several centuries earlier. They thus became the first settlers of Polynesia.

They were highly successful traders, carrying such materials as obsidian, stone tools, and their distinctive pottery over maritime distances of as much as a thousand miles. For this, they needed outrigger canoes and highly developed navigational skills involving knowledge of prevailing winds, open water currents, cloud patterns over land areas, bird behavior, and the positions of the stars.

Coarse Lapita pottery was stamped with geometric designs that are reflected in the Polynesian tapa decorations, tattoo motifs, and reliefs carved into clubs, ceremonial staffs, and batons of types that have been employed by artists up until recent times. Some Lapita sherds also bear curvilinear incisions that relate somewhat to the two-dimensional designs of New Guinea as they are found along the Sepik River, on the north coast from the Sepik to Lake Sentani, and among the Asmat on the southwest coast. These motifs are also used in some two-dimensional designs of the Marquesas, and, among those of the remotest of all the Pacific cultures, Easter Island. The curvilinear conception of so much of the sculpture and two-dimensional design of Oceania may originally have been inspired by the early and pervasive presence of the Lapita tradition.

Although Tonga and Samoa were populated by the Lapitas by the beginning of the first millennium B.C., about eight hundred years passed before additional migrations into other parts of Polynesia occurred. Sometime before the first century B.C., however, expansion to the outlying Marquesas was undertaken from the western islands. It was a remarkable achievement, requiring sailing over two thousand miles of ocean without landfall. Double canoes were used, and by utilizing some of the same skills as those developed by their Lapita predecessors, these "Vikings of the Pacific" were able to navigate without the aid of instruments. For their new lives, they brought with them seeds, domestic fowl, and agricultural implements, and by the first century B.C., the Marquesas were successfully populated. Over the next several centuries, the Marquesans continued their explorations. They traveled southeastward some 2,500 miles to Easter Island, which was settled in the fifth century A.D., and then northward an almost equal distance to Hawaii by the year A.D. 500.

Because some of the Cook Islands are less than a thousand miles away from the western Polynesian homeland, it remains a mystery why central Polynesia was not inhabited sooner. Nonetheless, it was not until about A.D. 600 that the Cook Islands, the Society Islands, the Austral Islands, and Mangareva were occupied, again by peoples from the Marquesas. Finally expeditions from the Society Islands set forth for New Zealand, which was probably settled in the ninth or tenth century, even though the earliest confirmed radiocarbon dates are only of the eleventh century. At any rate, New Zealand was the last large habitable area of the world to become populated.

Other contacts between the various Polynesian peoples occurred after these initial migrations. Voyages from Tahiti to Hawaii and New Zealand in the eleventh century have been surmised, and intermittent connections between the various island groups undoubtedly were made over the centuries before the coming of the Europeans in the eighteenth century. However, periods of isolation allowed for independent development, which of course accounts in part for the distinctive artistic expressions to be found on each of the island groups.

## Micronesia

The settlement of Micronesia occurred in a different manner from that of Melanesia and Polynesia. Rather than having been populated in different waves from a single island or island group, these small island chains seem to have been inhabited directly from Asia. Although theories continue to develop, and there is still some debate as to where the original Micronesians came from, they are now thought to have migrated from the Philippines and Indonesia. Linguistic studies have concluded that settlers speaking an Austronesian tongue of an Indonesian nature arrived on the western high islands (that is, the Marianas, Babelthuap, and Yap) by about 2000 B.C. They brought pottery with them which is thought to be from the Philippines and Indonesia. There is no evidence that elements of the Lapita culture ever came to Micronesia. A second migration of eastern Austronesian speakers from Fiji and Vanuatu then settled the central and western islands by the beginning of the first century A.D. Because the Micronesians were such good navigators, considerable contact between the island groups was maintained in prehistoric times.

## Religion

The peoples who inhabited these three widespread areas developed their own beliefs, social customs, and art expressions. These will be described in the sections opening each chapter, but there are commonalities of religion and thought that define all of the cultures of the South Pacific and provide a base for these further discussions.

Throughout Oceania, myths of creation center around primordial male and female gods. The gods may take the form of the Sky Father and the Earth Mother whose progeny ultimately became the humans and the other life forms of the world. They were sometimes regarded as lords of the animal or plant kingdoms or as the originators and creators of subsistence. In every case, the gods were aloof and did not concern themselves with day-to-day events. They were not worshiped, nor were they often represented in art.

Nonetheless, most of the art of Oceania is religious by nature. It is made in response to a series of related beliefs that the universe is governed by invisible forces that can determine and influence the events of life. These forces are thought to be everywhere. While they do not actually cause the behavior and nature of inanimate objects and living things or the inexplicable phenomena of the world, they are expressed by them. Through these forces, a mystical relationship between the people and the elements of their environment is established.

It is also universally believed that the soul can leave the body and exist independently. During life, the soul manifests itself in dreams, and at death, it becomes a permanent part of the spirit world. The soul also has influence on the lives of people, particularly those belonging to the family of the deceased. These beliefs led to the reverence of ancestors in Melanesia, and to the transmutation of ancestor worship as found in to the clan and family deities of Polynesia and Micronesia. Through various complex ceremonies directed towards their forebears, the people tried to influence their present and future. It is understood that none of these powerful spirits and forces could be controlled, but if they were properly respected and treated, they might at least benefit the individual, family, and community. To serve this end, a great variety of prohibitions and ritually prescribed systems of behavior were developed by the societies of Oceania.

Adherence to these time-honored strictures and the ceremonies that surrounded them established a close link between these societies and their beliefs. Preparation for the rituals (which in some Melanesian societies might take years) and the witnessing of those parts of them that could be seen by all served to unite the community. Performers themselves gained considerable prestige for having participated. Traditions, myths, and tribal hierarchies were preserved through these events as well.

The sculptures, architectural decorations, masks, costumes, implements, drums, and other musical instruments that were made for these ceremonies—and comprise much of the art of the Pacific—are far more than simply symbols of ancestors and the life forces of nature. These objects are the personification of the spirit they depict. Sometimes they were used only to remind those who saw them of traditional myths and beliefs. In other instances, if the objects had been exposed to the proper ritual observances, they could serve as temporary abodes for the spirits themselves.

Most Oceanic art is based on the human form, although some animal sculptures and composites also exist. Those that are embodiments of unseen forces cannot be realistic. They are nonnaturalistic and, in some cases, even abstract. As tangible representations of the supernatural, they transmit something of their spirit content through exaggeration of some forms and the reduction or elimination of others. Such other conventions as flexed legs, over-life-sized heads, hunched shoulders, and large hips and feet also suggest the potential presence of a powerful spirit. Much Melanesian art is comprised of these powerful combinations of forms and includes both figures and masks. Such methods of imparting form to these canons of belief are not unique to the arts of Oceania. For example, they are especially prominent in some of the sculptures of west and central Africa.

Another class of human figure sculpture in the Pacific is more naturalistic. Certain carvings refer to specific human ancestors or semihuman deities and as such were conceived to be somewhat representational. Polynesian art is particularly notable for works of this nature, but a similar approach to representation of the human form can also be found in some of outlying Melanesian areas.

### Organic Material

The artists of the Pacific                                their
natural environment to g
and philosophies. Because o.
fauna that exists on the large
much wider choice of materials v.
ration into art objects than in Polyn.
Micronesia, but it seems that practica
existed was at some time skillfully work
ment of a visual expression. In Vanuatu, fo.
spiderwebs were fashioned into head ornam.

some figures and masks. We know of no other place in the world where such an ephemeral material is used for art. Similarly, in parts of interior New Guinea, tree moss is fashioned into rudimentary spirit figures.

Among the organic products of nature, wood is obviously the prime medium for sculpture. Most ceremonial pieces, drums and musical instruments, weapons and shields, utensils, and other items of daily use are made of wood. It was carved with adzes having stone or shell blades. After the initial shaping had been done, smaller cutting tools such as chisels and awls with points of flint, obsidian, sharpened shells, bone, boars' tusks, or shark or mammal teeth were employed to add the finer details. Shark or ray skin was then sometimes used with vegetable oil for smoothing rough surfaces.

Many of the natural materials derived from trees, shrubs, and plants were also carved, woven, sewn, attached to, and made into costumes, accessories, and ritual objects. Such materials include leaves, ferns, stems, palm tree spathes, pith, tree fern, coconut shells, nuts, seeds, fruit, flowers, moss, burrs, paper mulberry bark, roots, and root buttresses. Other vegetable materials that were added to art objects or carved and used separately are gourds, bamboo, grasses, and fibers. The latter were also added as decorative accessories and woven into cords, baskets, masks, and costumes, and even fashioned into three-dimensional human and animal figures.

The use of such a great variety of materials from the plant kingdom was particularly prevalent in Melanesia and reached its greatest expression in New Guinea, where some objects are so covered with decorative and symbolic additions that much of their underlying sculptural form is completely hidden from view. These objects appear as collages of things from the natural world. The origin of this form of additive representation is undoubtedly body decoration, which is perhaps our most ancient art. As we have already seen, there is evidence that it was employed in New Guinea by at least 15,000 B.C. Body decoration is still practiced today, and from recent field photographs and anthropological reports, most of the above-described materials comprise elements of human adornment in one context or another. If anything, there is an even greater variety of items that are worn as body decorations than is found in the art itself.

Any description of the use of such vegetable materials in the arts serves as a reminder of the ephemeral nature of so much of Oceanic art, particularly that of Melanesia. Many works that have survived, including some shown here, are mere skeletons of the images they presented to the people who made and saw them in use. Not only have the grasses, leaves, fibers, and fruits that were originally attached to them long since fallen off, but those bits and pieces that remain are now dried out, brown, and lifeless, providing only a hint of the vibrancy and even more spectacular appearance they once had. This is particularly true of Melanesian art, much of which was newly created for each ceremony, or, if old, renewed with fresh materials before each ritual appearance.

However, certain of the arts of Oceania, especially those of Polynesia, were made to last and were carefully kept and preserved so that they could be passed on from one generation to the next. Such works have survived basically intact. In addition, much additional organic material included in the art is of a more permanent nature. Human and animal skulls were sometimes over-modeled with clay mixed with oil and fruit or nut paste and often painted to represent ancestors and clan totems. The Maori of New Zealand also preserved the tattooed heads of important chiefs and family members. Human hair was added to sculptures and masks in Melanesia and made into beautifully woven necklaces in Hawaii. In New Guinea, bird, animal, and human bone was fashioned into daggers with elaborately incised designs. In Polynesia, whale ivory and animal bone were carved into fan and staff handles, pendants, hair and ear ornaments, and human figure sculptures. Whale bone was also carved by the Maori into short, heavy clubs that were used both for fighting and prestige display. A number of these Polynesian bone and ivory objects show signs of considerable use, and some undoubtedly date from the precontact times of the eighteenth century.

Pig tusks, grown to large sizes, were worn through the septum and sometimes added to human sculptures and masks. This custom was particularly prevalent on Vanuatu. Whale, animal, and human teeth were made into necklaces in parts of Melanesia and Polynesia, and used as inlays for sculptures, staffs, and clubs, particularly on the eastern Polynesian islands. Shark teeth provided the cutting surfaces for weapons in Micronesia and on Hawaii. Bird skulls and beaks were sometimes added to sculptures in parts of Melanesia, and feathers were incorporated into costumes and sculptures throughout all of Oceania. Some of the most spectacular uses of feathers are in the very large headdresses that were worn in ceremonies held along the Lower Sepik River and on the adjoining coast of New Guinea. Feathers were also woven into impressive capes worn by rulers in Hawaii and New Zealand, and they were worked into elaborate mosaic

designs on panels by peoples living along tributaries of the Middle Sepik River.

Reptile and cassowary skins provided the tympani for the drums of Melanesia, while shark skin served this purpose in Micronesia and Polynesia. Marine shells of many kinds were used for inlay, jewelry, pendants, and decorative additions everywhere. On the Solomon Islands, large pieces of tridacna shell were sawn into openwork anthropomorphic designs and placed on mortuary huts in which the skulls of deceased chiefs were kept. Turtle shell was intricately carved in openwork designs and affixed to tridacna disks to make pendants in Melanesia. It was also used for inlay, and the people of the Torres Strait in New Guinea sewed pieces of it together to make masks and head ornaments. On the Marquesas, tortoise shell was cut, carved in relief, and mounted with tridacna shell to form unique head ornaments.

## Inorganic Materials

The inorganic materials of clay and stone were also often used for artistic purposes. The manufacture of ceramics existed in various parts of Melanesia prior to the coming of the Lapita culture, and after its arrival, knowledge of the craft spread to other areas of both Melanesia and Polynesia. In Micronesia, pottery making was introduced from Indonesia and the Philippines. However, the production of pottery died out in many parts of Oceania. This may have been caused by a lack of abundant resources of clay in many areas and the ubiquitous use of wood vessels which could be easily substituted for those made of ceramic. Pottery making did, however, survive and flourish in the Middle Sepik River area of New Guinea where incised and painted cooking and eating vessels were made. In the nineteenth century the Fijians also developed a distinctive form of slab-built pottery and made numbers of incised and relief ornamented water vessels that were coated with pine gum.

There is also an impressive tradition of stone carving to be found in Melanesia and Polynesia. It undoubtedly stretches back to early times, but datable prehistoric stone pieces are not yet known. The mortars and anthropomorphic bird-form pestles from New Guinea that are still found from time to time by farmers in the highlands are presumed to be quite ancient, but no dates have been assigned to them. Many stone artifacts from more recent, but undetermined, times exist as well. Basalt *poi* pounders were made on all of the Polynesian islands. Stone human and animal sculptures, bowls, and mortars are fairly common in Melanesia and Polynesia. They are made of coral limestone, volcanic tuff, and basalt, a much harder stone. Human ancestor figure sculptures of a chalky limestone were carved in central New Ireland.

In addition, monumental stone constructions were erected throughout Polynesia. Many are in the form of large, dressed stone temple platforms that were used throughout the islands by priests for elaborate ceremonies. They were particularly well developed on Hawaii, Easter Island, and the Marquesas. One such multilayered structure on Tahiti so impressed some early explorers that they assumed its construction was of Egyptian inspiration. On Tonga, large tombs faced with coral slabs were constructed for the burial of many generations of sacred kings.

Over-life-sized stone carvings in human form were also made in Polynesia. The most renowned of these are the hundreds of heads and torsos of Easter Island, but monumental figures were also carved from volcanic stone on Raivavae in the Austral Islands and on the Marquesas. Petroglyphs are also found throughout almost all of Polynesia and Melanesia. Many were originally painted, and some have even been carved in bas relief.

Nephrite is only found in New Zealand, and the Maori developed a unique carving tradition to take full advantage of the qualities of this beautiful, dense stone. Hundreds of human-form heirloom pendants were laboriously worked from it, and other bird-form and hook-shaped amulets and tongue-shaped clubs were made as well.

Although volcanic tuff and coral limestone can be carved with relative ease, the working of basalt and nephrite requires hours of hard labor. Techniques of hammer dressing, grinding, and pecking with hard stone tools were used to create the basic forms. Bow drilling was employed to apply circular motifs and the drill holes for suspension. Finer details might then be picked out with tools having points made of small mammal teeth. The Maori cut nephrite with sandstone saws and then worked the stone for hours with wood, stone, and bone tools using abrasives made of sand and water.

## Pigments

The pigments of Oceanic art are both organic and inorganic. Clays of rust, yellow, white, and ocher colors were ground into powders and applied when wet with water. White could also be obtained from the lime of marine shells, and black was formed by charcoal mixed with vege-

table oil. Vegetable dyes were used for tapa decorations.

A number of pigments now seen on Oceanic artifacts were also introduced from the outside world during the last century. Blues, greens, oranges, and certain types of vivid reds and yellows are for the most part trade pigments that have been readily substituted for the rarer and more difficult to prepare indigenous colors. In some instances, trade pigments were applied to older carvings to renew their appearance and spiritual vitality. These synthetic colors often seem garish and inappropriate to our eyes, which seek evidence of the antique in the art of the Pacific. However, aesthetic judgments of this kind were not made in the minds of the creators, and the use of exotic pigments may only have enhanced the importance and power of the objects to which they were applied. The same could be said for the use of other trade materials, such as wool and cotton cloth, glass inlays, beads, buttons, aluminum, tin, and other metals.

*Iron*

With the coming of the European explorers to the Pacific in the eighteenth century, many new materials were introduced. Artists quickly took advantage of their availability, thus maintaining the tradition of using whatever might be at hand for the creation of their works. Not the least of these exotic imports was iron, which, as soon as it could be procured, replaced the points of stone and shell on carving tools, and, ominously, those of weapons as well.

This hitherto unknown element had first become familiar to the Tahitians when Captain Samuel Wallis of HMS *Dolphin* discovered their island in 1767. So many spikes and nails from his ship's stores were traded to the natives for provisions and the company of women that the stores were almost depleted. Unsecured pieces of iron left on shipboard within reach of the islanders were taken as well.

Two years later in 1769, Captain James Cook of HMS *Endeavor* arrived in Tahiti on the first of his three Pacific voyages that would forever change the people and the cultures of Oceania. The purpose of this expedition was to observe from Tahiti the transit of the planet Venus as it crossed the face of the sun on June third. Following this, Cook discovered the remaining Society Islands, sailed south to find Rurutu (one of the Austral Islands), and finally went on to New Zealand, which he was able to identify as being two large islands that were not connected to Australia, as had been previously believed.

While on Tahiti, Cook soon became aware of the natives' obsession with iron, some of which had been obtained not only from Wallis but also from Louis-Antoine de Bougainville as a result of his visit in 1768. Accordingly, Cook tried to restrict its availability to the Tahitians with the now-famous admonition, "No sort of Iron or anything that is made of Iron . . . [is] to be given in exchange for anything but provisions" (cited by Kaeppler 1978, p. 119). Although he was primarily concerned about protecting the morals of his crewmen and the health of the natives, Cook may also have recognized the threat that might ultimately be posed if metal-tipped weapons came into the hands of hostile peoples as discoveries in the Pacific continued. If so, his prescience may have been tragically confirmed when, according to his mate Nathaniel Portlock (cited in Buck 1957, p. 438), he was killed on Hawaii in 1779 by a dagger with a blade made of iron that had come from one of his ships. Despite its source, this information may not be correct. There has been much speculation as to exactly what kind of weapon was actually used. Adrienne Kaeppler (1978, p. 25, no. 89, fig. 40) illustrates a swordfish dagger in the Bishop Museum, Honolulu, which she believes "has a good claim to having been used in Cook's death." Several other weapons in various collections have also been surmised to be the one that killed Cook. It is nonetheless true that the increased availability of iron in Oceania added to the dangers faced by early European visitors.

From the first contacts of Cook and others, the use of iron gradually spread into the rest of the Pacific during the nineteenth and early twentieth centuries. Carving efficiency was greatly enhanced, and larger numbers of artworks could be made in shorter amounts of time. Objects cut with iron blades show sharper and more precise details than the rougher stone- and shell-carved examples. Many sculptures in Oceanic collections (including some in the Masco Collection) were made with metal tools. However, in certain pockets of Melanesia, particularly in the interior of New Guinea, in the highlands and along the Upper Sepik River, carving with stone, shell, and animal-tooth tipped tools has continued until recent times, to provide the finishing details on objects whose basic forms had been cut with metal.

The Decline of Native Cultures

Captain Cook's second voyage took place between the years of 1772 and 1775 with two ships, the *Resolution* and the *Adventure.* Its purpose was to discover the fabled

Southern Continent. Setting forth from Capetown, he circumnavigated the seas of the Antarctic, and although he came close, he never made landfall of Antarctica. Cook then returned to New Zealand, sailed to Easter Island, visited the Southern Marquesas, went to Tonga, and then to Melanesia, where he spent two weeks on New Caledonia, and made three separate landings in the New Hebrides (Vanuatu).

The third voyage of 1776–80 was undertaken with the ships *Resolution* and *Discovery* to find the elusive Northwest Passage. Cook first stopped again in New Zealand, then Tonga, Tahiti, and the Cook Islands, where he discovered Atiu and Mangaia. Sailing north, he came upon the unknown islands of Niihau, Kauai, and Oahu of the Sandwich Group (Hawaii) in January 1778. From there, he went to the Northwest Coast of North America and sailed through the Bering Strait into the Chukchi Sea before returning to the Hawaiian Islands in November. At that time he discovered Maui and the great island of Hawaii itself. It was on Hawaii at the age of fifty that he was killed in January 1779.

During each of these stops, objects were exchanged, and communications were established with the native populations that brought them knowledge of exotic customs, beliefs, and goods beyond imagination. Cook's voyages heralded the coming of increasing numbers of explorers, traders, whalers, adventurers, and missionaries who would discover, exploit, and convert the natural wealth and people they found there. These incursions could do nothing but bring rapid change and the ultimate impoverishment or destruction of many of the native cultures of Oceania as they had existed in precontact times. Although the introduction of metal initially increased the productivity of carvers who continued to fashion objects for traditional purposes, a decline in aesthetic quality was soon to follow. By the beginning of the nineteenth century, the idea of making art for exchange to foreigners began to take hold in Polynesia. Objects were made to satisfy the needs of curio collectors, not those who had a genuine interest in precontact cultures.

Adzes fitted with old stone blades with geometric relief carvings on the handle were manufactured for this purpose on Mangaia of the Cook Islands, as were richly decorated "ceremonial" paddles and food bowls on the Austral Islands. During the mid-nineteenth century, the Maori began to make carved treasure boxes for sale, and by about 1870, Easter Islanders were carving replicas of their distinctive figure sculptures for commercial purposes. Besides having iron tools, the artists also availed themselves of various kinds of easily workable soft woods brought in from the outside.

In addition, at the beginning of the nineteenth century, missionaries began to arrive in Polynesia, and they quickly converted the people to their religions. Artists not only lost the motivation to create objects related to their original beliefs, but the people themselves were often forced to destroy the "pagan images" that had survived from earlier times. In other instances, the destruction was carried out voluntarily by the natives so that the missionaries would agree to come to them. Much else was simply allowed to decay.

Similar events also occurred in Melanesia some seventy-five to one hundred years later. Missionaries did not seriously affect the religious beliefs of this area until this century, and some remote peoples have continued to maintain their traditions up to the present time. Instances of missionary ordained destruction of images are not as common here as in Polynesia. Tourist art began to appear from the Trobriand Islands of New Guinea at the turn of the century, and commercial carving centers were active along the Lower and Middle Sepik River from about 1930.

Nowadays, little legitimate ceremonial art is being made in Oceania except in remote areas of New Guinea, New Ireland, and New Britain. Even among these creations, there is little of the quality of the works of earlier times. Cottage industries have sprung up on many of the islands to supply tourists, who arrive in increasing numbers on cruise ships vainly seeking genuine old pieces. The once-great art traditions of the Sepik River are now represented by thousands of ghastly mud-smeared, mass-produced figures and masks being hacked out in what the villagers themselves call "carpenter shops." It is hard to believe that such travesties are being collected privately and by some museums, and some have even been the subject of exhibitions. When compared to the authentic Sepik carvings in the Masco Collection, the degradation of style and content is easy to see.

All of the art shown here was made when traditional values still prevailed and influences from the outside world had not yet disrupted native life. A review of the histories of settlement and migrations, the underlying philosophies, systems of aesthetics, and uses of materials and techniques that have been briefly described will help to define some of the common denominators of Oceanic art as well as to provide an explanation for the fundamental differences that can be found among its many styles. The native peoples of the Pacific may have origi-

nally come from the same parts of the world, held similar basic beliefs, used the same kinds of tools, and worked with materials from their immediate environment, but once their migrations ended, they developed their own cultures and expressions. They were subject to the demands of livelihood in their specific parts of the world, to their particular histories, to relative isolation or influences from the outside, and to customs that grew and developed over centuries, having proven efficacious in dealing with the needs, dangers, and demands of the locality.

The resultant diversity in the art styles of Oceania has made it possible for those who study its forms to examine a work taken completely out of its original context and accurately identify its origin as to island group, and, if appropriate, to a specific style area within that group. Each of these objects is a discrete expression that embodies the unique components of the culture from which it comes. Now that the continuities have been described, the following sections will examine some of these singular differences in further detail so that the variety of the many expressions of Oceania can be understood and recognized.

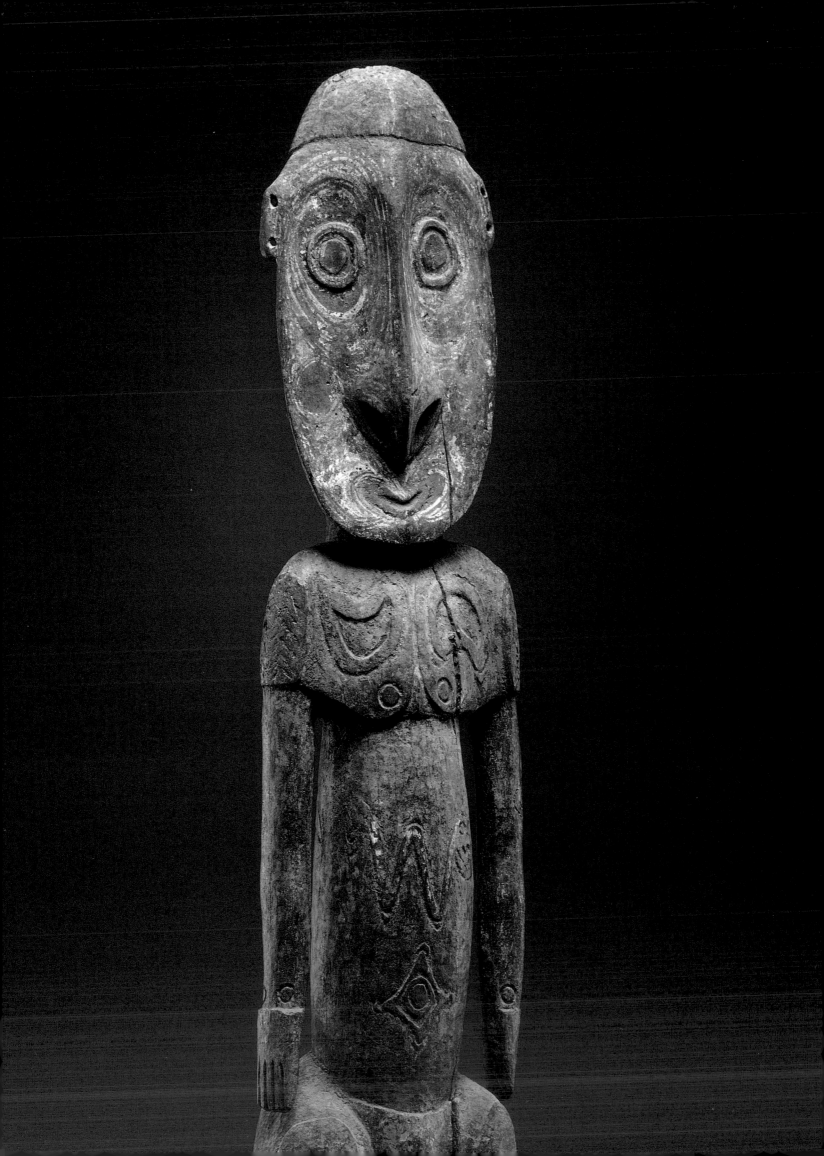

# Melanesia

ELANESIA IS COMPOSED OF A SERIES
of archipelagoes of large and small islands in
close proximity to one another. It stretches
along a twenty-five-hundred-mile band between the
Equator and the Tropic of Capricorn, running in a
northwest-southeast direction to the northeast of Aus-
tralia. The islands and island groups are New Guinea, New
Caledonia, Vanuatu (previously the New Hebrides), the
Solomons, New Britain, New Ireland, and the Admiral-
ties. The areas supporting human populations consist of
rain forests, lowland swamps and river basins, and moun-
tainous highlands of volcanic origin.

The great diversity and mixture of racial types on each
island, and even from group to group on some of the
larger islands, has resulted in a profusion of local cultures
and art expressions. Melanesia is by far the richest art-
producing area of Oceania. Indeed, it is not much of an
overstatement to say that every object used by its people
was decorated in some way or other. Weapons, food bowls
and containers, eating utensils, tools, musical instru-
ments, canoes and their equipment, architectural
ornaments, neck rests, and stools may bear relief carvings,
engraved designs, paintings, vegetable ornaments, shell
inlays, and other embellishments that render them into
significant works of art in and of themselves.

Belief that the spirit world pervaded every aspect of
life and niche in the environment motivated artists to
suggest its presence in articles of everyday as well as cere-
monial use. Among the relief sculptures and curvilinear
and geometric surface designs on many utilitarian objects
are human and animal faces and figures. It should also
be noted that in Melanesia there is not always a clear dis-
tinction between ceremonial and non-ceremonial art.
Shields, spears and other weapons, staffs, and adzes were
often made for ritual purposes and displayed along with
the masks, figures, costumes, and paraphernalia more
commonly associated with ritual cycles.

Melanesian religions were dominated by a profound
reverence for ancestors. It was believed that the ancestors
of a family were closer to their descendants than were any
other deities, and much art was made to honor them.
Human figures were carved to serve as forms the ancestor
spirits might temporarily inhabit, and during ceremo-

nies, masked and costumed dancers became infused with
their presence. The hair, bones, and skulls of important
deceased males were sometimes preserved and added to
these figure sculptures and masks so that their individual
presence might be assured. The ancestors' voices were
represented by the sounds of drums, flutes, pan pipes,
conches, and other trumpetlike instruments.

The origins of the deep respect held for ancestors in
Melanesia can be traced to two creation myths that are
told in varying forms throughout the islands. One is based
on an antagonism between humans and spirit forces and
the other represents a more benign relationship between
them. In the first, it is said that in primeval times, the
world was peopled by gods and protohumans who sud-
denly became threatened by a man-eating demon. He
took the form of a human but sometimes is described as
having the characteristics of an eagle or a boar. In
response to the danger, all of the inhabitants of earth fled,
leaving behind only an old woman who miraculously
conceived twin boys. As they grew up, she taught them
the arts of agriculture and warfare. After a long conflict,
the twins killed the demon, cut up his body, and boiled
the flesh. The gods and protohumans then returned and
honored the twins with ceremonies that included eating
the flesh of the demon. The twins then took wives and
populated the world with the original ancestors who
became the founders of the important clans in each
community. This story can be seen to provide the basis
both for ancestor worship and the headhunting cults and
ritual cannibalism that were known throughout Mel-
anesia.

The second creation myth concerns the exploits of a
culture hero in which he himself, or animals that do his
bidding, dives to the bottom of the sea to bring the land
to the surface. The hero then shapes the land, shooting off
pieces of it with arrows to create islands, and forming
mountain ranges where he throws his tools. The origin
of agriculture is attributed to the sexual union between
him and the Earth Mother. When his seeds penetrated
her body, she changed into a shapeless old woman. Upon
taking the seeds from her body to give to humans for
their crops, she regained her youth.

Although these stories provide a background for much

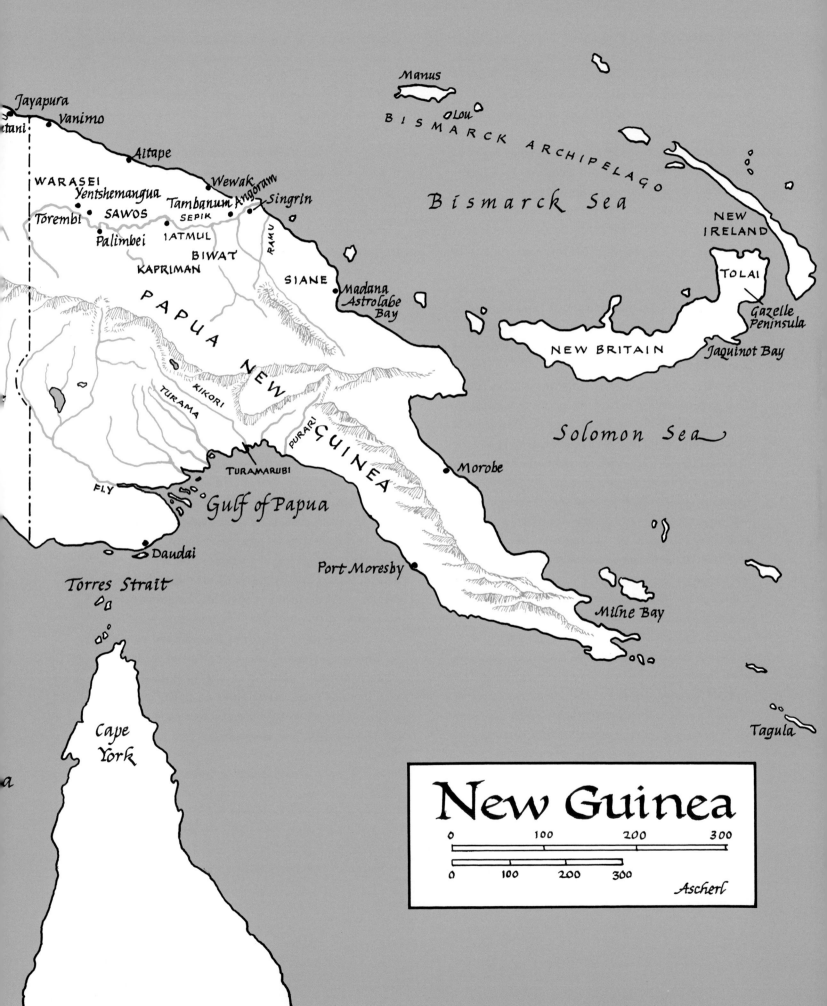

PACIFIC OCEAN

Manus

BISMARCK ARCHIPELAGO

Lou

Bismarck Sea

NEW IRELAND

TOLAI

Gazelle Peninsula

NEW BRITAIN

Jaquinot Bay

Solomon Sea

Jayapura
Vanimo
tani
Aitape
WARASEI
Yentshemangua
Wewak
Torembi
SAWOS
Tambanum
Angoram
Singrin
Palimbei
SEPIK
IATMUL
RAMU
BIWAT
KAPRIMAN
SIANE
Madana
Astrolabe Bay

PAPUA NEW GUINEA

TURAMA
KIKORI
PURARI
TURAMARUBI
FLY

Morobe

Gulf of Papua

Port Moresby

Milne Bay

Daudai

Torres Strait

Cape York

a

Tagula

# New Guinea

| 0 | 100 | 200 | 300 |

| 0 | 100 | 200 | 300 |

Ascherl

Melanesian art, images relating to them are not easily identified. The man-eating demon may sometimes be represented in figures having such attributes as a gaping mouth with sharp teeth, a protruding tongue, clawlike fingers, and the placement of the hands on the abdomen. He also may appear in the guise of a war or hunting god. Depictions of the Earth Mother and the primordial twins are even harder to find, and it is usually not known whether sculptures of boars or birds refer to animals in the entourage of the culture hero or to specific clan stories.

Most Melanesian human masks and figures depict culture heroes or mythical or real ancestors. Each have individual names that are recognized by the group to which they belong, and the manner in which they are carved is governed by clan myths. Specific information of this kind rarely accompanies the objects that have come down to us, and most of them are generally referred to as ancestor figures or masks, which, in a broad sense, of course, they are. The individual established his identity through the knowledge of the origins of his family and clan, and it was this that interested him more than the actual beginnings of the world.

Another class of spirits are those that dwell in nature. They were believed to inhabit the sea, the mountains, the rivers, and the bodies of certain animals. They behaved unpredictably, bringing either misfortune or good luck to the people, their actions dependent on whether or not the spirit had been properly honored. Because the iconography of Melanesian art is so complex, single objects may represent a number of different beliefs and depict more than one spirit. We can therefore only suggest a small part of the meaning these works had in their original contexts.

Each of the natural and/or human spirits represented in the art possessed a power known as *mana*, a force that required the utmost respect and attention if the spirit was to provide assistance to mankind. Great care was taken not to anger the spirits by adhering to time-honored prescribed customs and moral obligations that were associated with each of them. Sickness, death, poor crops, the inability to have children, and natural disasters were thought to be the result of lapses in behavior and esteem, and a complex system of taboos existed to provide a proper and beneficial relationship between human beings and the spirit world.

Melanesian society was dominated by males. The Sky Father of the myths of origin was more highly regarded than the Earth Mother, and where succession of leader-

ship occurred, it was patrilineal. In cultures where succession was not the custom, an enterprising male, through ambition, strength of personality, and character, and with the aid of spirits, could become the head man. In either case, the family unit was very strong, and the clan systems that developed were based on descent from a male ancestor. Male elders in each community were also highly regarded as decision makers and interpreters of the law, and they were frequently deferred to by chiefs and clan leaders.

The role of males in Melanesian society was enhanced through ceremonies and initiations that were held at important moments in life. Such rituals might mark the taking of a name, circumcision, the passing from adolescence into the status of adulthood, marriage, accession to a level of leadership, and death, at which time the most powerful males entered the world of the ancestor spirits. In some communities, particularly on Vanuatu, men were able to reach ever-higher social levels through sacrifices of pigs and the acquisition and distribution of goods that were used to pay for elaborate displays and feasts. At each occasion, they were elevated to a higher grade. The attainment of each grade did not necessarily depend on the age of the aspirant himself or the observation of a passage of life. Rather, accession to each level involved the right to display and use certain ceremonial objects which was gained through the giving of a feast and the killing of pigs. Only the wealthiest individuals could attain the upper levels, and upon death, these men would inhabit the realm of the ancestor spirits.

The art that was made for these passages of life, initiations, and grade societies takes many forms. Masks and costumes covering most of the body of the wearer so that the human element was concealed were worn in dramas that reenacted the myths of each cult. Sculptures ranging from a few inches in height to monumental, over-life-sized creations were displayed to personify and symbolize supernatural forces and ancestors. Most of them are anthropomorphic males, but carvings of crocodiles, birds, pigs, fish, and other animals also exist. The human sculptures and masks sometimes include plant forms and animal imagery in their compositions to suggest something of the presence of other spirits. Masks and faces with birdlike noses, or lizard, insect, or bird forms on the faces and ears indicate that these animals are part of the ancestry of the clans that display them.

Many other objects also include human and animal motifs among their decorations, such as the clubs, ceremonial adzes, paddles, and dance shields that were carried

by performers in rituals. Percussion and musical instruments were also decorated with representations of spirits. Hand, slit, and friction drums, flat, tongue-shaped boards known as bullroarers (which are swung over the head to make a humming noise), and mouth and nose flutes often bear relief ornament and painted designs. Pan pipes, horns made of gourds, and conch shells are also sometimes engraved with fine geometric, animal, and human motifs. In addition, in New Caledonia and parts of New Guinea, cult houses were erected where the young bachelors and other men gathered for meetings. Sacred objects were kept in them, and they were decorated with gable masks, house posts in human form, roof finials, and paintings on palm spathe panels representing spirit figures and faces.

On first encounter, one is usually overwhelmed by the spectacular, emotional, and often threatening quality of much Melanesian art. Its scale, the exuberant use of color, the aggressive sculptural forms, and the seemingly limitless addition of decorative ornament tend to obscure the fact that there are actually several strains of expression to be found among these styles. Although there are exceptions, the styles of the island groups of New Guinea, New Ireland, New Caledonia, New Britain, and Vanuatu are the more monumental and dramatic, with a tendency to distortion. The art from certain other areas such as the Trobriand Islands, the Admiralties, the Solomons, Cenderawasih Bay, and Lake Sentani is comparatively formal and understated. Works from these regions are generally smaller in scale and somewhat naturalistic in appearance.

Much of the art in this latter style does not employ color in the spectacular manner in which it is often used on works from the central areas. If it is applied at all, it is used sparingly and in symmetrical patterns. Fine inlays of shell are also sometimes meticulously set into sculptures to provide elegant decorative designs in the place of pigment. Many figures completely lack surface embellishment of any kind and rely on carefully modeled, smooth, oiled features to transmit their spirit content.

Because of its formal qualities and its tendency towards naturalism, this particular art expression becomes one of the most easily identified among the sculptures of Oceania. Examples from western New Guinea at Lake Sentani and Cenderawasih Bay reflect stylistic elements from Indonesia. The fine decorative art and human figure sculpture of the Trobriands is another notable manifestation of it. Much of the art of Polynesia also shows close affinities to this aesthetic, especially among the sculptures of Fiji, Tonga, Mangareva, Hawaii, and Easter Island.

With such a long history of settlement, migration, trade, and exposure to various outside influences as has occurred in Melanesia, it is impossible to unravel all of the sources for its many art expressions. A few, however, are relatively easy to identify. For example, there is the already-noted correspondence between the two-dimensional designs of Lake Sentani and Cenderawasih Bay with those of Indonesia. We can also suggest that the basis of the curvilinear motifs found in much of the art of Melanesia can be found in the relief designs on early Indonesian bronzes that were traded to various places. Fragments and examples of them have been found on some of the islands, particularly New Guinea. In addition, the presence and pervasive influence of the Lapita culture should be recalled as a basis for some two-dimensional designs.

Over the years, various theories have been developed to provide a stylistic and chronological context for this art despite the difficulties presented by the lack of much archaeological evidence. Styles such as "the primary," "the curvilinear," and "the beak" were described by Felix Speiser (1936) and assigned to specific periods. Similarly, Carl Schmitz (1969, pp. 41–46) found evidence of either Neolithic or Bronze Age expressions throughout the sculptures of Oceania, the former obviously being earlier than the latter. Other connections to north Asian art styles have been made, and such scholars as Robert von Heine-Geldern (1937) and Miguel Covarrubias (1954, pp. 9–72) have connected motifs found throughout the Pacific basin to early Chinese bronze relief designs. Carl Schuster (1951) and Mino Badner (1966) have also made similar studies that relate some motifs from the art of the Far East to those of Melanesia, Polynesia, and even the Americas.

While there may be some validity to parts of most, if not all, of these ideas, local conditions and independent development also account for much of the richness and variety of Melanesian art. No specific influences still exist in their pure unadulterated forms, and if there were any prototypical styles from which later expressions developed, with the exception of Lapita pottery and some early Indonesian bronzes, the original works have long since disappeared. In cases where a certain object might be seen to have a predominance of one particular stylistic trait over another in its overall conception, it should be remembered that there is much borrowing and amalgamation of design elements and forms within these arts.

Melanesian art represents a mixture of local developments with a variety of influences that stretch back to

early times and continue into the twentieth century with the incorporation of exotic pigments, materials, and motifs. The combination of these factors as well as those of history, environment, and belief have produced a series of distinctive expressions that are among the most diverse of the world.

# Polynesia

POLYNESIA COVERS A VAST AREA OF THE Pacific in the form of an equilateral triangle with sides of almost five thousand miles. Easter Island and New Zealand form the base, and Hawaii is at the apex. Even though it has strong cultural links to Melanesia, Fiji has also been placed in the Polynesian section of this volume. Notable among its Melanesian customs are the existence of men's secret societies and the past practice of cannibalism. The population of Fiji is also predominantly Melanesian, although some Polynesians settled on the easternmost islands. Despite a Melanesian presence, however, Fijian art styles are much more closely related to those of Polynesia.

The Polynesian islands comprise both low atolls and high volcanic masses and are divided into three groups: the central islands, consisting of the Cooks, the Societies, and the Australs; the western islands of Fiji, Samoa, and Tonga; and the outliers of New Zealand, the Marquesas, the Hawaiians, Mangareva, and Easter Island. Geographically, New Zealand differs considerably from the other Polynesian islands. It is located in a cooler subtropical zone, and its over one hundred thousand square miles of land area supplied abundant natural resources of wood, stone, and flora and fauna not found elsewhere in Polynesia. Nonetheless, its art and customs are typically Polynesian. Polynesian culture is noted for the social stratification that grew under the control of nobles, royal families, and priests. This system engendered the near deification of the most important people in each community. Although the technology of Polynesia was at the same low level as that of the rest of Oceania, the presence of numerous full-time specialists who did not have to concern themselves with the problems of day-to-day existence and the political organization with which they surrounded themselves led to the development of highly advanced archaic cultures that were several stages beyond those of Melanesia.

Although these factors gave rise to a belief that humans could control their destiny to a far greater extent than was believed by those who lived in other parts of Oceania, religion still played an important, if somewhat different role in the lives of Polynesians. There were a large number of deities incorporated into the mythology, many of whom were highly regarded. The three cosmic gods, however, remained largely aloof from daily life and were not important to ceremonial traditions. These were the principal creator, Tangaroa, a sea deity; Tane, the god of fertility and crafts; and Rongo, the god of agriculture.

Below them were gods related to such activities as fishing, healing, navigation, warfare, and especially certain highly esteemed crafts including canoe and house building, wood carving, and the creation of tapa and tattoo designs. These patron gods were thought to be descendants of the cosmic deities. They were influential in the affairs of men, and therefore revered and ceremonially honored. Also important were numerous local deities, culture heroes, and demi-gods who watched over families and communities. Many of these were ancestral and had originally been human beings.

Although all such deities were respected, it is not quite correct to say they were worshipped. They were approached more as beings that had to be placated and properly treated so that they might be manipulated into bringing benefits to those who did so. The minor gods were served by powerful priests who were mediums of communication with them and the arbiters of religious custom and behavior. The priests' positions were hereditary, and, to maintain their status, they relied greatly on the art of oratory which took the form of sacred chants and oracular pronouncements.

This priest class also had the power of controlling the effects of *mana* and *tapu* on the people. The concepts of *mana* and *tapu* held the religions and societies of Polynesia together. Although the belief in *mana* was also present in Melanesia, there it was related specifically to the presence of spirits, and it did not exert quite as much of a binding force on its cultures as it did on those of Polynesia.

In Polynesia, *mana* was regarded as a supernatural force that had an influence on all the achievements and abilities of humans. It was everywhere, but its distribution in nature, objects, and mankind was not consistent. *Mana* could be acquired through inheritance, but ordinary people could gain it and increase their possession of it through ritual performances and careful attention to patterns of behavior and pursuits thought to be particul-

arly beneficial. It might be easily lost through carelessness, ignorance, or out of neglect to follow any number of meticulously prescribed actions. Bad fortune could also deprive a person of his *mana*. An individual who was taken captive or killed lost all of his accumulated *mana* to his adversary. The more *mana* an individual had, the more powerful he was, and many deities were regarded as different from mortals only because they possessed greater amounts of it.

*Mana* was recognized in an individual by his position, skills, reputation, and influence. A person might show its presence through acts of courage, great skill in such activities as carving, dancing, or entertaining, and the ownership of things that had their own *mana*. Among the latter, *mana* was measured by degrees of efficiency, association, and effectiveness. An adze that was particularly well balanced, was fitted with an especially hard and sharp blade, and had been previously owned by a master carver had more *mana* than an average tool with no history. Fishing equipment that brought in good catches, unusually fine and seaworthy sailing canoes, weapons that had proven their effectiveness and deprived others of their *mana*, and drums that were judged to make the best sounds are other examples of the presence of this force within the things that were employed in the lives of the Polynesians.

A necessary component to *mana* is *tapu,* from which, of course, is derived the English word "taboo." *Tapu* consisted of a series of prohibitions, abstinences, and things, actions, and places that were to be avoided or at least approached with caution or the proper preparation in order to protect one's own *mana*. The presence of *tapu* was proclaimed by those who possessed great amounts of *mana*, especially priests, and might apply to creatures, people, and customs. Food was a commodity that was particularly subject to *tapu*. Chiefs could only eat indoors with utensils that had not been or would not be used by anyone else. At certain times, the food they ate could not touch any part of their person, including the lips. If such rules were not followed, great loss of *mana* would occur.

Death might even result if a common person ignored some restriction or came into contact with things that had been declared *tapu*. Certain places and objects acquired *tapu* simply by having been exposed to someone with great *mana*. Chiefs were therefore expected to monitor their behavior carefully so that their subjects would not be exposed to these potential dangers. Everyone had to know how to use and handle objects infused with *tapu* and how to prepare themselves ritually for encounters with individuals who would otherwise be extremely dangerous to them.

Almost all of the observances relating to the maintenance and enhancement of a person's *mana* were carried out by men. The societies of Polynesia were male oriented to an even greater extent than those of Melanesia. Women were not permitted to eat with men, to use canoes unless for very necessary travel with the family, or to participate in any activities with men that related to men's acquisition of *mana*. Exceptions can be found among the well-born women of New Zealand and Hawaii who sometimes reached the status of chieftainesses, but in most other areas women only played supporting roles.

To become an important leader through inheritance, a man had to be the first born who could trace his ancestry down a long line ultimately to the founding deity of the family. In order to prove his affiliations, the names of each ancestor had to be recited, a process that among the most powerful families might include as many as fifty names. The living descendants bearing such impressive lineages were thought to possess the accumulated *mana* of all those that had preceded them. Each generation was therefore regarded as more powerful than the last. Because of this belief, the Polynesians have sometimes been referred to as among the least conservative indigenous peoples of the world. They always looked forward to the next, more *mana*-infused generation, and readily accepted new concepts and customs as they were introduced to them. This led to the quick absorption of their cultures into those of the outside world when the Europeans came to the Pacific after Captain Cook.

While this observation concerning the lack of conservatism in the Polynesian outlook may be true in one sense, the art of Polynesia cannot be regarded as anything but conservative. The most important art form of Polynesia was not, in fact, sculpture, but the spoken word. What was said about a person or object is what gave it its *mana*. Recitation of genealogies, ritual incantations, chants, songs, and speeches relating to people and things added to their power. Works of art therefore become symbols of their histories. Stories of who had made them, why they had been made, who had owned them, what they had represented, how they had performed, and what sort of status they had conferred on the people who had owned and used them were told again and again. These stories became far more important to those who heard them than the actual appearance of the object. Without the accompaniment and accumulation of these words, a work would

lose its *mana* and, to the Polynesians, would thereby become relatively meaningless.

Polynesian art was therefore meant to survive and is not of the ephemeral nature that characterizes so much of Melanesian art. Many pieces were passed from one generation to the next. Although we have no way of knowing how old they are, because they were so carefully kept, some wood sculptures undoubtedly date from well before the eighteenth century, and certain of the ivory, bone, and stone carvings must be truly ancient.

Most of the sculpture is in human form, and animal imagery is not common except in some of the creations of New Zealand and Easter Island. There is no mask-making tradition here. The reasons for this have to do with the lack of strong beliefs in the power of magic supernatural forces in Polynesia. It was not therefore necessary for the people to disguise themselves as spirit beings and become possessed by them, especially when it was believed that humans could attain so much power from their own ancestry and *mana* as to become almost like gods themselves.

Another factor often lacking in Polynesian art is the sense of drama and emotion that pervades so much of Melanesian art. While some of the figure sculptures from Hawaii, New Zealand, and Easter Island are comparatively dynamic and express a kind of kinetic energy, many Polynesian sculptures in human form are self-contained, sober, and formal in their conception. Heads are disproportionately large, arms hang straight down to the hips or the hands rest on the abdomen, and the legs are flexed at the knees. Use of color is limited, and bone and shell inlay is employed throughout the area. It will be recalled that such features are also found among the styles of outer-island Melanesia.

Because so many surviving Polynesian works are small, it is tempting to conclude that this is a characteristic of the art. However, enough sculptures of large scale have survived from New Zealand, Hawaii, the Marquesas, and Mangareva to indicate that in places where good sources of wood were available, works of considerable size were made.

Among the arts of the central islands—the Cooks, the Societies, and the Australs—there is much emphasis on fine surface ornamentation. It consists of meticulously repeated symmetrical geometric and abstract anthropomorphic relief patterns. Figure sculpture is rare here, and when it does appear, the forms are abstracted and reduced to a series of angular components.

There is less application of surface ornament and more emphasis on three-dimensional carvings of the human figure in the art of the outlying islands. Some of these are of relatively large size and naturalistic proportions. The art of both New Zealand and the Marquesas combines rich surface embellishment consisting of both curved and angular lines with the full three-dimensional treatment of the human form.

Polynesian art is harmonious, formal, and restrained. There is a balanced quality to it, particularly when compared to the bold freedom of the dramatic expressions of Melanesia. As is the case with the arts of all indigenous people, the physical appearance of the art and evolution of styles were arrived at unconsciously and governed by pervading beliefs and philosophies. In Polynesia, the importance of craft, the presence of priests who were also craftsmen, and the existence of certain deities associated with some of the more significant crafts are factors that have already been emphasized. All of them provided great incentive for the artist to demonstrate his skills through his works. To achieve status, however, he not only had to have the ability acquired from a long apprenticeship to a master, but he had to demonstrate his genealogical relationship to predecessor craftsmen. He also had to know the rituals, chants, and stories with which to accompany his works as he made them so that they would acquire their initial layers of *mana*.

The *mana* of the artist himself could be imbued into his works through the creative energy, skill, and words that flowed from him to them. Even the amount of time he spent completing a work could add to its indwelling power. This would account for the meticulous, time-consuming application of the surface ornament found in the art of the central islands, the Marquesas, and New Zealand. Among certain old and heavily decorated objects of the Maori, in fact, it is occasionally possible to find areas where the decorations are incomplete and some surface patterns have not yet been applied. It is as if the artist had intended to keep returning to his creations in order to add more of his *mana* to them over a long period of time. In addition to *mana*, Maori artists sought to incorporate three other intangible forces into their sculptures: *ihi* (power), *wehi* (fear), and *wana* (authority). If he was successful, those who saw the completed carving would respond to it on both emotional and physical levels.

The naturalistic strain that runs through much Polynesian figure sculpture has a philosophical basis to it. As in Melanesia, most of the human figure sculptures served to offer a place where a spirit might occasionally come to

rest and provide benefits to an individual or group. In Polynesia, the being, and thus the symbol of it, was genealogically related to a living human, whereas in Melanesia, the spirit that was believed to inhabit a carving could be either the manifestation of a supernatural power or an ancestor. It might therefore be said that Polynesian art tends towards naturalism because of the close relationship between the human world and the world of its spirits and deities, while Melanesian art is nonnaturalistic because of the distance between the two. While much Polynesian art may lack the supernatural orientation, drama, richness, and variety of style and expression of its western counterparts, its permanence, formalism, and naturalism symbolize a philosophy that placed individuals rather than the forces of magic and the supernatural as the determinants of their fate.

# Micronesia

THE SMALL ISLANDS OF MICRONESIA ARE scattered over an area of the Pacific that is slightly larger than that of the contiguous United States. They lie north of the equator to the east of the Philippines and north of Melanesia. Although there are more than 2,000 islands, their total land area is only 1,042 square miles, which is roughly the size of Rhode Island. There are four archipelagoes: the Marshalls to the east, the Carolines in the center, the Marianas to the north and west, and the Gilberts to the south. Kaniet, Wuvulu, and the Hermit Islands in the Ninigo Archipelago to the west of the Admiralties, although geographically close to Melanesia, are usually included in the Micronesian sphere in studies such as this.

Almost all are low coral atolls with few natural resources beyond limestone, fibrous plants, shells, and woody materials from low trees. Although the larger islands such as Guam, Babelthuap, and Pohnpei may have more abundant growths of timber and stone other than coral limestone, they could not be regarded as being environmentally rich.

Micronesian cultures reflect influences from both east and west. The loom-weaving techniques and the cultivation of rice on the Marianas were introduced from Indonesia, and the complex social structures of the societies of the Marianas and the Carolines are Melanesian traits. Being to the east, the societies of the Marshalls and the Gilberts show affinities to Polynesia. Similar systems of social stratification exist here, and there is emphasis on the decorative arts and geometric surface ornamentation applied to wood carvings.

The people lived in small communities ruled by chiefs and were organized into castes. In general, their religion centered around the worship of clan deities, culture heroes, and ancestors. Certain gods served specific functions and were associated with plants and animals. Only rarely are they given sculptural form, as in the male and female *tino* figures of Nukuoro atoll in the Carolines and a few sculptures depicting gods from Babelthuap. More often, these ancestors and deities were represented by cult objects such as conch shells, staves, or uncarved stones. Such icons were carefully wrapped up and only exhibited on special occasions when offerings of food were made

to them. The concept of *mana* existed in Micronesia but not as strongly as it did in Polynesia. It seems to have been associated with the spirit of a person or thing rather than with the entity itself, and therefore the belief reflects more of the Melanesian idea of this force.

Nowhere in Oceania are the cultures and arts as homogeneous as they are in Micronesia. This can be partly attributed to the considerable trade and communication that was maintained between these small and widespread islands. Many regard the Micronesians as even greater sailors and navigators than the Polynesians. The art of canoe building was highly developed and, because of the lack of large trees, the crafts used for interisland travel had to be made by lashing many small pieces of wood together. Canoes were made watertight by the application of tree gum at the seams.

Micronesian navigators were particularly adept at reading refractive swell patterns from waves that had broken against island masses. Such effects could be discerned as many as fifty miles away from the land itself. In addition, the Marshall Islanders developed ingenious sailing charts. They are made of irregular openwork caning with objects of shell and limestone attached at various points. Some of these designate islands and others the forms of currents on the ocean surface and other water patterns that were only apparent to those who had learned the meaning of the subtle differences that occur in the characteristics of the open sea.

Another factor that accounts for the uniformity of the material cultures, societies, and arts of Micronesia was the paucity of the environment. Wood was not common and, on coral atolls, no kind of stone but limestone exists. The blades of carving adzes were therefore made of shell from the giant clam. To practice cultivation, pits had to be excavated into the coral, and soil then built up from plant and human refuse over periods of many years. These small plots could be instantly ruined by high waters brought on by tropical storms. Much human energy was spent on the demands of survival, and there was little extra time for the development and enactment of complex ceremonies let alone the existence of materials with which to make the paraphernalia that might accompany them.

The art of Micronesia is correspondingly spare and economical. Much of it is in the form of utilitarian items such as bowls, containers, adzes, and weapons. Some of the finest works are made of plaited vegetable fibers woven on backstrap looms and made into mats, loincloths, belts, and skirts. Weaving reached a high degree of specialization on the Gilbert Islands, where protective suits of armor were made. They consist of a sennit shirt over which was worn a helmet, a breastplate, and a back plate made of thick coils of coconut fiber.

Because wood was only available in small pieces on most islands, great skill in carpentry and joinery was required to fashion it into useful objects. Techniques of lashing and caulking were perfected to create such things as bowls, containers, and boxes that were large enough to hold considerable quantities of food and other goods. Color was not often applied, but much effort was expended to produce smooth and highly finished surfaces on objects of daily use.

An appreciation of pure statements of form is evident in many utilitarian objects such as the food bowls of Wuvulu and the coconut graters of Nukuoro. A similar aesthetic is found in some Polynesian furnishings, especially among the neckrests of Tonga, the chief's stools from the Cook Islands, and the kava bowls of Fiji. Canoe prows and stern pieces representing elegant abstractions of bird forms were made on the Carolines, and those of a spiral form derived from Melanesian prototypes are found on Kaniet and the Hermit Islands.

Sculpture is rare. It is restricted mostly to human images associated with house decorations such as the female gable ornaments and male figures of Babelthuap and the weather charms of the Carolines. On Kaniet, a few large male figures showing stylistic details that relate them to those of Melanesia, especially Astrolabe Bay in New Guinea, are known. With the exception of the house masks of the Carolines, the mask form does not appear in Micronesia. Traces of Melanesian influence are also evident in some Micronesian sculptures, notably these house masks and the figures of Babelthuap and Kaniet. Despite these Melanesian affinities, however, all of the sculptures of humans show the forms reduced to their essential elements, and little attention is given to surface detail. Nukuoro sculpture as represented by male and female *tino* figures is comparably spare, and the poses are Polynesian in style and expression. The Micronesian minimalist aesthetic is perhaps best expressed in these small sculptures. With their economy of line and form, simplicity, and balanced restraint, they eloquently capture the precarious and yet tenacious life of these islanders.

# Australia

...INENT OF AUSTRALIA COM-

con
geo
by
fro
eas
pr

ra
th
th
r
a

ISLAND
ANCESTORS

*Masterpieces of Oceanic Art*

including plant shoots, roots, seeds, nuts, fruits, grubs,
...small reptiles, and amphibians. There was no
n of animals. Men were
ance of sacred ceremonies
ting expeditions, and, when
arfare. Women built tempo-
, carried water, and provided

that the earth was originally
in that stretched beyond the
d during a period poetically
a number of quasi-human and
ged from the earth. As they
hey created light, fire, life of all
he components of the lives of
s and rituals. When they were
ed themselves into the rocks,
, water holes, and other topo-
land.
s were called "Dreamings." They
ould be reached through ritual
e. They are represented as totems
elements of the landscape. Such
be the actual ancestors of clans.
d the group and possessed great
d ceremonies were given to honor
nization of the Aborigines also
ws relating to land affiliation and
ritories by clans, the maintenance
h marriage, and the initiation of
e of adulthood.
highly developed and complex social
ure of the Aborigines was quite
object types are efficient and inge-
d number were used, and they are
on and form: spears, spearthrowers,
clubs, shields, merangs, digging sticks, and bark
dishes. They are usually decorated with simple geometric
engraved or painted designs. Although rudimentary
painted wood sculptures were carved in Arnhem Land
in the north, tree sculptures were made in New South
Wales, and wood mortuary sculptures were used on Mel-
ville and Bathurst islands, such three-dimensional work

Over this long period and... Aborigines developed a code of laws, beliefs, and subsistence patterns that were highly successful despite the limited resources of their vast but poor land. They lived as nomads in small family units and had little need for permanent shelter or even clothing. They hunted such animals as the kangaroo, the opossum, and the flightless emu, and gathered whatever edibles could be found,

is exceptional. Most Aboriginal art is two dimensional and its decoration is of a graphic nature.

Throughout Australia, body ornament was highly developed and its use of great antiquity, as were rock and cave engravings and paintings. Creation of sand paintings was also widespread. Portable works of art were few. Shell pendants engraved with rectilinear designs were made in western Australia, and a tongue-shaped wood or stone object with geometric engravings called a *tjuringa* was used throughout the continent during such rituals as initiations, rainmaking, and ensuring food supplies.

The artworks, sand paintings, rock decorations, and utilitarian objects appear as or are decorated with totemic symbols so that the power of the ancestor might come into the work or object itself. The art motifs are highly schematic and were used to suggest the presence, location, or essential nature of the totem. They might symbolize animal footprints, specific human or animal body parts, and the various topographic features that were formed by the Great Ancestors. Some designs relate to events that occurred to the Ancestors during their dream-time wanderings and tell of their hunting experiences, sexual exploits, battles, and ceremonies.

The engravings and paintings are in the form of spirals, concentric circles, crosshatching, zigzags, diamonds, lozenges, chevrons, meanders, and dotted and parallel lines. These geometric devices had multiple meanings and appear throughout the art of the Aborigines in endless variations. Except for stone and shell, the mediums of this art were ephemeral, consisting mostly of wood and bark and sand paintings, and much was allowed to decay after a single use. The design patterns themselves rather than the things they decorated had by far the greatest significance to the Aborigines. They could be applied over and over again to any number of newly made objects.

The well-known bark paintings of Melville Island, Groote Eylandt, and Arnhem Land in north Australia fall into a class of their own. Long strips of bark were taken from eucalyptus trees, flattened, and laid together to form temporary shelters. Their insides were painted with pigments of kaolin, charcoal, and yellow and red ocher. There are several different styles, but all of them are two dimensional and of simple and rough though often detailed execution.

Many of the same design elements already described appear on bark paintings and depict totems, topograph-ical features, and the activities of the Great Ancestors. Other motifs might represent specific designs owned by clans, or lands over which they had hunting rights. Bark paintings also include representations of human and animal forms. The forms are depicted in various ways: in profile, in frontal squatting and splayed poses, elongated to occupy the entire bark surface, and in the X-ray style by which the skeleton and internal organs are depicted. This latter device both refers to the way a hunter sees his quarry and relates to the Great Ancestors whose anatomical parts became the elements of the landscape.

Many of the anthropomorphic figures are rendered in active, dynamic poses. To suggest something of their vitality and power, they are shown running, dancing, copulating, or fighting. These actions represent the activities of the Ancestors during dream time and the myths associated with them. Animal forms include fish, reptiles, kangaroos, crabs, frogs, birds, and practically anything else that lived where the paintings were made. Trees, vines, and tuberous plants also appear in some paintings. All such motifs are the totems of the Great Ancestors. Because the bark paintings, and, in fact, most Aboriginal art, is suggestive and symbolic, the meaning of much of it has been lost. However, interpretations of certain works that were made in this century have been recorded from their creators so that it is sometimes possible to make educated guesses as to what some of the older undocumented works may represent.

Although the appearance of geometric forms and figurative representations throughout Aboriginal art seems to us to be of almost endless variation, their employment was actually subject to rigorous control. All art was regarded as being the recreation of works that had originally been made by the Great Ancestors. Some motifs were thought to have been given by them to clans and were carefully guarded. Male elders in each group had strict control over which artist could use certain designs, and outright invention of new forms would have been regarded as sheer heresy.

Upon initial encounter, Aboriginal art is thus doubly deceptive. Its apparently limitless variation is actually governed by an extremely conservative, ancient, and time-honored tradition, and its relative simplicity, two dimensionality, and sometimes rough execution belie the extraordinarily rich mythology and social systems that provide it with its inspiration.

# THE MASCO COLLECTION

## 1 Anteater

Papua New Guinea, Western Highlands Province
*Stone*
Height: 9 1/2 in. (24 cm)

OVER THE YEARS, A NUMBER OF ENIG-matic stone objects and sculptures in the form of mortars, pestles, disks with holes in the center, and animal and human figures have been found in various parts of the highlands of New Guinea. Although they are presumed to be prehistoric, none has been excavated scientifically, and no reliable dates have as yet been assigned to them. They are additionally puzzling because, as Douglas Newton (1984) notes, although some of them display intriguing relationships to certain recent expressions from the lowland areas, none has anything in common with styles of the highland regions from which they come.

This example represents the spiny anteater, a species found only in Australia and New Guinea. It belongs to a published group now totaling five (ibid., and Newton 1979b, p. 56, 3It2, 3It3, 3It4), and several other unpublished examples also exist (Heathcote 1991). Nothing is known of the significance of this animal or the actual use of these sculptures, but it is thought that they may have been cult objects of some kind.

The Masco anteater is said to have been found during the construction of a new road in the highlands about 1950. At that time it became part of the collection of a missionary. From there, it went into an Australian collection, where it remained largely unknown until it was acquired by Wayne Heathcote in 1986. In size and appearance, it relates closely to one that was found in a cave in the Ambun Valley in 1962 (*Journal of the Polynesian Society* 1965) and is now in the National Gallery of Australia, Canberra. Both show a fine sense of balance and form that belies the laborious process of stone hammer dressing and pecking by which they were made.

Previous collection: Wayne Heathcote, New York

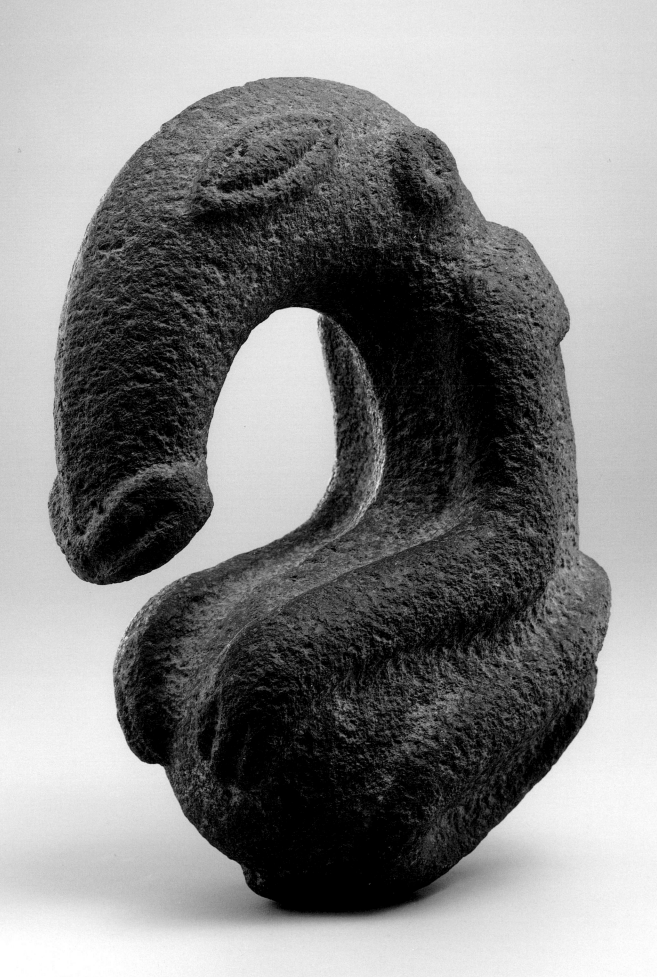

## 2 Canoe Prow (haluan perahu)

Irian Jaya, Cenderawasih Bay
*Wood, cassowary feathers*
Length: 82 3/8 in. (210 cm)

THE EXUBERANT OPENWORK PROWS OF Cenderawasih Bay (formerly Geelvink Bay) are made of several separate pieces that were affixed to the bows of large outrigger, sea-going canoes when they were used for transportation to important ceremonies or for war expeditions. Both the canoes and their decorations were the work of male carvers who inherited from their fathers the knowledge of the magic they infused into their creations, as well as the design motifs they used. Among the components of the prows are a series of small, squatting *korwar* figures (see cat. no. 3) which represent ancestors and served to protect those in the canoe (Kaufmann 1979, p. 42).

The prow panels were attached with bamboo strips that were held in place by pegs (Powell 1958, pp. 114–15). Each of the elements was originally colored red, white, and sometimes blue. Tufts of cassowary feathers, some of which remain here, decorated the heads of the small *korwar* figures that are incorporated into the designs. When not in use, the prow carvings were wrapped and carefully stored.

Much of the art of Irian Jaya shows close affinity to that of neighboring Eastern Indonesia. Here this relationship can be seen in the complex interlacing scroll patterns that reflect motifs found in Indonesian textiles and wood reliefs. The human figures are also in the squatting pose often found in Indonesian sculptures.

Collected by Pierre Langlois at Cenderawasih Bay in 1962 (Friede 1991)

Previous collections: John Friede, New York; Carlo Monzino, Lugano

Publication: Sotheby's, New York, 1987, no. 132

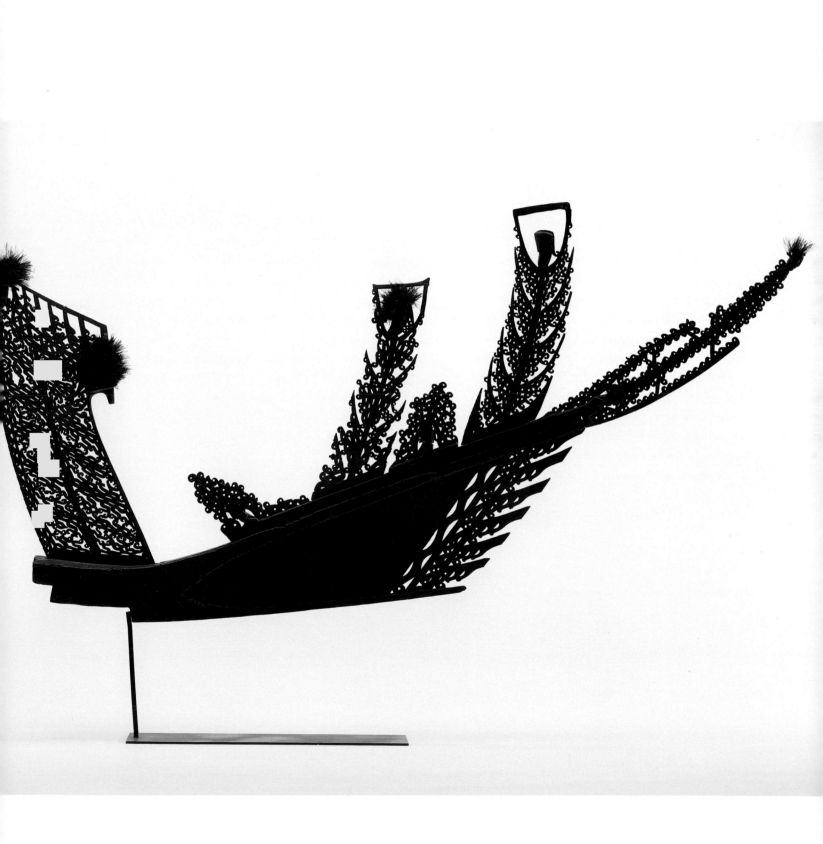

## 3 Male Ancestor Figure (*korwar*)

Irian Jaya, Cenderawasih Bay, Doreh People
*Wood, beads*
Height: 12 1/4 in. (31 cm)

MOST *KORWAR* FIGURES WERE MADE for the families of deceased males and occasionally females immediately following their death. During the carving, chants were sung to assure that the spirit power of the ancestor would enter into the figure. The figures then served as intermediaries between the living and the dead. Their advice was sought through the actions of a shaman who went into a trance and was then able to pass on the words of the spirit to the living descendants.

*Korwars* were brought out at such times as embarkations for war parties, fishing expeditions, or other potentially dangerous ventures which might last for several days. When not being consulted, they were wrapped and stored by the family. If bad advice had been given by one, it might be intentionally damaged or even destroyed. After some years, when additional carvings had been made to honor more recently deceased family members, the old *korwar* was placed with the skeleton of the ancestor it represented, and it ceased to have a ritual function. Many of those now in collections were sold before having been taken to the cemetery (Solheim 1985, pp. 150–51). At the beginning of this century, German missionaries became active in this area, and the people were converted to Christianity by about 1929. From that time, *korwars* ceased to be made (ibid., pp. 157–59).

There are a number of different regional carving styles represented by *korwars*, and this piece has been attributed to the Biak people (Sotheby's, New York, 1987, no. 131). Most Biak examples, however, depict seated figures, while those showing a standing figure carrying an open-work "shield" are ascribed to the Doreh people (Baaren 1968, figs. 23, 45). The facial features of the Doreh-style figures are also described by Baaren (ibid., pp. 76–77) as the most naturalistic of the types and conform well to those seen here.

The nature and meaning of the shield form have generated considerable discussion. Baaren (ibid., pp. 81–82) believes it to represent a single snake or two intertwined snakes. In the mythology of the region, snakes symbolize the underworld and its dangers as well as the powers of regeneration. Relevant to this object, he also notes that "the snake may turn out to be a young man. This last conception perhaps offers an explanation for the smaller figure which some *korwars* have in front of them."

Previous collections: Völkerkundeliches Mission Museum, Wupperthal, collected about 1900; Carlo Monzino, Lugano

Publications: Sotheby's, New York, 1987, no. 131

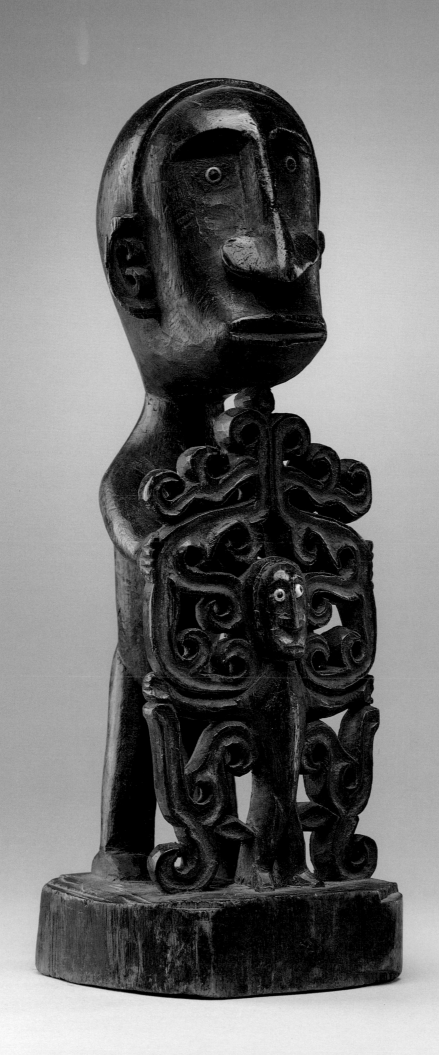

## 4 Lime Spatula

Irian Jaya, Lake Sentani
*Wood*
Height: 8 1/2 in. (21.5 cm)

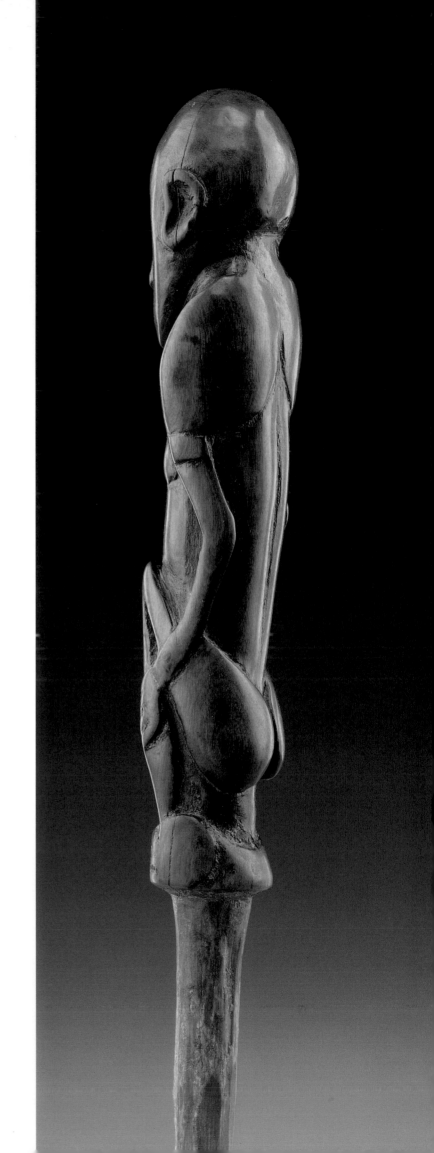

BETEL CHEWING IS PRACTICED THROUGH-
out New Guinea and its neighboring islands. The
necessary ingredients are areca palm seeds, pop-
ularly called "betel nuts," fruit or leaves from the betel
plant, and lime obtained from burnt coral. The areca
palm seeds are crushed into mortars with pestles, and the
paste is then spread on the betel fruit or leaves, mixed
with lime, and then chewed. The chewing of this mixture
is mildly stimulating, producing "feelings of good
humour, well-being, and an increased capacity for work"
(Beran 1988, p. 5). The paraphernalia associated with this
practice usually includes a decorated gourd or bamboo
container to hold the lime and a stick or spatula with
which to remove the lime from the container and to use
as a utensil for eating the paste. Although primarily
utensils, some lime sticks and spatulas are extremely well
made and are among the finest miniature carvings of
Melanesia.

The carved lime spatulas of Lake Sentani are made of
palm wood and have handles in the form of standing or
seated human figures. Their significance is not recorded,
but the display and use of some of the finest examples
such as this one must have conferred prestige on their
owners. The small figure of a seated female shows all of
the characteristics of full-scale Sentani sculpture. These
include the elongated face with a pointed chin, the broad
hunched shoulders, a straight nose, and deeply inset eyes.
In general, the figures "convey an air of equanimity and
tranquil repose" (Kooiman 1959, p. 18), qualities well
expressed in this small work. The deep, even patina indi-
cates long use prior to the time of its collection in 1929.

Collected by Jacques Viot, Pierre Loeb Expedition, in 1929

Previous collections: George Ortiz, Geneva; British
Railway Pension Trust, London

Publications: Sotheby's, London, 1978a, no. 108; Sotheby's,
London, 1988, no. 24

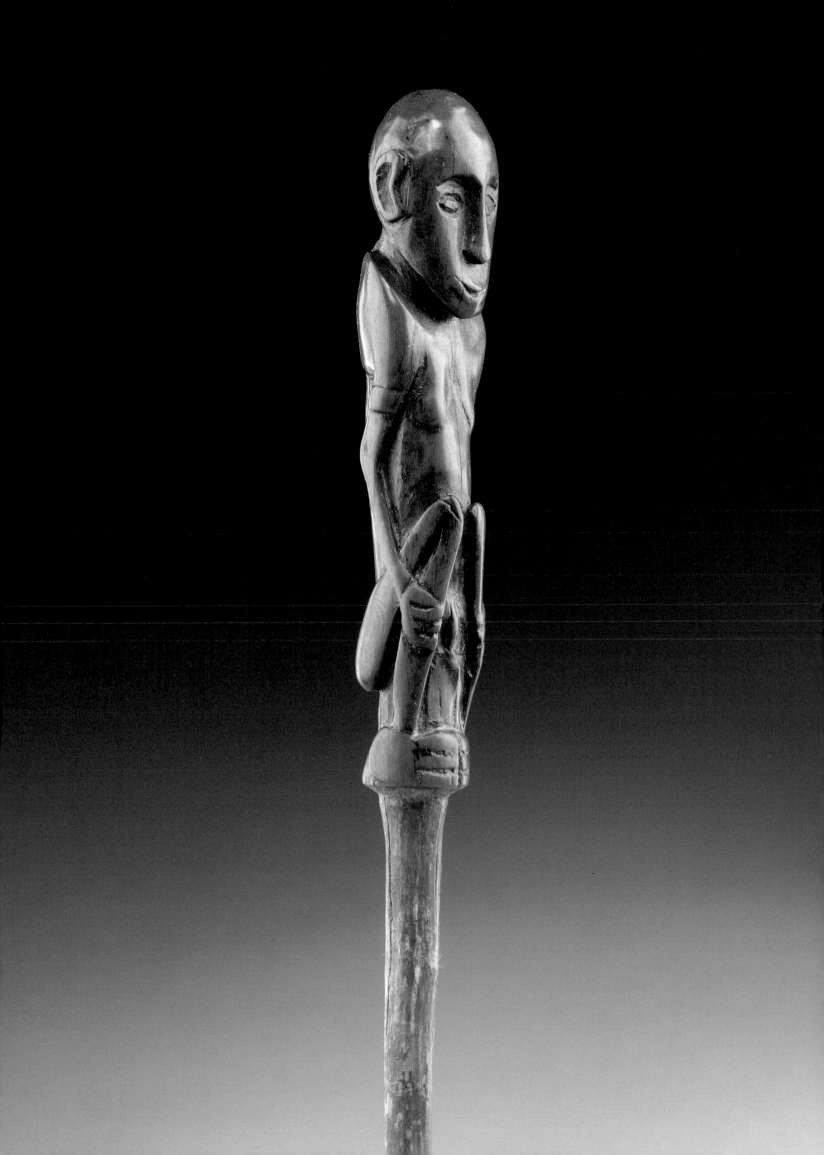

## 5 Ancestor Figure (*nggwal*)

Papua New Guinea, East Sepik Province,
Abelam People, Maprik area
*Wood, traces of pigment*
Height: 85 1/2 in. (217 cm)

THE ABELAM LIVE ON THE NORTH SIDE of the Middle Sepik River in the foothills and plains of the Prince Alexander Range. Their most important men's ceremonies involve initiations into ever higher grades of membership. In some areas, as many as eight levels could be achieved during a lifetime. Each is named after a different cosmological spirit.

The ceremonies are highly theatrical and require the creation of sculptures of spirit figures as well as the painting of the sago bark panels in the interior of the spirit house. The figures were decorated with garlands and headdresses of fruits, leaves, flowers, and feathers, and then displayed to the initiates. The initiates were then subjected to ordeals by their elders such as beatings and penis incisings. The eating of large amounts of yams also accompanied the rituals. Afterwards, men from neighboring villages came to see the carvings and paintings and to comment on their artistic quality. Elaborate costumed dances were finally performed by participants whose bodies and faces were heavily and brightly painted.

The figures used in such ceremonies represent ancestor spirits called *nggwal* or a female witchlike creature, *ku tagwa*. The appearance of a penis and beard on this figure indicates the representation of an ancestor. In the northern areas from which this sculpture comes, only a few very large figures were displayed in the cult houses during initiations (Losche 1982, pp. 51–54). As monumental as it now appears, the sculpture's eroded and broken base indicates that it was once of even larger size. Most Abelam sculptures known today were made in relatively recent times. This figure is from an earlier generation of carvings and probably dates from the early twentieth century. Only traces of the original ocher pigments remain.

Previous collections: Walter Randel, New York; Wayne Heathcote, New York

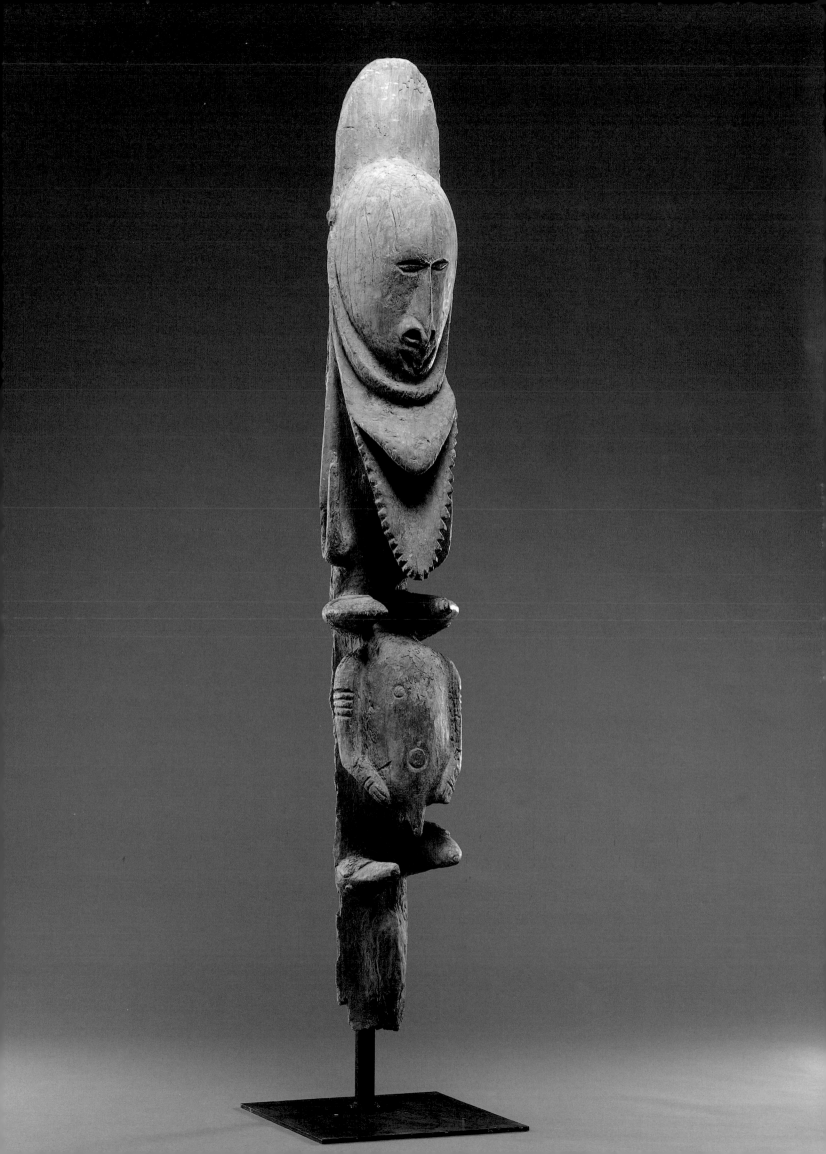

## 6 Figure Fragment

Papua New Guinea, East Sepik Province,
Southern Abelam or Boiken People
*Wood; white, red, and black pigment*
Height: 29 in. (73.5 cm)

THIS SCULPTURE WAS MADE FOR DISplay at one of the initiation cycles that govern the ceremonial lives of Abelam men (see cat. no. 5). It is the top part of a carving that was originally at least life-sized. In contrast to the few works of this nature that were made for initiation rituals in the north, the southern Abelam and Boiken peoples to the east made many human figure carvings for initiations. They were stacked side by side along the walls in the interior of the ceremonial house. As in the north, they represent ancestral *nggwal* or the witchlike *ku tagwa* (Losche 1982, pp. 52–53).

The figure displays the typical round head, small ears, and facial painting patterns of the art of the area. The spirit portrayed, probably a specific ancestor, had the parrot among its totems. It is represented by the two heads carved just below the head on each side. The carving was probably made during the first quarter of this century. Whereas Abelam figures are apt to be carved with simple forms representing the nose, eyes, and mouth, here they have been given a more detailed and naturalistic treatment. The openwork carving below the head also suggests that the figure is earlier in date than the majority of Abelam sculptures encountered today.

Previous collections: Bruce Seaman, Bora-Bora; Carlo Monzino, Lugano

Publication: Sotheby's, New York, 1987, cover, and no. 121

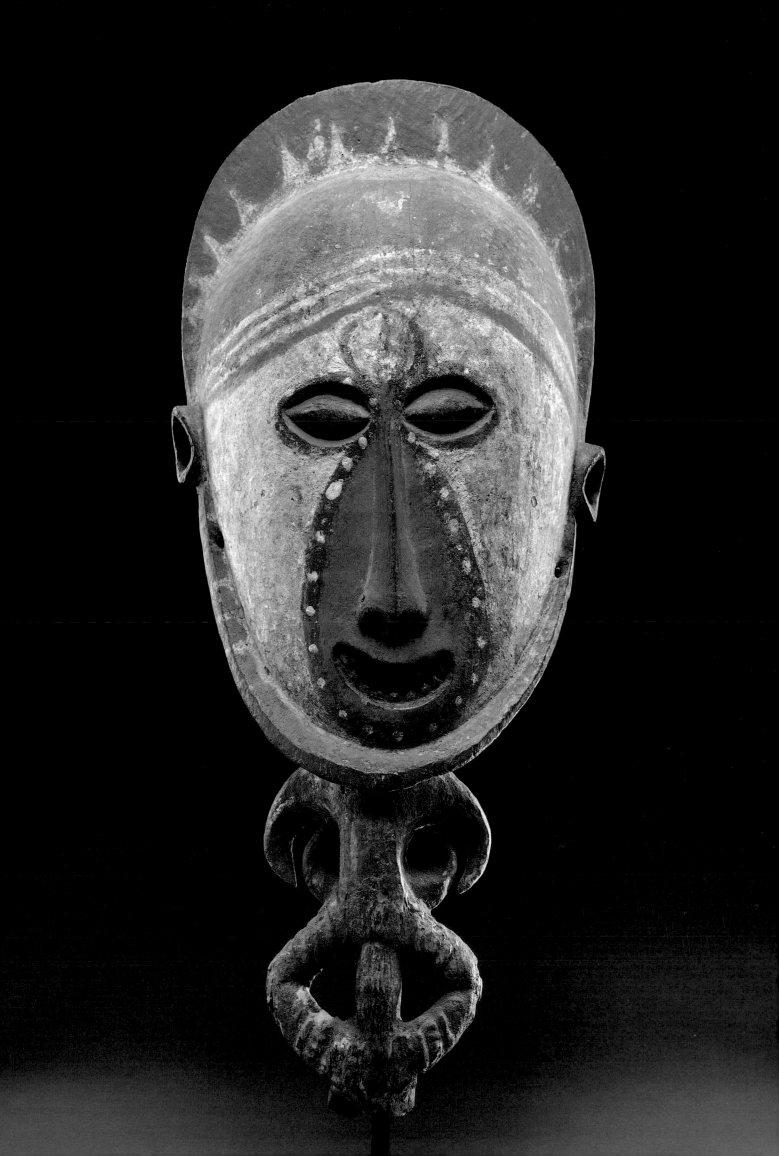

## 8  Male Figure

Papua New Guinea, East Sepik Province, Lower Sepik River
*Wood*
Height: 10 in. (25.5 cm)

AMONG THE HUMAN FIGURE SCULPTURES that were made along the Lower Sepik River are numerous examples of small size. They are all in standing positions, and many of them appear to be miniature versions of works of larger scale. Such pieces were used as personal amulets and represent ancestors. Several of the smallest types, which are only two or three inches high, were carried around in net bags, while the somewhat larger ones such as this were sometimes worn attached to belts or simply kept in dwellings among other carvings.  The small lizard at the top symbolizes the totem of the ancestor. Its shiny and well-worn surface indicates considerable use and handling by its owner.

Collected in 1961

Previous collections: Peter Kohler, Ascona, Switzerland; Wayne Heathcote, New York

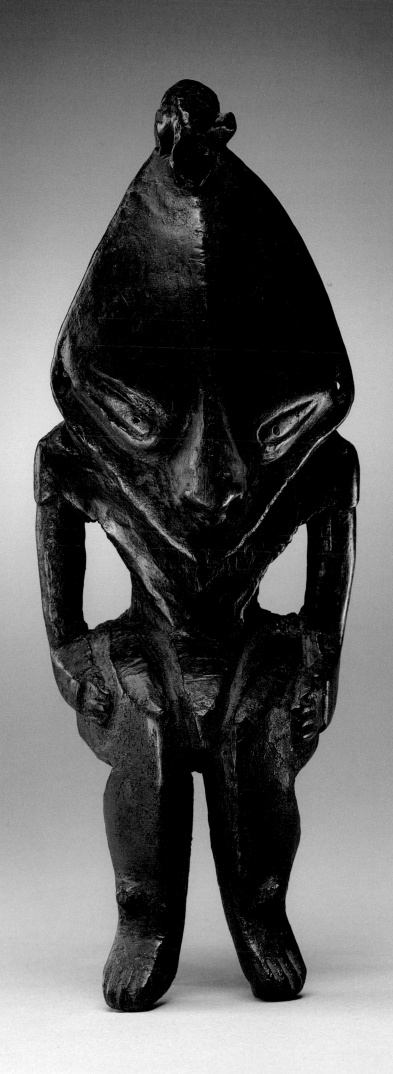

## 9 Mask

Papua New Guinea, East Sepik Province,
Lower Sepik River, Coastal Zone
*Wood, traces of red and white pigment*
Height: 16 1/2 in. (42 cm)

MASKS SERVED A VARIETY OF PUR-
poses in the cultures along the Lower Sepik
River. Many were worn in dances; some dec-
orated the gables and other parts of men's houses; others
were affixed to shields and canoe prows; and miniature
masks, attached to clothing and carried in bags, served
as amulets. Although many dance masks can be distin-
guished by the fact that the eyes have been cut with holes
enabling the wearer to see, some formed parts of larger
costumes and such holes were not necessary.

Dance masks in human form, of which this is one, rep-
resent mythical or actual deceased ancestors. At the time
the mask was worn, a song or chant relating specifically
to the ancestor it represents was sung. The masks were
worn either at community ceremonies such as those cele-
brating the harvest, fertility, name-giving, marriage, and
death, or at restricted gatherings such as initiations and
other secret society events (Wardwell 1971, p. 12).

One of the mask styles of the coastal region that is well
represented by this example shows an oval face with a
pointed chin, an elongated beaklike nose, and eyes placed
in slanting positions (Kelm 1966, vol. 3, nos. 155–58).
Most of these masks are simply carved with little surface
detailing on the face. Some, however, such as this one, bear
relief carvings on the forehead representing the totem of
the ancestor depicted by the mask. The splayed pose of
the lizard is beautifully integrated into the mask form. It
successfully transmits the idea of the pervasive presence
of this totem as being integral to the spiritual nature of
the ancestor.

Collected by F. Hefele in 1909

Previous collection: Wayne Heathcote, New York

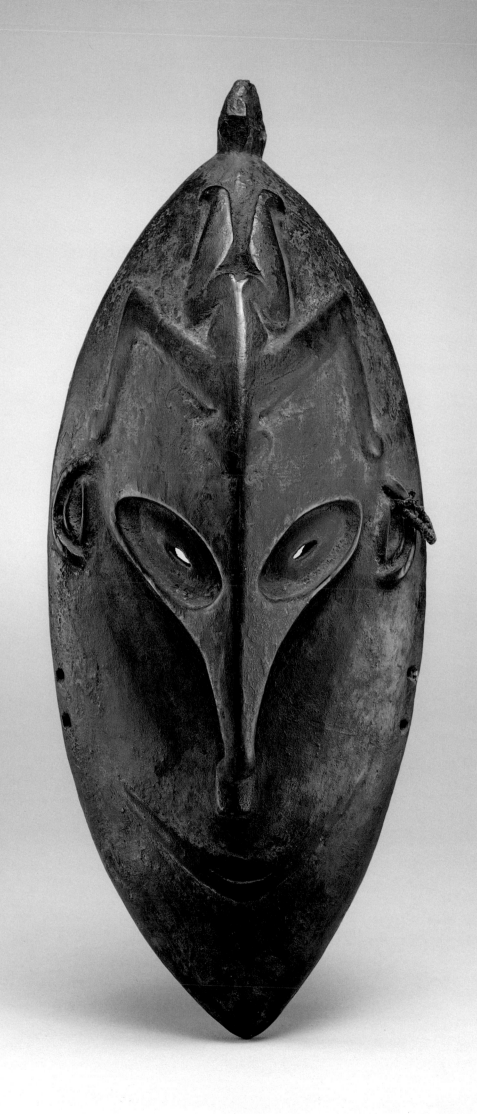

## 10 Mask

Papua New Guinea, East Sepik Province,
Lower Sepik River, Coastal Zone
*Wood, traces of red and white pigment*
Height: 13 1/4 in. (33.5 cm)

AS WITH CAT. NO. 9, THIS MASK REPRE-
sents an ancestor and could have been worn in a
number of community and secret society cere-
monies. It too is from the coastal region of the Lower
Sepik River where a number of mask forms combine the
human face with bird beaks (see, for example, Wardwell
1971, pp. 17, 20–22, nos. 1, 8, 10, 12–24; Kelm 1966, vol. 3,
nos. 191–92). The beak on this mask is probably that of a
cassowary, one of the totemic animals related to the
ancestor represented by the mask. The incorporation of
this zoomorphic element with a human face is an effective
method of showing the relationship between ancestors
and their animal spirits. The holes along the sides were
made for the attachment of fibers, hair, or parts of the
costume.

Publication: Sotheby's, New York, 1987, no. 125

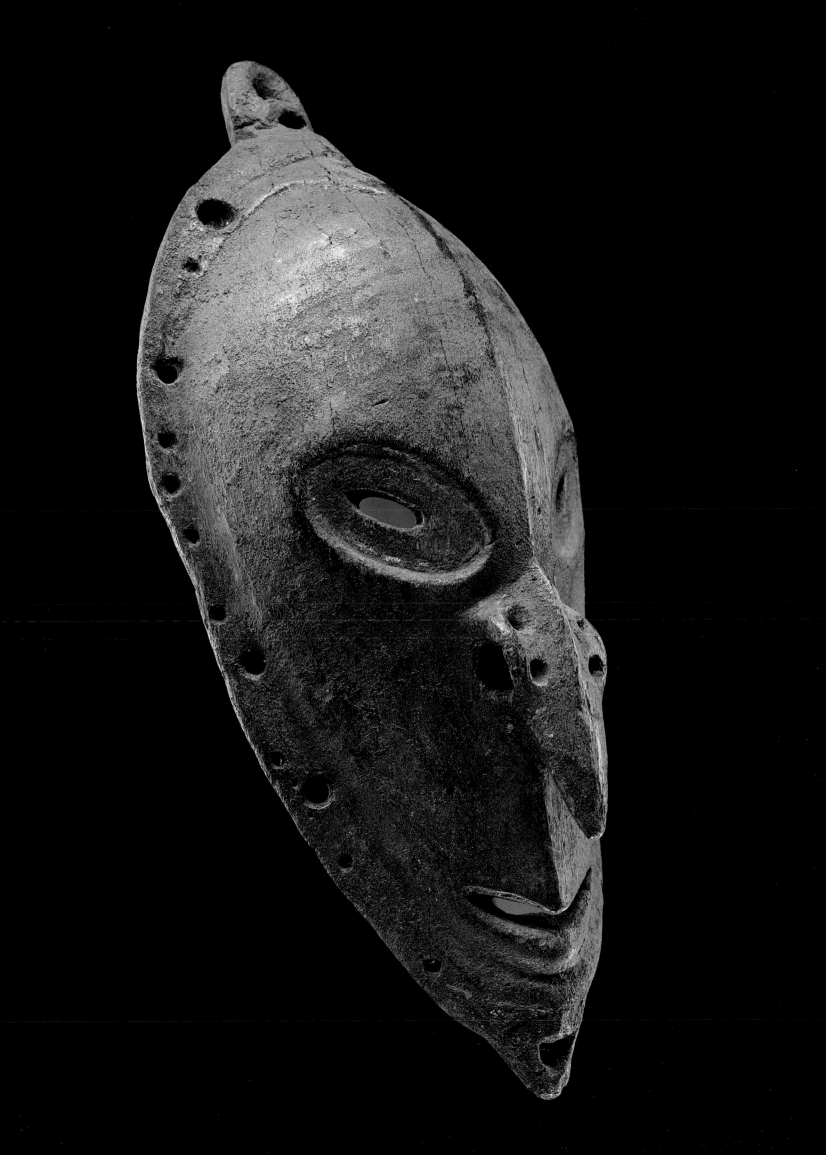

## 11 Male Figure

Papua New Guinea, East Sepik Province, Yuat River,
Biwat People
*Wood, traces of red and white pigment*
Height: 24 in. (61 cm)

THE HUMAN FIGURE SCULPTURES FROM the Sepik River and its tributaries sometimes represent spirits of the water or the forest, but usually depict legendary or recently deceased ancestors. Each of the latter was individually named and recognized as such by the family or community group to which it belonged. Except in rare instances, the name of the figure and the stories that were told about the being it represents have not been preserved. Certain large figures, some of them over life-sized, were kept in the ceremonial house and were lashed to the houseposts and displayed at initiations (see cat. no. 15). Smaller ones, such as this, were kept in the house of their owner and could be seen by women and children. Although they were privately owned, they could also be used to benefit the entire community (Schmid 1985, p. 202, no. 136).

This sculpture and cat. nos. 12–14 were made by the Biwat, a group that lives along the middle part of the Yuat River, one of the tributaries of the Lower Sepik. Biwat sculpture is known for its unbalanced, sometimes asymmetrical, and seemingly threatening poses. Other characteristics of the style are the forward-thrusting head, the hunched shoulders, the bulbous forehead, and the thick nose. All of these elements are well represented in this carving.

Previous collections: Walter Randel, New York; Jacques Kerchache, Paris; Wayne Heathcote, New York

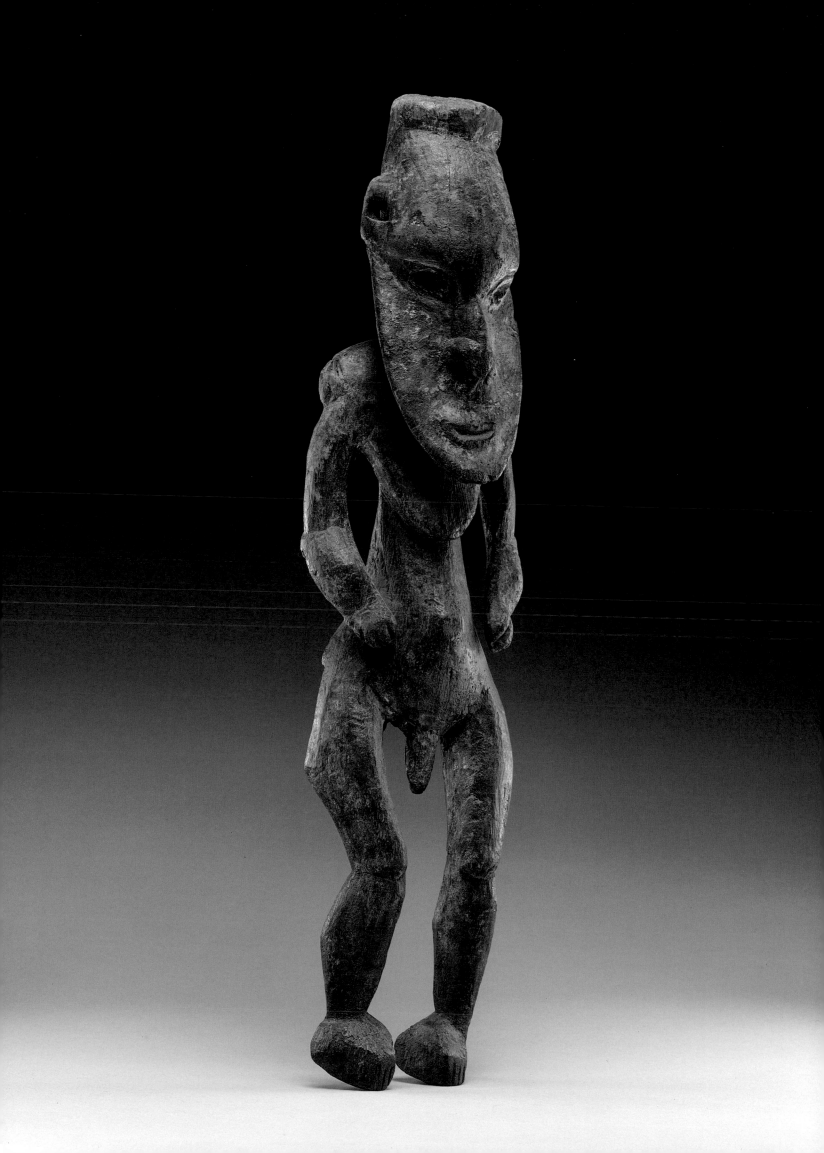

## 12  Stopper for a Sacred Flute

Papua New Guinea, East Sepik Province, Yuat River,
Biwat People
*Wood, shell inlay, cassowary feathers, human hair*
Height: 26 1/2 in. (67.5 cm)

THE BIWAT MADE HUGE BAMBOO FLUTES, some eight to ten feet in length, always in pairs. They were among the most important of family possessions and were sometimes used as part of a bride's dowry. It was believed that the mother of the flute was a large water drum that was kept in an enclosure by the river. When the new flutes had been cut, rituals were performed to give them a sacred birth. They were then decorated with a sculpture of a standing male figure and a great variety of materials including cassowary and other bird feathers, shells, fur, human hair, snake vertebrae, and fibers, some woven into chains. Following their completion, they were displayed to the entire village before being hidden away, from then on only to be seen by the family that owned them. The flutes were not actually played and should therefore be regarded more as sacred idols than musical instruments (M. Mead 1934, pp. 237–38).

This sculpture was originally plugged into the upper end of one such flute by means of the post on which it is standing. Flute stopper figures represent the children of an ancestral crocodile spirit (Newton 1967, no. 47). Some examples were simply painted and decorated with a few ornaments. Others were heavily embellished. This is one of the latter, and although it displays the basic characteristics of the Biwat sculptural expression, little of it would have been apparent to those villagers to whom it was shown. Thick hair or a shell beard would have been attached to the chin, the high forehead completely covered with fiber and shell ornaments, with shell ornaments or pig tusks piercing the septum, and the body draped with shells and chains of feathers and fibers. All that was therefore originally visible of the sculpture we now see were the eyes, nose, and mouth.

The cassowary feathers on the head of this example are probably restored, and as is the case here, most of the flute figures that survive today have lost their original ornamentation. However, one collected by Margaret Mead for the American Museum of Natural History, New York, is still almost completely intact and has been published by Carl Schmitz (1969, color pl. 15).

Previous collections: John Hewitt, London; Alastair McAlpine, London; Wayne Heathcote, New York

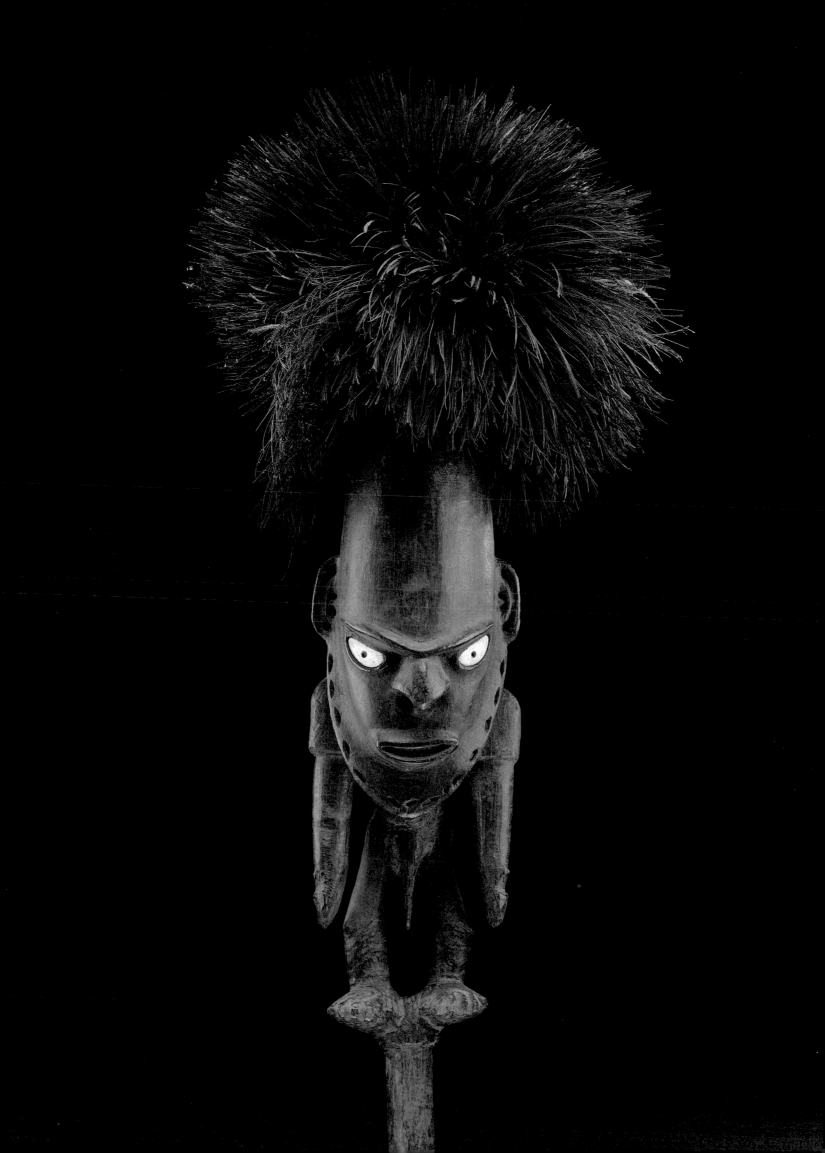

## 13 Hair Ornament from a Flute Figure (*manyan*)

Papua New Guinea, East Sepik Province, Yuat River,
Biwat People
*Wood, shell inlay, red and white pigment*
Height 20 1/16 in. (51 cm)

AMONG THE MANY ORNAMENTAL SUPPLE-
ments that decorated the elaborate flutes made by
the Biwat are carvings that were affixed to the
hair of the figures placed at the end of the instrument
(see cat. no. 12). Although this example compares some-
what to one now in the Metropolitan Museum of Art
(Wardwell 1971, p. 54, no. 102) in its combination of open-
work carving with intricate juxtapositions of animal
forms, it is unique.

The principal figure is that of a standing hornbill with
a skeletalized body. A lizard facing downwards grasps the
hornbill's abdomen, and on the back is a crocodile with
its serrated tail stretching to the base of the carving. Two
small animal heads appear below the eyes of the hornbill
in the area of the ears. At the bottom of the ornament is
the standing figure of another bird, a cassowary, the form
of its beak metamorphosed into the skeleton of the
hornbill. The combination of so many animal motifs in a
single carving may represent all the clan totems that were
associated with a single family, and the carving would
have been an object of great prestige. Because of its many
unusual qualities and intricate details, there is some con-
troversy about the age of the ornament. Some scholars
claim that it is of relatively recent origin, while others see
it as one of the great examples of nineteenth-century,
small-scale Sepik sculpture.

Although no corroborating evidence exists, it has been
suggested that the ornament was collected by the
German ethnologist Reichard Thurnwald in 1912
(Sotheby's, New York, 1987, no. 126).

Previous collections: Colonel Woodman, ca. 1920; Gene
Van Grecken, Sydney; Wayne Heathcote, New York;
Carlo Monzino, Lugano

Publications: Rubin 1984, vol. 1, p. 47; Sotheby's, New
York, 1987, no. 126

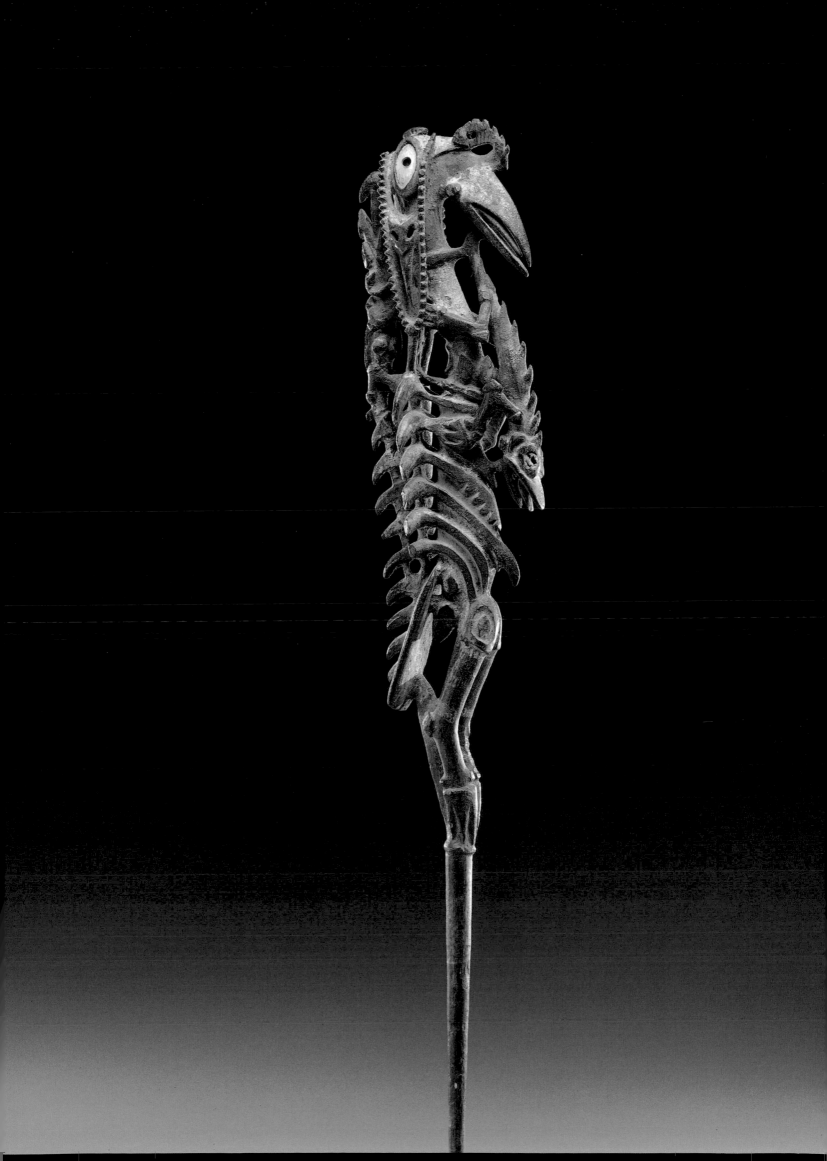

## 14 Mask

Papua New Guinea, East Sepik Province, Yuat River,
Biwat People
*Wood, traces of red and black pigment*
Height: 12 1/2 in. (32 cm)

ROUND MASKS OF DISTINCTIVE BOLD forms with bulbous noses, heavy overhanging brows, protruding open mouths, ears placed at right angles to the head, and relief bands that converge from the top of the head to the nose are unique to the Biwat (see, for example, Kelm 1966, vol. 3, nos. 206–9). The patterns with which they were painted are as striking as their aggressive three-dimensional forms. Stripes, dotted lines, and large areas of color were used to reinforce sculptural components. Although the colors are somewhat darkened, this mask was originally painted black on one side of the face and red on the other.

Such masks, along with flutes, figures, and other objects, were used in initiations. According to Alfred Buhler (1969, p. 86), they represent clan spirits and were worn by a male elder who was in charge of initiation ceremonies. He also reports that they were traded outside of the Yuat River region, and have been used at various places along the Lower and Middle Sepik River.

Collected in 1909

Previous collections: A. Speyer, Berlin; Wayne Heathcote, New York

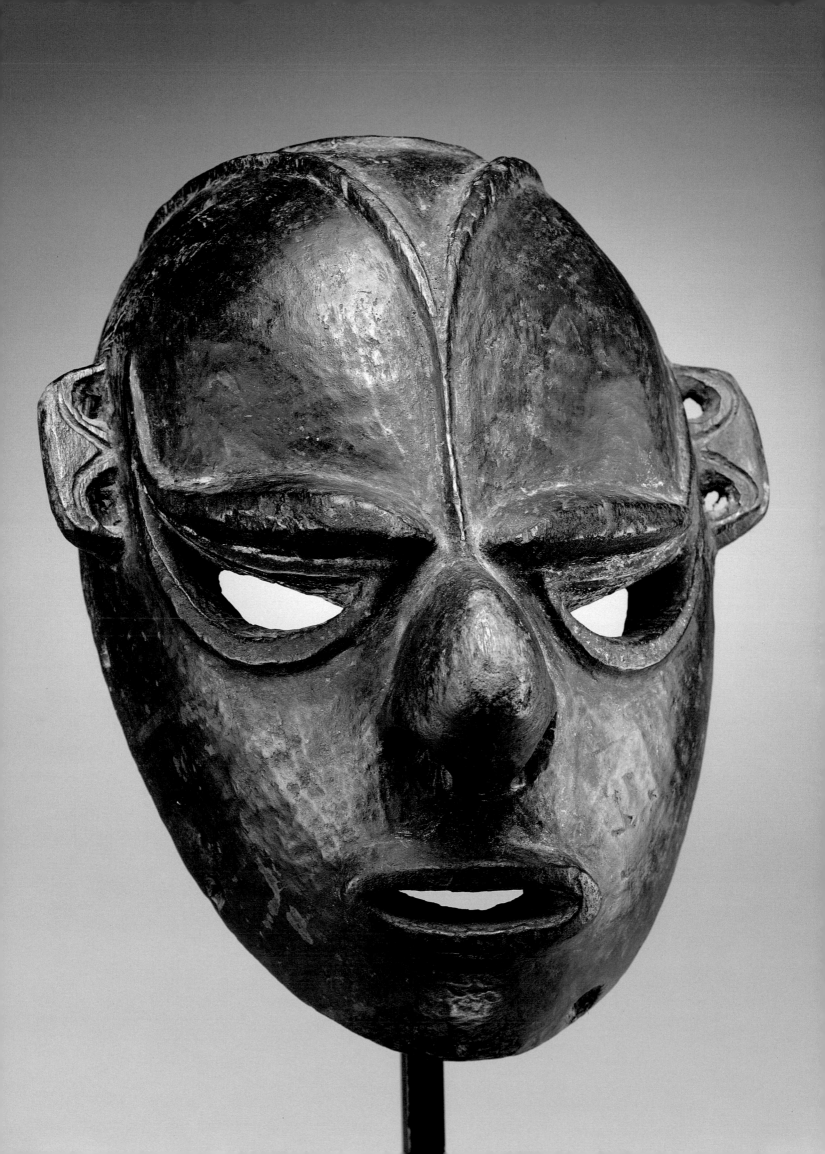

## 15  Male Figure (Mian'gandu)

Papua New Guinea, East Sepik Province,
Sawos People, Wolembi Village
*Wood, red and white pigment*
Height: 82 1/2 in. (210 cm)

THE SAWOS LIVE A FEW MILES NORTH OF a part of the Middle Sepik River; their art is closely related to that made by the Iatmul to the south of them (Newton 1967, no. 51 supra). Their most impressive carvings are over-life-sized male figures such as this one. These and other large figure sculptures from the Lower and Middle Sepik that served similar purposes have been described by Carl Schmitz (1969, p. 67) as "among the most important works of art produced anywhere in Oceania."

Marian Pfeiffer (1983) has studied all of the known Sawos figures in this group. This figure is one of six that were collected around 1960 and are now in museums in Europe, America, and Oceania. Pfeiffer attributes all of them to a particular stylistic expression that developed around the village of Yamok (ibid., pp. 249–52).

Every Sawos clan originally displayed such a figure tied to the central housepost in its cult house. Each figure was responsible for the well-being of the clan and represented a specific culture hero or ancestral creator. Among the Yamok the figures were thought to be representations of the ancestor who had founded the village and were also known to have made "the swampy ground firm" (ibid., p. 256). They were associated with hunting and war, and, prior to such expeditions, they were offered food and hung with betel nuts. If the proper rituals had not been observed, the spirit represented by the figure could bring misfortune to the hunter or the warrior (Kaufmann 1970, p. 76). The figures were individually named, and according to Barry Craig (cited in Pfeiffer 1983, p. 158), this one was called Mian'gandu and came from the cult house at the hamlet of Wolembi near Yamok. All of the sculptures in this group show crescent designs carved above the breasts and a serpent motif on the abdomen above the navel. These represent scarification patterns that were applied to initiates as a part of their ordeal and to mark them as having gone through the ceremony (ibid., pp. 43, 299).

The imposing and supernatural nature of these works is well represented by the Masco sculpture. The frontal, rigid, hieratic pose with its oversized head and repeated vertical rhythms set up by the long torso, arms, legs, and penis emphasize its impressive size and truly sacred nature. The rich curvilinear facial painting is also characteristic of these works and was a mark of a successful headhunter among the Sawos (ibid., p. 287).

Collected by Bruce Lawes about 1957

Previous collections: Harry Franklin, Los Angeles; Bruce Seaman, Bora-Bora; Wayne Heathcote, New York

Publications: Lunsford 1970, no. 44; Pfeiffer 1983, pp. 149–58, figs. 33–35

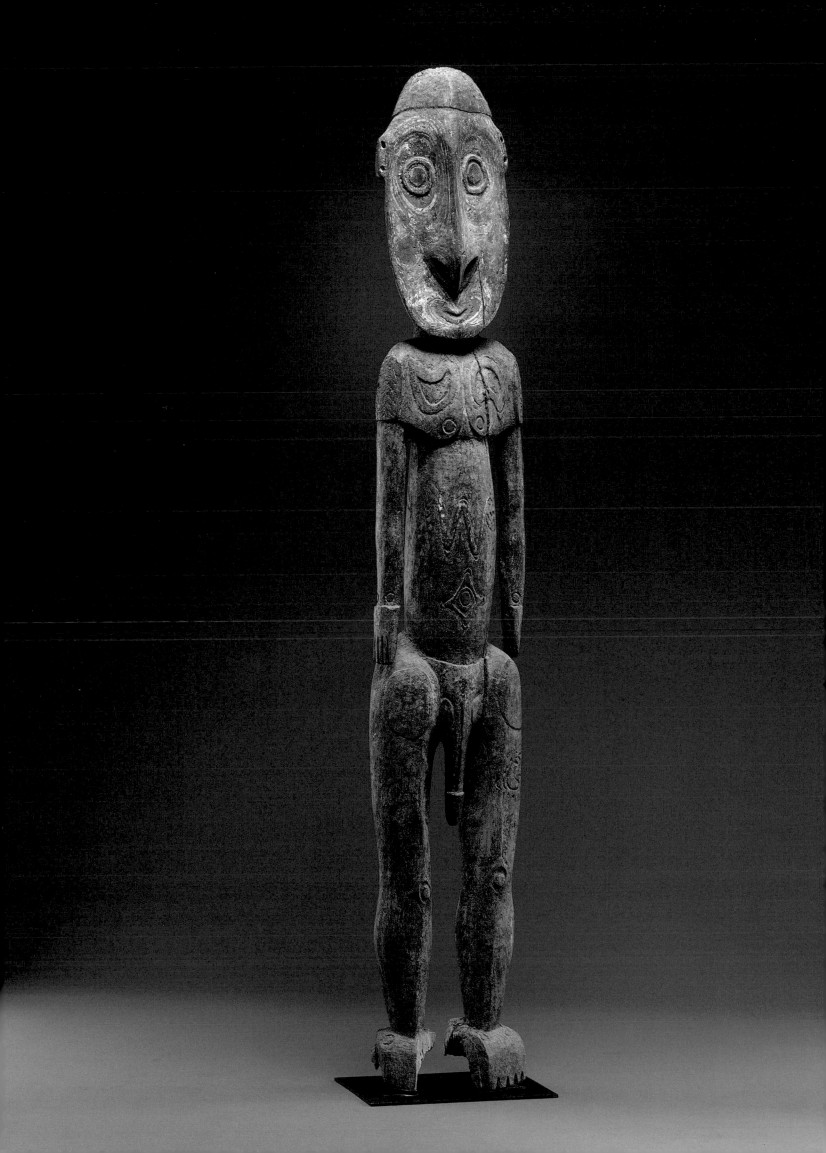

## 16 Suspension Hook

Papua New Guinea, East Sepik Province,
Sawos People, Torembi Village
*Wood, traces of red and white pigment*
Height: 58 in. (147 cm)

SUSPENSION HOOKS WERE MADE IN ALL parts of the Middle Sepik River region. They were hung from the rafters of both cult houses and dwellings and were used to protect food and other possessions from the depredations of rats and other vermin. To prevent animals from climbing down, a large disk was attached to the fiber rope from which the hook was hung between it and the roof. Net bags were suspended from the prongs. As here, the shafts of the hooks are usually of human form, but representations of fish, reptiles, and birds were also made.

There are many different kinds of hooks, and without specific collection information, it is difficult to know whether an example might have been utilitarian or may also have had religious significance. In this case, however, the monumental size of the sculpture and its close stylistic association to the powerful cult figures of the Sawos (see cat. no. 15) suggest both the representation of a powerful culture hero and a highly sacred function.

As is true of the cult figures, the most important hooks were responsible for the general well-being of their community, and this was most probably one of them. Such hooks had specific names and were the property of clans. They were used to ward off disease and evil and to assist in hunting animals or in headhunting expeditions.

Before embarking on headhunting quests, flowers, pieces of chicken, and betel nuts were hung on the hook. An attendant then induced the spirit to enter the hook by eating the chicken and betel nuts. In an ensuing trance, the spirit spoke through him, and gave advice as to the outcome of the venture. The spirit might also accompany the warriors to help weaken or trap victims. On their return from a successful hunt or raid, additional offerings of food were made to the hook (Smidt 1975, p. 74, no. 68).

Collected by Roy Hedlund and L. R. Webb at Torembi village between 1956 and 1960

Previous collections: Robert Browne, Honolulu; Walter Randel, New York; George Ortiz, Geneva; Merton Simpson, New York; Wayne Heathcote, New York

Publications: Honolulu Academy of Arts 1967, p. 19, no. 160; Sotheby's, London, 1974, no. 69; Loudmer-Poulain, Paris, 1978, no. 81; Pfeiffer 1983, pp. 210–20, figs. 61–63

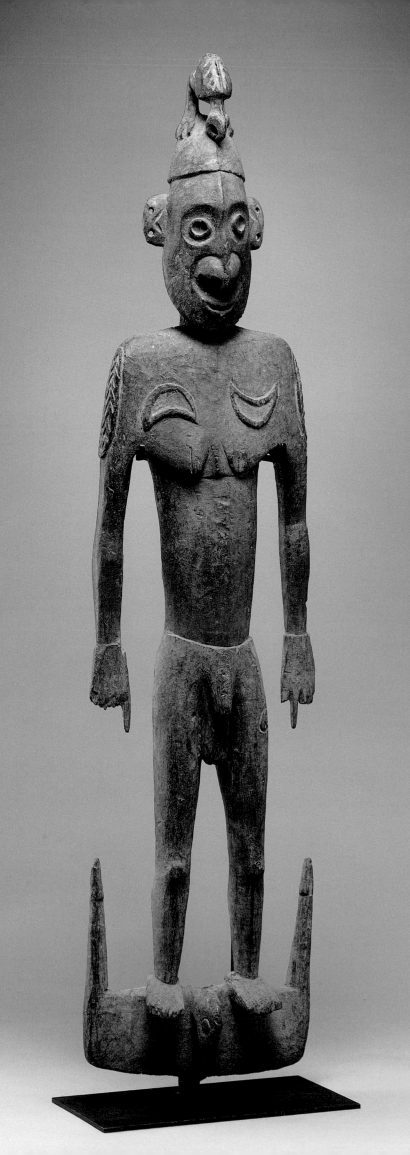

## 17 Male Ancestor Figure

Papua New Guinea, East Sepik Province,
Iatmul People, Yentschemangua Village
*Wood, fiber, human skull, human hair, cowrie shells,*
*red and white pigment*
Height: 68 1/4 in. (173.5 cm)

SOME OF THE ANCESTOR FIGURES MADE along parts of the Sepik River incorporate the very skulls of the individual they represent. Their skulls were overmodeled with clay and painted with the patterns of body ornament the deceased employed during his lifetime. The elegant concentric curvilinear motifs are typical of the art of the Iatmul of the middle course of the Sepik from where this work originates. These composite figures were used in funerary ceremonies honoring the ancestor (Wardwell 1971, p. 81, no. 172).

The base is carved into a hook form imitating the food hooks that were made in great numbers throughout the Middle Sepik region (see cat. nos. 16 and 18). However, because of the small size of the prongs here, it is doubtful that the figure served any such utilitarian function. Nonetheless, the close association of ancestor figures with food hooks themselves would account for the inclusion of the hook form at the base of this figure. In this case, it has become a symbolic vestige of what is a functional component of other objects.

Previous collections: Walter Randel, New York; John Friede, New York; Wayne Heathcote, New York

Publication: Sotheby's, New York, 1987, no. 105

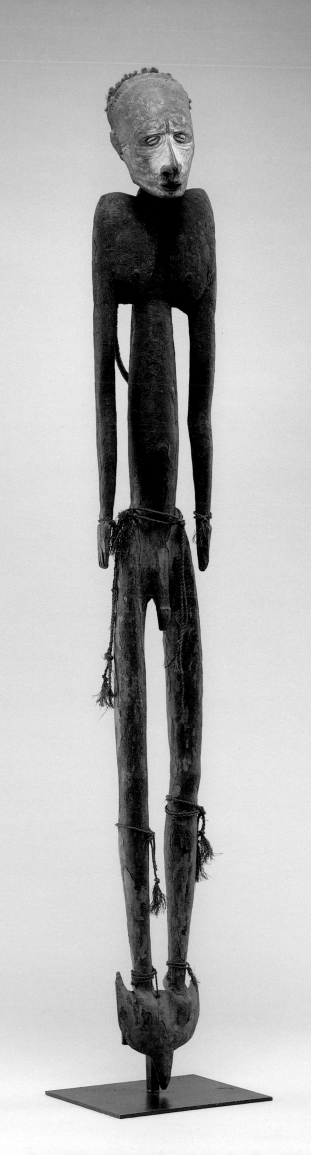

## 18  Suspension Hook

Papua New Guinea, East Sepik Province,
Karawari or Krosmeri Rivers
*Wood, red and white pigment*
Height: 34 in. (86 cm)

THE ART OF THE MIDDLE SEPIK RIVER and its tributaries relies as much on the use of curvilinear surface ornament as it does on pure sculptural form. The ornament takes the form of circles, ovals, and concentric arcs that are formed by a combination of reliefs and painted designs, resulting in an elegant expression. Some inventive creations, such as this hook, incorporate openwork into their conception to enhance the fluid surface decorations. Hooks of this style were developed by the peoples of the Karawari and Krosmeri rivers and then traded into the Middle Sepik region, and they are therefore found over a relatively widespread area (Newton 1991).

Here, the motif of the hook has been used as a repeated and unifying design element within the shaft of the piece. These forms would obviously not have had any utilitarian function. The hook carving at the bottom is also of such small size that the object may have only been used to represent an ancestor figure.

Previous collections: E. J. Wauchope, Sydney; Gene van Grecken, Sydney; Wayne Heathcote, New York

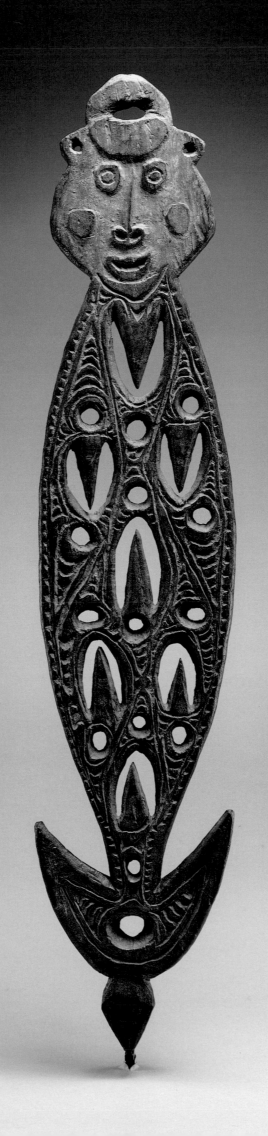

## 19  Mask (*mei*)

Papua New Guinea, East Sepik Province,
Eastern Iatmul People
*Wood, shell, fiber, traces of red and white pigment*
Height: 15 1/2 in. (39 cm)

SUCH ELONGATED MASKS OF THE IATMUL were originally mounted on a conical fiber construction that covered the head and shoulders of a dancer. They appeared in pairs (a male and female in each) and represented the ancestral brothers and sisters of a village clan. Each pair belonged to a specific clan, and when not in use, they were kept in the house of the clan elder.

*Mei* masks also had important additional functions and significance. During initiation, young men were under the tutelage of a leader who wore such a mask. After the leader had struck the first symbolic blow, the initiates killed a prisoner who had been captured on a headhunting raid. During such raids, the masks were pointed at the adversaries and shaken at them in order to bring about their defeat (Newton 1967, no. 59).

This mask was once completely encrusted with shells, which may have been removed at the time it was collected (for two examples retaining their original decoration, see Gathercole et al. 1979, p. 319, nos. 22.42, 22.43). The two holes at the top indicate where it was attached to the fiber costume, and the elongated beaklike nose culminates in the head of a bird, again representing a clan totem. According to Newton (1967, no. 60), *mei* masks of broad cross section and comparatively flat facial features such as those seen here originate from the Eastern Iatmul.

Collected by Dr. Karsten in 1914

Previous collections: Philip Goldman, London; Bruce Seaman, Bora-Bora; Wayne Heathcote, New York

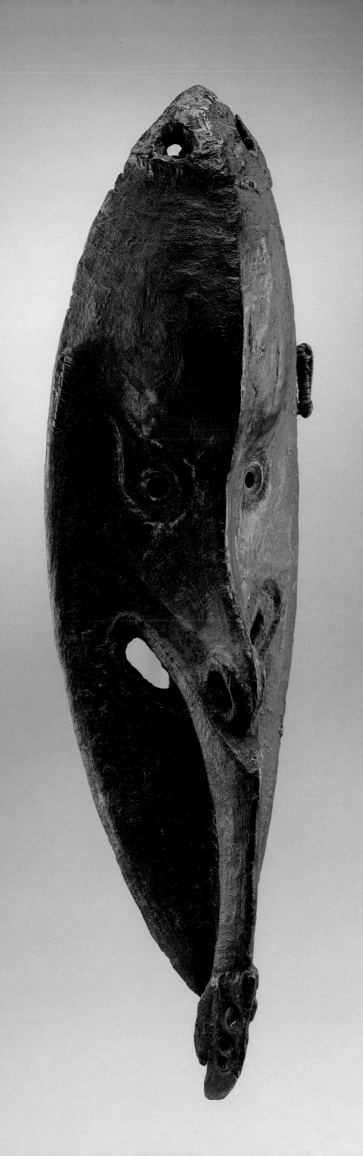

## 20 Headpiece

Papua New Guinea, East Sepik Province,
Iatmul People, Tambanum Village
*Wood, fiber, bark, shell, red and white pigment*
Length: 51 in. (130 cm)

**B**ECAUSE IT IS INTACT, THIS OBJECT serves as a reminder of the fragmentary nature of some of the Melanesian objects in this and other collections. In many cases, the wood sculptures that originally formed parts of costumes were sometimes removed by the people themselves, who may have felt it was easier to carve substitutes for them than to make a new costume. The sculptures may also have been separated by the collector who was only interested in the carvings and did not want to take the trouble packing and shipping the materials with which they were originally associated. It has already been noted that the *mei* mask (cat. no. 19) is one such object that was removed from its fiber headpiece.

In this case, if only the head had survived, we would not have had a representation of the entire animal whose body is formed by the head covering and whose long tail identifies the animal represented. It is a dog, one of the totemic animals of the Sepik peoples. The mask is additionally significant because two photographs of it in use were made by Felix Speiser at Tambanum village in 1927. They are now in the archives of the Museum für Völkerkunde, Basel (Newton 1991).

Previous collections: Linda Cunningham, New York; Wayne Heathcote, New York

*Three masked dancers at Tabanum Village photographed by Felix Speiser in 1927. The costume and original coloring of the Masco headpiece are clearly indicated. Haddon Photo Collection, MNG 27; courtesy Museum of Archaeology and Anthropology, Cambridge University, Cambridge, England.*

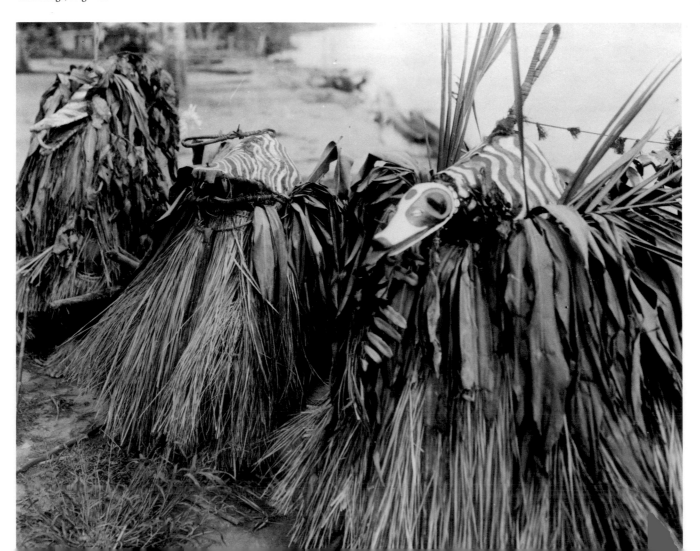

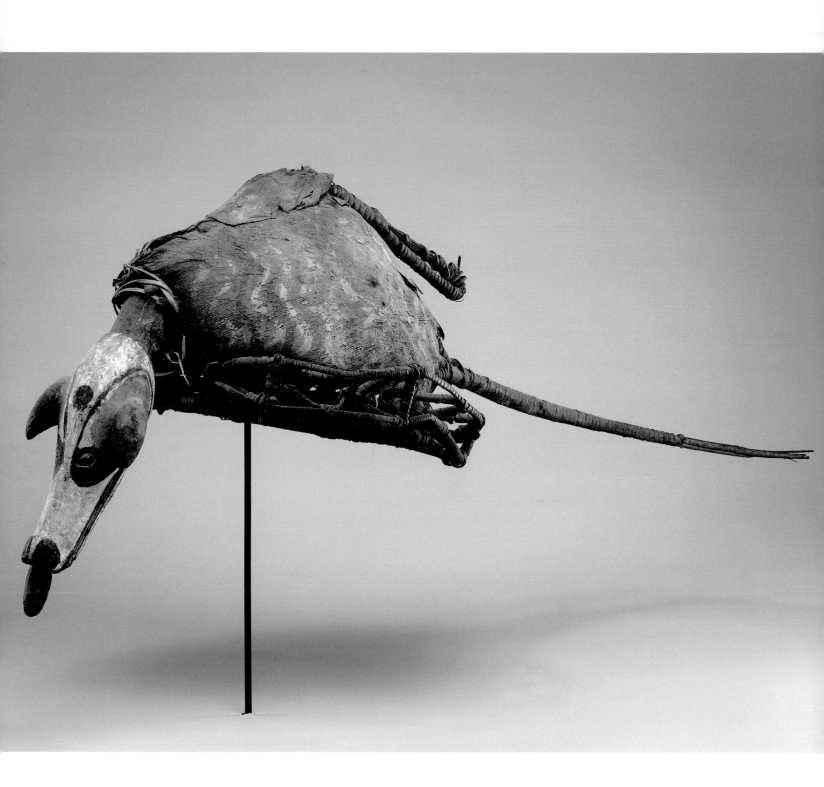

## 21 Mask (*didagur*)

Papua New Guinea, East Sepik Province,
Blackwater River, Kapriman People
*Basketry, cassowary feathers, white and red pigment*
Height: 26 in. (66 cm)

**D**IDAGUR IS A MALE OR FEMALE SPIRIT that inhabits the water or the hollows of trees, and it could be induced to inhabit this mask during the times it was being worn (Schmid 1985, p. 198, no. 120). It is possible to tell which sex is represented in such masks by the length of the nose, that of a female being short, as here, and that of a male being much longer. This mask form is believed to have originated among the Iatmul. Because there was much trade of objects and sharing of art styles along the Sepik River and its tributaries, the type came to be used not only by the people of the Blackwater River but by those of the Karawari River as well (Gathercole et al. 1979, p. 310, no. 22.28).

All such masks have wide gaping mouths through which the wearer could look, circular eyes, pronounced noses, small ears, and some form of extension at the top of the head. They are extraordinary examples of the basket weaver's art, even in an area known for excellent work in this medium. An interesting detail on this one is the openwork design on the lower jaw, which represents a spider web.

Previous collection: Wayne Heathcote, New York

Publication: Sotheby's, New York, 1983b, no. 23

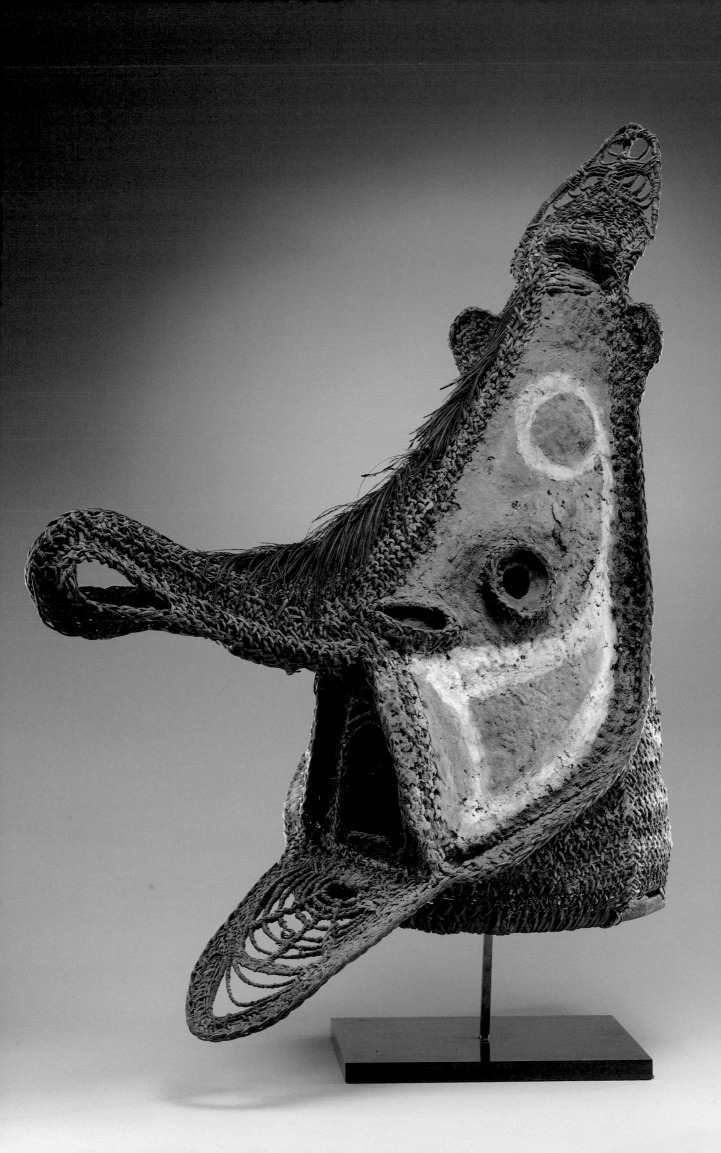

## 22 Hand Drum

Papua New Guinea, East Sepik Province,
Eastern Iatmul People
*Wood, fiber, shell, animal hide, red and white pigment*
Height: 23 in. (58.5 cm)

THE PEOPLE OF THE SEPIK RIVER MADE a variety of relief-ornamented drums including large slit gongs and water drums, neither of which required a membrane. The hourglass-shaped hand drums such as this one were used to provide accompaniment to clan songs that were sung at such ceremonies as funerals, the inauguration of a newly made canoe, or the completed construction of a clan house. They were often employed in public secular contexts as well (Schmid 1985, p. 186, no. 49).

The body of the drum is decorated with a series of harmonious spiral relief motifs and concentric arcs that are painted in red and white. Underneath the handle is a large grimacing human face. Figures of cassowaries are carved at both ends of the handles.

This drum is closely related to three others. One is in the Museum of Mankind, London (Cranstone 1961, pl. 9c), another is in the Tropen Museum, Amsterdam (Rijksmuseum 1966, p. 62), and the third, from the Friede collection, is now in the Brooklyn Museum. The latter example is accompanied with the information that this design was that of a Chambri drum which had been captured by the Iatmul and subsequently used by them to commemorate their victory (Newton 1991).

Collected by Captain Haug in 1909

Previous collections: A. Speyer, Berlin; Carlo Monzino, Lugano

Publication: Sotheby's, New York, 1987, no. 118

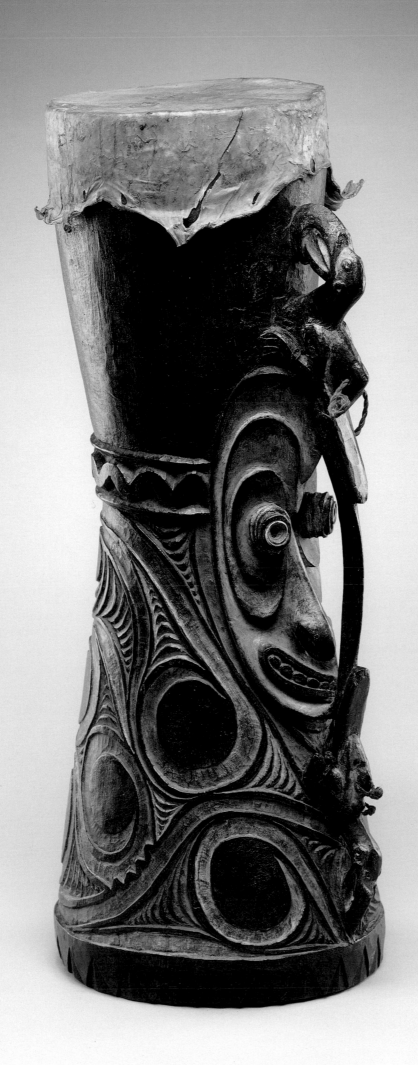

## 23 Pigment Dish

Papua New Guinea, East Sepik Province,
Iatmul People
*Wood, fiber, white pigment*
Length: 12 in. (30.5 cm)

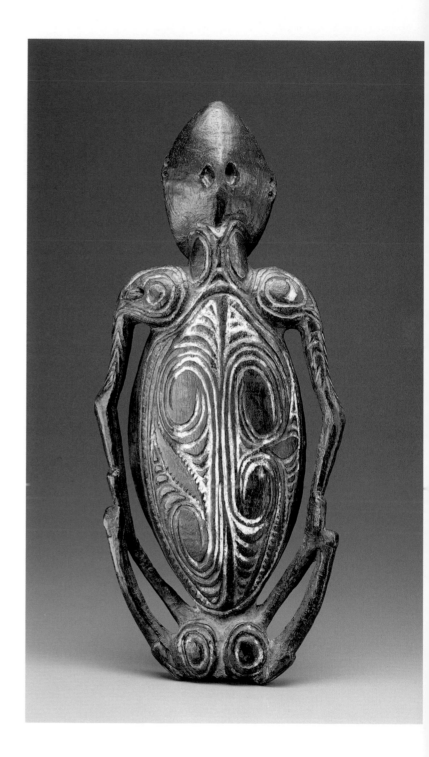

DISHES IN WHICH TO MIX PIGMENTS used for body painting were made along the entire middle course of the Sepik River (Schmid 1985, p. 189, no. 66). Most of them are in animal form, the hornbill, cassowary, crocodile, and sawfish being among the species represented. Dishes of human shape such as this one seem mostly to have been made by the Iatmul.

A squatting female figure is represented. The back is decorated with beautiful flowing asymmetrical curvilinear relief carving. This type of ornament is typical of Iatmul art at its best. The ears of the figure were originally ornamented with fiber strands, and the dish has a rich patina indicating long use. Native repair to a break on the left shoulder demonstrates that the dish was highly regarded by its owner and was not simply discarded when it had been damaged. A similar example illustrated by Rawson (1973, p. 294, fig. 218) is now in the Friede collection.

The fine sculptural quality of many Sepik pigment dishes and the care with which they were made far transcends their utilitarian purpose. As these represent totemic clan animals and ancestors, it was perhaps believed that their spirits would enter into the pigments that were to be painted onto the bodies of those people who participated in ceremonies honoring them.

Previous collection: Gerd Rosen, Berlin

Publication: Kunsthaus Lempertz, Cologne, 1989

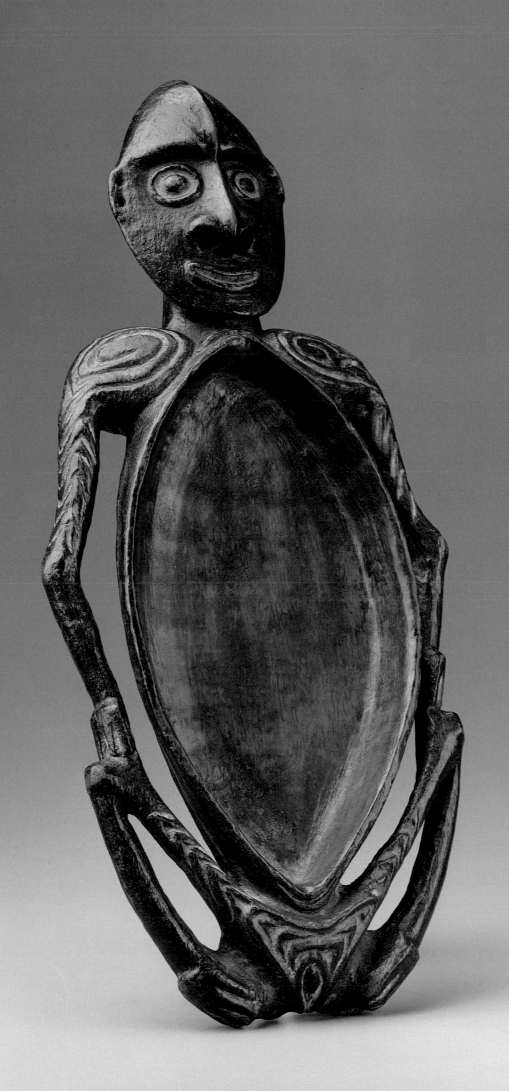

## 24 Three Daggers

Papua New Guinea, East Sepik Province

ALONG THE SEPIK RIVER, EVERY MAN owned a dagger made of bone that was used for fighting, ritual, and prestige display. They were valuable pieces of property, and the material itself was associated with supernatural power and was a metaphor for strength (Newton 1989, p. 307). Their shafts are decorated with engraved, incised, and sometimes relief carved designs. Most are made of the tibia of cassowaries, but some are of human femur.

## 24a Dagger

Kwoma
*Human femur, cowrie shells, fiber*
Height: 15 in. (38 cm)

AMONG THE KWOMA, HUMAN BONE WAS used for daggers more frequently than was bone of the cassowary. The bone was either the femur of the father of the dagger's owner or that of an enemy he had killed. To increase its effectiveness, magic plant materials were added at the top. The engravings, which closely relate to the palm spathe paintings of the Kwoma, are applied to the whole shaft of the dagger (Newton 1989, pp. 318–21). Here two human faces are carved right side up and upside down.

Collected by Wayne Heathcote about 1968 in the Washkuk area

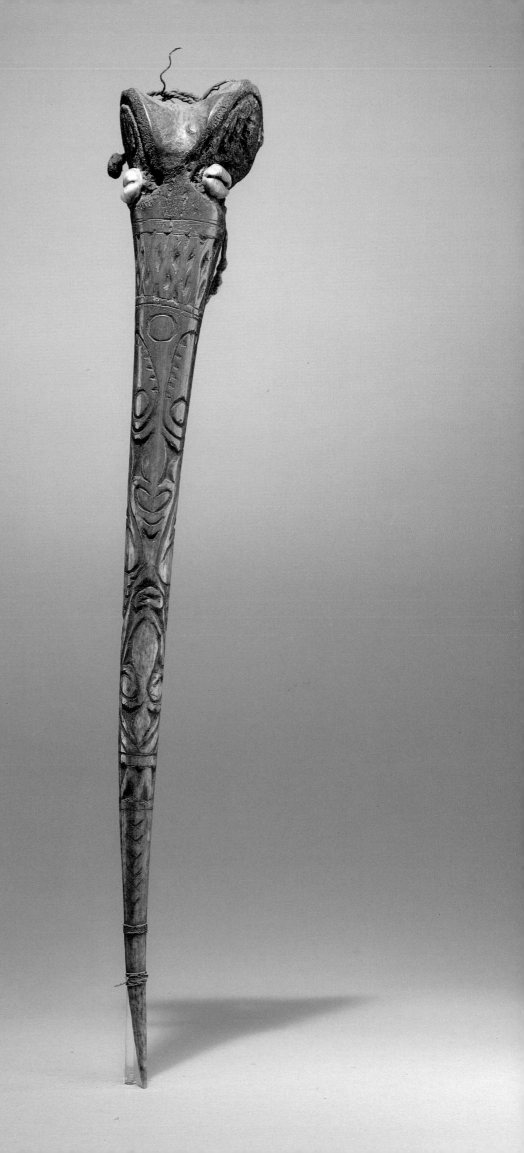

## 24b Dagger

Southern Abelam People
*Cassowary tibia*
Height: 15 in. (38 cm)

THE ATTRIBUTION TO THE SOUTHERN Abelam is made by Douglas Newton (1991). At the top are two parrot heads, below which is a standing frontal female figure carved in high relief. Two birds face each other in profile below the figure, and at the bottom are cut the initials *K P W.* These are probably later additions as the dagger itself shows evidence of considerable use and was carved prior to the time that writing had been introduced.

Collected by Wayne Heathcote about 1968

## 24c Dagger

Abelam People
*Cassowary tibia*
Height: 13 1/2 in. (34 cm)

THE ABELAM MADE A LARGE VARIETY OF daggers. Although regarded as symbols of male aggression, the daggers were used more for ritual purposes than actual fighting. Most are made of cassowary bone; they were displayed at initiations and other secret society ceremonies and used as peace tokens. They are among the most elaborately decorated of such implements, the designs reflecting those of the paintings on Abelam ceremonial houses (Newton 1989, p. 316). This design is typically Abelam with its fine application of curvilinear and geometric incisions and the representation of the human face in the center.

Collected by Wayne Heathcote about 1968 in the Abelam area

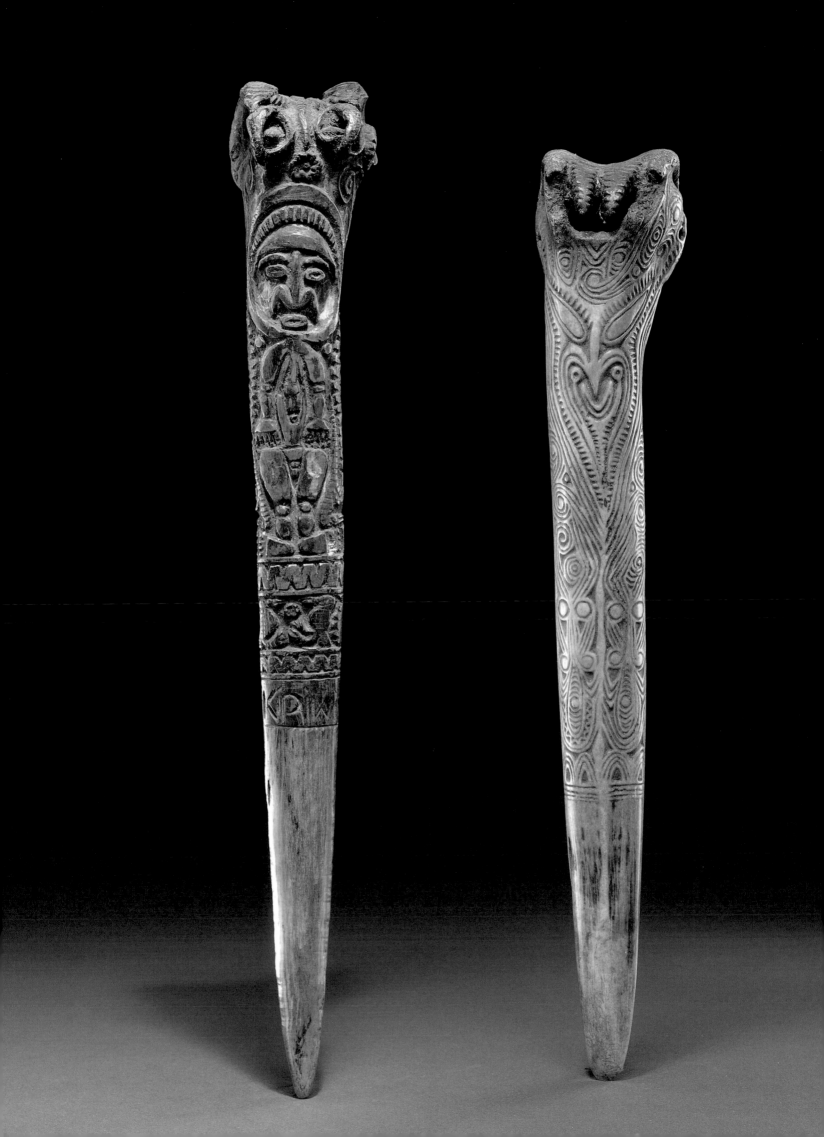

## 25 Limestick

Iatmul People, Palimbei Village
*Cassowary tibia*
Height: 16 in. (40.5 cm)

A S WITH THE OTHER LIMESTICKS SHOWN here (cat. nos. 4 and 52), this example was originally accompanied with a gourd or bamboo container to hold lime. The carving of the entire figure of a cassowary on the tibia of the bird itself literally combines the symbol with the medium. The cassowary was an extremely important creature associated with initiation ceremonies and creation myths (Newton 1989, pp. 309–11). An illustration of a similar limestick with its original gourd is accompanied with the information that the "container was most probably used by shamans when going into a trance or at divining rituals before head-hunting raids" (Schmid 1985, p. 185, no. 40).

Collected by Wayne Heathcote at Palimbei about 1968

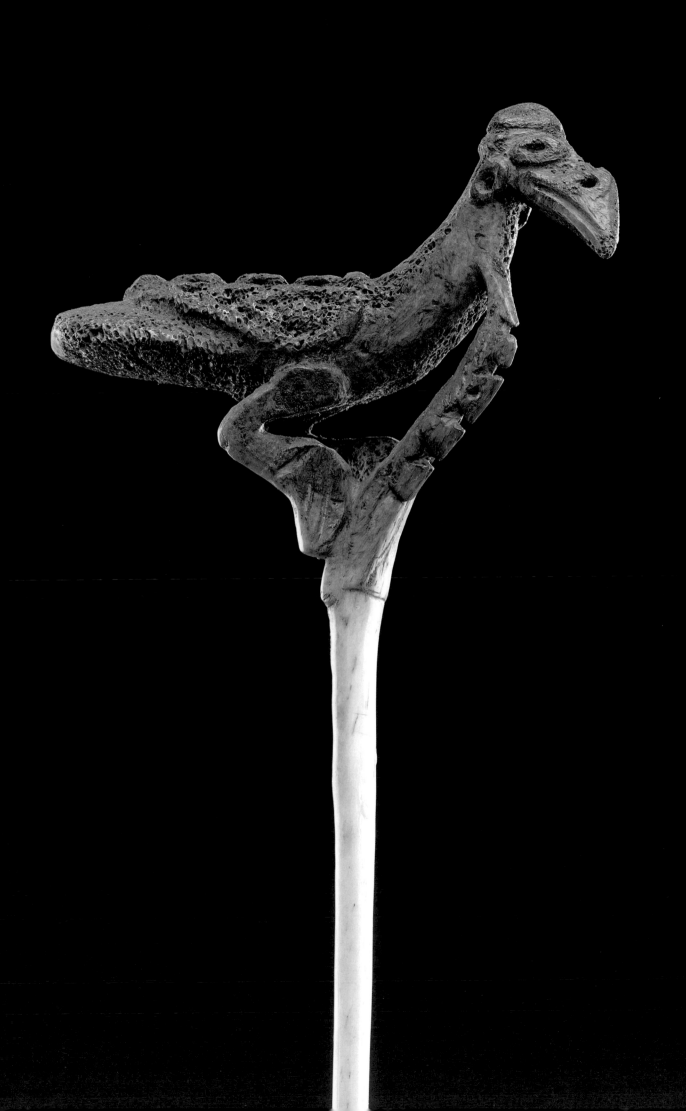

## 26 Yam Cult Figure (*mindja*)

Papua New Guinea, East Sepik Province, Warasei People
*Wood; yellow, red, black, and white pigment*
Height 70 1/2 in. (179 cm)

T HE PEOPLE WHO LIVED ALONG THE
Upper Sepik River and its tributaries practiced a
number of rituals associated with the yam harvest.
Each of them required the display of a different kind of
figure sculpture. The first cycle was called *yina*. This cult
object was displayed during the second cycle of ceremo-
nies, *mindja-ma*, which preceded *nogwi* (see cat. no. 27).
Although they may look like large masks, these carvings
were not worn but displayed in pairs during yam harvest
rituals. The triangular designs below the face symbolize
banana leaves, and the wavelike form carved in relief run-
ning along the axis is a snake, its head at the bottom of
the carving. Taken as a whole, these sculptures represent
water spirits that could sometimes be seen by the people,
swimming just below the surface. Some accounts also
associate them with spirits of the sky and thunder
(Newton 1971, pp. 86–87).

During the *mindja-ma* ritual, in the early morning, a
pole was set up in the ceremonial house, and at its base
was laid a basket containing yams. A pair of carvings, of
which this was one, was placed against the pole, back to
back, and each was decorated with the feathers of birds of
paradise and chickens. Men then participated in cycles
of singing, dancing, and feasting throughout the day and
night until dawn the next day. When the ceremonies
ended, the carvings were taken down, wrapped up, laid
on the slit gongs that had provided music for the dances,
and removed to shelters. Only then could yams be distrib-
uted throughout the village (ibid., pp. 87–88). There are
several stylistic differences among *mindja* carvings depen-
dent on the area from which they come. Those with
regular triangular depictions of banana leaves, arched and
painted brows, and the pointed head such as are repre-
sented here are from the Warasei district (ibid., p. 100,
nos. 162, 163; Gathercole et al. 1979, p. 333, no. 22.71).

Collected by Wayne Heathcote in the Warasei area in 1963

Previous collection: Bruce Seaman, Bora-Bora

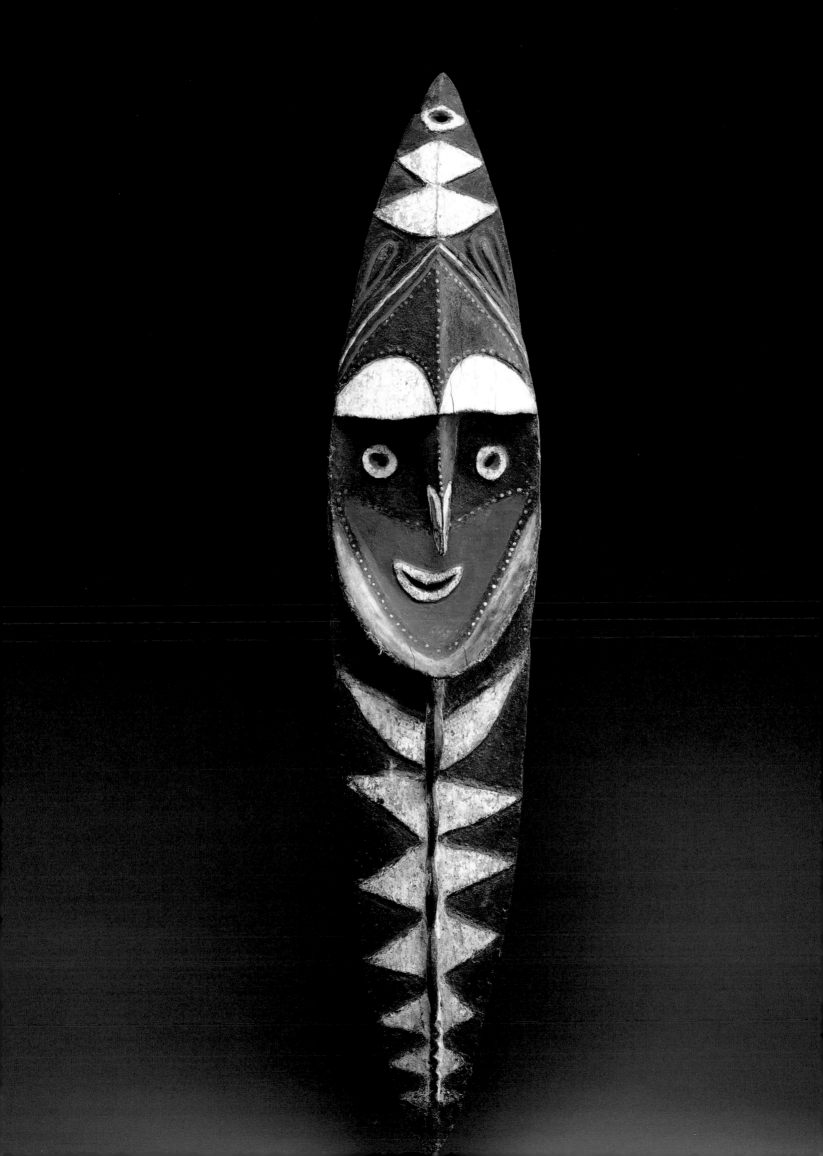

## 27 Yam Cult Figure (*nogwi*)

Papua New Guinea, East Sepik Province, Warasei People
*Wood, red and white pigment*
Height: 35 1/2 in. (90 cm)

THIS FIGURE WAS USED IN CONJUNC-
tion with the third and last Warasei yam harvest
ceremony, *nogwi*, which was attended only by the
most powerful men of the community (see cat. no. 26).
After the yams had been harvested and stored, because
they were so powerful, they could not be eaten until all
three ceremonies had been performed in sequence
(Newton 1971, p. 84).

The carving represents a female spirit. It was one of two
representing the female spirit Hameiyau or Sanggriyau
that was set up on a platform in front of a basket con-
taining yams and decorated with shell ornaments, hair
from clan members, and, attached to a headband, two bags
holding nuts, fish, meat, and eggs. During the ensuing
ceremonies which lasted until dawn, it was believed that
the two figures danced with each other. When the carv-
ings were put away, the food from the headband bags was
distributed to women to bring about success in fishing
(ibid., pp. 88–89).

Upper Sepik art is somewhat cruder than that made
along the lower and middle regions, and human figure
sculptures are not common. Here, the facial features,
breasts, navel, and vagina are shown as geometric forms
in high relief. The other designs probably represent body
painting.

Collected by Wayne Heathcote in the Warasei area in 1965

Previous collection: Bruce Seaman, Bora-Bora

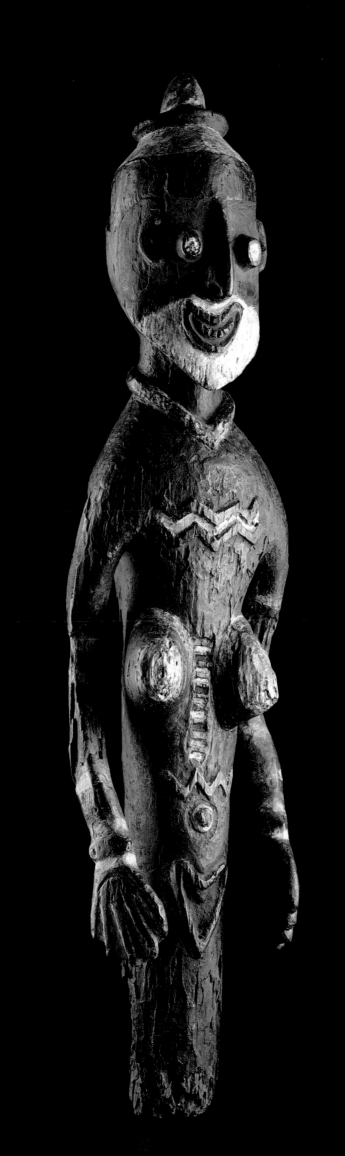

## 28 Figure (*wenena gerua*)

Papua New Guinea, Eastern Highlands Province,
Siane People
*Wood; blue, ocher, and red pigment*
Height: 58 in. (147.5 cm)

THE SIANE LIVE IN THE EASTERN HIGH-
lands of New Guinea, some distance south of the
Sepik River. They developed a series of complex
rituals but are not known to have produced much in the
way of sculpture (Newton 1967, no. 96, supra). Notable
exceptions, however, are the brightly painted *gerua*
boards such as this one that were used in a spectacular
ceremony associated with the feeding of ancestor spirits
and the propagation of pigs.

Each clan group performs this ceremony every three
years. It is a complex event involving initiation and other
coming of age celebrations and the killing of pigs. Its
climax occurs at the full moon, when several thousand
people gather around as many as two hundred male
family heads who dance, wearing *geruas* strapped to
their heads and carefully balanced on them. The boards
have been spiritually activated through the placement of
a crown of human hair at the top and various valuables
attached to other parts of it. The dance culminates in the
killing of pigs. To ensure the continuing fertility of pigs,
pork is then ceremonially fed to spirits. At the end of the
festivities, the *geruas* are placed in bamboo groves and
allowed to decay.

Two types of *geruas* were made: large ones, *wenena
geruas* such as this example, which are up to six feet high,
and the smaller *korova geruas* that are of simpler design.
The large boards are of anthropomorphic form, the dia-
mond-shaped body representing the moon, the round
head symbolizing the sun, and angular arms and legs
indicating the passage to be followed. The painted pat-
terns applied were the property of each family (Salisbury
1965, pp. 66–69).

Collected by Dadi Wirz in 1955

Previous collection: Carlo Monzino, Lugano

Publications: Rubin 1984, vol. 1, p. 44; Sotheby's, New
York, 1987, no. 110

## 29  Suspension Hook

Papua New Guinea, Morobe Province, Tami Islands
*Wood*
Height: 12 in. (30.5 cm)

THE TAMI ISLANDS ARE LOCATED IN THE Huon Gulf about three hundred miles east of the mouth of the Sepik River. A rich and distinctive wood-carving tradition developed there. It combines depiction of human and animal figures with geometric relief designs which are often enhanced by the application of lime and red and black pigments. Because the islands are coral and lack good soil, clay, or sources of hard stone, it was necessary for the inhabitants to produce items that could be traded for food, pottery, and stone for adze blades. Quantities of bowls, neckrests, lime spatulas, and suspension hooks were therefore made for exchange as well as local use.

Regarding the hooks, there has been some misinformation concerning their exact function. One source (Reichard 1933, p. 76) refers to them as net sinkers, which seems unlikely as no examples show evidence of prolonged exposure to water. They are also often referred to as food hooks that were hung from the rafters of houses with bags of food suspended from them out of reach of rats. As has been noted, hooks were used along the Middle Sepik River for this purpose. Compared to most of those from the Sepik, however, Tami hooks are of the same generally small size and would not have been able to hold substantial bundles of food. It therefore seems most likely, as has been stated by Tibor Bodrogi (1961, p. 97), that they were used to suspend less weighty "net bags, pig trapping nets, and fishing nets" so that rats could not get at them and gnaw through the fibers. They were hung mostly below the roof in dwellings, and sometimes were also used in cult houses.

This example is carved in the shape of a female Janus figure standing on the hook, her hands at the hips, and her arms forming an elegant arc falling from the shoulders. It is one of the three forms in which these hooks were created. The others either have a human head carved on the shank of the hook or one in relief on the face of the hook itself. All have a hole at the top, enabling them to be hung from rafters. The zigzag ornament at the bottom of the hook and on the forehead is a motif called *kalikali*, which often appears in Tami relief design. It represents a glowworm centipede often found in the dry places of houses, which, when disturbed, produces a strong pulse of light (ibid. p. 171).

Previous collection: Walter Randel, New York

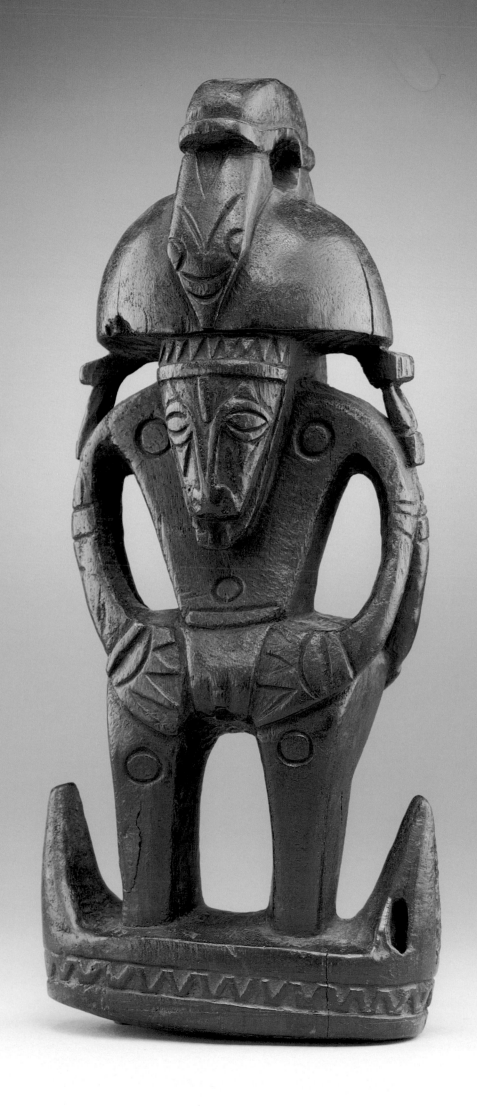

## 30 Dance Wand (*kaidiba*)

Papua New Guinea, Milne Bay Province, Trobriand Islands
*Wood, traces of white pigment*
Length: 29 3/4 in. (75.5 cm)

IN MOST SURVEYS OF MELANESIAN ART, the island archipelagoes that lie off the eastern end of New Guinea are referred to as comprising the Massim district. The art from this area is notable for the extremely detailed and complex scroll designs that are carved in low relief on such objects as lime spatulas, neckrests, canoe prow decorations, and dance wands such as this one. Among the motifs incorporated into the scrollwork are the stylized heads of frigate birds whose long, down-curving beaks metamorphose into the spiral designs.

The *kaidibas* consist of two lunette forms joined by a bar that served as a grip for a dancer when the *kaidiba* was in use. Each of these lunettes consists of "a large comma-shaped element resting on a rectangular element representing a bird" (Newton 1975, p. 7). Here the bird head can be clearly seen in profile just above the horizontal projections below the "comma." As symmetrical as both ends of these wands may seem, close study reveals that this is not the case, and the small differences between them were undoubtedly intentional.

*Kaidibas* were used for a variety of different ceremonies including those at harvests, prior to the launching of a new canoe, and in preparation for war. As they were held, they were twirled back and forth to the rhythms made by hand and finger drums (cat. no. 32), the curvilinear relief designs enhancing their circular movements. They were originally painted red and sometimes black, with white lime filling in the cuts, traces of which remain here.

Collected by D. Fred Gerritz, World Health Organization, in the 1950s

Previous collections: Loed von Bussel, Amsterdam; Wayne Heathcote, New York

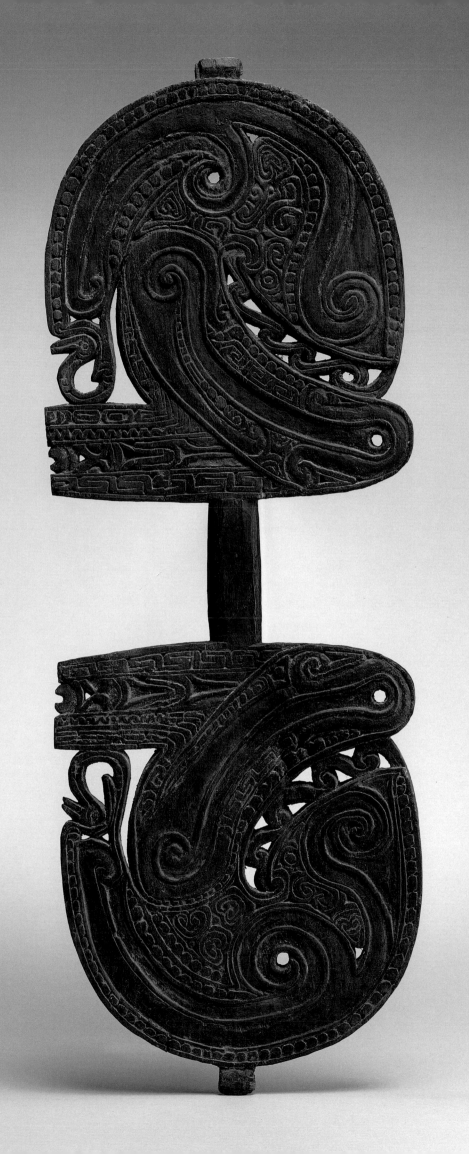

## 31 Ceremonial Spatula (*gabaela*)

Papua New Guinea, Milne Bay Province,
Louisiade Archipelago
*Turtle shell, lime pigment*
Height: 8 1/4 in. (21 cm)

ALTHOUGH OF SPATULATE FORM, THESE turtle-shell objects were not associated with lime and betel chewing but were items of considerable value used for display and trade. They were made on the islands of the Louisiade Archipelago, perhaps only on Tagula and Wanim (Beran 1988, p. 49), and were among a number of specific object types that were exchanged throughout the Massim area as part of a highly organized network of trade relations called *kula* (Newton 1975, pp. 4–6).

When a family acquired a *gabaela*, it was carried by a woman of marriageable age in dances and became an important part of her dowry. Its value was further enhanced by groups of spondylus shells that were attached by the artist or owner herself through holes that are drilled into the top (Seligmann 1910, pp. 516–17). As with most surviving examples, the shells are missing here, but it was additions of this kind that gave the spatula its true value (Beran 1988, p. 45).

Both sides are identically carved in relief in elegant symmetrical designs. The heads of three pairs of frigate birds emerge from the ends of scroll forms. One pair turns inward at the top of the spatula shaft, another is below, facing upward, and the third is upside down directly underneath the second pair.

Previous collection: Wayne Heathcote, New York

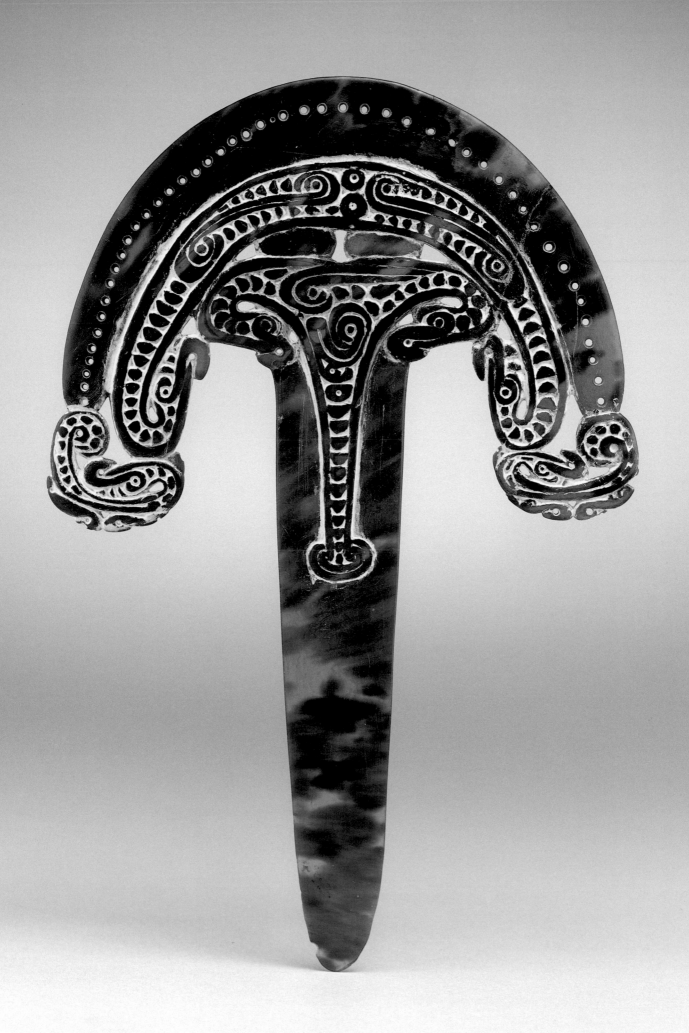

## 32  Pair of Finger Drums (*katunenia*)

Papua New Guinea, Milne Bay Province, Trobriand Islands
*Wood, lizard skin*
Length: 11 1/2 in. (29.5 cm)

ALTHOUGH HAND DRUMS OF VARIOUS kinds are common throughout Melanesia, this type of small finger drum is unique to the Massim region. The drums seem to have been used together, perhaps one played by each hand, and are usually published in pairs (see, for example, Chauvet 1930, pl. 57 nos. 210, 211; Force and Force 1968, p. 322). When struck with the finger, they produce a high-pitched sound. The handles of this pair show two typical frigate bird heads facing the top and bottom of the drums with scroll patterns extending from them. The raised projections on the bottom half of each drum are perforated and originally held fiber and shell ornaments.

Previous collection: Wayne Heathcote, New York

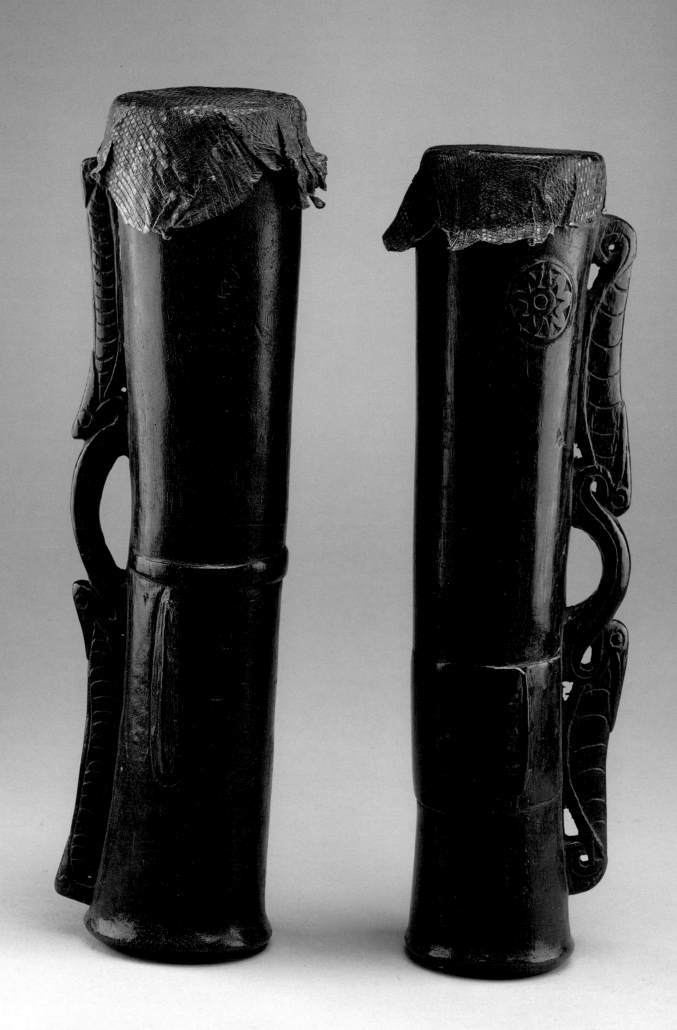

## 33 Female Figure

Papua New Guinea, Gulf Province, Turamarubi People
*Wood, human hair, fiber, shell, seeds; red, white, and black pigment*
Height: 44 in. (112 cm)

THE TURAMARUBI PEOPLE INHABIT THE estuary of the Turama River, which runs into the Papuan Gulf. The Fly and the Bamu rivers are to their west, and the Omati River and its delta are to the east. Most of the art of the Papuan Gulf area is two dimensional, and sculpture in the round is not common. Such figure carvings as were made are direct in expression and somewhat crude in execution, as is this one.

During the course of research for this volume, no accounts of Turamarubi rituals that employed human figure sculpture were found. However, Douglas Newton writes (1961, p. 15) that aspects of the culture of the Kerewa people who live directly to the east were adopted by the Turamarubi. Among the Kerewa, large figures of men, a woman, and such animals as crocodiles and pigs were made to be displayed to young initiates on the last night of their ordeal. Some were laid on the floor of the ceremonial house and surrounded by trophy skulls, while others were tied to the central post (ibid., p. 17).

Assuming that the Turamarubi maintained this Kerewa ceremony, this figure would have been used in a similar manner and may represent a mythical ancestress. Two similar sculptures in the collection of Bruce Seaman were shown at the National Gallery of Art, Washington, D. C., in 1979 (Gathercole et al. 1979, p. 348, nos. 25.10, 25.11). The shell pendants on this piece are restored.

Collected by George Craig about 1965 (Friede 1991)

Previous collections: John Friede, New York; Wayne Heathcote, New York

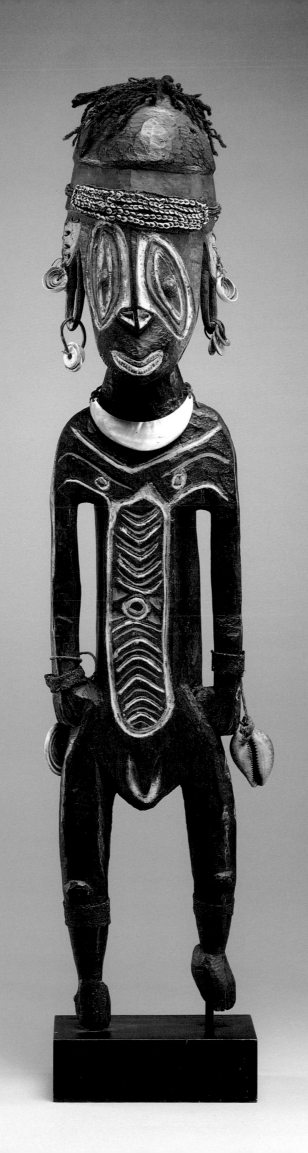

## 34 Male Figure

Papua New Guinea, Gulf Province, Lower Fly River
*Wood*
Height: 66.5 in. (169 cm)

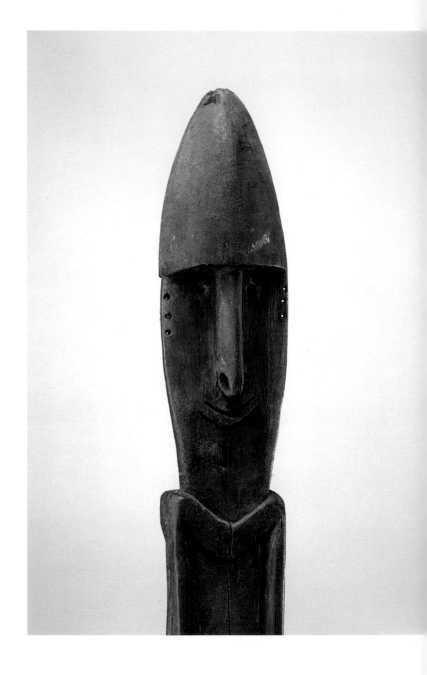

S WITH CAT. NO. 33, THERE IS LITTLE specific information that can be given about the use of this unique, elongated, and minimal carving of a male figure. It is said to be from the delta area of the Bamu or Fly rivers. In style, it relates somewhat to two rare female figures from the Bamu River (Newton 1961, pp. 44–45, nos. 80–81) but lacks the surface relief carving and application of pigment such as is apparent on these two sculptures. It bears an even closer resemblance to a group of male and female figures that come from the north bank of the Fly River (ibid., pp. 42–43, nos. 66–74). These figures are largely devoid of body ornamentation and pigment, and three (ibid., nos. 69, 70, and 74) show similar overhanging brows and the long thin nose with a pierced septum such as are represented here. These stylistic components suggest a Fly River attribution.

Throughout this area, an important ceremonial cycle called *Moguru* was enacted once a year. It involved the preparation of boys and girls for adult life. A sexual orgy to ensure the fertility of both the initiates and the sago palm took place, mock marriages were held, and a wild boar was sacrificed and eaten. Among the objects used in this ritual were protective figures (ibid., p. 10). It is reasonable to assume that this figure was made for display during the *Moguru* ceremony.

Previous collections: Bruce Seaman, Bora-Bora; Wayne Heathcote, New York

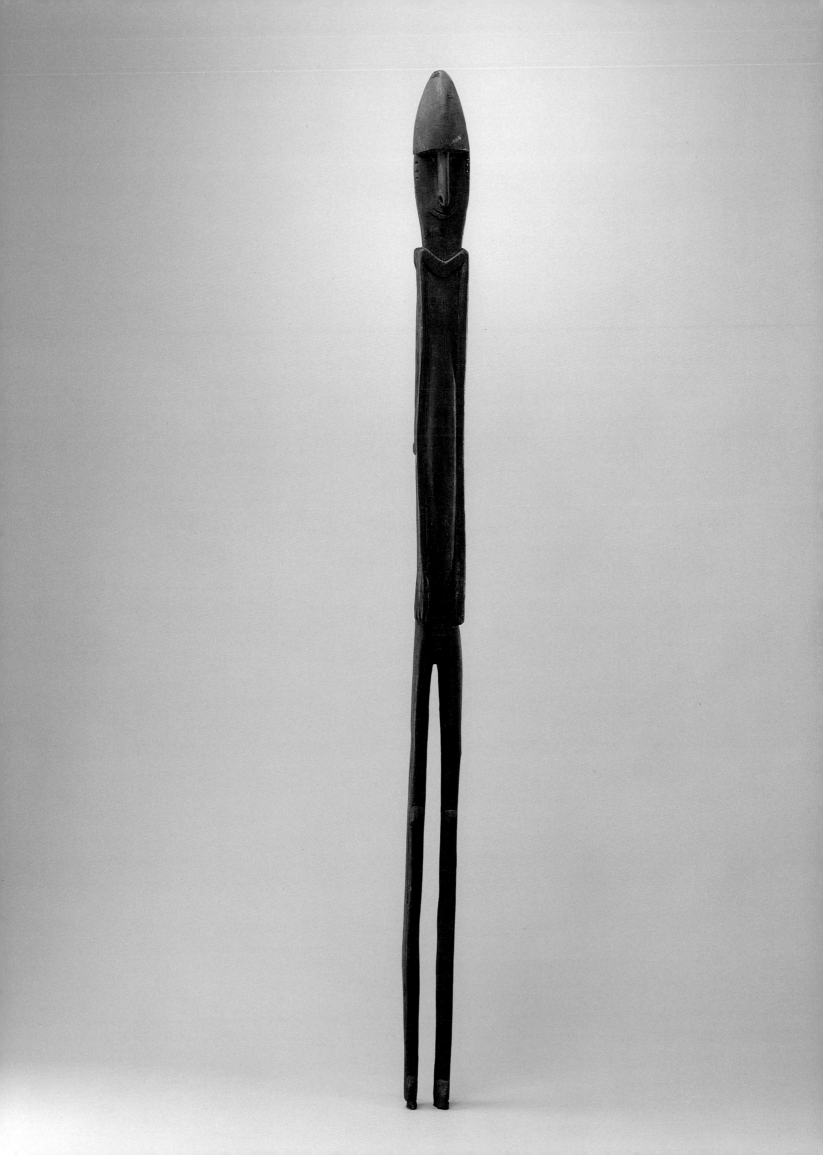

## 35 Skull Rack (*agiba*)

Papua New Guinea, Gulf Province, Kerewa People
*Wood, fiber, clay, human skulls; red, black, and white pigment*
Height (rack only): 28 1/4 in. (72.5 cm)

THE PEOPLES OF THE PAPUAN GULF were active headhunters and cannibals. Headhunting raids were made in preparation for initiations and for such rituals as the inauguration of a new ceremonial house or the completion of a canoe. Among the Kerewa, who inhabited the western portion of the Papuan Gulf, skull racks such as this one representing male or female ancestors were carved by a man just after he had taken a head. Following the hanging of the skull of a recent victim on the new *agiba*, other initiates added skulls which they had taken to it and may also have included skulls of their relatives. At each subsequent time the rack was prepared to receive other skulls, it was repainted by an elder known as the "father of the *agiba*." By this act he imbued it with spirit power (Newton 1961, pp. 17–18).

Each clan owned at least one *agiba*, and some owned a pair, of which the larger one was believed to represent a male ancestor and the smaller one a female ancestor. They were kept in separate compartments in the ceremonial house. The rack itself was lashed to a pole supporting the roof, and a shelf was built in front of it to hold the skulls (ibid., p. 16, figs. 17, 18, 108, 109; Haddon 1918, p. 176, pl. M; p. 178, fig. 2). Haddon (ibid., p. 178, 180) reports that some racks had as many as sixty skulls attached to them and mentions that one men's house had up to fifteen racks in it which held a total of about seven hundred skulls (see also Newton 1961, p. 18).

As is illustrated by this example, each rack depicts a human face and body with prominent shoulders and long arms. The upright hook forms may also represent legs. The Kerewa are known to have produced "the most highly developed art styles of the western gulf . . . [and] the greatest number of art objects" (Newton 1961, p. 54). The use of such two-dimensional design elements as chevrons, circles, concentric circles and arcs, and curving lines is typical of Papuan Gulf art.

Previous collections: Paul Wirz, Basel, 1930; Wayne Heathcote, New York

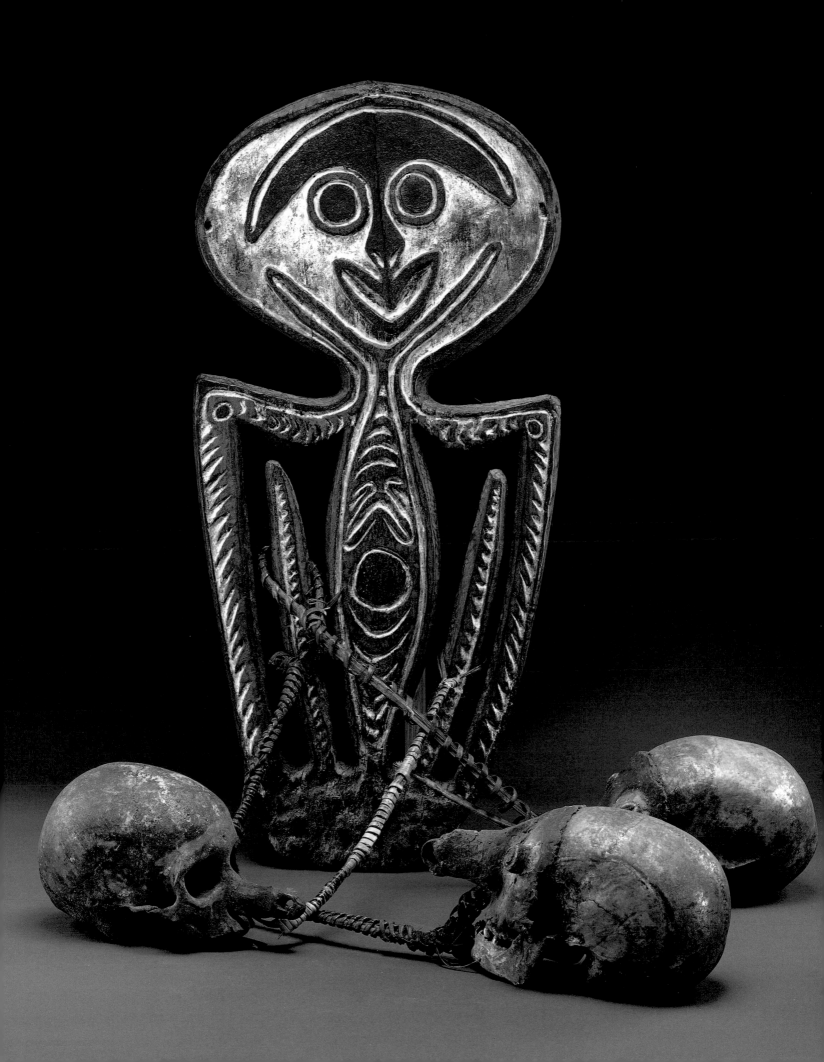

## 36 Belt (*kava*)

Papua New Guinea, Gulf Province, Purari Delta
*Bark, red and white pigment*
Width: 2 in. (5 cm)

THE BARK BELTS OF THE PAPUAN GULF range in width from about two to twelve inches and in length from two to three feet. Both ends are decorated with the same designs incorporating the human face with the typical geometric and curvilinear two-dimensional motifs that characterize this art (see cat. no. 35). On this example, the relief area below the face may represent a highly stylized human body. The faces represent clan ancestors, and the belts could only be worn by men (Cranstone 1961, p. 95). According to some accounts, they could be used only after the wearer had gone through all the levels of his initiation and was "entitled to partake in all feasts and dances" (Haddon 1894, p. 111).

To make them, strips of bark were cut, and the side to be decorated was carefully scraped. After the bark was dried, the designs were cut in with a knife originally having a blade of oyster shell, but in later times of metal. The outside surfaces were then sometimes blackened with wet charcoal while the incised areas were painted with white lime and red pigment to bring out the design. Each belt encircles the body about two times, and the ends are attached with a shell button passing through a rattan loop (Lewis 1931, pp. 2–3).

Previous collection: Wayne Heathcote, New York

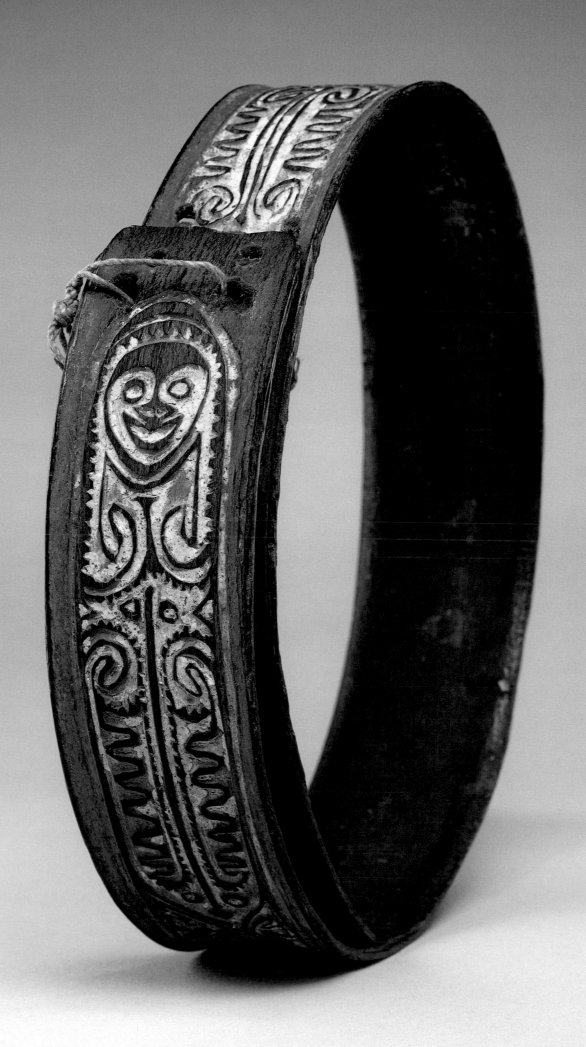

## 37 Canoe Prow Ornament

Papua New Guinea, Torres Strait, Saibai Island
*Wood, oyster and cowrie shells, cassowary feathers,*
*red and black pigment*
Width: 13 1/2 in. (34 cm)

THIS ORNAMENT IS ONE OF ONLY THREE known, the other two being in the collections of the Museum of Mankind, London, and the University Museum of Archaeology and Anthropology, Cambridge, England. They were affixed to canoe prows and served as spiritual guides to help hunters locate turtles and dugongs (Moore 1989, p. 30, fig 21).

The face is that of a female spirit called Dogai. Although she sometimes brought benefits to mankind as in this context, she was better known for her mischievous and sometimes dangerous nature. While grotesque in appearance, this spirit could assume an attractive form when she sought men for husbands. She was also known to have killed children by eating them and had the ability to transform herself into various kinds of animals and trees (Haddon 1904, p. 353).

The disproportionate size of the ears on this carving and the profuse application of cassowary feathers to represent hair is explained by Haddon's description of this spirit: "a typical Dogai was a big-bodied woman, with long skinny legs but small feet, hideous features, and ears so large that she could sleep on the one while the other covered her like a man sleeping between two mats.... One named Uzu was at one time offered a pillow and a mat, but declined both on the score that her ears and hair answered the purpose sufficiently well" (ibid., pp. 353–54).

Previous collections: James Hooper, London, acquired in Birmingham, England, in 1941; Wayne Heathcote, New York

Publications: Phelps 1976, p. 262, pl. 157, no. 1022; Christie's, London, 1979, no. 42

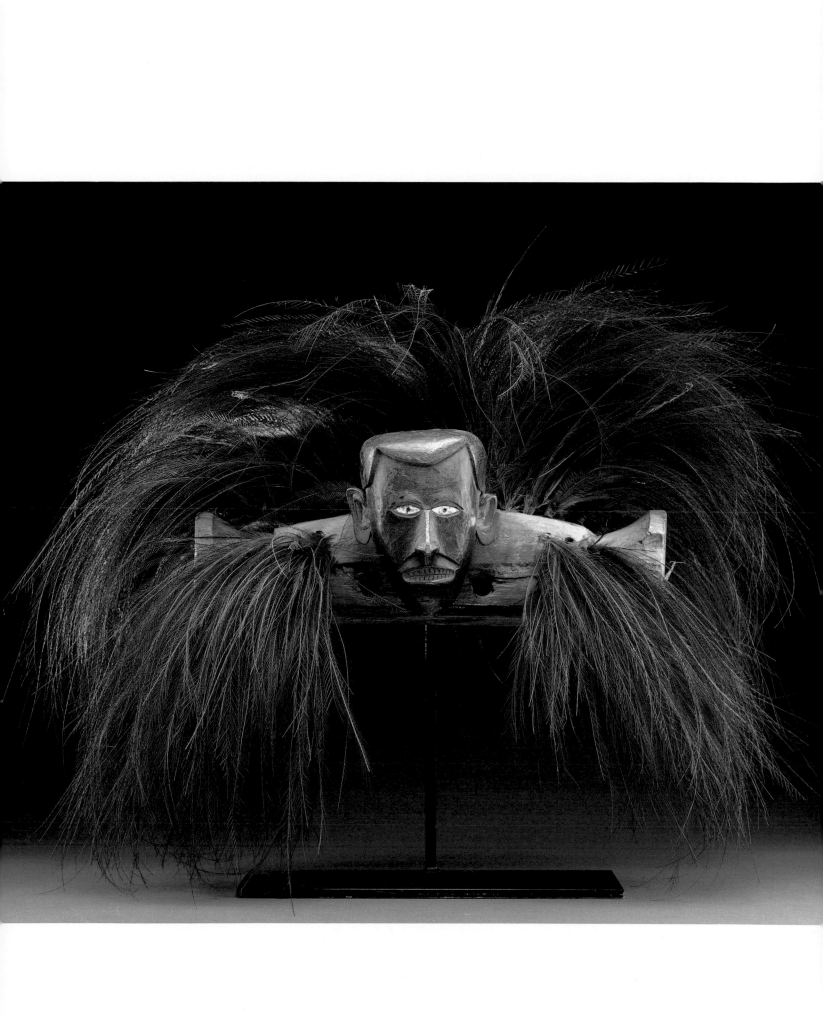

## 38 Hand Drum (*warup*)

Papua New Guinea, Torres Strait
*Wood, fiber, shell, cassowary feathers*
Height: 45 in. (114.5 cm)

SUCH HOURGLASS-SHAPED DRUMS ARE characteristic of the Torres Strait. They are said to have been used mostly on the islands to the west (Haddon 1912, p. 315) and, when played, could be either set on the ground or carried. As no trees of sufficient size grew on the islands of the Torres Strait, it was necessary to import roughly cut pieces from Daudai on the New Guinea mainland. These were then finished and decorated by carvers of the Strait (Moore 1989, p. 37). The drums are fashioned from a single piece of wood, carefully hollowed out, with a circular opening at one end on which the tympanum was set and what appears to be a gaping mouth, perhaps representing that of a crocodile, at the other. Various relief designs in the form of geometric, human, and animal motifs (such as turtles, lizards, hammerhead sharks, skates, and other fish) are carved into the surface.

On this example, both fish and geometric forms can be seen. Some of the original embellishment that was attached at the sides and bottom end has been lost; this would have originally consisted of additional seeds, shells, nuts, and feathers. The central portion is heavily patinated, indicating extensive use, and a long split at the bottom has been carefully repaired and filled.

Previous collection: Tristan Tzara, Paris

Publication: Loudmer, Paris, 1988, no. 156

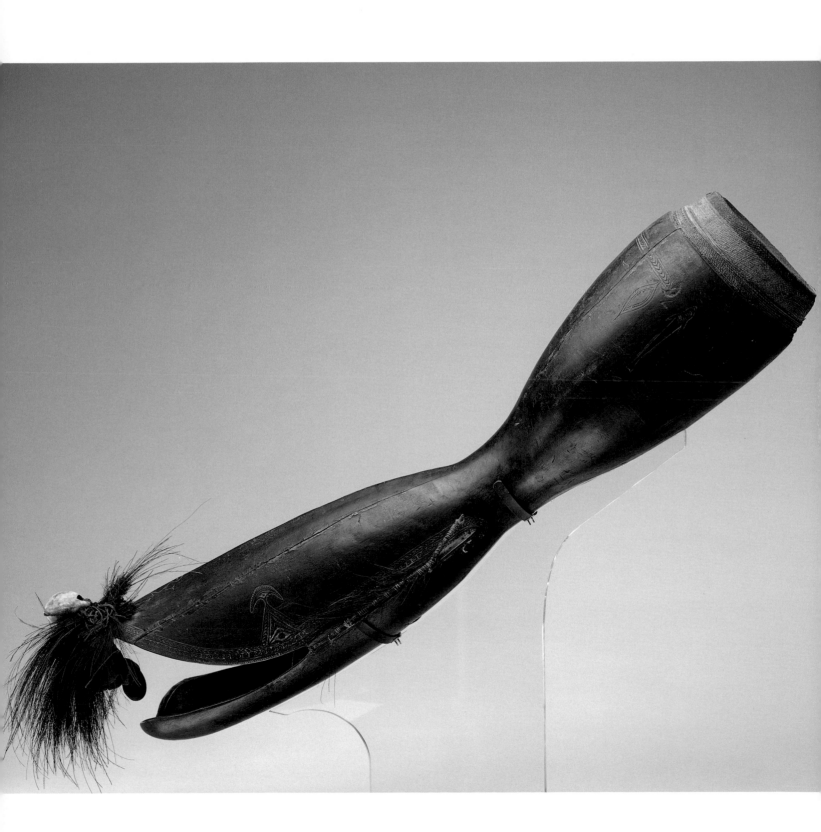

## 39 War Charm

Admiralty Islands

*Wood, feathers, fiber, glass beads, dog teeth, white pigment*
Length: 20 in. (51 cm)

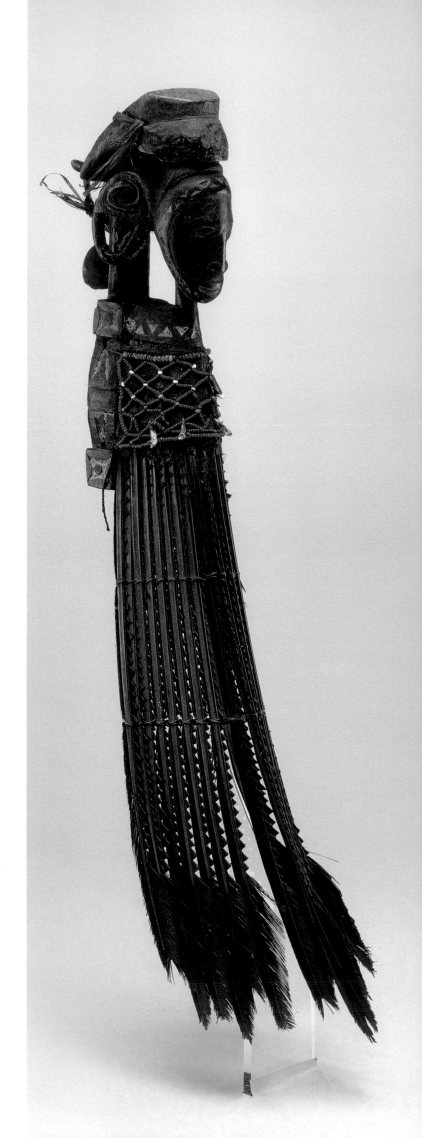

THESE PENDANTS, SOMETIMES ERRON-eously referred to as hunting charms, were, in fact, worn to give strength and courage in battle, to provide immunity from wounds, and to ensure protection from the influence of evil spirits. Instead of being suspended to hang in front of the body, they were put on so that the charm was carried at the nape of the neck, and the feathers extended almost horizontally away from the body. Jean Paul Barbier (1977, p. 76) published a field photograph showing how they were carried in this position. Each was the personal property of a warrior and was not passed on from one generation to the next. Many of them also contain the humerus bone of a relative to provide them with additional spirit power. They were used throughout the Admiralties until the end of the nineteenth century and apparently on the island of Pak well into the twentieth (Nevermann 1934, pp. 138–40).

A finely carved naturalistic face bears geometric relief carving in the form of small triangles that is typical of Admiralty Island art. Below is a carefully woven bead collar. As with all such charms, the feathers (probably those of the frigate bird) have each been cut away except at the ends to leave small dentate forms along the shafts.

Collected by Captain Carl Nauer in 1885

Previous collections: Übersee Museum, Bremen; C. P. Meuldendijk, Rotterdam; Carlo Monzino, Lugano

Publications: Christie's, London, 1980, no. 269; Sotheby's, New York, 1987, no. 86

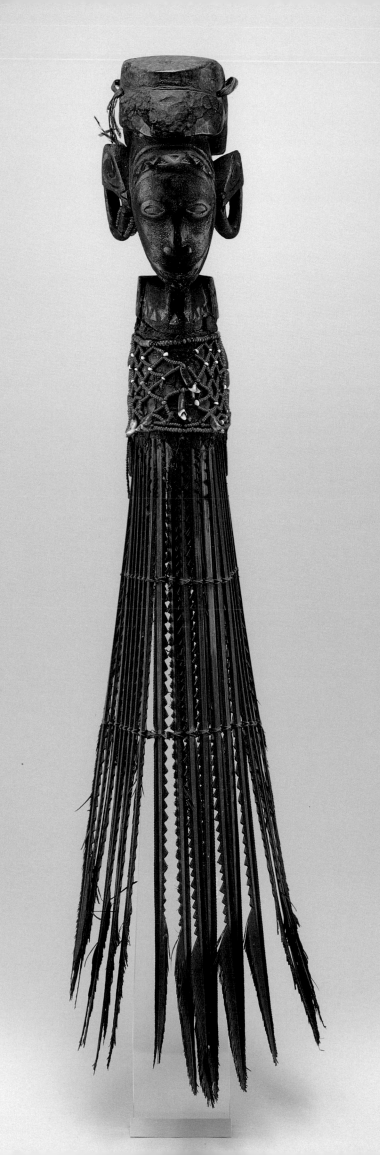

## 40 Ladle

Admiralty Islands
*Wood, coconut shell, fiber, parinarium nut paste*
Height: 13 in. (33 cm)

L ADLES CONSISTING OF A WOOD HANDLE
lashed to a gourd or a bisected coconut shell are
fairly common in parts of Melanesia. On the Admiralties, the handles are often openwork geometric or
curvilinear forms or in the shape of animals and other
abstract zoomorphic designs (for an idea of the range of
shapes, see Museum für Völkerkunde 1931, nos. 189–94).

Ladles such as this one, showing a naturalistic standing
human figure, are not common. One other published
example, collected in 1896 by Rudolf de Tolna, is in the
Budapest Ethnographic Museum (Guiart 1963, p. 321, pl.
320; Bodrogi 1959, pl. 80). The patina on the handle of the
Masco ladle is considerably deeper and suggests a date to
the middle of the nineteenth century if not somewhat earlier. Also notable is the meticulous scalloping along the
outer edge of the shell container.

Previous collection: Wayne Heathcote, New York

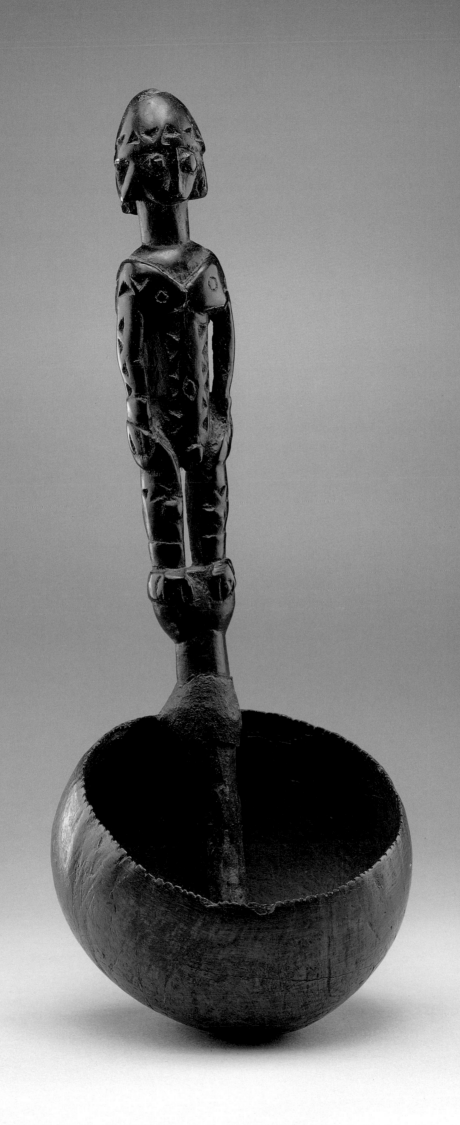

## 41 Food Bowl

Admiralty Islands, Lou Island
*Wood, parinarium nut paste, traces of white pigment*
Height: 24 in. (61 cm)

EAST BOWLS, SOME AS LARGE AS FIFTY inches in diameter, were made on Lou Island and traded throughout the Admiralties. They were used for communal ceremonial feasts (Gathercole et al. 1979, p. 257, no. 18.2). The handles are attached separately with paste of the parinarium nut and are purely ornamental, as they would break away if any attempt were made to use them for lifting. Often they take the form of spirals such as those seen here, a motif that may be based on a lizard tail. Other handles show reclining human figures or animal forms.

The bowl itself and the four feet it stands on are made of a single piece of wood; an ornamental geometric band in relief is applied around the top. Other examples show relief decoration on the entire outer surface of the bowl.

Previous collections: Übersee Museum, Bremen; Wayne Heathcote, New York

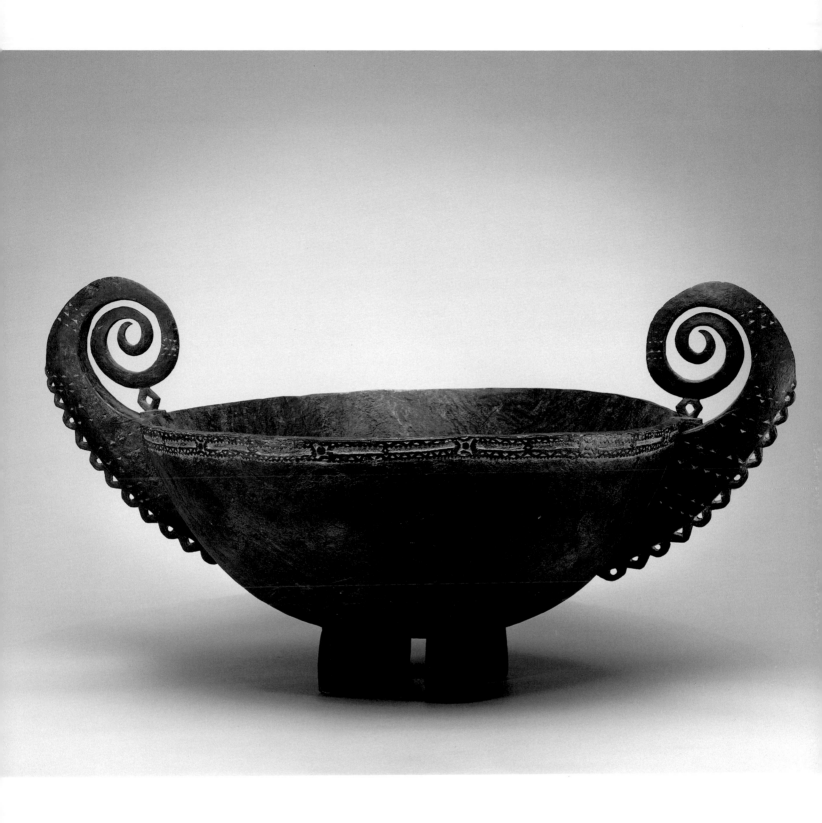

## 42 Memorial Figure
### (*uli, selambungin lorong* type)
New Ireland
*Wood, shell inlay, fiber; red, white, and black pigment*
Height: 52 in. (132 cm)

ULI FIGURES WERE MADE IN CENTRAL New Ireland and served as the focus for memorial ceremonies honoring a recently deceased head man. Following the death of such a village chief, a series of pig feasts were held every month for a full year. They culminated in a final gathering for which the figure had been carved to represent the deceased. People from neighboring villages assembled at this time to participate in dances and feasting. They brought with them old *ulis* that had been repainted for the occasion and that they displayed in huts constructed especially for this purpose. When the newly carved *uli* was brought out, a shaman assisted in inducing the spirit of the deceased chief to enter into the carving, and after the ceremony, the work was kept in the men's house where it would continue to aid the successor and his people.

Each *uli* is depicted wearing ceremonial dress in the form of wristlets, anklets, and a crested headpiece similar to those worn by the people during times of mourning. All have fiber beards, traces of which remain on this example. Although *ulis* represent male chiefs, they are also hermaphroditic, as indicated by the female breasts. At some of the dances associated with the penultimate ceremonies, men wore wooden breasts as part of their costume. These dances, as well as the addition of breasts to the male *uli* figures, signified the importance of fertility to the community and the chief's care for the women in the village (P. Gifford 1978).

There are several different styles of *uli* carving. Some of the most sculpturally complex, such as this one, show the figure with hands raised, the incorporation of two additional small figures perhaps also representing deceased chiefs at the sides of the head, and parts of the costume hanging from the chin, elbow, and abdomen. Christine Valluet (1991, p. 39) interprets these draperies as being bird feathers representing a powerful spirit protector.

The Masco *uli* is quite similar in style to a piece in the Linden Museum, Stuttgart, collected by Albert Hahl at the village of Lusigi in 1906 (Schmitz 1969, pl. 177). As was this one, most *ulis* were collected during the first part of the twentieth century, when the ceremonies were no longer held and such carvings ceased to be made.

Previous collections: Linden Museum, Stuttgart; John Friede, New York; Wayne Heathcote, New York

Publications: Kramer 1925, p. 27; *Cahiers d'Art* 1929, p. 81

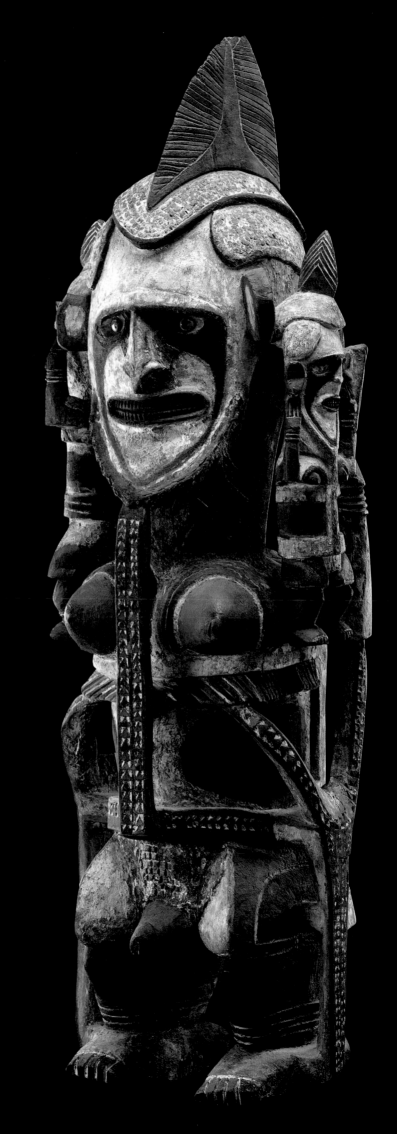

## 43 Mask

New Ireland
*Wood; red, white, and black pigment*
Height: 19 in. (48 cm)

THIS MASK WAS ONE OF MANY CARVINGS made for an elaborate postmortuary ritual called *malagan* that was held in northern New Ireland. The ceremonies took place at intervals of every one to five years and each might be spread out over a period of up to nine months. They honored deceased ancestors and commemorated other cosmic heroes who were a part of New Ireland mythology.

Several months after the death of an important male, members of his family commissioned a carver and his helpers to create carvings for the festival. Among them might be included single figures or sculptures of figures superimposed over one another, horizontal friezes, wall panels, and other architectural elements that decorated specially constructed enclosures in which the figures were displayed. The works were shown to the accompaniment of dances and feasts that lasted for a period of several weeks (Bodrogi 1988, pp. 21–25). All are made in the flamboyant painted and openwork style that is so distinctive of *malagan* art (see Lincoln 1988, pp. 90–96, 120–160). This work was costly, and the display of the finished carvings brought considerable prestige to the family.

The various dances and performances required many dance ornaments and masks of different kinds. The masks depict specific deceased individuals or their souls and spirits (Bodrogi 1988, p. 30). This somewhat unusual example is now missing its coiffure, which originally would have been made of fiber or sea sponge. Over the head are carved two interlocking bunches of cockerel feathers.

Collected by Dr. Huesker in 1878

Previous collection: Museum für Völkerkunde, Leipzig (Me 10389)

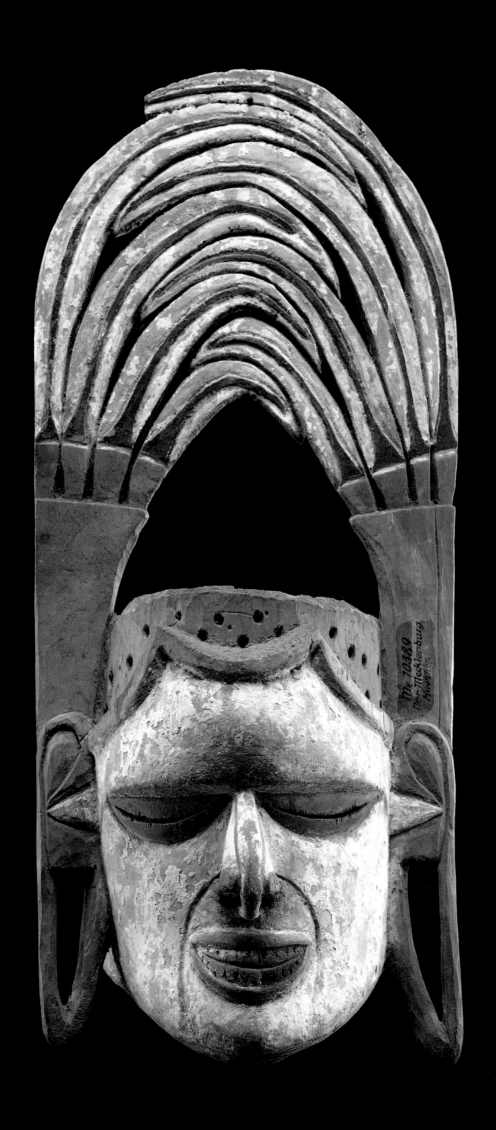

## 44 Mask

New Ireland
*Wood, snail opercula, fiber, seeds; red, black, and white pigment*
Height: 19 in. (48 cm)

IN COMPARISON TO THE MORE EXUBERANT creations from New Ireland, this type of mask is relatively restrained. It lacks the elaborate openwork carving and complex painted designs that are found on other examples. It is ornamented with a fiber beard and coiffure and has eye inlays of snail opercula. Seeds are set around the outside of the face. In style, it is similar to a group of three in the Museum für Völkerkunde, Berlin, that were collected from the south central coast of New Ireland (Helfrich, 1973, nos. 134–36). As was cat. no. 43, it was worn in *malagan* ceremonies to represent a deceased person or his spirit.

Collected by Baron von Heyking in 1876

Previous collection: Museum für Völkerkunde, Leipzig (Me 10372)

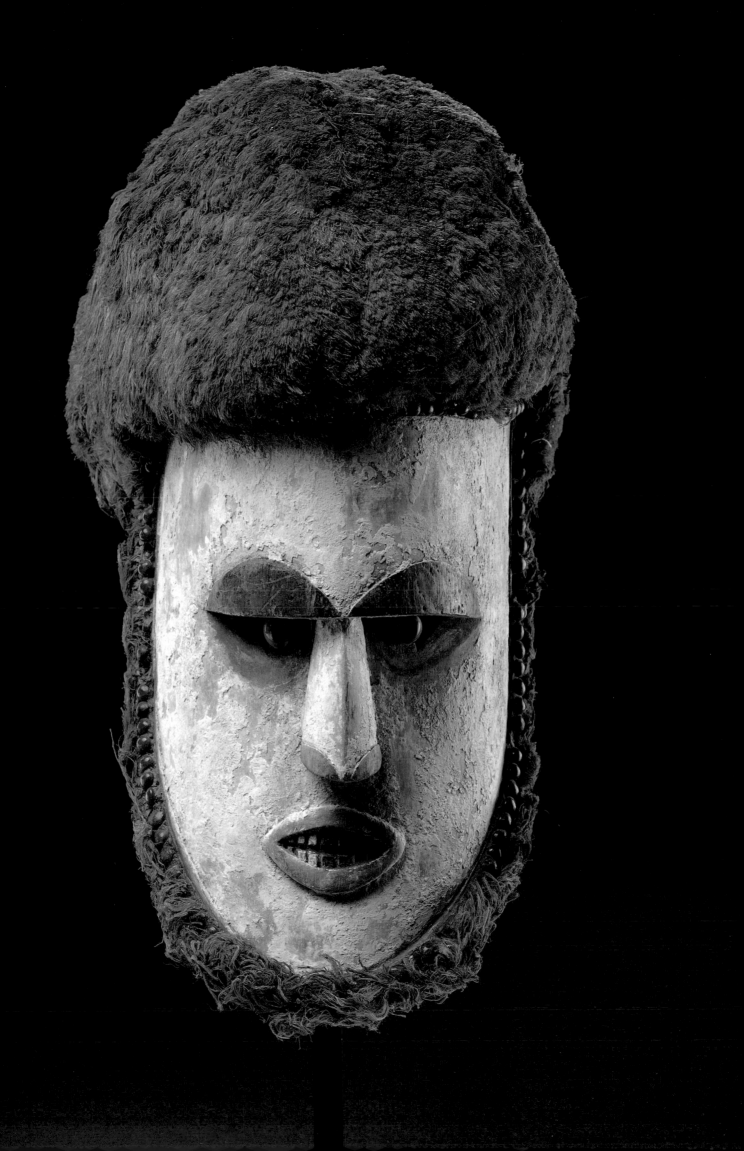

## 45 Mask (*murua*)

New Ireland

*Wood, sea sponge, snail opercula; red, white, and black pigment*

Height: 37 1/2 in. (95.5 cm)

**M**URUA MASKS ARE THE MOST ELABO- rately carved of all the masks from New Ireland. They were used for a variety of purposes including initiation and the clearing away "of all traces of a dead person from where he lived: they also remove the taboos under which the deceased's house and part of his property had been put" (Heintze 1988, p. 52).

These masks were also employed in mortuary ceremonies. William Groves (1936, pp. 225–26) describes one such event. The masked dancers appeared in a group of six, emerging from the area where the dead had been cremated. The bodies of the dancers were covered in leaves and, as they proceeded slowly forward, mourners gathered around them. With "each deliberate step the figures paused to turn their great ungainly *murua* heads slowly from side to side as if peering uncertainly into the unfamiliar world of mortal man." Elder women surrounded the masked figures calling out the names of the deceased. As the dance ended, and the maskers returned to the cremation ground, the women accompanied them, saying, "'Wait for me; soon I too will come'" (ibid.).

The three-part *murua* masks have a central section and two carved flanges at the sides (Bodrogi 1988, p. 30). They are composed of a rich combination of human and animal figures that symbolize any number of cosmic beings, mythological or historical ancestors, legends, or actual events. This fine example consists of a grotesque open-mouthed human mask. It is surmounted by a standing male figure who holds a flying fish in front of him. A snake emerges from the mouth of the fish and is joined to the mouth of another fish below the mask. Other snake forms are carved on the sides of the mask. The side panels show pairs of cockerels carved upside down and two additional fish forms at the bottom. No two *murua* masks are the same. In their combination of a rich iconography with great artistic skill and inventiveness, they are among the most spectacular mask forms of Melanesia.

Collected by Weber

Previous collections: Museum für Völkerkunde, Leipzig (Me 10259); Wayne Heathcote, New York

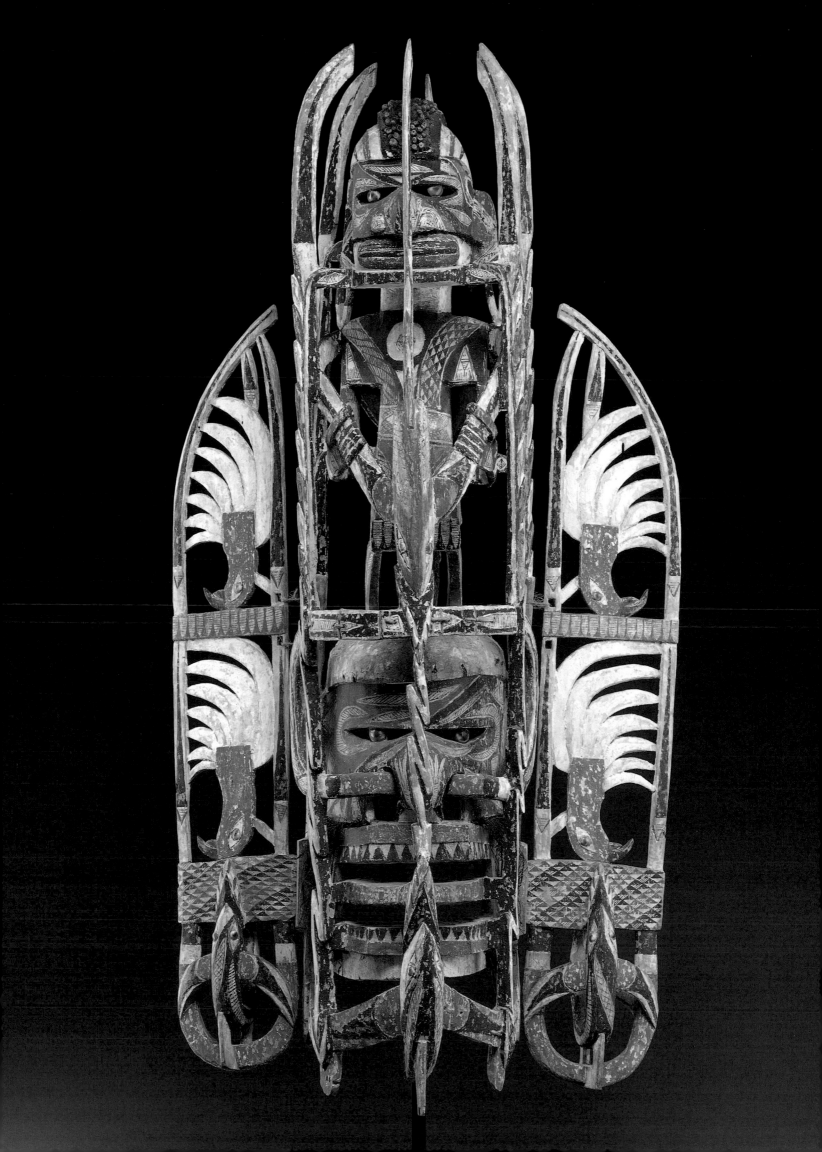

## 46 Dance Staff

New Britain, Gazelle Peninsula, Tolai People
*Wood, wool yarn; red, blue, and white pigment*
Height: 15 1/2 in. (39.5 cm)

THE LIFE OF THE MEN OF THE TOLAI AREA on the northern coast of the Gazelle Peninsula of New Britain was dominated by a secret medicine society called *Iniet* (Corbin 1988, p. 248). Part of the initiation ceremonies into the society involved dancing with staffs that are flat with openwork designs of humans, animals, or fish surrounded by a frame. They were used in mock assaults on the initiates (Newton 1979a, p. 52). Related to them are a group of staffs such as this with figures with raised arms which represent ancestors (Buhler 1969, p. 214).

The Tolai are said to have migrated to New Britain from New Ireland, and certain similarities between the art of the two areas can be noted. The upraised arm pose seen here is frequently found in New Ireland as are the inset eyes, the grimacing mouth, and the elongation of the human form. Although this example has been referred to as belonging to a dance costume (Schmitz 1969, pl. 163), the cylindrical extension below it enabled it to be held by the hand, and it was probably a staff (see also Stöhr 1971, p. 159, pl. 65; Corbin 1988, p. 248, pl. 19). An alternative possibility is that the post was placed in the ground and served a similar role as the larger figures to which initiates were taken during name-giving rituals (Gathercole et al. 1979, p. 52, no. 16.6).

Collected by Fellman

Previous collections: Linden Museum, Stuttgart (I.C. 57435); John Friede, New York

Publications: Schmitz 1969, pl. 163; Sotheby's, New York, 1984, no. 78

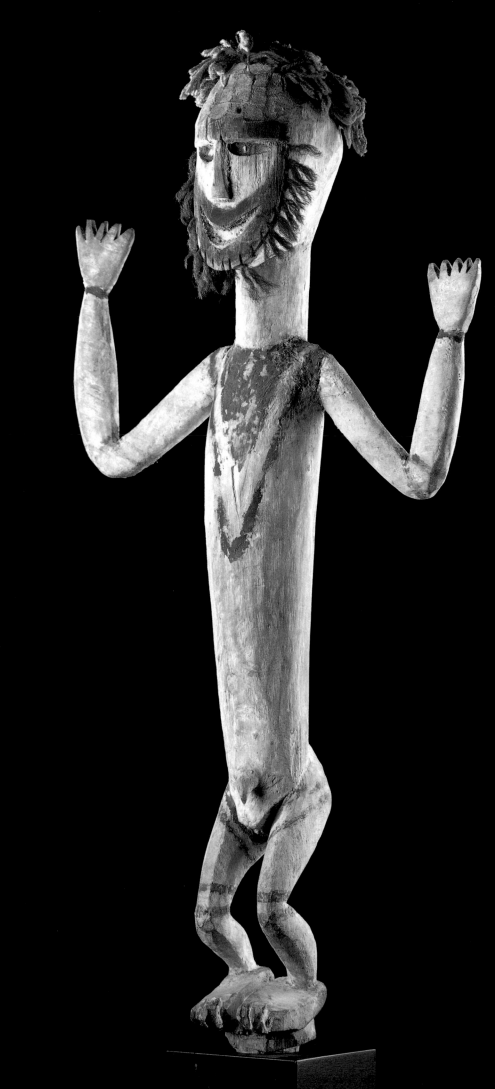

## 47 Mask (*lor*)

New Britain, Gazelle Peninsula, Tolai People
*Forepart of human skull, human hair, wood, fiber,*
*parinarium nut paste; red, white, and black pigment*
Height: 10 1/4 in. (26 cm)

S UCH MASKS WERE WORN IN ASSOCIA-
tion with *Iniet* society ceremonies (see cat. no. 46).
They represent ancestors and are made of the actual
skull and hair of the recently deceased individual they
signify. The masks were worn in nocturnal dances, carried
in front of the face with the aid of a piece of wood held
in the mouth that is affixed to the inside behind the nose.

Most examples are quite similar to this one, and show
no attempt to depict the characteristics of an individual
(see Damm 1969, tafeln XLI–XLV). They have beards, and
bands of white pigment are painted around the face, the
eyes, brows, and in points below the eyes. Jean Paul
Barbier (1977, p. 79) notes that this latter design is char-
acteristic of the sculpture of the area. He also cites Richard
Parkinson, who was in New Britain in 1882, as stating
that by that time, such masks were no longer in use, and
those that still existed were kept as relics of the past.
Accordingly, Barbier dates a similar mask in the Musée
Barbier-Mueller, Geneva, to the period prior to 1850
(ibid., pp. 78, 113).

Previous collections: Linden Museum, Stuttgart (15142);
John Friede, New York; Wayne Heathcote, New York

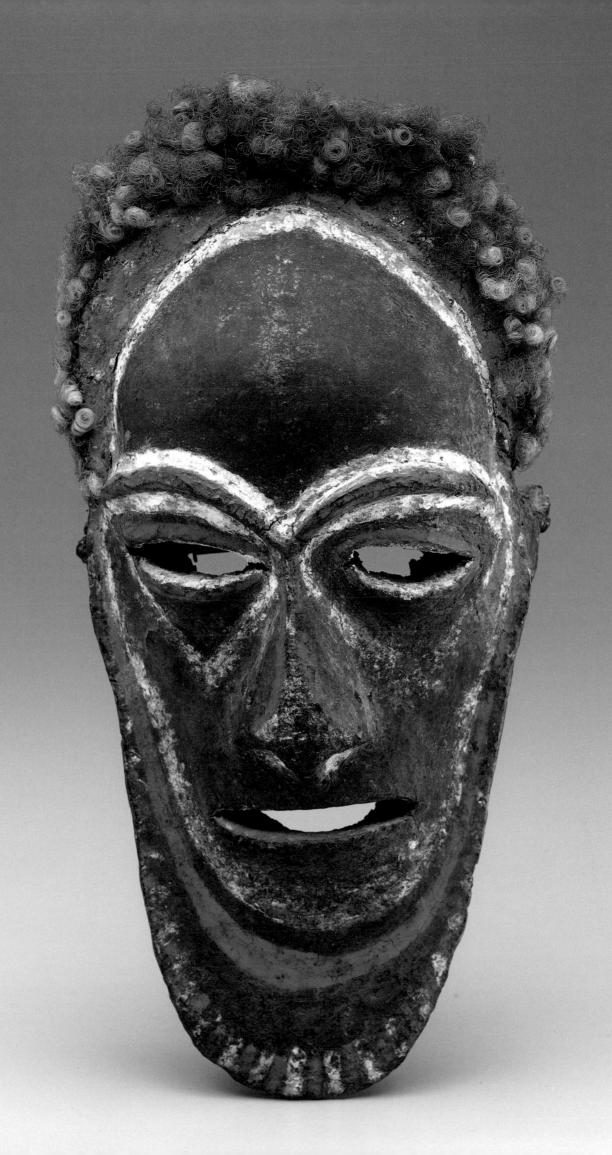

## 48 Dance Headdress

New Britain, Sulka People

*Wood, fiber, bark strips, shell, cassowary feathers;*
*red, white, and green pigment*

Height: 61 in. (155 cm)

THE SULKA, WHO LIVE IN THE EASTERN portion of New Britain at Wide Bay, are famous for their large-scale sculptured basketry headdresses. They were worn during mortuary rites honoring the death of an important man or woman and at such life passage celebrations as birth, initiation, and marriage. When in use, they were believed to provide a temporary abode for spirits. These complex weavings took at least six months to make, and following their one-time use, they were discarded and allowed to decay. Both the forms they take and the colors with which they are painted are unique to Oceania. The greens, pinks, and yellows are all derived from indigenous mineral and plant sources (Corbin 1988, p. 240).

The headdresses are often cone-shaped helmet masks, but some of the more spectacular examples are huge umbrellalike constructions or in the form of animals, birds, and even praying mantises. Others, such as this one, show dancing figures. The small wooden breasts that are attached separately identify it as representing a female. The wooden hands and feet are also separately attached, but the rest of the construction is fashioned entirely of bark strips and fiber. The wearing of such a creation in a slow and stately dance lent great dignity and spirit power to the ceremony in which it appeared.

Previous collections: Völkerkundeliches Mission Museum, Wupperthal; Wayne Heathcote, New York

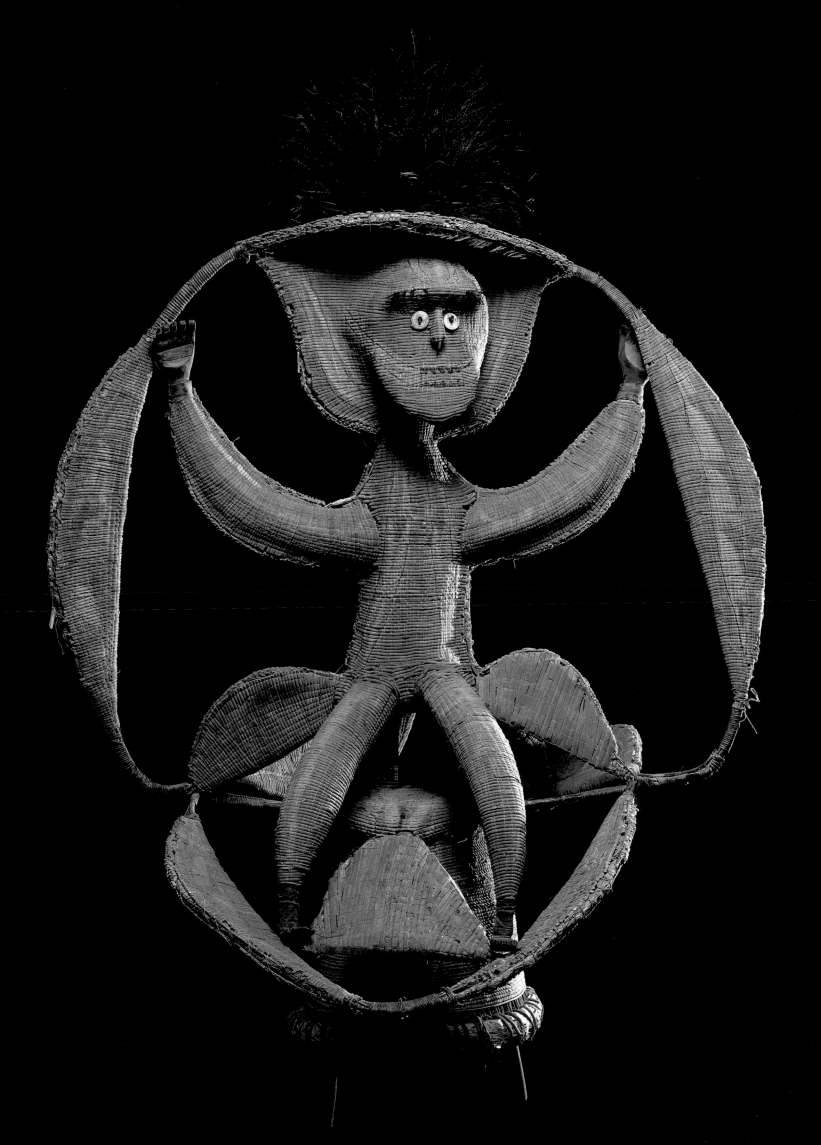

## 49  Mask *(kavat sowelmot)*

New Britain, Gazelle Peninsula,
Uramot Baining People
*Bark cloth, wood, fiber, red and black pigment*
Height: 61 in. (155 cm)

THE URAMOT BAINING LIVE IN THE INTE-
rior mountainous rain forests of eastern New Britain
on the Gazelle Peninsula. They engaged in a series
of rituals that took place both by day and night in honor
of births, the coming harvest, initiations, and mourning.
A group of large masks called *kavat* were worn at night.
They are constructed of sheets of bark cloth stretched over
a wood or bamboo framework. Each embodies spirits
that are related to hunting and the finding of food in the
bush. They represent such beings as a male cannibal
spirit or his wife, the grasshopper, the praying mantis, the
cassowary, leaf and tree spirits, and the spirit of a pig
vertebra (Corbin 1988, pp. 232–37).

This example symbolizes the spirit of a tree fork which
is signified by the two large winglike forms that project
above the eyes. Tree forks were used by the Baining as sup-
port posts for houses, garden huts, and the shelters in
which masks were made. The remains of the dead were
also placed in tree forks near streams. Such masks were
worn at initiations for young men as they entered into the
grade level achieved by reaching a specific age. Masked
dancers emerged from the bush and performed all night.
At dawn, the orchestra that had provided the music and
rhythm for the dances forced the masks back into the
bush to reestablish the primacy of civilized order over
the powers of the wild spirits (Corbin 1984, pp. 49–50,
figs. 13–21).

The form of this example is typical with an open mouth
through which the wearer could see; large, round, con-
centric painted eyes; and a tonguelike projection below
the mouth. The geometric paintings below the "neck"
may represent seeds.

Previous collections: Mission Museum, Hiltrup,
Germany; Wayne Heathcote, New York

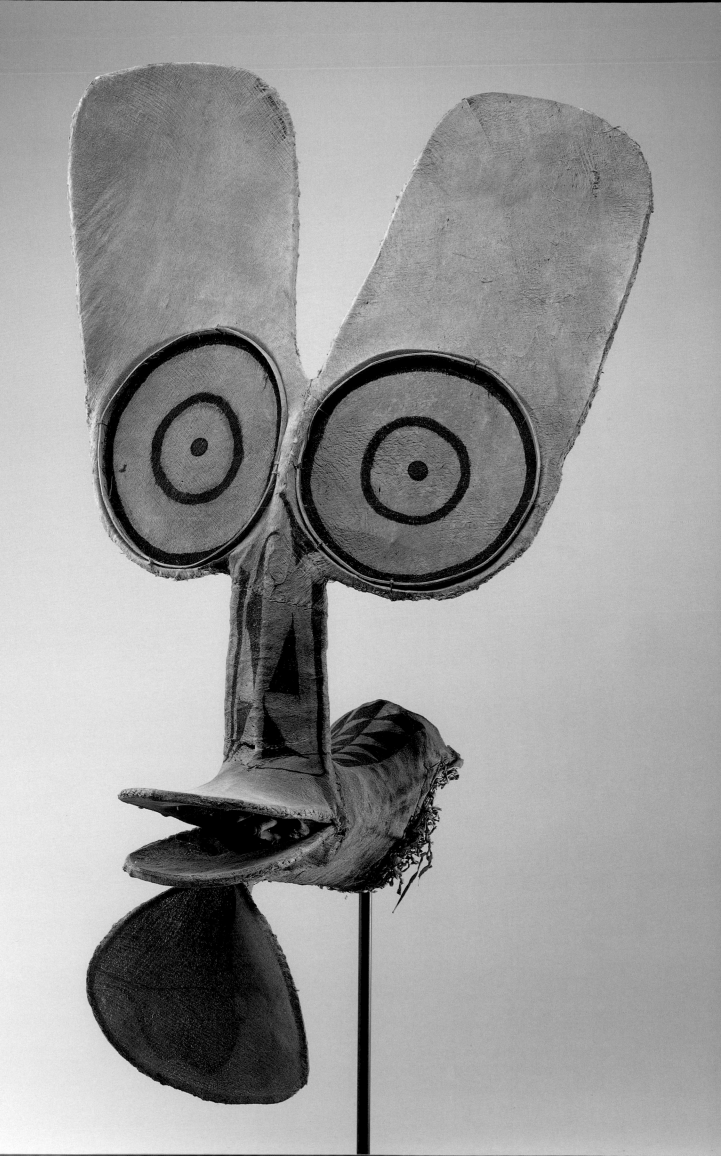

## 51 Canoe Prow Ornament (*musumusu*)

Solomon Islands, New Georgia
*Wood, bone, shell inlay, red and black pigment*
Height: 7 in. (17.5 cm)

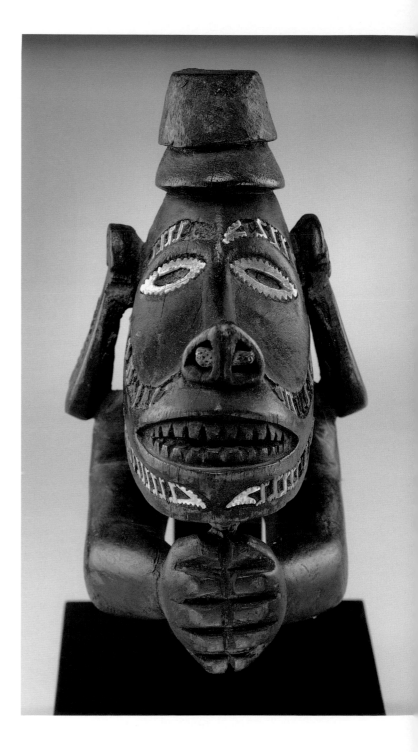

IN THE SOLOMON ISLANDS, THE CANOES that were used for headhunting and bonito fishing were beautifully shaped and had fine carved hulls inlaid with shell so as to become works of art themselves. Small human sculptures were lashed on the prows just above the waterline. They are mostly in the form of seated figures or simply show a head with the hands raised to the chin as here. They served a protective function and were associated with a spirit called *Kesoko*.

Deborah Waite (1990, pp. 51–53) notes two different interpretations of the significance of these carvings. In one, she cites Lieutenant Boyle Somerville who was on New Georgia in 1893–94 as saying that they guarded against the threat of *Kesoko* spirits who were thought to be "water fiends which might otherwise cause the winds and waves to overset the canoe, so that they might fall on and devour its crew." In the other view, the prows are actually thought to depict the spirit itself who helped pilot the canoe through difficult waters and looked out for enemies. *Kesoko* was also known to be an expert bonito fisherman and had additional skills in net fishing and headhunting.

Figureheads were made on the islands of Choiseul, New Georgia, Santa Isabel, and Florida, and each island developed its own distinct expression. Those with tall, pointed skulls and a marked forward extension of the face, such as is evident in this example, were made on New Georgia and its neighboring islands (Waite 1983a, p. 117, no. 11). The extreme elongation of the face and the graceful arc formed by the nose and forehead of the Masco prow suggest the forward motion of the canoe itself when it was under way. As is characteristic of all Solomon Island shell inlay, each piece of shell was carefully shaped and cut to fit a specific part of the carving. The placement of a bone cylinder in the septum is unusual.

Previous collection: Tristan Tzara, Paris

Publications: *Cahiers d'Art* 1929, p. 86, fig. 83; Galerie Pigalle, 1930, no. 369; Loudmer, Paris, 1988, no. 163

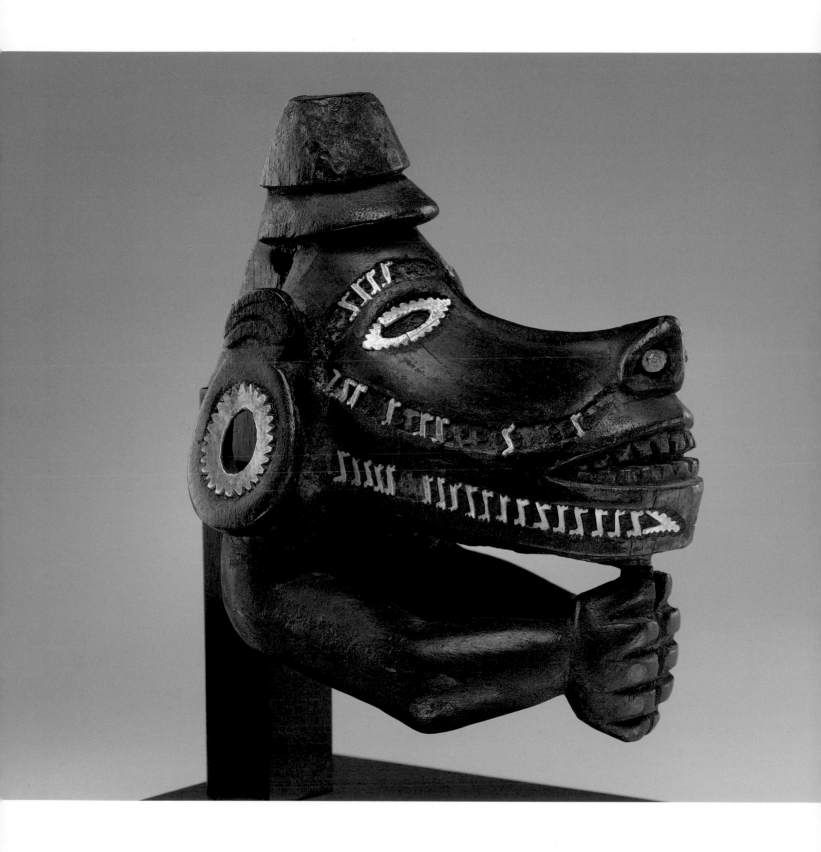

## 52 Limestick

Solomon Islands
*Wood, glass beads*
Height: 15 in. (38 cm)

THIS LIMESTICK, WITH A FINELY CARVED female figure on the upper portion, has a rich, thick patina indicating long use and considerable age. A slightly smaller example of very similar sculptural style with a standing male figure on the top is now in the Musée Barbier-Müller, Geneva (Waite 1983a, no. 36). In her comparison of certain features of the Geneva piece to other Solomon Island sculptures of known provenance, Waite concludes that it comes from the eastern islands. The characteristics of this carving style include shell circlets inset in the eyes, the "dark smooth-surfaced wood, and the rounded contours of the limbs and torso" (ibid.).

Although the hands of the Masco example are held at the abdomen and are not raised and pointing towards the face, and glass bead inlays are employed instead of shell, the two are sufficiently alike to suggest a similar origin and age. Among the eastern Solomons from which these two limesticks could have come are San Christóbal, Guadalcanal, and Florida.

Previous collection: Wayne Heathcote, New York

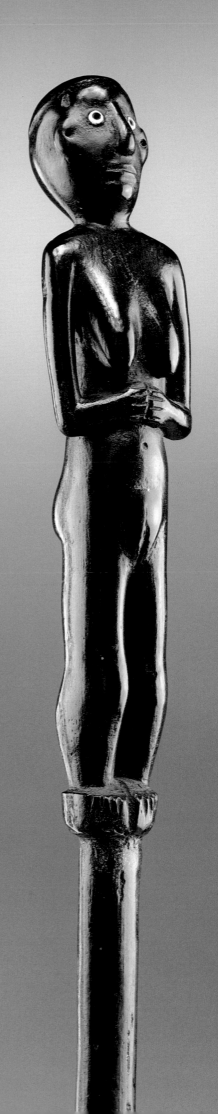

## 53 Shield

Solomon Islands, Santa Isabel
*Basketry, parinarium nut paste, shell inlay,*
*black and red pigment*
Height: 36 1/4 in. (92 cm)

DEBORAH WAITE HAS MADE A PRELIMI-nary survey of all the known Solomon Island oval shields of this type. She lists twenty-one examples, all of which are approximately the same size and design (1983b, pp. 120–21). They show a standing human figure with a long rectangular body in the center with upraised arms and the hands held to the side of the face. Below the figure is a band of inlay sometimes including representations of heads, three of which appear on this example. The inclusion of the human head motif may have had some reference to headhunting. At the bottom, the inlays are placed in a series of semioval designs that follow the shape of the shield itself. Additional depictions of heads are sometimes placed in the bottom center, but such is not the case here.

Two or three bands of inlay run around the entire outer edge of the shield. A pair of human heads is also sometimes found at the center, such as those at the sides of the Masco example. Although many wicker fighting shields were made on the Solomon Islands, this type is much too fragile to have been made for anything but display, and these shields were undoubtedly the prestige property of important men.

They were probably first recorded by the French priest Chaurain at Thousand Ships Bay on Santa Isabel in 1846 (ibid., pp. 117–18). Two of those in museums bear reliable collection or acquisition dates of 1852 and 1859, and another in a private collection is said to have been collected prior to 1850 (ibid., p. 119). Although a number of scholars have placed the origin of these shields as Florida Island, Waite compares the linear inlays to those on certain clubs that were made for prestige display on Santa Isabel and concludes that they were made there and may well have been used in conjunction with the clubs (ibid., p. 129). The fact that they are all so close in design and the similar early collection history of four examples have furthermore led her to conclude that the twenty-odd surviving oval shields were made at the same place and during the period between 1840 and 1855 or somewhat earlier (ibid., p. 124).

This example appears in Waite's inventory (p. 120) as being in an unknown collection, but she notes its illustration in one of the W. D. Webster catalogues (1901, no. 104). In the catalogue, Webster listed the shield as having already been sold. Presumably the purchaser was the collector Adolph Baessler, who subsequently presented it to the Museum für Völkerkunde in Dresden in 1902. Waite's text (1983b, p. 117) also cites Anatole Von Hugel as mentioning the existence of a Solomon shield in a German museum by 1906 (ibid., p. 117). He could well have been referring to the Masco shield.

The shield is missing some of its inlay, and the nut paste has broken away at the top and on some small areas of the lower right side to reveal the wicker construction. The two heads at the sides each show only one eye, a detail found on only one other example in the Royal Scottish Museum, Edinburgh (ibid., p. 123, fig. 6). They could represent profile heads.

Previous collections: W. D. Webster, London; Adolf Baessler, Berlin; Museum für Völkerkunde, Dresden (15 503); Everett Rassiga, Budapest

Publication: Webster 1901, no. 104; Guhr and Neumann, 1985, p. 238, no. 268

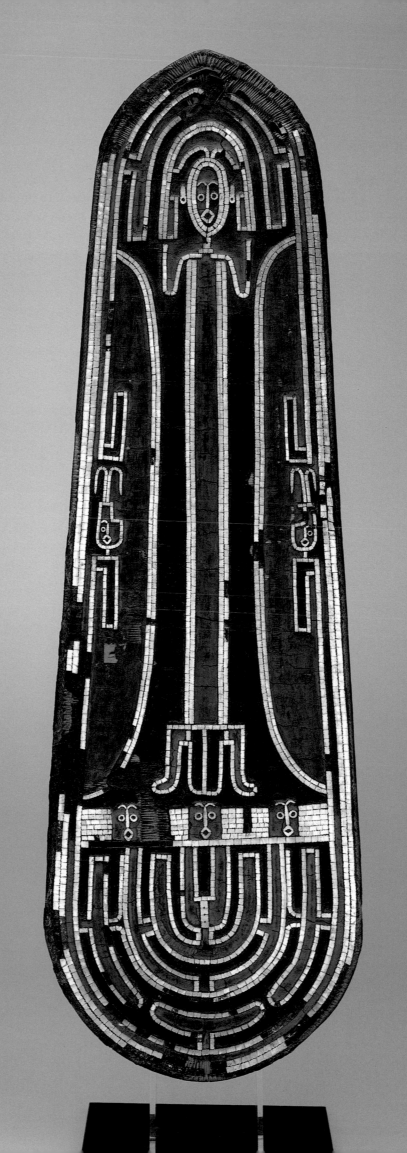

## 55 Grade Society Figure

Vanuatu, Banks Islands
*Fernwood*
Height: 46 1/2 in. (118 cm)

DURING HIS LIFETIME, A MAN OF Vanuatu might ascend through as many as twenty individually named grades in his society, attaining more status and power with each elevation. On Banks Islands, the origin of this example, the society is called *Sukwe* (Gathercole et al. 1979, p. 217, no. 14.1). The ceremonies connected with the acquisition of each grade were accompanied with dances, initiations, feasts, and pig sacrifices, all of which called attention to the individual's greatness and high religious standing in his community. They required the expenditure of considerable amounts of wealth through the ownership and offering of pigs to be killed.

At each ceremony, the sponsoring individual had the right to wear certain types of ritual paraphernalia and sometimes masks or headdresses (see cat. no. 58). Specific objects were also displayed and special structures were built for the events. The man also had the right to have a figure made of fernwood, its form dependent on the codes of the particular grade level. These sculptures were displayed on platforms in shelters under which dances were performed. During the ceremonies, it was believed that the figures became inhabited with the spirits of ancestors.

Information about the name and nature of the grade for which this figure was made has been lost, as is usually the case. Its form, with the thin torso, clearly defined arms and legs, and an elongated head with pointed chin and cap, is diagnostic of the Banks Islands style (see cat. no. 56). On some examples, the rough fernwood surface was originally covered with a coating of powdered earth mixed with sap of the breadfruit tree to provide a proper base for painted designs that again were appropriate to each grade. The painted layer has worn away from many such figures. In this case, however, not even small traces of it remain, and the figure may never have had such a coating.

Previous collections: Sir Jacob Epstein, London; Ben Heller, New York

Publications: Fagg 1960, pl. 9, no. 72; Gathercole et al. 1979, p. 217, no. 14.1; Sotheby's, New York, 1983a, no. 15; Bassani and McLeod 1989, p. 45, fig. 57; cat. no. 451, p. 133; Sotheby's, New York, 1991, no. 30

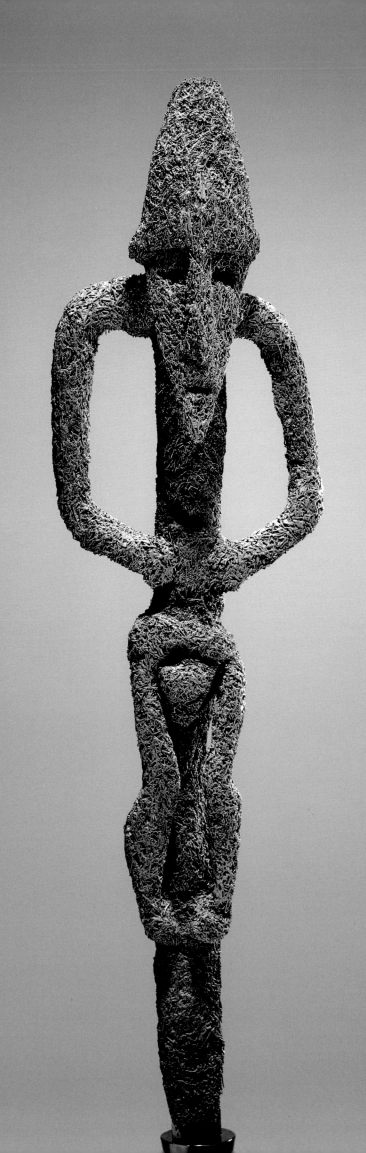

## 56 Grade Society Figure

Vanuatu, Banks Islands
*Wood*
Height: 35 in. (89 cm)

ALTHOUGH MOST OF THE VANUATUAN sculptures that were made for grade society display were made of fernwood (see cat. no. 55), some rare examples such as this one are of wood. They were used in much the same manner as the fernwood figures.

This example of a human figure on a post was set up on a platform. It was probably originally taller, as it appears that the post was cut short at the bottom. Nothing is known of the specific grade for which this figure was made, but it does make an interesting comparison to the Banks Islands fernwood figure in the Masco collection (cat. no. 55). The elongated torso, well-articulated treatment of the limbs, and pointed chin and cap are similar on both figures. As has already been noted, these are conventions of the Banks Islands style of carving. This sculpture also has a sharply serrated backbone, a detail lacking on the fernwood figure.

Previous collections: Lance Entwhistle, London; Alan Brandt, New York; John Friede, New York; Carlo Monzino, Lugano

Publication: Sotheby's, New York, 1987, no. 92

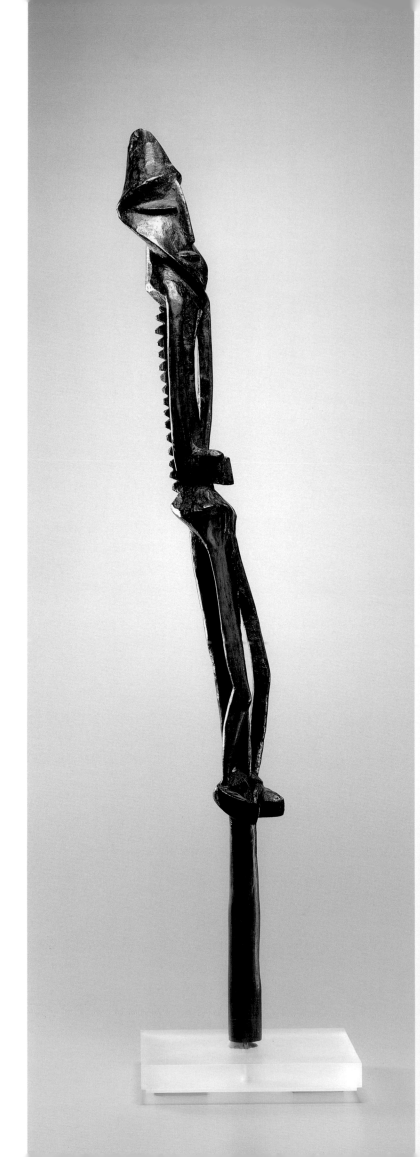

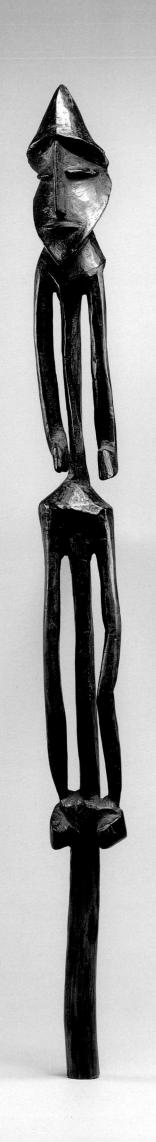

## 57 Food Platter

Vanuatu, Espíritu Santo
*Wood, fiber*
Height: 32 in. (81 cm)

THE PEOPLE OF ESPÍRITU SANTO, PAR-
ticularly those who lived in the northern and
northwestern regions, made many large food plat-
ters for use on ceremonial occasions. Most of them have
handles of geometric openwork design, but some are of
stylized human shape and others are in the form of
human heads (Speiser 1923, nos. 5–7, 9, 13, 14). One inter-
esting example represents a bird, its head serving as the
handle, its tail at the other end (Guiart 1963, p. 240, pl.
219).

This is one of only two known platters showing a full,
comparatively naturalistically carved human figure on
the handle. The other is in the Musée Barbier-Müller,
Geneva, and was collected in the early part of the nine-
teenth century by a Reverend Yates (Barbier 1977, pp. 95,
116). The only substantial difference between the two is
that this one depicts a female on the handle, while the
Geneva piece shows a male. Close examination of both
works reveals very fine adzing and the use of nonmetal
tools. The two are undoubtedly from the same period
and could well have been made by the same artist as a pair.

Previous collection: Wayne Heathcote, New York

Publication: Christie's, London, 1981, no. 40, p. 16

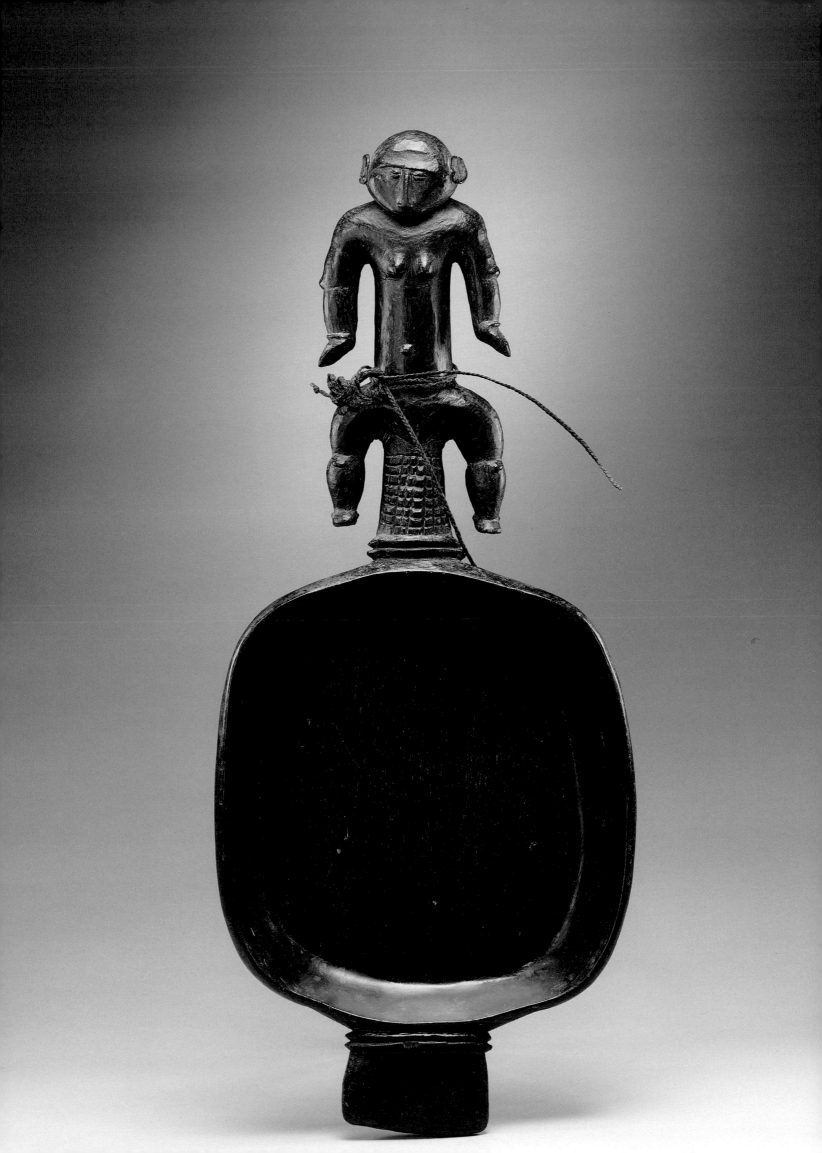

## 58 Headddress *(ambar leo)*

Vanuatu, Malekula
*Fernwood, fiber, paste; orange, black, and white pigment*
Height: 13 in. (33 cm)

SEVERAL OF THESE UNUSUAL MASKLIKE headdresses with arms emerging from the sides are known (see, for example, Guiart 1965, no. 92; Ader, Picard, Tajan, Paris 1990, no. 48). In order to describe something of their use and significance, it is necessary to provide an outline of the very complex traditions that developed around the grade society system on the island of Malekula.

One of the major men's organizations there was called *Nalawan.* It was divided into eleven grades, and the ninth of these, *Nalawan Nimbwilei* had within it six additional subgrades. Each of these grades and subgrades could be attained by making payments of pigs and following specific ritual observances. With the successful entrance into each higher grade, a man assumed greater standing in his community. Besides having their own names, all grades had "an individual gong rhythm, a special title for its members, a special kind of hat or mask called *temes mbalmbal* which was also named, and a distinctive structure which was set up in the dancing ground for the ceremony" (Deacon 1934, p. 387).

The fourth subgrade of *Nalawan Nimbwilei* was called *Nimbwilei Ambar Leo.* It is "said to have a mask peculiar to it, called *ambar leo* which is described in a brief note as 'a long mask with two hands to it' which is put on the head" (ibid., p. 427). In order to achieve this particular subgrade, the cutting of a sacred yam was followed by the stoning of a pig. The headdress was then worn in a dance that culminated in the killing of a pig (ibid, pp. 414–15).

When in use, the masks and headdresses were believed to provide a temporary abode for the spirits of immediate ancestors, and, most specifically, the grandfather (ibid., p. 384). This piece has a wood pin inserted in the septum. Whereas the face is shown in a full rounded form on other examples, here the skull-like features may refer to its representation of an ancestor.

Previous collection: Carlo Monzino, Lugano

Publication: Sotheby's, New York, 1987, no. 91

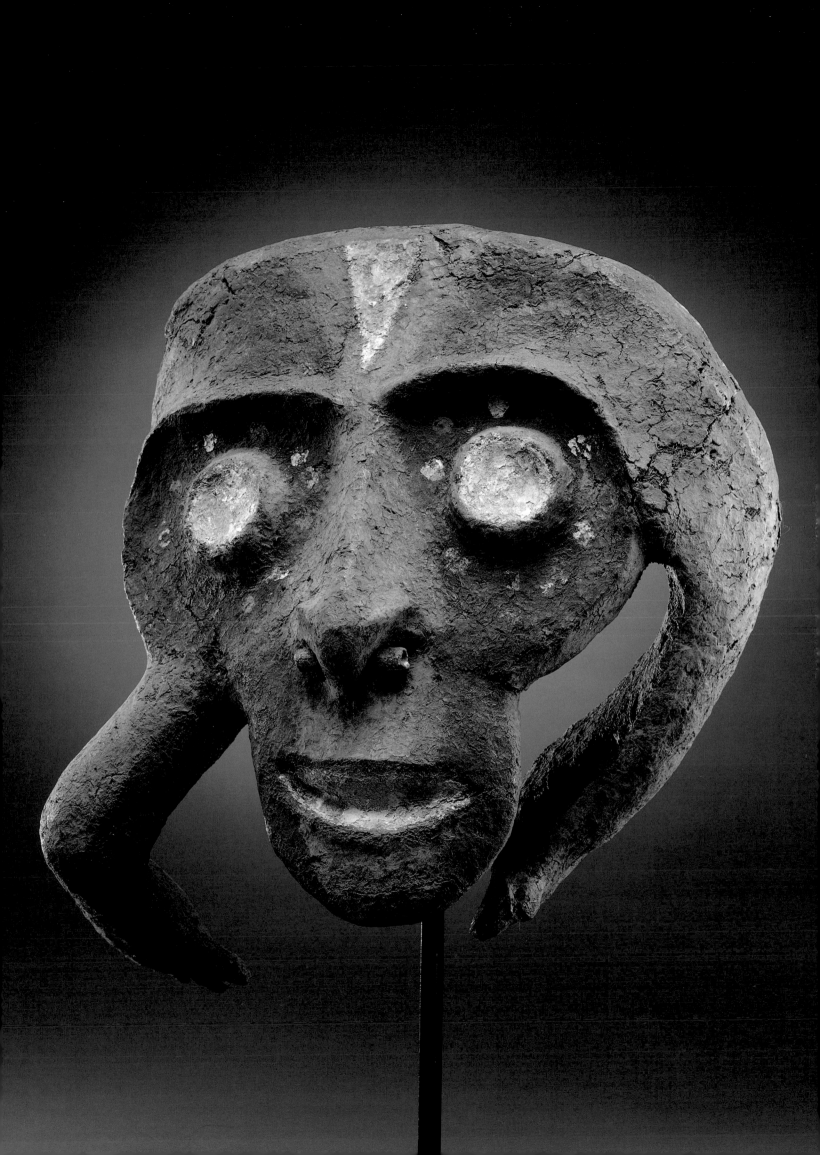

## 59  Ceremonial Adze

Vanuatu, Malekula
*Wood, fiber, iron*
Length: 18 in. (47 cm)

THE PEOPLE OF CENTRAL AND SOUTH Vanuatu, particularly those of Malekula, made adzes for both utilitarian and ceremonial use. The form of this one is based on that of adzes which were used to split breadfruit (Edge-Partington 1890–98, p. 146, no. 16). Certain ceremonial adzes are carved with heads, some facing away from the blade, as here, and others showing two heads, with the other placed at the top of the blade. Another type from southern Malekula has a handle that is in the form of human figures or superimposed heads (Speiser 1923, taf. 85, nos. 1, 4, 5, 7, and 8). They were carried in dances performed during grade society observances.

The angular treatment of the human face with its pointed chin, overhanging brows, protruding eyes, and pointed head is representative of the art of Vanuatu (see cat. no. 56). From its patina, this one certainly dates from well into the nineteenth century, but its original blade has been replaced by one of iron (most old ceremonial adzes still have blades of shell or stone). The addition of such an exotic element might well have enhanced the value of the object to its owner.

Previous collection: Wayne Heathcote, New York

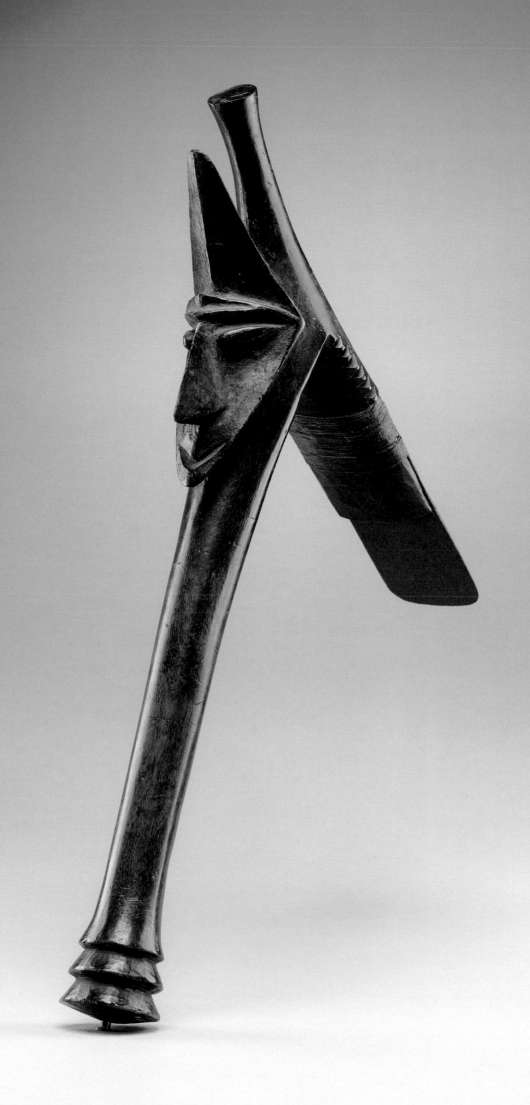

## 60 Male Ancestor Figure

New Caledonia, Northern Area
*Wood*
Height: 10 1/4 in. (26 cm)

ALTHOUGH THE ART OF NEW CALEDONIA is best known for its remarkable mask forms (see nos. 61 and 62) and the carved roof finials, door jambs, lintels, and other architectural ornaments that decorated ceremonial houses, some three-dimensional sculptures in human form were also made. Among these are a group of small male and female figures such as this one that are often identified as spirits associated with the bringing of rain. This information is based on the identification by Fritz Sarasin (1929, taf. 69, no. 3) of a single figure in the Museum für Völkerkunde, Basel, as a *regendamon*. Even though Sarasin publishes a number of other similar figures that he simply describes as idols (ibid., nos. 4–7), the designation of many of these figures as rain spirits seems to have spread into the literature from this one source.

Although it is apparent that rain sorcery was practiced on New Caledonia (Schmitz 1969, p. 256), it is probable that most of these figures were associated with ancestor worship. They, and in fact all of the sculptures of New Caledonia, were carved by artists who had been selected not only because they were skilled craftsmen, but because they had a relationship to the supernatural spirits they represented in their works (Davenport 1964, p. 3).

As can be seen here, New Caledonian figure sculpture is composed of a series of rounded, full, and bulbous interrelated forms. Facial features emphasize the large nose, an overhanging brow, and a grimacing mouth. This well-carved example is very similar to one that was previously in the Carlo Monzino collection, Lugano (Sotheby's, New York, 1987, no. 95).

Previous collections: Linden Museum, Stuttgart (N.S. 10590); Wayne Heathcote, New York

Publication: Sotheby's, London, 1983, no. 109

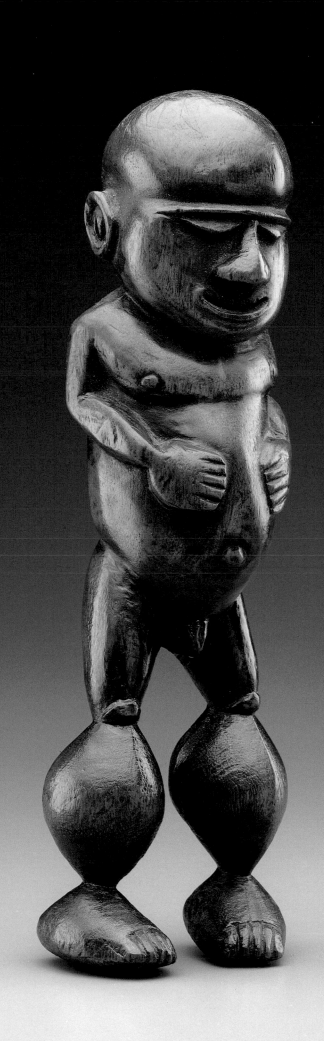

## 62 Mask

New Caledonia, Northern Area
*Wood*
Height: 20 in. (51 cm)

These renowned masks, with their grimacing mouths, bean-shaped eyes, and enormous noses, were made only on the northern part of New Caledonia. As has already been noted (see cat. no. 61), they are often and perhaps wrongly associated with the water spirit *Apouema,* and not enough is known of their exact use to connect them with specific rituals. It is, however, possible to present two theories regarding the exaggerated size of the nose. One is based on mythology, the other on possible outside stylistic influences.

The former theory concerns the legend of Azyu, one of the culture heroes of northern New Caledonia. He was the son of Dea of Belep Island and Tea Pulivac, the ruler of Poc Island, both islands located to the north of New Caledonia. As he grew older and more powerful, Azyu gained the enmity of his rivals. After a series of failures, his enemies finally managed to kill him, tearing off his nose and tongue in the process. Dea vainly tried to bring him back to life, but because he was so ashamed of the appearance of his face, Azyu would not allow her to do so. He then traveled to the land of the dead, where he made a mask of this type and sent it back to New Caledonia. The large nose, of course, represents the nose that he had lost (McKesson 1990, p. 85, adapted from Leenhardt 1954).

Concerning possible stylistic influences, John McKesson (ibid., pp. 89–92) notes several factors that suggest a foreign origin of this mask expression. These include the northern locus of such masks on New Caledonia itself, the myth of Azyu, which takes place in the north, and the unproven function of the masks. He finally compares the New Caledonian masks with several having quite similar features from the Vanuatuan islands of Ambrym and Pentecost, which are also to the north. He therefore believes that the form originated there and was subsequently brought to New Caledonia.

This example is a fine old piece, having a shiny, thick patina and showing other signs of considerable use. Although the nose is huge, it is still anatomically related to the other parts of the face. The holes around the perimeter were used to affix the beard, hat, and other elements of the costume such as are seen in cat. no. 61.

Previous collections: Anthony Moris, Paris; Wayne Heathcote, New York

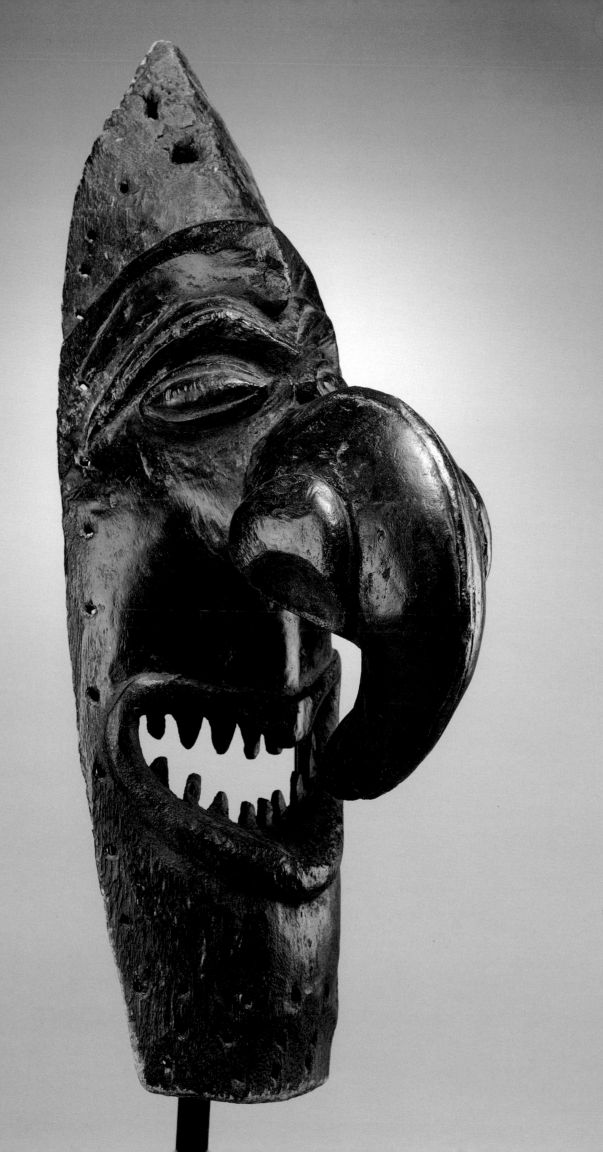

## 63 Female Figure (*matakau*)

Fiji Islands
*Wood, shell inlay*
Height: 27 1/2 in. (70 cm)

LOCATED ON THE WESTERN EDGE OF THE
Polynesian triangle, the Fiji Islands share cultural
and artistic traits with both Melanesia and Poly-
nesia. With its elongated form, inset face, overhanging
brows, and forward-thrusting pose, this figure can be seen
to have some affinities with Melanesian sculpture.

Only a few wood figures survived the missionary-
ordained burning of idols that took place during the
second half of the nineteenth century. All of them repre-
sent ancestors, and besides a discrete group of small
images under a foot in height (see cat. no. 64) some, such
as this one, are of larger size. Because none of the latter
were made to stand alone, and all also seem to look down-
ward, Fergus Clunie (1986, p. 167) believes that they were
cut from the tops of posts and meant to be seen from
below.

Besides its rarity and sculptural quality, the figure is
interesting for having been collected by the Reverend
Joseph Waterhouse, an Australian Methodist who served
in Fiji for three periods between 1850 and 1878. While
there, he wrote three accounts of native life which are
among the first reliable documents of Fijian customs.
Unfortunately, there is no record in his writings of how
this particular sculpture came into his possession.

Previous collections: Reverend Joseph Waterhouse;
his heirs; Alastair McAlpine, London

Publication: Bonhams, London, 1991, no. 126

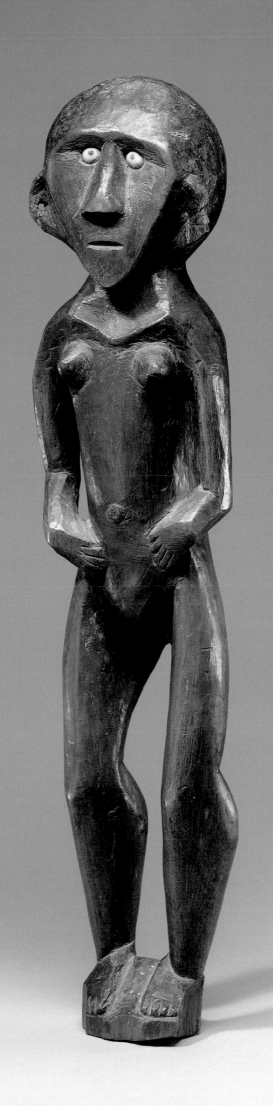

## 64 Female Figure (matakau)

Fiji Islands
*Wood*
Height: 9 in. (23 cm)

THIS SMALL FIGURE IS ONE OF A GROUP of perhaps as many as a dozen that exist today. They are all approximately of the same size and have squared shoulders, hands at the hips, pointed chins, round pierced ears, and ridged eyebrows. Each was once named and represented a specific ancestor whose spirit was thought to occupy it at certain times, especially when it was placed on the grave of the person it represented. When not being venerated, such figures were kept in spirit houses, and their dark, deep, and even patina was acquired from the smoke of the fire that was kept burning there (Clunie 1986, p. 166).

In precontact times, Tonga exerted considerable influence on Fiji. Its people settled in the eastern Lau Islands and exerted political control over some of the high islands as well (Mack 1982, p. 258). This explains why figures of this kind have been found on Tonga and are recognized as having Tongan stylistic traits. Mack (ibid.), in fact, mentions the theory that "canoe builders of Tongan ancestry residing on Viti Levu were responsible for these figures."

The Masco piece is typical of this group in every respect. It originally had inlays of shell or another material in the eyes.

Previous collections: Kenneth A. Webster, London; James Hooper, London; Wayne Heathcote, New York

Publications: Phelps 1976, p. 86, no. 754; Christie's, London, 1979, no. 135; Mack 1982, pp. 258–59, pl. 115

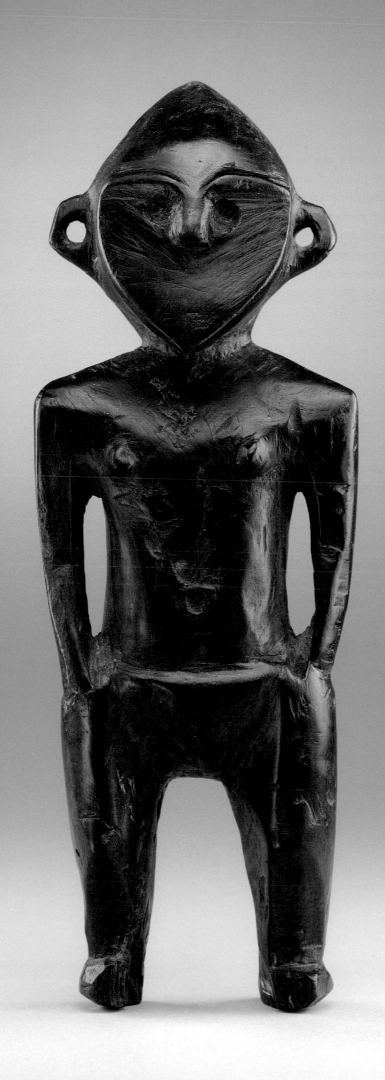

## 66 Breast Ornament (*civavonovono*)

Fiji Islands, Viti Levu
*Whale ivory, pearl shell, fiber*
Diameter: 7 in. (18 cm)

THIS UNIQUE TYPE OF ORNAMENT WAS developed on the Fiji Islands during the nineteenth century, when increasing amounts of sperm whale ivory became available through trade with visiting whalers. To fashion these prestige ornaments, plates of whale tooth were lashed onto the edges of a large, black-lipped pearl shell. They were often also decorated with additional attachments in the center in the form of stars and crescents. Although the significance of these elements is not known, they relate closely to the ivory inlays found on some of the more elaborate neckrests and clubs of Tonga (see no. 71a), demonstrating yet another connection between these two island expressions.

Such pendants were suspended from the neck with fiber cords that were often decorated with beads. To prevent them from becoming dislocated during combat or dancing, another cord was attached to the sides and tied at the wearer's back (Clunie 1986, pp. 163–64, no. 119). This example, having the two side and bottom pieces of ivory carved with serrated edges and a raised band, a plain pointed element at the top, and a four-pointed star in the center, is very similar to one in the Metropolitan Museum of Art (Wardwell 1967, p. 17, no. 9).

Collected by Admiral John Erskine, HMS *Havana*, in 1850

Previous collection: Wayne Heathcote, New York

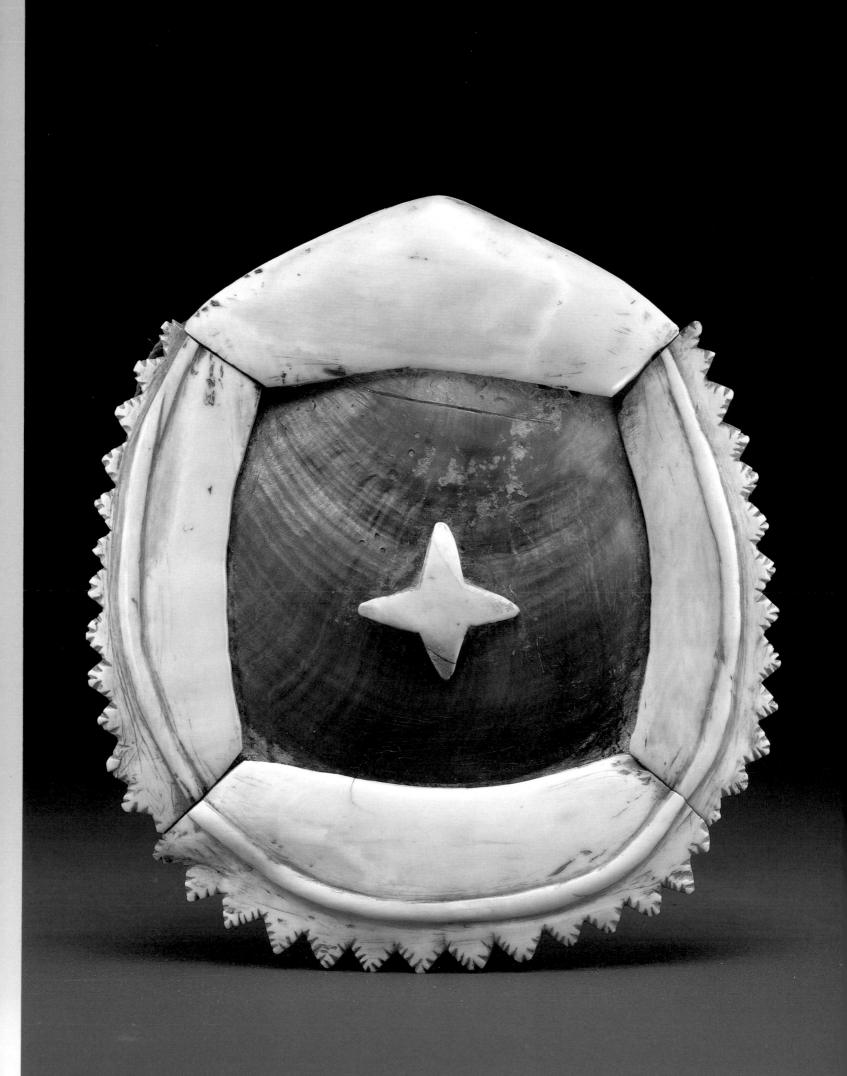

67b **War Club** *(vunikau bulibuli)*
*Wood, ivory*
Length: 41 1/2 in. (105.5 cm)

THIS IS A FAIRLY COMMON FIJIAN CLUB type made from the bottom part of a small tree, the top part of the root buttress forming the macelike end. The various projections where the rootlets were sawn off bear whale ivory and human teeth inlays, some of the latter perhaps of victims. The purpose of the *vunikau* was to smash skulls (Clunie 1977, p. 58, fig. 17, b–e).

Previous collection: Wayne Heathcote, New York

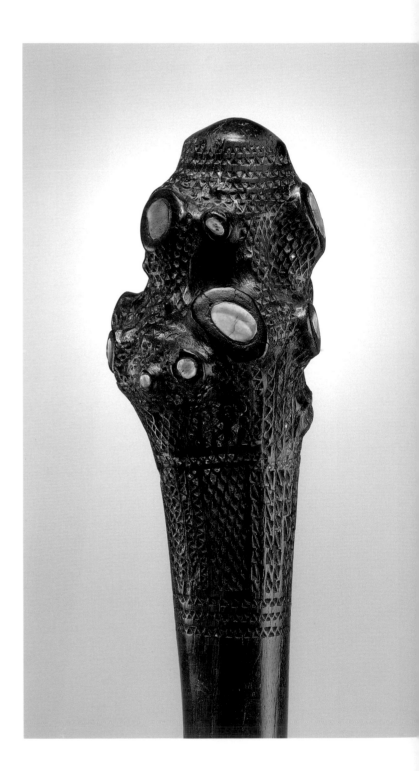

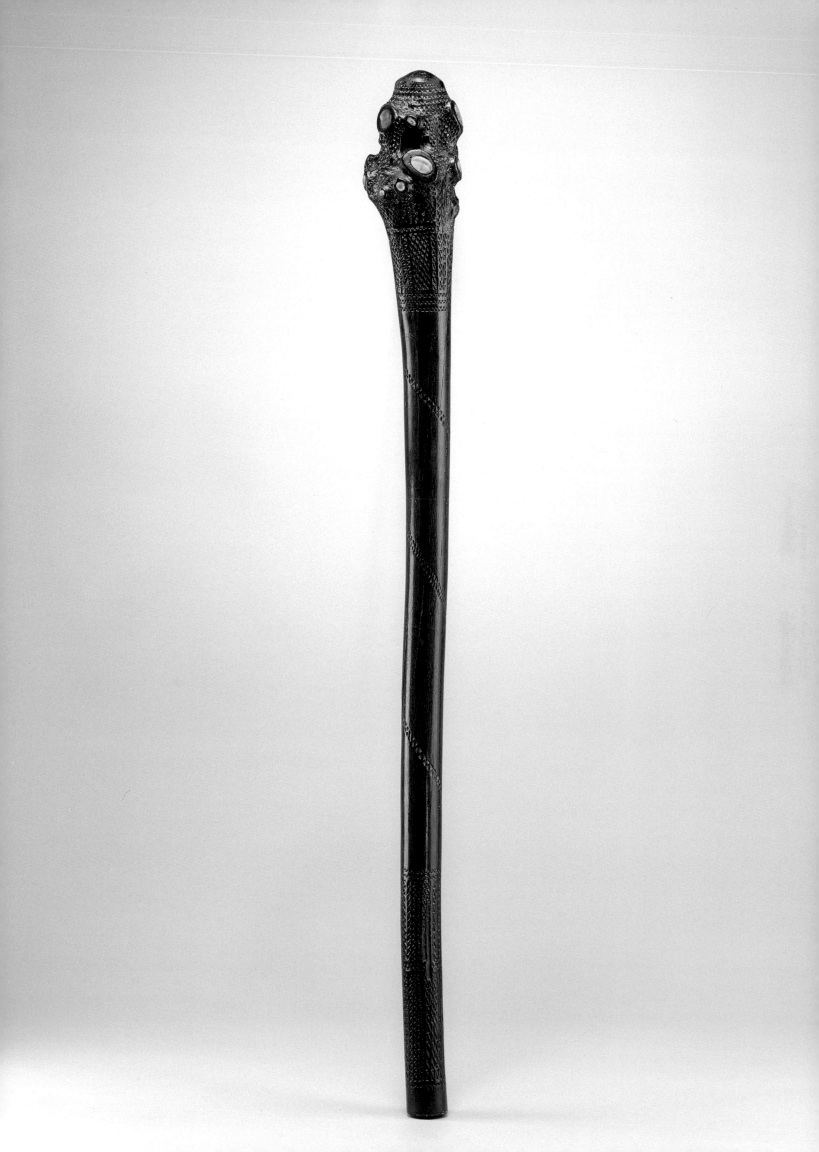

67c **War and Dancing Club** *(sali)*
*Wood*
Length: 48 in. (122 cm)

Because its shape is related to that of European rifle butts, this type of lipped club is commonly called a gunstock club. The form is actually based on the flower of a plant in the banana family. According to Clunie (1977, p. 54, fig. 3f, g), "bladed cheeks [are] designed to cut through and snap bone rather than smash it." The spur might also have been used to put a hole in the skull, and the club was also used for parrying.

A number of *salis* were made only for dancing. They were held in two hands, one holding the handle, the other the spur. However, of necessity, dancing clubs were of lighter weight than this fine old piece, which must have been used only for fighting or prestige display. The surface ornament is beautifully conceived and applied, and the club may well date to the end of the eighteenth century.

Collected by Reverend Joseph Waterhouse between 1850 and 1857

Previous collection: Wayne Heathcote, New York

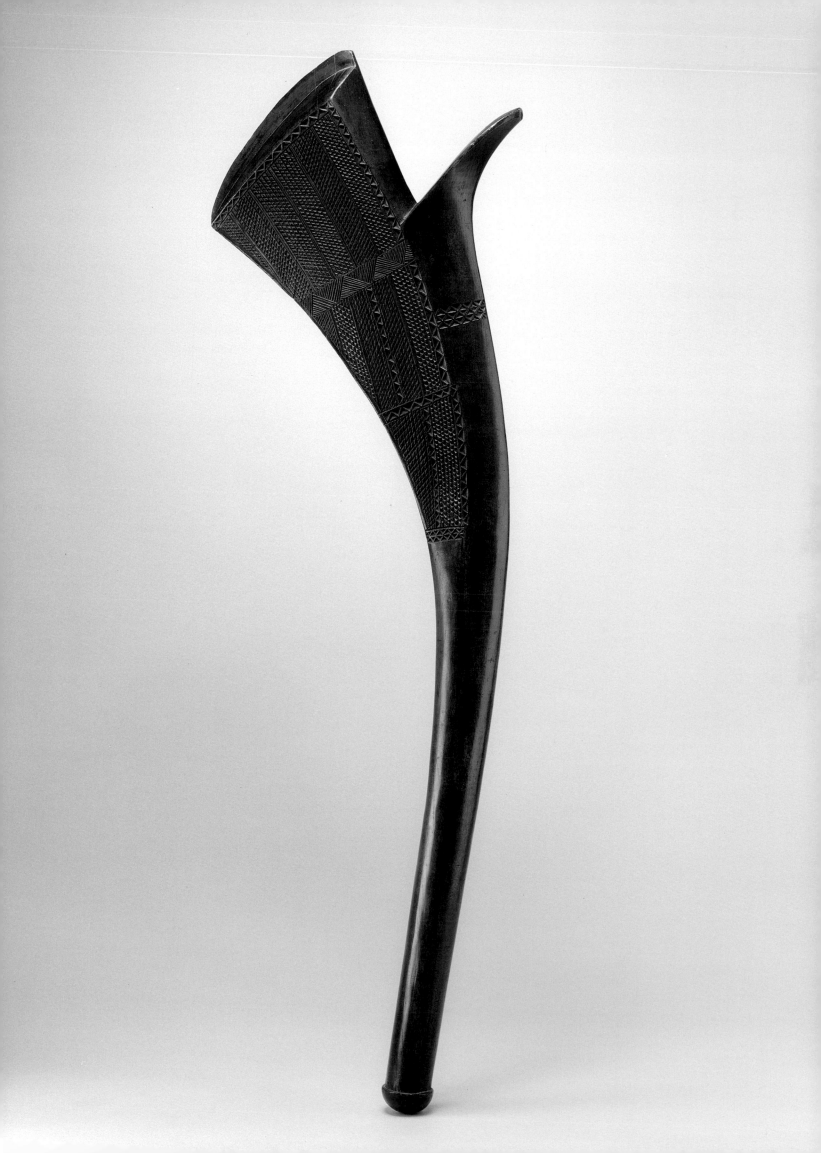

67d **War Club** (*gata*)

*Wood, ivory*

Length: 39 in. (99 cm)

LIKE THAT OF THE *SALI* (NO. 67C), THE salient edge of this club was made to cut into and break bones. *Gatas* were among the most common fighting clubs of Fiji, and they may have been so named because they represent the wide open jaws of the Pacific boa snake called *gata* (Clunie 1977, p. 53, fig. 1d–g). Distinguishing characteristics of some of the finer examples are the roughly carved parallel grooves on the upper inner side such as are seen here. These are caused by carving with stone tools into the growing tree before it was cut (ibid., p. 53, fig. 2c, d).

Previous collection: Wayne Heathcote, New York

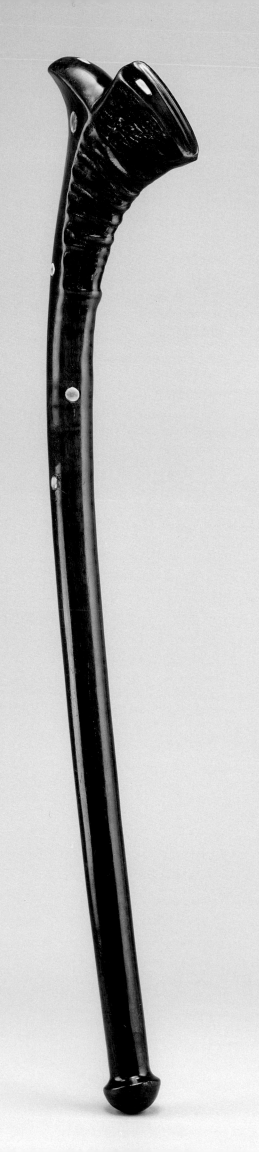

### 67e  Dance Club (*gugu*)

Viti Levu
*Wood*
Length: 42 3/4 in. (108.5 cm)

OFTEN INCORRECTLY REFERRED TO AS lotus or axe bit clubs, the surface designs of these clubs are actually very stylized renderings of the flat butterfly fish, *gugu* (Clunie 1977 p. 16; p. 54, fig. 4c, d). Here, the body of the fish is represented by the square panel, below which are the eyes and pointed head. The diagonals extending from the eyes indicate fins. Such clubs were used exclusively for dancing. Although it has been suggested that they only come from the region of Nadroga Navosa on Viti Levu, the comparatively large number of clubs of this type that exist today suggests a more widespread area of origin.

Collected by Reverend Joseph Waterhouse about 1850–57

Previous collection: Wayne Heathcote, New York

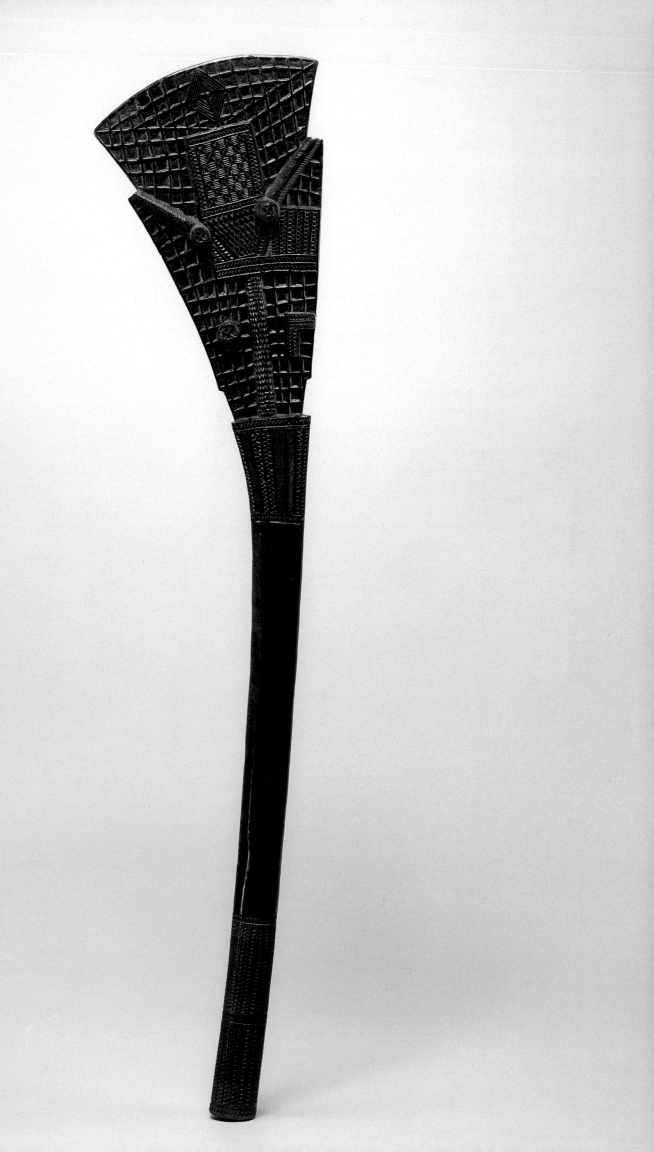

## 68  Drinking Vessel (*sagamoli*)

Fiji Islands
*Ceramic*
Diameter: 11 in. (28 cm)

IN THE NINETEENTH CENTURY, THE FIJ-
ians developed types of slab-built ceramic drinking
vessels that were used by chiefs of the islands of Viti
Levu and Bau. They were made watertight by the appli-
cation of a pine resin (*makadre*), which was rubbed on as
it melted over the warm clay just after the vessel had been
removed from the kiln. The containers appear in unusual
and eccentric shapes that include turtles, sperm whale
teeth, canoe hulls, and fruits and vegetables, some com-
bining more than one of these motifs in a single vessel
(Clunie 1986, p. 143, pls. 16–18).

This one represents a bunch of citrus fruits known as
shaddocks (ibid., pl. 17), which are here all connected
with a single spout at one end that was used for drinking.
They are also joined together by a handle that is typically
decorated with raised, knobbed ridges.

Previous collections: Pitt Rivers Museum, Farnham,
England (5728); Wayne Heathcote, New York

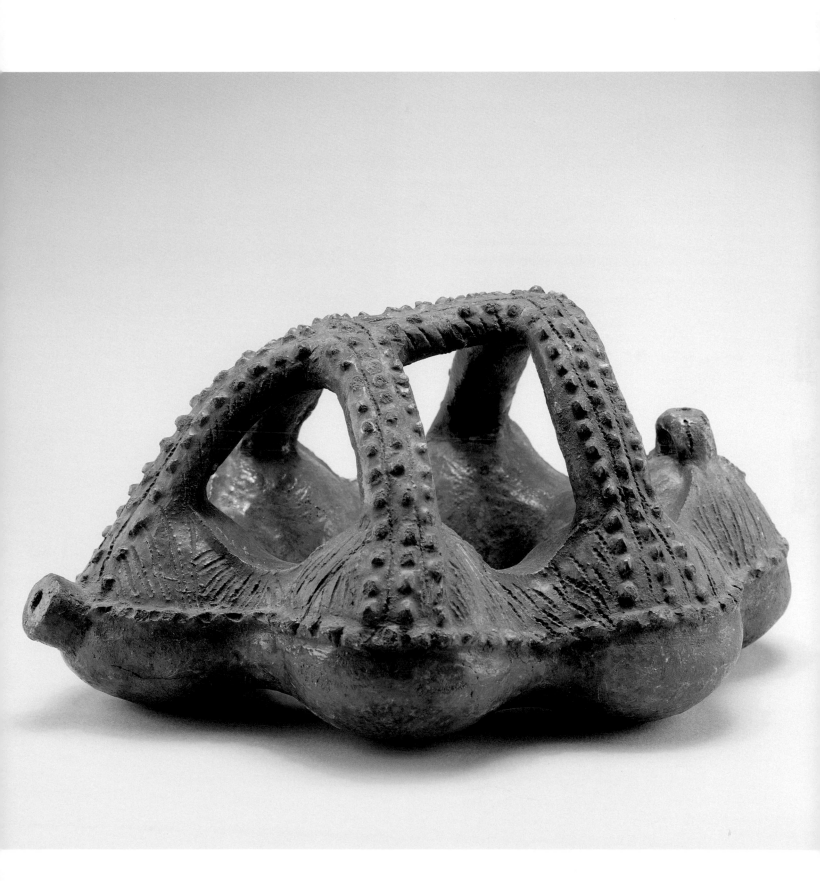

## 69 Female Figure

Tonga Islands
*Sperm whale ivory*
Height: 3 in. (7.5 cm)

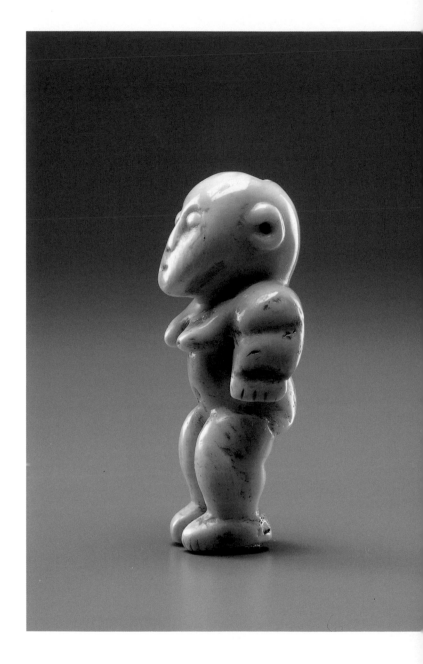

THIS SMALL STANDING FIGURE IS ONE of a group of nineteen known today. Five are made of wood, and the rest are of whale ivory. All are female, with stocky, well-proportioned bodies and simply carved facial features. Because two of the wood examples were collected at Lifuka, one of the islands of the Ha'apai group in central Tonga, all of the wood sculptures are thought to have come from there. On the basis of this, the ivory ones have sometimes been attributed to the same region (Wardwell 1967, pp. 20–21). This provenance has been questioned by Charles Mack (1982, p. 248), who cites the lack of supporting evidence and describes four different styles of ivory figure sculpture, each of which suggests a different origin.

One of these styles is represented by three small figures that were collected in Tonga by Captain Cook (Kaeppler 1978, pp. 207–8, nos. 1–3). Although they are all under two and one-half inches high, this slightly larger example falls into that group. As here, many are drilled for suspension and were probably worn as pendants either singly or with others. A unique necklace with eight female figures of similar style has in fact survived from Fiji (Barrow 1972, p. 85, no. 125). Some single ivory figures have also been collected on Fiji where they had been traded from Tonga. They were worshiped by the Fijians as ancestor figures (Clunie 1986, pp. 165–66).

The larger ivory figures have at times been ascribed by some scholars to the early postcontact years when whale teeth had become more readily available from trade with European whalers. However, the migration routes of sperm whales took them to the Tongan Islands from early times, and, as is shown by the Cook provenance on three of the figures, whale ivory was available during the eighteenth century. Although the making of these sculptures could have continued after contact, most examples, including this one, are from the mid-eighteenth century, if not earlier.

Previous collections: Purchased in 1851 by a member of the Dawson family at Exeter (England) Centenary Hall in a sale of articles from a voyage to the Pacific taken by John Wesley; by inheritance to William Dawson, Sunderland, England; Wayne Heathcote, New York

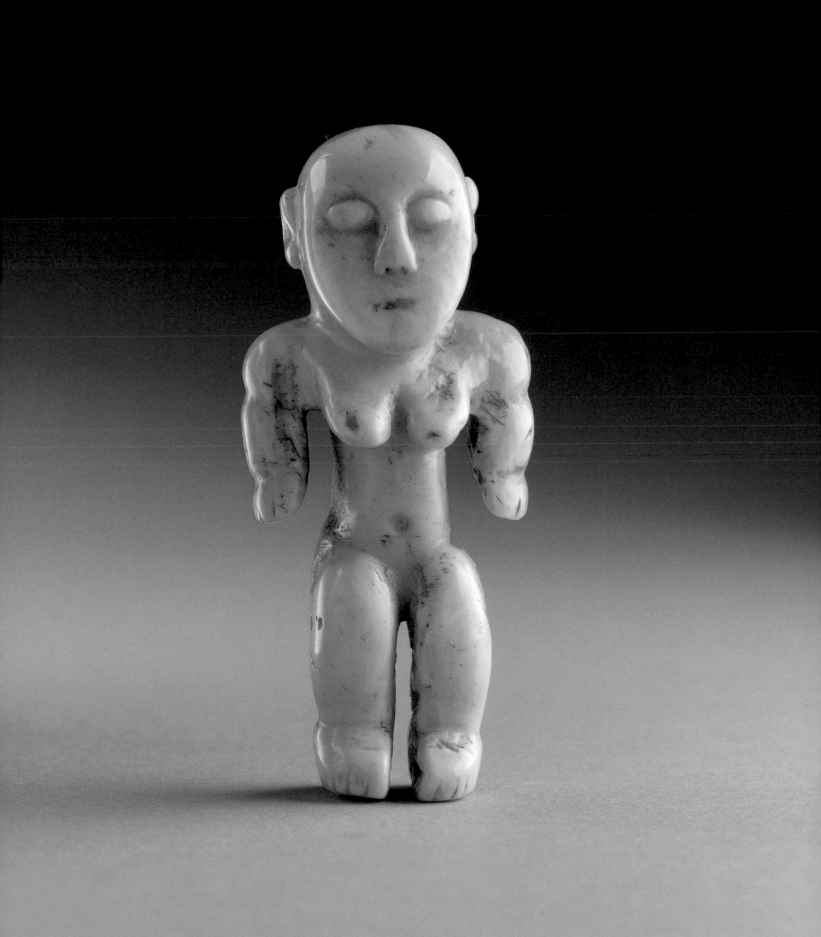

## 70 Neckrest *(kali sauthoko)*

Tonga Islands
*Wood*
Length: 29 in. (73.5 cm)

O F THE THREE TYPES OF TONGAN neckrests, the earliest are those such as this one having U-shaped legs with disk feet and made of one piece of wood. Because two were certainly collected by Cook, and a dozen others have eighteenth-century collection histories, the form was undoubtedly developed during the precontact period (Kaeppler 1978, p. 228, nos. 1–14). It was also adapted for use on the Fiji Islands, but there the legs were carved separately and lashed on with fiber cords.

The basic function of such neckrests was to protect the elaborate coiffures of their owners. Nevertheless, by being the property of important chiefs and through their long association with them, neckrests gained great *mana* and became powerful objects in and of themselves. The elegance of this example is enhanced by the ridge that is carved in the center of the bottom, which runs the length of the neckrest. Although an old label still affixed to the bottom only traces its provenance to 1885, it is comparable to those from the eighteenth century mentioned above and belongs with the group. One of the legs is restored.

Previous collections: Leon Michaud, Staff Officer to the Governor of New Caledonia, 1885 (old label); Wayne Heathcote, New York

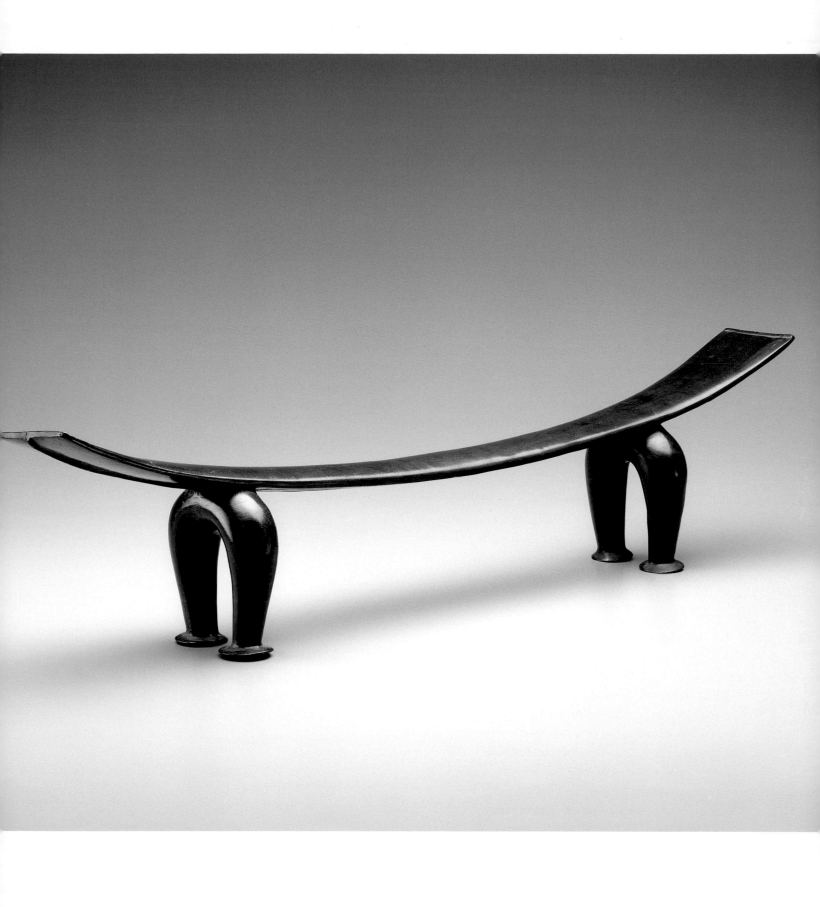

## 71 Three Clubs
Tonga Islands

## 71a Club *(bovai)*
*Wood, ivory*
Length: 30 1/4 in. (77 cm)

A S  I N  O T H E R  P A R T S  O F  P O L Y N E S I A ,  W A R-
fare was an important element of Tongan culture, and long clubs were among the favored weapons. Of all the artifacts collected on Cook's voyages, in fact, Tongan clubs were the most numerous (Kaeppler 1978, p. 238). Some chiefs won their high positions "with the use of the club on the battlefield" (E. Gifford 1929, p. 123), and they were sometimes entertained by contests between two adversaries who fought with clubs until one was killed (ibid., p. 124). Many clubs also served as insignia of rank.

Tongan clubs were made in a variety of shapes, but most of them are of elongated form, ranging in length from about thirty to fifty inches or more. Some important examples have whalebone, shell, or ivory inlays of crescent, star, or geometric shapes similar to those found on some Fijian clubs. It is believed that these inlay techniques originated on Tonga and were later adopted by Fijians (Mack 1982, p. 256). Most Tongan clubs are beautifully decorated with intricate relief designs applied over their entire surfaces. The human and animal figure motifs that sometimes appear among them may relate to the totem of the club's owner (Barrow 1972, p. 73, no. 110).

In order to gain something of the *mana* of the spirits who resided in sacred places, clubs and other weapons were often left in such precincts for considerable periods of time. If a charged weapon was lent to another man by its owner and the proper rituals were followed, its power could be transferred to the new user (Gifford 1929, p. 327). As among the great *taiahas* of the Maori (see cat. no. 89), some Tongan clubs that were especially infused with *mana* assumed divinatory and mythical roles.

Regarding one of these, Edward Gifford (ibid., p. 327) quotes John Havea as follows: "Vahai's club was so full of *mana* that it could not lie still and was always moving as it reposed in the house. On one occasion, a man was sent to fetch from the house Vahai's club, which was wrapped in a mat. Entering, he could see no club, but only the bundle of mat, which kept moving, and he thought it to be a child. Returning he said there was no club, but only this child. Vahai's club gave warning of war planned against Vahai by moving. The movement was caused by the *mana* of the god."

C L U B S  O F  T H I S  S H A P E  A R E  S O M E T I M E S
referred to as leaf stalk clubs, as their graceful shapes are compared to the appearance of the leaves of the coconut plant where they meet the stalk of the tree (Duff 1969, p. 51, no. 84). The superb geometric relief designs and the finely crafted ivory inlays that cover the entire surface indicate that this one was undoubtedly the property of a high chief and used for the display of rank rather than actual fighting. Such elaborately decorated implements may reflect the wish on the part of the craftsman to imbue his own *mana* into his works through the labor and careful thought that went into their creation.

Previous collection: Wayne Heathcote, New York

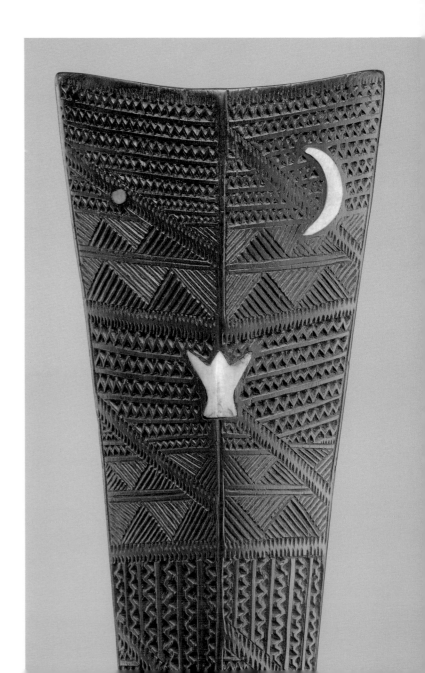

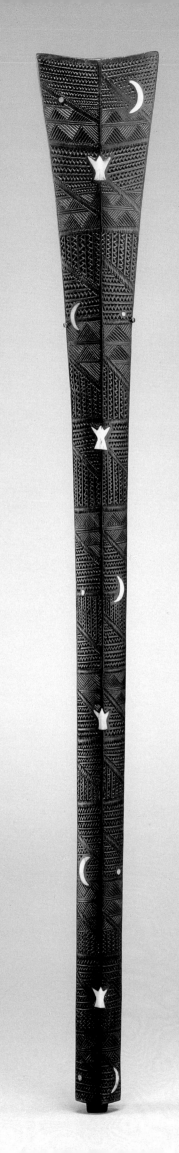

71b **Club** *(apa'apai)*
*Wood*
Length: 41 in. (104 cm)

ALTHOUGH LACKING INLAY, THE METIC-ulous geometric designs on the handle of this example and the rows of carefully cut projections of the end render it as important a chiefly possession as cat. no. 71a. The end is carved in a manner to make it an effective fighting weapon. Even though metal tools were used to carve the intaglio designs, workmanship of this quality required scores of hours of labor.

Previous collection: Wayne Heathcote, New York

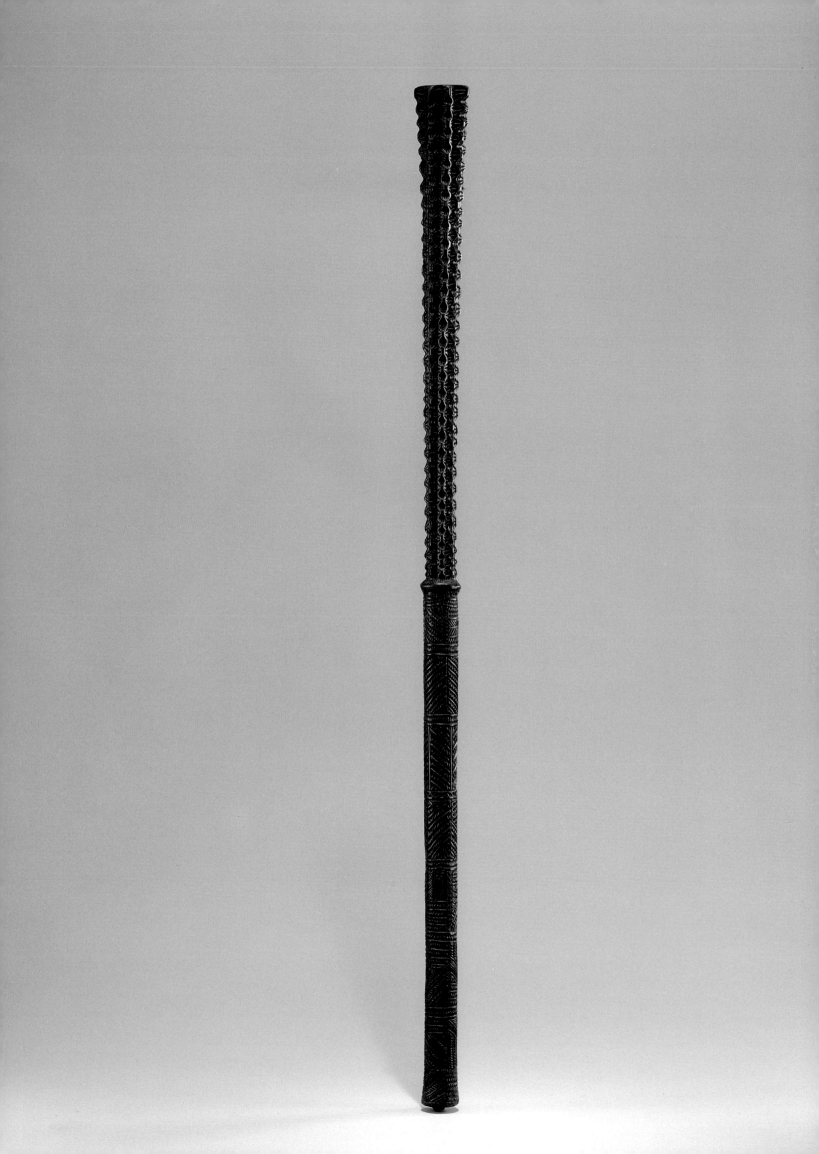

71C **Club**

*Whalebone*

Length: 53 in. (134.5 cm)

Whereas the other two Tongan clubs shown here rely on surface detail to convey their importance and *mana,* this rare example is noteworthy for being made of a single large piece of whalebone. Its form closely follows a well-known wood Tongan type that was an effective weapon (see, for example, Barrow 1972, p. 27, pl. 31, second from top). Because of its material, however, this club would probably only have been used for prestige display.

Collected by Reverend John Waterhouse, HMS *Triton,* in 1840

Previous collection: Wayne Heathcote, New York

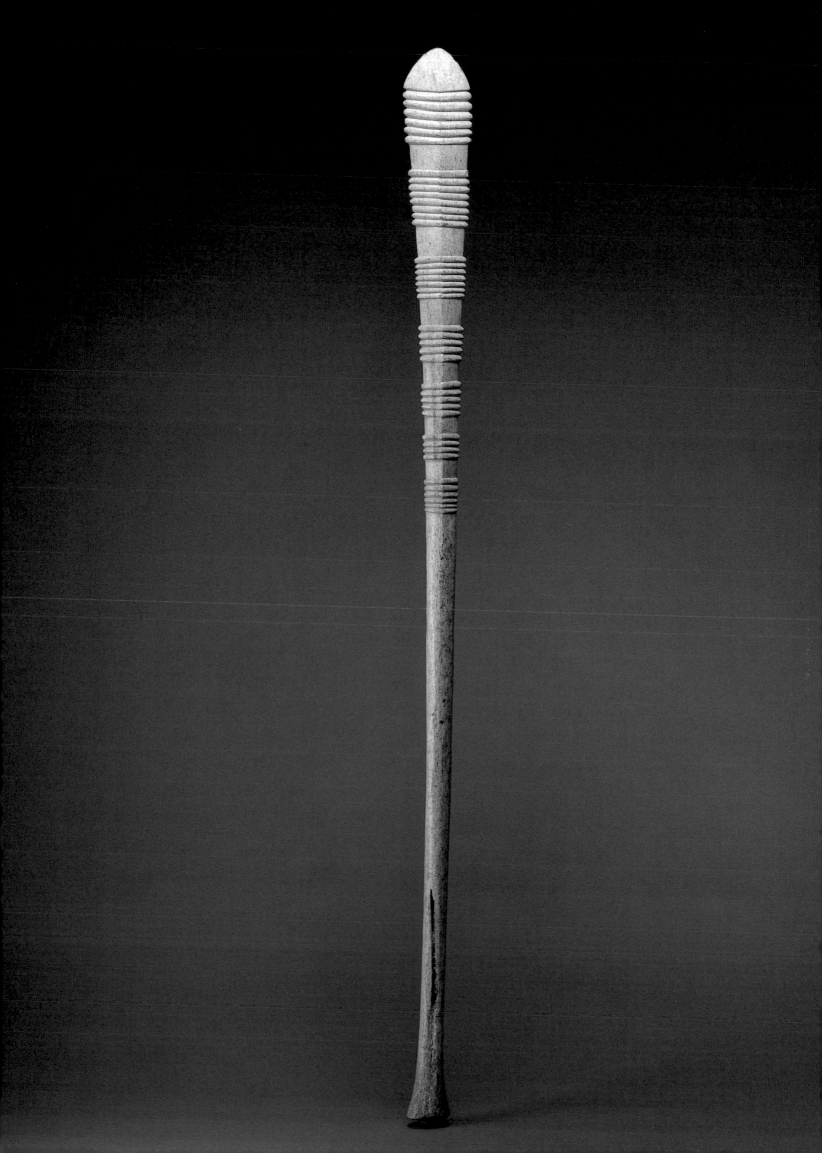

## 72 **Poncho** (*tiputo*)

Tahiti

*Bark cloth, brown dye*

Height: 34 in. (86.5 cm)

T HE TAPA CLOTHS OF POLYNESIA ARE
made from the inner bark of the paper mulberry
tree, a plant that originated in eastern Asia and
was brought into Oceania by early settlers who carried
cuttings with them on their voyages. It could grow only
on the rich soils of high volcanic islands that had good
rainfall. The bark was beaten with flat wood implements
and then decorated with brown dyes obtained from
boiling the bark of an indigenous tree. Tapas from Tahiti
and Hawaii are the finest that were made. They were
beaten into the thinness of paper and ornamented with
the most delicate patterns. The cloth was usually prepared
in long carpetlike strips and used for long skirts, as a cov-
ering during sleep, and for gift giving.

The fashioning of tapa into the poncho form rep-
resented by this example was not developed until
postcontact times, and the shape here may imitate a cas-
sock or another type of clerical dress. Once it had been
adapted, it soon became the most prestigious item of
clothing to the native Tahitians (Barrow 1990, no. 26).
Most tapa designs are made by the process of stretching
the cloth over a relief-carved design tablet and rubbing
the dye over the board. In this case, however, the delicate
motifs of vegetable sprigs, fern leaves, zigzags, and inter-
connected diamonds were individually painted, resulting
in a freer composition than could be obtained by the
more mechanical rubbing process.

Because they could be easily carried and did not require
much care, tapas were popular curios among visiting
missionaries, traders, and whalers. Many fine early
examples are therefore now in collections throughout
the world.

Collected by George Bennet of Sheffield, England, who
was in Polynesia with representatives of the London
Missionary Society between 1821 and 1822 (see cat. no. 75)

Previous collections: Pitt Rivers Museum, Farnham,
England; Mrs. Stella Pitt Rivers, Farnham, England;
Wayne Heathcote, New York

Publication: Sotheby's, London, 1978b, no. 162

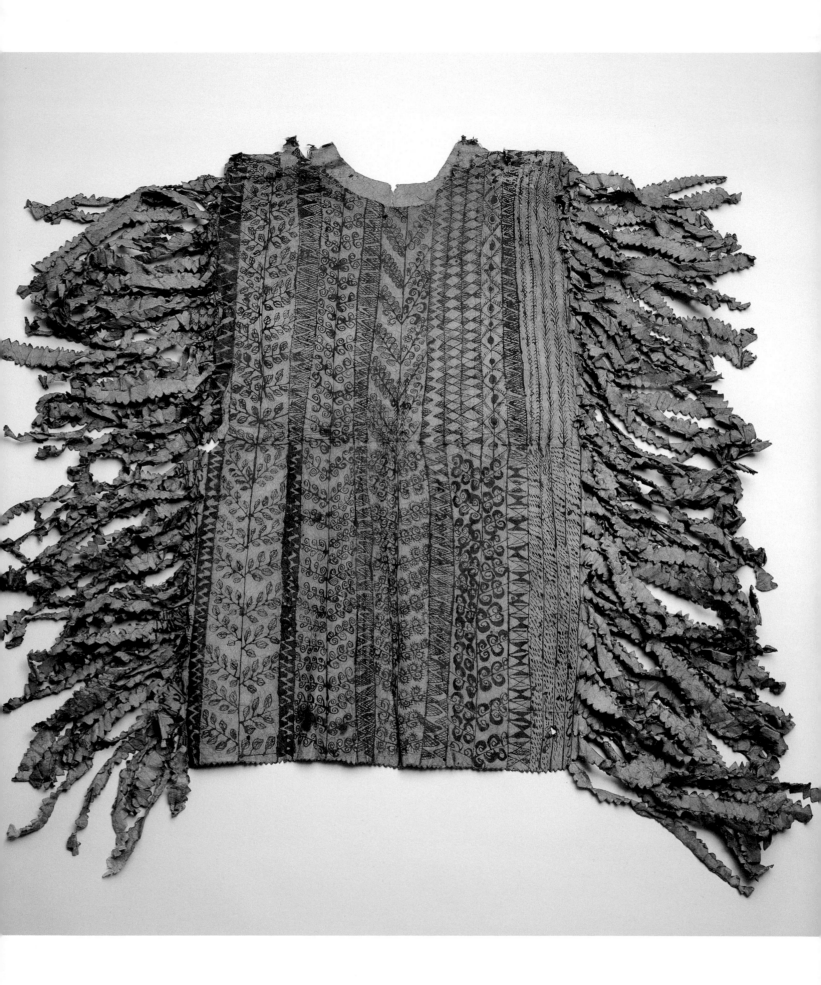

## 73 Fly Whisk Handle

Tahiti
*Sperm whale ivory, wood, fiber*
Length: 13 in. (33 cm)

THIS IMPORTANT HANDLE WAS LARGELY unknown until it emerged at an auction in London in 1983 (Phillips 1983, p. 20, no. 155). Although it has no provenance, it is closely related to two others, one now in the Metropolitan Museum of Art, the other in the Wielgus collection in Tucson (Wardwell 1967, pp. 32–33, nos. 28, 29). These two were presented to Reverend Thomas Haweis by the ruler of Tahiti, Pomare II, in 1818, and their old and abraded surfaces indicate that they date from well into the eighteenth century if not even earlier.

Through comparison with the Metropolitan Museum specimen, which is the least abstract of the three, it can be surmised that the carving on the butt end of the Masco whisk shows a single figure bending over backwards. The openwork designs of the three carved segments are somewhat similar to those on the bodies of the staff gods of the Cook Islands (see cat. nos. 74 and 75). As with them, it is tempting to speculate that the designs represent abstract human figures standing on one another and symbolize ancestors, but there is no evidence that this is the case.

The size of sperm whale teeth required that these whisks be carved in several sections. One such section on the Masco whisk is made of hardwood and is undoubtedly an old replacement of a broken piece of ivory. Such implements were carried as insignia of royalty by rulers on Tahiti. At the bottom can be seen the well-worn hole through which fiber cords were run so that the implement could be used as a whisk. The use of whale ivory, a rare commodity until the coming of whalers in the nineteenth century, is indicative of their importance as objects of prestige.

Previous collection: Wayne Heathcote, New York

Publication: Phillips, London, 1983, p. 20, no. 155

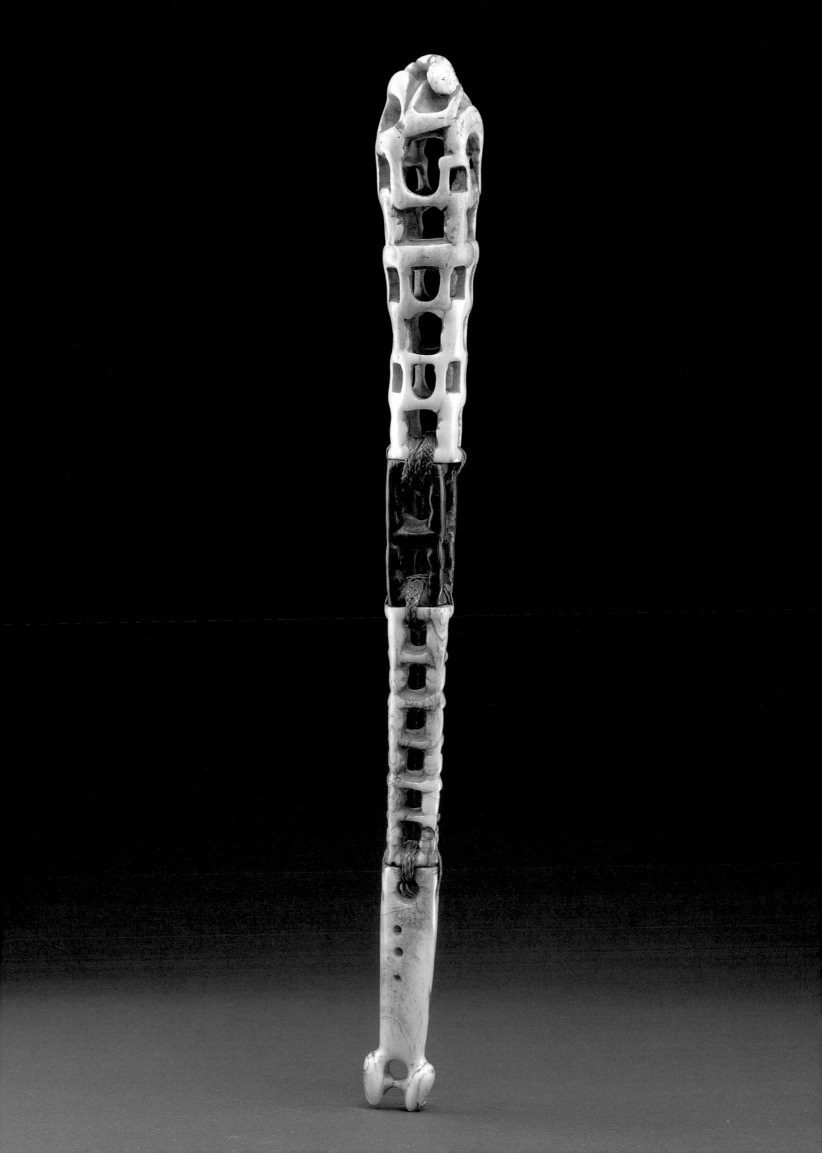

## 74 Staff God

Cook Islands, Mangaia
*Wood, fiber, human hair, feathers*
Height: 46 in. (117 cm)

COOK ISLAND STAFF GODS ARE AMONG the most esoteric of all the arts of Oceania (see also cat. no. 75). To the untutored eye, they appear to be little more than damaged fragments of strange and incomplete objects. While it is true that parts of all those that have survived have been broken and only a few bear significant traces of their original feather and fiber ornamentation, to concentrate only on their present condition is to ignore their historical importance and sculptural complexity. As they once appeared, with their openwork carving intact and a full complement of feathers and sennit, they were truly impressive objects. It was, in fact, the fibers and feathers that gave them their true significance, because, as Terence Barrow (1979, p. 88) informs us, "Sennit and feathers were thought to attract and accommodate the gods, and thus were regarded as more important than the wooden part which we today treasure as sculpture."

This one is unusual in the amount of feathers, human hair, and fibers that still adhere to it. Most of the others known today are missing the better part of this ornamentation. The carved portion consists of nine tiers of looplike forms. The undercutting, raised lozenge shapes, loops, and transverse bands are meticulously sculpted and have occasioned Barrow (ibid., p. 90, pl. 100) to remark that "no single carvings in Polynesia exceed these mace gods in sheer complexity except New Zealand canoes and house carvings." Reinforcing this view, Peter Buck (1944, pp. 372–78) describes in exhaustive detail the many steps that were necessary to create these works. They required cutting a rectangular piece of wood into a series of longitudinal ridges that were then carved out into arches, notches, and lozenge-shaped holes with chevron relief designs on their surfaces. The butt ends are also carved in small relief designs. All of this work was, of course, accomplished with shell and stone tools.

Of equal if not even greater significance is the possible history of this particular piece. One of only six known from Mangaia, it is generally thought to have been among thirteen whose creation and use is described in an account of 1823 from the London Missionary Society (Mack 1982, p. 230, no. 1). Peter Buck (1944, pp. 362–63, 472) provides the following summary: material representatives of the

Mangaian gods in the form of thirteen staff gods were kept in a national god house in the Ke'i district of Tahiti. They were cared for by an attendant who changed their white clothing and cooked food for them each evening. At some time in the late eighteenth century, all of the staff gods were destroyed by a fire that burned down the god house. As a result, a famous craftsman named Rori who had been in exile was freed by the ruler Manaune to carve a new set. This he did, making all but the one that represented his own god, which had to be made by Rori's friend Tapaivi.

Soon after the establishment of a Christian mission on Tahiti in 1823, a group of rulers decided to surrender the staff gods to the church. They were subsequently carried before the Tahitians, their wrappings discarded, and "for the first time since they were carved by Rori, they were exposed to the vulgar gaze" (Gill 1894, p. 333). They were then collected by the missionaries Reverend John Williams and Reverend Platt and sent back to the London Missionary Society Museum.

Each one of these staff gods was named and uniquely carved. Many red parakeet feathers still remain on this one. In addition, although human hair was often woven into the sennit lashings and was sometimes attached in small tufts to them, none of the other five surviving examples show four prominent woven coils of hair as are still around the base of the Masco staff. This suggests that it is the one representing the god Motoro, the guide of daily life, and a deity second in importance only to the creator, Rongo. The identification of the staff god of Motoro at the time of its deconsecration is given by William Gill (ibid., pp. 204, 235) as having "beautiful parakeet feathers brought to this island [from Tahiti] by his [Rori's] grandfather [Ume, that] . . . were used by him to adorn Motoro to the great admiration of men that day. . . . Rori obtained some of [his aunt's] beautiful hair to adorn the then newly carved image of Motoro. At the period of the surrender of the idols to Mr. Williams, the hair of this woman was still on it."

If these prominent coils of hair and remaining parakeet feathers indeed serve to identify the Masco image, we know that it was made in the late eighteenth century by the skilled craftsman Rori and the other information

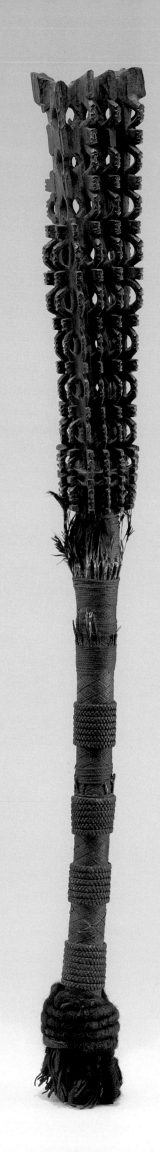

## 75 Staff God

Cook Islands, Mitiaro
*Wood*, fiber
Height: 8 1/4 in. (21 cm)

given above is confirmed. The staff god descended into the possession of J. F. Keep, London, and was known to be in the family from at least 1880. According to family tradition, it was said to have been used by the Mangaians to kill a missionary and therefore taken from them (Sotheby's, London, 1980a, no. 64). In view of the foregoing, this is unlikely.

Collected by Reverend John Williams and Reverend Platt of the London Missionary Society on Mangaia in 1823

Previous collections: by inheritance to J. F. Keep, London; Wayne Heathcote, New York

Publication: Sotheby's, London, 1980a, no. 64

THE STAFF GODS OF MITIARO ARE ALL of this particular construction, having a tapering rounded top with two or three openwork sections and four or five pointed vertical elements around the sides. The body consists of a series of vertical openwork rows of arched forms with relief-cut lobes at the ends. Below this, and missing from this example, was a simple spatulate form handle. Originally, a fiber tail was affixed to the base, and fibers and feathers were lashed to the top portion. As with the Mangaian staff gods (cat. no. 74), they only gained their true significance when feathers, believed to be impregnated with divinity, had been attached (Buck 1944, p. 471).

There are today only ten known Mitiaran staffs in this comparatively good state of preservation. Mack (1982, p. 230) mentions nine, but the Masco example was unknown to him at the time. Most of them are documented as having been collected for the London Missionary Society in 1823 when the people renounced their old beliefs.

Most were meticulously made with shell- and tooth-pointed tools in precontact times. The carving techniques are described in detail by Peter Buck (1944, pp. 352–55) and are similar to those used to create the staff gods of Mangaia (see cat. no. 74). Hundreds of hours of labor were required to make each one of these. The methods involved the cutting of a round piece of wood into a series of vertical channels which were then pierced and sometimes further carved in relief as can be seen on this example. These relief forms are often construed as representing stylized ancestor figures, so that the staff itself becomes "a powerful symbol of the pantheon of the gods" (Duff 1969, p. 62, no. 115). Buck, however (1944, p. 353), accounts for their use simply as "ornamental cleats ... for the attachment of feather decorations" and cites the lack of any traditional or documentary evidence that they are of human shape. The same can be said about the similar relief decorations on Mangaian staff gods.

The Masco staff god comes with an interesting provenance recently supplied by Linda Finer (1992). It was most probably collected on Mitiaro with others now in English museums by the Reverends John Williams and Robert Bourne of the London Missionary Society in 1823, when the people were converted. It was subsequently

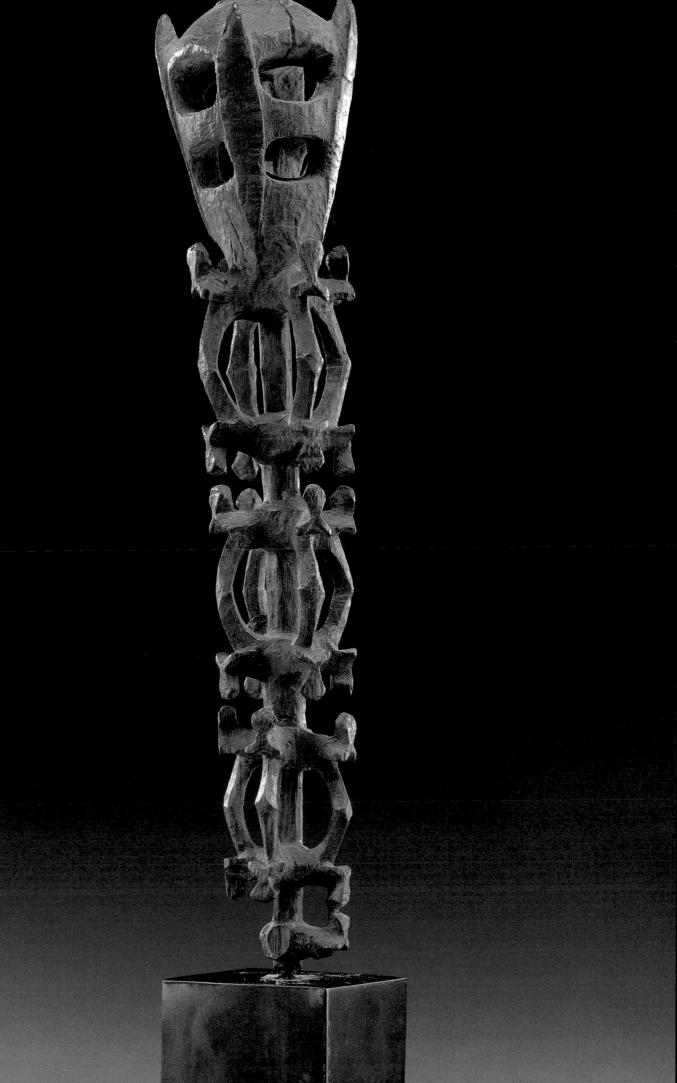

## 76 Pole Club ('akatara)

Cook Islands, Rarotonga
*Wood*
Length: 90 in. (228 cm)

turned over to George Bennet and Reverend Daniel Tyerman with one complete example and some other fragments of staff gods that are now in the Cambridge Museum of Archaeology and Ethnology. Bennet and Tyerman then proceeded to India and other parts of the world before Bennet returned to England in 1829 (Tyerman had died in Madagascar the year before).

When they were in India in 1826, they visited the Baptist missionary at Serampore on the Hooghly River, some twelve miles north of Calcutta. At that time, Bennet most probably presented this staff god to the mission. The collections at Serampore were subsequently transferred to a Baptist Missionary College in England. The staff was then acquired from it by Linda Finer within the last decade.

Collected by Reverends John Williams and Robert Bourne, London Missionary Society, on Mitiaro in 1823

Previous collections: Baptist missionary, Serampore, India; Baptist Missionary College, England; Linda Finer, London; Wayne Heathcote, New York

THESE LONG CLUBS WITH POINTED broad blades having beautifully scalloped edges are unique to Rarotonga. They were used as weapons as well as for prestige display and are exceptional examples of simple and pure design. About them, Peter Buck (1944, p. 281) writes, "the neat workmanship and the fine dark polish make the clubs the most attractive of Polynesia."

The butt end is in the form of a penis, and many clubs, such as this one, have a small band of relief designs representing eyes running around the pole just below the blade. If the serrations of the blade are interpreted as teeth, the top of the club might be seen to represent the head of an animal. Terence Barrow (1979, p. 72, pl. 79) notes the theory that the design "perhaps derives from the crocodile motifs of Indonesia and Melanesia." Buck (1944, p. 288), however, simply observes the similarity of the treatment of the eye carvings on these pole clubs to their appearance on the wood god images of Rarotonga. It seems more probable, therefore, that the eyes suggest the presence of an ancestor spirit in association with the club.

Collected by the Reverend John Williams between 1821 and 1839

Previous collections: By inheritance to the granddaughter of John Williams, Clackton, England; James Hooper, London; British Railway Pension Trust, London

Publications: Phelps 1976, pp. 141, 424, no. 606; Sotheby's, London, 1988, no. 18

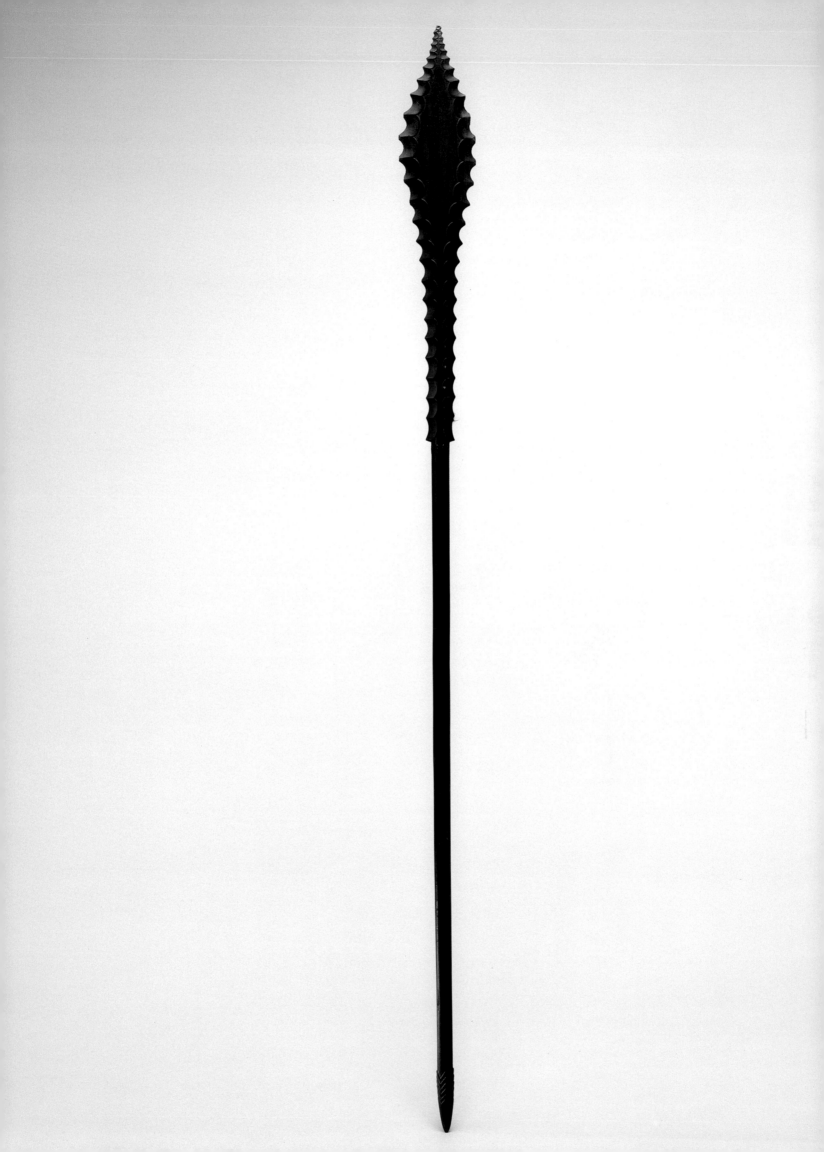

## 77 Stool (*no'oanga*)

Cook Islands, Atiu
*Wood, fiber*
Length: 18 in. (45.5 cm)

MANY EXAMPLES OF THIS FORM OF stool from the Cook Islands exist today. They were made until well into the twentieth century and are a local variation of a type that was originally developed on Tahiti (Buck 1944, p. 421). All of them are of the same approximate size and construction, having an elegant shallow curved seat, forward-arching splayed legs, and heart-shaped feet. This close stylistic conformity is explained by the fact that they were made only by craftsmen of Atiu Island and traded throughout the Cook Islands from there.

While easily appreciated as examples of pure and harmonious form, they also represent high technical achievements, requiring considerable labor to complete. They were carved from a single block of wood and then carefully and evenly finished. Such objects were among the very few pieces of furniture in Cook Island houses. They could be used only by chiefs on ritual occasions as symbols of rank and served no other utilitarian purpose (Duff 1969, p. 122, no. 122). When not in use, they were kept in the chief's house or storehouse, hung by a fiber cord strung between two of the legs such as can be seen still in place here (Buck 1944, p. 48). Later examples are of comparatively crude workmanship, but this early stool, collected about 1830, represents the type at its best. The even, yellowish color and patina indicate considerable use prior to 1830.

Collected by Gamaliel Butler about 1830

Publication: Bonhams, London, 1990, p. 44, no. 189

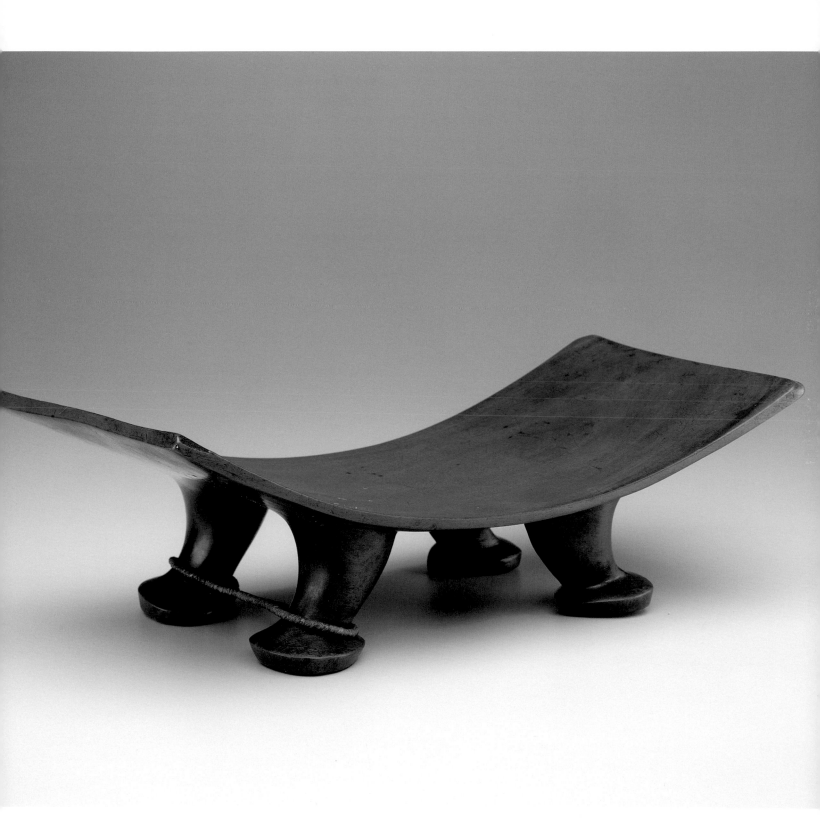

## 78 Fly Whisk Handle (*tahiri ra'a*)

Austral Islands
*Wood*
Height: 15 1/2 in. (39.5 cm)

UNTIL RECENTLY, FLY WHISKS OF THIS form have erroneously been said to come from Tahiti or the Society Islands, when, in fact, they are from the Australs (see, for example, Schmitz 1969, pl. 245; Wardwell 1967, pp. 28–31; Barrow 1972, pp. 106–7, no. 174). The confusion existed because there was much trade between the two island groups at the time the whisks were collected, and many actually have a Tahitian provenance, even though they had been made on the Australs. In addition, at the beginning of the nineteenth century, some Austral Island craftsmen were working in Tahiti and probably made such objects for the early curio trade (Mack 1982, p. 212).

The tops consist of two figures seated back to back, their hands joined across the abdomen. The faces are elongated with overhanging brows and a straight nose. There are two conical projections at the top of the head that represent topknots in the manner in which the Austral islanders wore their hair. The human forms are conceived in a series of angular rhythms, from the forward thrust of the head and the squared shoulders and elbows to the sharply bent knees and pointed feet. These rhythms are repeated by a group of disks of varying numbers that are carved below the figures. Beneath them is another broader, flatter disk with relief designs carved along the outer edge which may represent abstract crouching human forms (Rose 1979, p. 204, fig. 10–3) or stylized pigs (Mack 1982, p. 214). The lower portion of all such whisks were originally covered with finely woven fiber and human hair braiding, and at the end were strands of fiber cord that served as fly flaps.

Such implements were not actually used to keep flies away, but were insignias of high rank held by chiefs and rulers at ceremonies. The significance of the disks is not certain, but they may have represented different generations of ancestors, and could have been used as memory-aiding devices during recitations of genealogies.

Roger Rose (1979) has classified Austral janiform whisks into three types, two of which he suggests were made in precontact times. The third, which he calls Type A, of which this is an example, is distinguished by its larger size and evidence of having been cut with metal tools. There are more examples of Type A whisks than the others, and Rose believes them to have been carved for trade during the early part of the nineteenth century (ibid., p. 212). Although they are not as carefully made as the earlier and rarer examples, many, including this one, seem to have been handled extensively. They are probably of early nineteenth-century manufacture, but nonetheless could have been used in the traditional manner.

Previous collection: Wayne Heathcote, New York

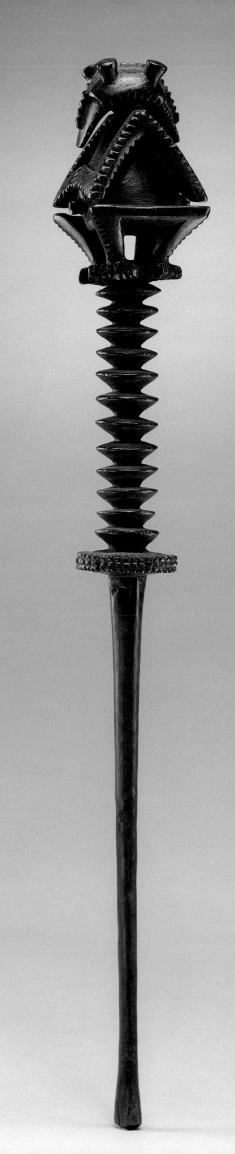

## 80  Gable Peak Figure *(teko teko)*
New Zealand
*Wood, shell, human teeth, traces of red pigment*
Height: 38 1/2 in. (98 cm)

THE MAORI EXCELLED IN THE CON-struction of buildings. Two types were developed: those that were raised above the ground and made for the storage of food, weapons, and canoe equipment belonging to a chief, and those used as assembly halls or dwellings of chiefs and their families. They were all heavily decorated, having relief-carved lintels, gables, door jambs, and doorways, and interior side posts and ridge panels. The carvings show frontal anthropomorphic figures and the motif of a figure and face seen in profile called *manaia*. Much labor and artistic creativity went into the construction and ornamentation of these structures, because it was believed that the better they were, the more prestige would be brought to the chief and his people (Mack 1982, p. 100).

Also among the architectural ornaments are masks and figures such as this one which were mounted on the peak of the roof between the gable ends. They decorated storehouses as well as assembly halls and chief's dwellings, and this example most probably comes from one of the two latter structures. Such carvings represent genealogical ancestors of the chief who owned the building and were thought to protect the people in the house.

This sculpture shows a male figure astride another male with a human head below it. The hands of both figures, which are held to the abdomen, are typically in the form of three birdlike claws, a reference to the mystical connections between man and birds that are found in New Zealand and throughout Polynesia (Barrow 1967, pp. 203–9). The inclusion of human teeth in the mouth of the upper figure is unusual, but they may well be the teeth of the ancestor represented. The eroded surface was caused by its exposure to the elements over many years. Close examination of the carving reveals that it was carved with stone tools and suggests that it was made during the latter part of the classic "flowering" period of Maori art in the eighteenth century (S. Mead 1984b, p. 74).

Previous collections: James Hooper, London, acquired in 1932; Wayne Heathcote, New York

Publications: Hooper and Burland 1953, pl. 4; Cooper 1963, pl. 267e; Dodd 1967, p. 277, ill.; Poignant 1967, p. 56, ill.; Phelps 1976, p. 33, no. 2; Christie's, London, 1977, no. 123; Mack 1982, pp. 100–1, no. 1

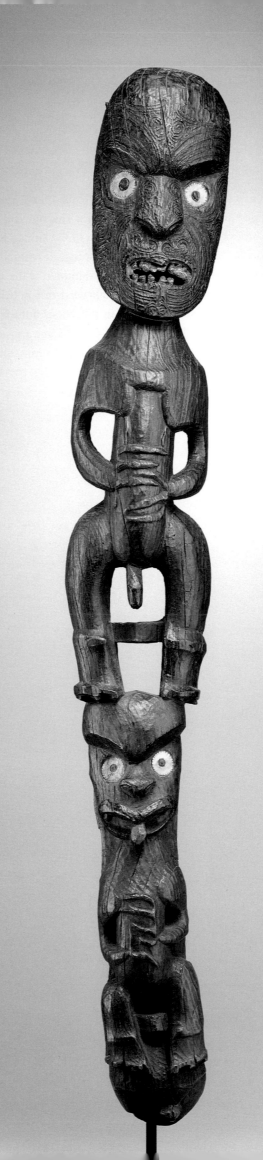

## 82 Carved Bar (paepae)

New Zealand

*Wood, haliotis shell*

Width: 11 1/4 in. (28.5 cm)

THIS OBJECT IS ONE OF A GROUP THAT has puzzled scholars of Maori art since examples first began to appear in the literature. William Oldman published three such pieces in 1946 (pl. 57, nos. 170, 339; pl. 58, no. 635). Concerning number 339, he writes, "The use of these objects is unknown to me. It has been suggested that they may be fishing rods, hand net handles, parrot snares, or bird perches." In the following years, most publications refer to them as either of the latter two (cf. Wardwell 1967, pp. 88–89, nos. 119–22; Barrow 1969, nos. 171, 172). Regarding one that was collected by Cook, however, Adrienne Kaeppler (1978, p. 210, no. 1) suggests that it was a canoe prow, and he questions the objects' employment as snares (ibid., no. 2).

Yet another suggestion of their function was provided by David Simmons in 1984 (p. 209, no. 103; p. 212, no. 114). Concerning the former, he writes, "This *paepae,* a carved bar, was probably for the end of a latrine seat. The seat was a flat board on which a person squatted. In certain rites, biting the end of the latrine seat was the final act for removing *tapu.*"

Whatever their use, they are all very well carved, having an openwork carved human face at the end, a head or full figure along the bar, and complex curvilinear relief. The slots cut into the bar itself are for the attachment of some additional fixture, the identification of which might someday solve the question of their function.

This is an exceptionally fine example with faceted shell inlays, beautifully conceived relief ornament, and an ingeniously posed standing figure on the bar. It was cut with nonmetal tools and probably dates to the eighteenth century.

Previous collection: Morris Pinto, Geneva

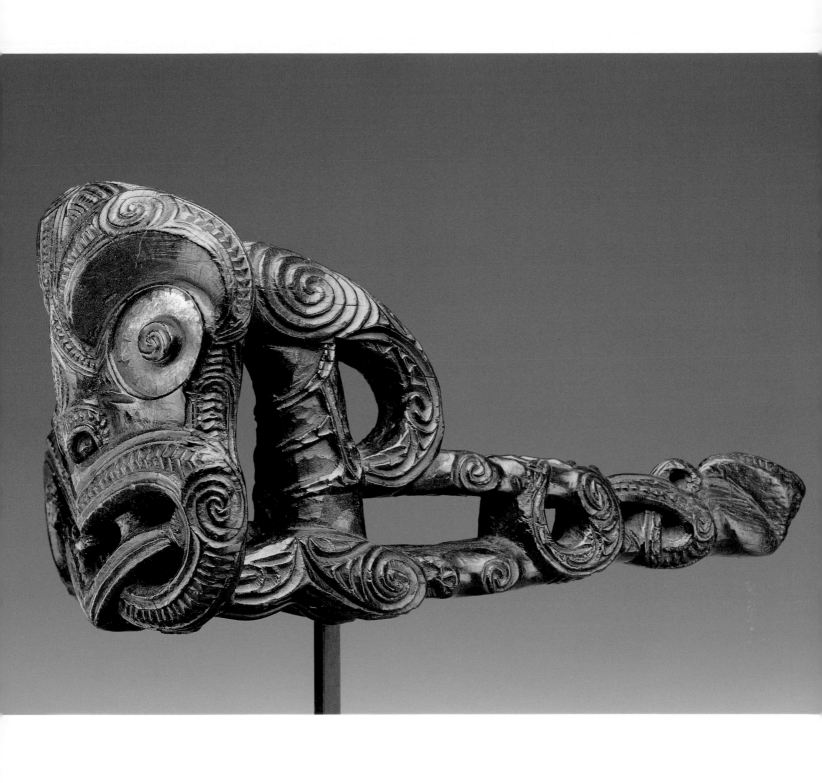

## 83  Pendant *(hei tiki)*

New Zealand
*Nephrite, haliotis shell*
Height: 3 1/2 in. (9 cm)

T HE MAORI WERE THE ONLY PEOPLE OF
Polynesia to work nephrite, a magnesium silicate
that is a form of jade. It is found on South Island
in the form of waterworn boulders at a beach called Pak-
iroa or in two river beds in the west where its collection
was controlled by a single tribe (Skinner 1966, pp. 5–6).
Nephrite was fashioned into tools, weapons, and orna-
ments of various kinds. Its soapy appearance belies the
hardness of the stone itself. When carved, it had to be
laboriously worked by abrasion with bow drills and
sandstone saws and files.

The most common ornaments are pendants such as
this one of grotesque figures known as *hei tikis*. Charles
Mack (1982, p. 126) has estimated that an average of seven
hundred and fifty hours of labor, or about five month's
time, were required to make a single example. The pen-
dants were worn by both men and women, suspended
from the neck with a cord of flax which passed through
a hole at the top of the head. As here, a toggle made
from the bone of a bird wing was usually tied onto
the end of the cord.

As is evident by the fact that at least four such pendants
were collected by Cook on different voyages (Kaeppler
1978, pp. 176–77, nos. 1–4), the form was developed in pre-
contact times. The carvings represent ancestors and were
family heirlooms. Each had its own name, and when they
were brought out from the elaborately carved treasure
boxes in which they were kept (see cat. no. 84), they were
addressed in person and believed to be viable spirits.
Whenever they passed into another generation, they
gained additional *mana*.

New Zealand nephrite ranges in color from a white-
gray green to a very dark blackish green. This example,
of a soft green hue, is in the most characteristic pose, with
the hands resting on the thighs and the head tilted to the
left shoulder. Those with the head tilted to the right are
somewhat more common, but the significance of this
pose, if there is one, is not known. One of the shell inlays
is missing. From its abraded surface, it appears to be
quite old and probably passed through several generations
of owners.

Publication: Christie's, London, 1989, no. 40

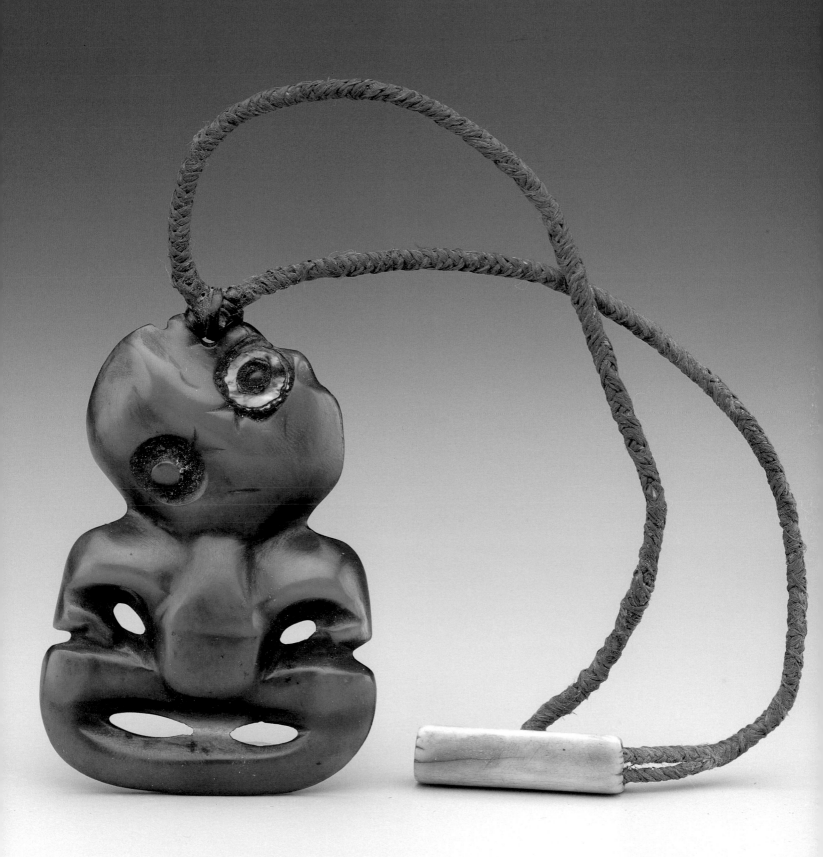

## 84 Treasure Box (waka huia)

New Zealand
*Wood, haliotis shell*
Length: 22 1/4 in. (56.5 cm)

BOXES SUCH AS THIS ONE WERE THE property of chiefs. They were used to hold valuable family heirlooms including the tail feathers of the *huia* bird (that were worn in the hair to indicate rank), combs, and nephrite ear and neck pendants (see cat. no. 83). By the nineteenth century, in order to protect the feathers from insect damage, tobacco was also placed in them (Mack 1982, p. 138). The larger boxes such as this one might also have contained a kind of short club made of nephrite.

This beautifully carved example shows three heads and the bodies of two human figures in profile on each side. The handle for the top is composed of two reclining, copulating figures. As is typical of much Maori carving, the entire surface is embellished with interrelated double-spiral and chevron relief designs. Many of the smaller boxes were hung from rafters of chief's houses and also carved on the bottom as they were often seen from below. This one has no carving on its base and was therefore kept on the floor or a shelf.

Previous collection: Carlo Monzino, Lugano

Publications: Sotheby's, London, 1980b, no. 66; Mack 1982, pp. 138–39, pl. 55, no. 1; Sotheby's, New York, 1987, no. 99

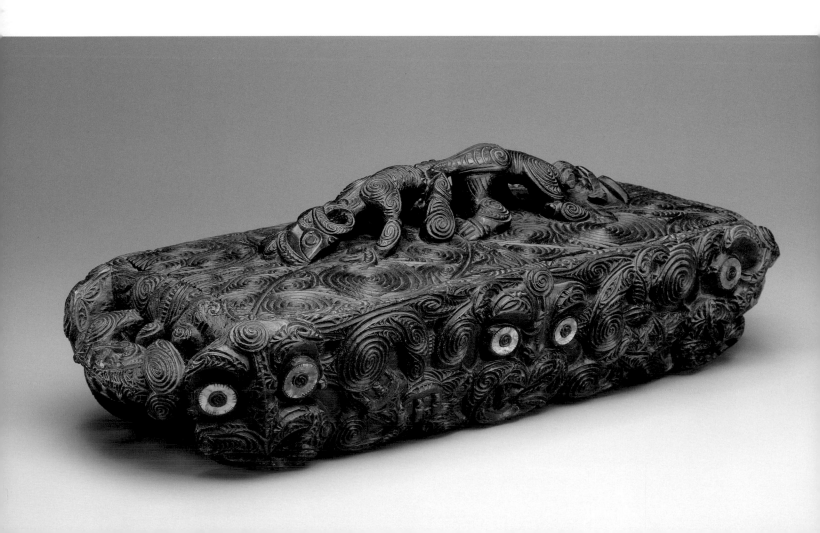

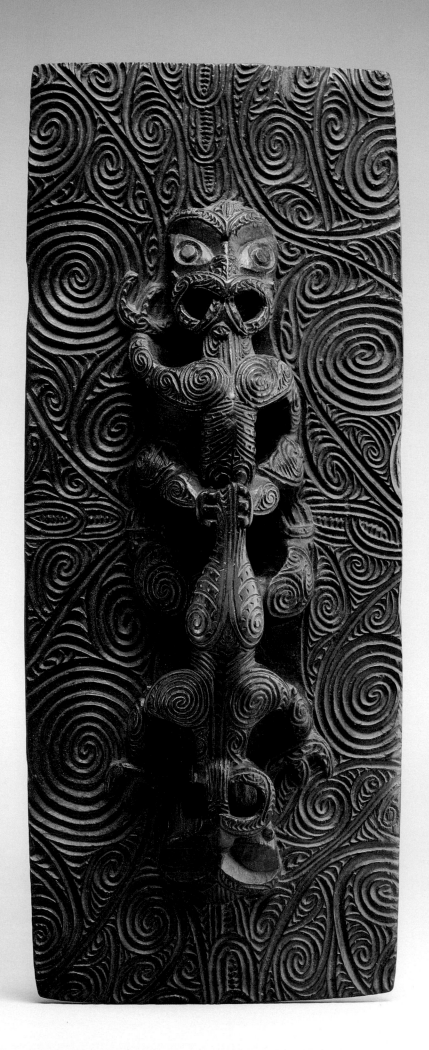

## 85 Feeding Funnel (koropata)

New Zealand
*Wood, haliotis shell*
Length: 14 1/2 in. (37 cm)

TATTOOING WAS ONE OF THE GREAT Maori arts, and many parts of the bodies of chiefs, especially their faces, were fully decorated. After the lips had been tattooed, and during the time required for healing, it was believed to be *tapu* for food to touch the skin. The head itself and the tattoos were regarded as having great *tapu* of their own, and "cooked food had the property of removing or diminishing *tapu*. If any food touched the lips when they were still raw from tattooing, it would remove the *tapu* from the work and cause it to fail" (Simmons 1984, p. 186, no. 140). Funnels were therefore used to feed semiliquid food to a chief during this process. The funnels were the chiefs' personal property and through continued use gained their own measure of *tapu* themselves.

Most funnels are of conical shape, but this large and unusual example consists of an open bowl with a handle in the form of a head at one end and a troughlike spout at the other. Another example of this form from the Oldman collection is now in the National Museum, Wellington (Duff 1969, p. 40, no. 53). The outer surface of the Masco funnel is covered with free asymmetrical designs of faces, contorted bodies, and the familiar double-spiral and chevron motifs. It was carved with stone tools and most probably dates from the late eighteenth century.

Previous collections: Morris Pinto, Geneva; Merton Simpson, New York; Wayne Heathcote, New York

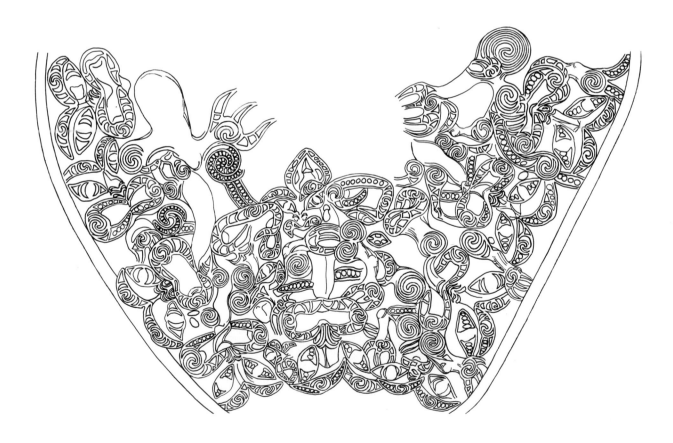

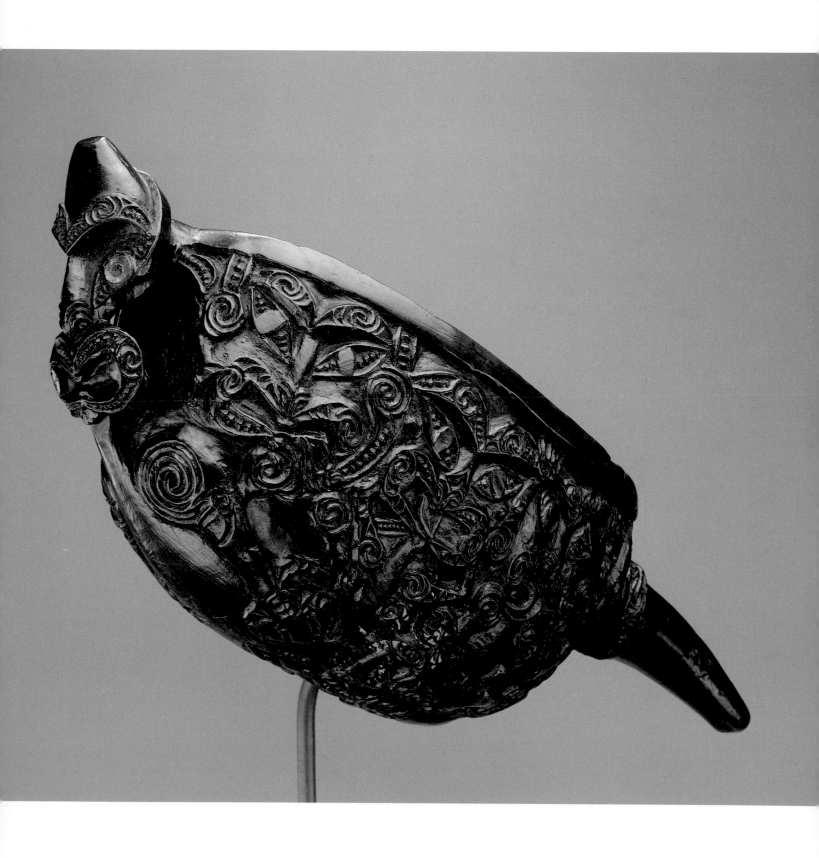

## 86 Pigment Container

New Zealand
*Wood, haliotis shell*
Height: 3 1/2 in. (9 cm)

PIGMENT USED FOR TATTOOING WAS made of soot from burnt resin. When used, it was mixed with pigeon fat in small containers such as this (Mack 1982, p. 120). Ownership of the pigment itself was an important factor, as it was believed that the *mana* of the owner could be transferred to the person being tattooed through its use. Accordingly, many sons requested that they be tattooed with pigment belonging to their fathers (Simmons 1984, p. 209, no. 102).

Such objects are rare. Only six others have been found in the literature. Simmons (ibid.) published one now in the National Museum, Wellington, and Oldman (1946, pls. 11, 12) published two others from the same collection. He also mentions the existence of one in the Alexander Museum, Wanganui, New Zealand, but does not publish a photograph of it. Another is in the Whangarei Public Museum, New Zealand (Duff 1969, p. 41, no. 57), and the sixth recently emerged on the London art market (Christie's, London, 1992, no. 200). All of them are decorated with the heads and bodies of figures. The well-worn surface of this example, combined with clear evidence of stone tool carving, suggests an eighteenth-century date.

Previous collections: Harry Beasley, Chislehurst, England; John Klejman, New York; Wayne Heathcote, New York

Publications: Sotheby's, New York, 1974, no. 164: Mack 1982, pp. 120–21, pl. 46, no. 1

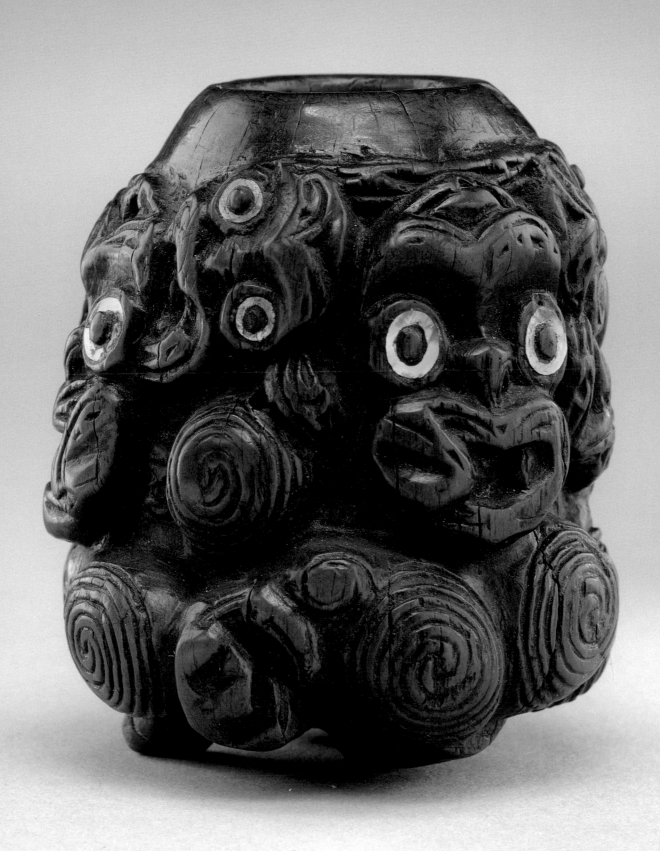

## 87 Bugle Flute (*putorino*)

New Zealand
*Wood, fiber, haliotis shell*
Length: 15 1/2 in. (39.5 cm)

THESE INSTRUMENTS WERE MADE BY first carving a piece of wood into the desired elongated shape and then carefully splitting it down the middle. Each side was next evenly hollowed out, in some cases, as here, to extreme thinness. The hole was then cut and sculpture and reliefs were carved around it and at the ends. Haliotis shell inlays were often also added. The sides were finally tied with cords of flax or the creeping vine. When they were blown through one end, fingers were moved over the hole in the center and at the end to produce two distinct notes. Although they are commonly referred to as flutes, current information suggests that they may have served more as signaling devices to announce the return of a chief to his village than as musical instruments (Simmons 1984, p. 210, no. 108).

Quite a number of *putorinos* exist, but this one is unusual in showing the head around the hole carved in profile. Almost all other examples depict it frontally. Also reflecting this feature is the head carved in profile relief at the top. To date, only one other similar example has been published and its present whereabouts is unknown (Oldman 1946, pl. 28, no. 33).

Collected by Vice Admiral George Tryon, HMS *Nelson*, in 1884–87

Previous collection: Wayne Heathcote, New York

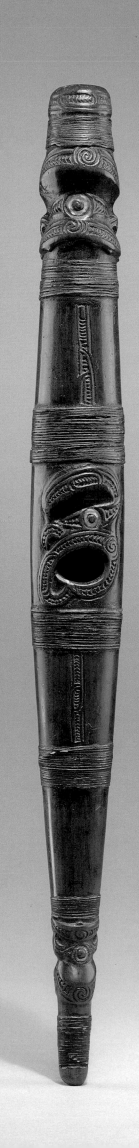

## 88 Club (*wahaika*)

New Zealand
*Wood*
Length: 16 1/4 in. (41.5 cm)

THIS FORM OF SHORT CLUB WITH THE broad tongue-shaped blade is unique to New Zealand. Its name, *wahaika,* is literally translated as "fish mouth," a reference to the shape of the blade. Such clubs were used for combat and in dances, during which they were brandished in mock battles. In battle, they were employed in thrusting and jabbing motions, the end, not the sides, being the part that inflicted damage. They were also important elements of chiefly regalia that were carried in the belt when not held in the hand. Most have a human head carved below the handle and a small reclining figure just above the handle on the inside of the blade. Both of these figures represent mythological ancestors (Simmons 1984, p. 188, no. 45). The hole at the base was for the attachment of a flax suspension cord that was looped around the wrist.

Several details of this club indicate that it was made in the eighteenth century. All of the later examples have a small opening carved in the center of the outer blade that was used for the insertion of feathers. This detail is lacking from the *wahaikas* collected by Cook and his immediate followers (Kaeppler 1978, pp. 185–87). In addition, nineteenth-century carvings of the reclining figure are larger and ornamented with elaborate incised reliefs. The simplicity of both the carving and the head at the end further reinforces an eighteenth-century date for this example (Mack 1982, p. 158).

Previous collection: James T. Hooper, London

Publications: Phelps 1976, p. 56, no. 220; Christie's, London, 1990, no. 122

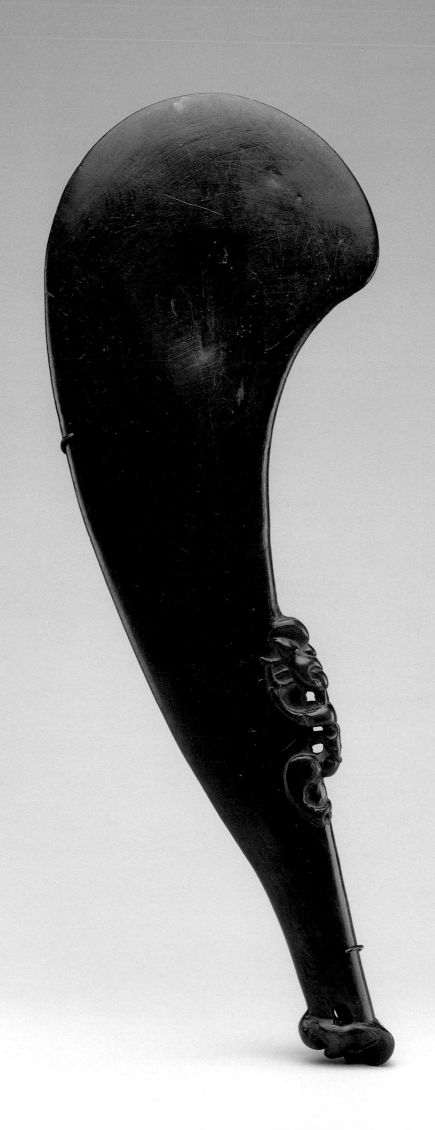

## 89 Chief's Staff (*taiaha*)

New Zealand
*Wood, haliotis shell*
Length: 71 in. (180 cm)

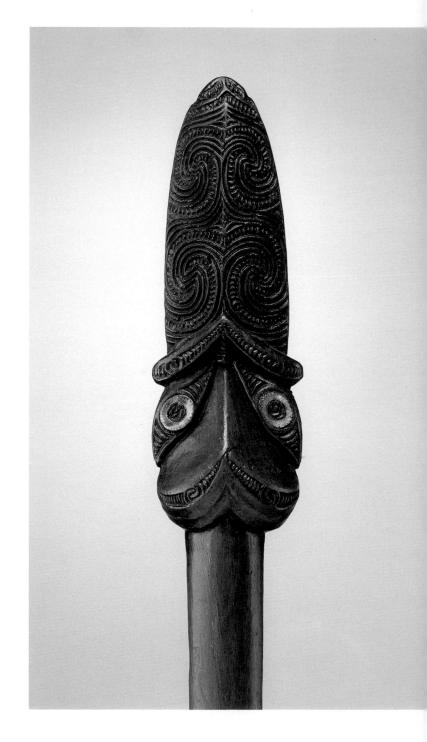

ALL HIGHLY BORN MAORI MALES CARried such staffs as insignias of rank, and consequently many examples of them exist today. This one is distinguished by the fine detailed carving of the point and the painted inscription: *This Spear Was Presented to Mr. Samuel Int. Sum. by Capt. F. Suggars on the 2 of Feb. 1860. Taken from the Natives of New Zealand.* It originally had a woven flax cylinder four to six inches thick decorating the shaft below the point, which was ornamented with tassels of dog hair and red parrot feathers. As is often the case, this cylinder has rotted away.

Besides being symbols of rank, *taiahas* were also used to emphasize points of oratory, for hand-to-hand combat, and in ceremonial displays. They are not spears but are essentially designed for parrying and sparring, and the spatulate end was the actual part of the weapon that would wound an adversary. The point, showing a Janus face with a protruding tongue, was used for prodding during sparring motions (Barrow 1984, p. 94). The movements associated with *taiaha* usage were carefully taught, and, as has been observed by Augustus Hamilton (1896, p. 176), "the management of a *taiaha* as a fighting weapon was studied with as much care and attention by a Maori warrior as ever a swordsman gave to his glittering blade."

Hamilton (ibid., p. 178) also notes occasions when the most important staffs were used for purposes of divination, at times playing roles of mythical proportions: "In the hands of those capable of performing the proper incantations, the result of a battle could be ascertained beforehand. The usual method adopted was to lay the *taiaha* upon the ground before the war party while the *tohunga* [priest] performed the usual *karakias* [incantations]. Then if the gods were propitious, the *taiaha* would turn itself slowly before the eyes of the assembled tribe, to the utter confusion of the enemy."

Previous collection: Wayne Heathcote, New York

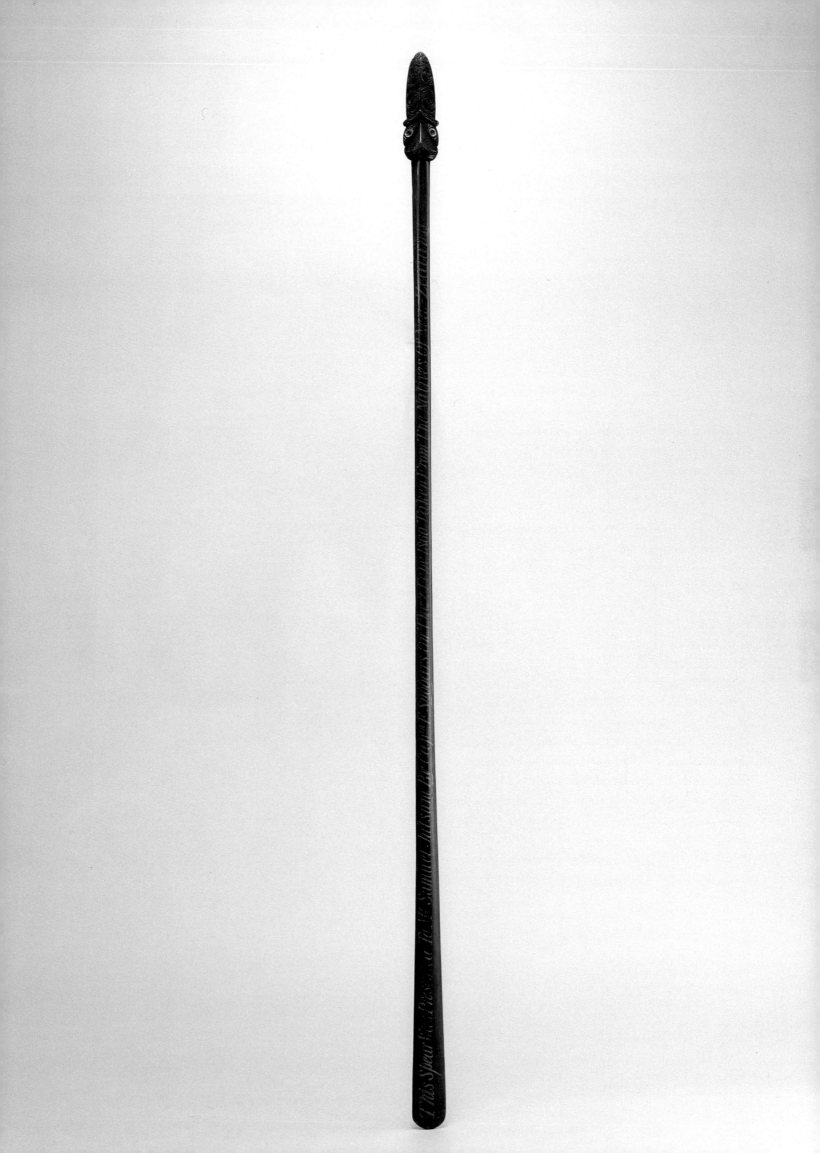

## 90  Ancestor Figure (Tiki)

Marquesas Islands
*Basalt*
Height: 6 1/2 in. (16.5 cm)

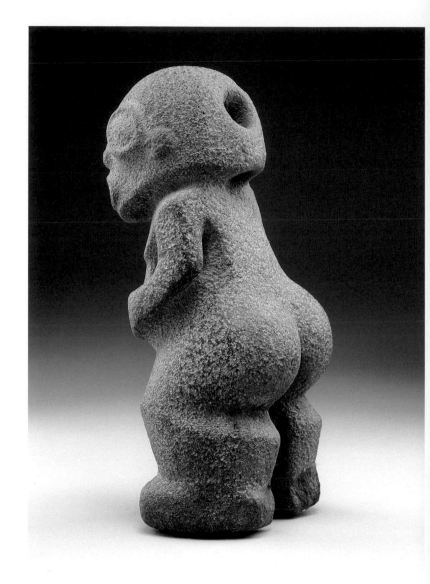

ALMOST EVERY EXAMPLE OF MARQUESAN art contains at least one image of the head or the entire body of Tiki, the god of creation. He lived in Havai'i, the land of the gods, and there created his wife out of sand. With her he fathered a son and a daughter. When they in turn produced their own children, Tiki left Havai'i and created the island of Nuku Hiva for the next generations of his descendants. When that island became well populated, Tiki left again and created another island, Ua Pou. To commemorate him on Nuku Hiva, a sculptor made a stone image representing Tiki. This process of departure, creation, and settlement was followed on each island of the archipelago until they were all populated (Handy 1930, pp. 122–23).

This legend gives a proper background both to the pervasive use of the *tiki* image in Marquesan art and the presence of so many stone images of him that are known today. It has been said of the Marquesans that they "were the most prolific producers of stone sculptures in Polynesia, and their finest efforts are without peer" (Mack 1982, p. 172).

The small basalt figures are all approximately the size of this one, typically with flexed legs and the hands held to the abdomen. In style they are so consistent that they must have all been made on the same island (ibid.). They were fashioned by the laborious techniques of dressing and hammering with other stone tools, the finer details brought out by carving with adzes tipped with points of rat teeth. This example and several others are drilled in the back of the head with a hole, from which they could be suspended at either the neck or the waist.

Such figures probably had more than one use. Ralph Linton (1923, p. 345) refers to them as having been employed as votive offerings, to cure the sick, and to bring success in various undertakings. According to Handy (1923, p. 238), the figures were originally dressed in a loin cloth.

Collected by Dr. G. Gordon, Royal Navy, on Tahiti in 1865

Previous collections: Kenneth A. Webster, London; Wayne Heathcote, New York

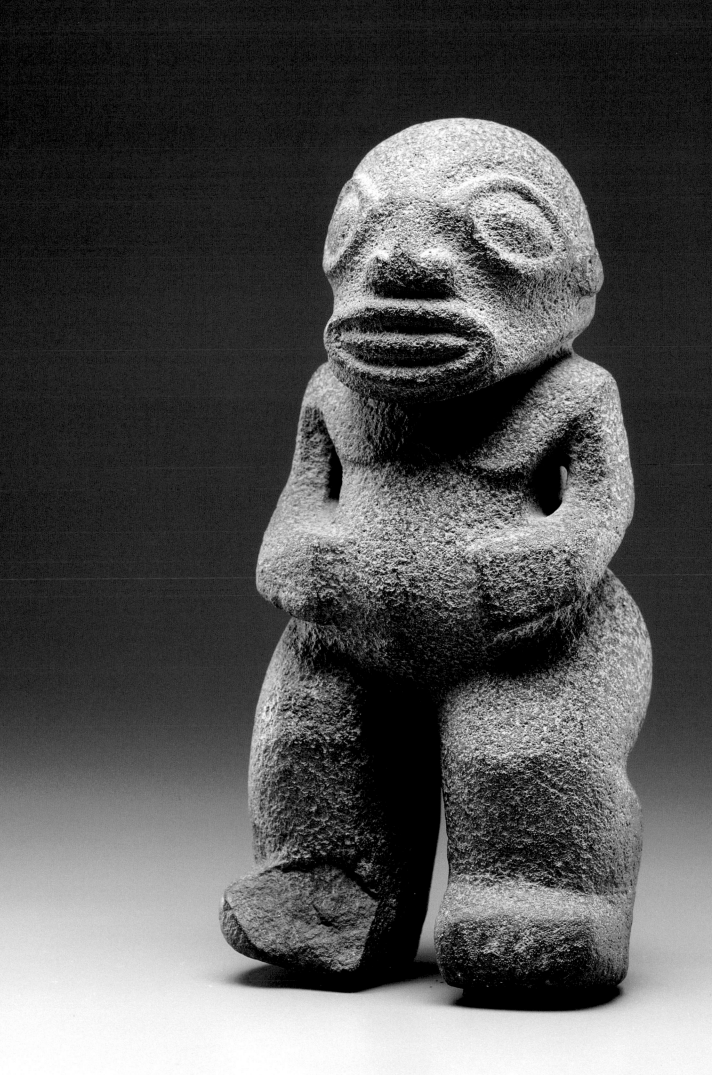

91  **Toggle** *(ivi po'o)*
Marquesas Islands
*Bone, human hair, fiber*
Height: 4 1/2 in. (11.5 cm)

The Marquesans made small bone cylinders with relief carvings of human heads and torsos to decorate the cords of drums, shell trumpets, and such household items as calabashes. They were also used as hair ornaments. They are made of human femur or humerus bones; in some cases, these are the bones of parents or ancestors, in others, the bones of enemies. If the latter, they signified that revenge had been taken, and the toggles themselves were regarded as trophies (Edler 1990, p. 68).

Regarding those that have tufts of human hair in them, such as this old example, there is conflicting information. Charles Mack (1982, p. 196, no. 7) simply states they were used "as ornaments attached to headbands, drums, shell war trumpets as well as other objects," therefore in a similar fashion as those without hair. Stephen Phelps (1976, p. 96), however, relying on Louis Rollin (1929), says that they were used for purposes of sorcery, and that the hair indicated the necessity to carry out a vow of revenge upon an enemy. If the vow was fulfilled, the hair was removed.

Publication: Christie's, London, 1988, no. 159

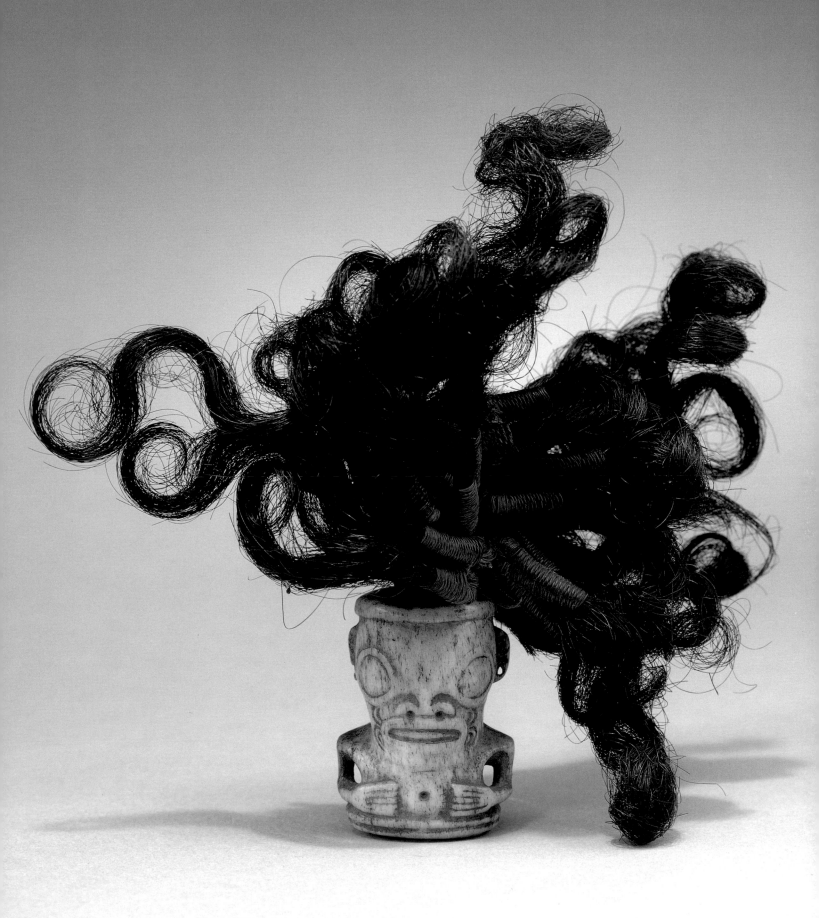

## 92 Fan Handles
Marquesas Islands

## 92a Fan Handle
*Whale ivory, fiber*
Height: 14 in. (35.5 cm)

FANS WERE USED FOR DISPLAY AT COM-
munal festivals by high-born Marquesan men,
women, and priests as insignias of their position.
They were valued for the craftsmanship of the carving of
the handles and the plaiting of the fan itself rather than
for any functional purpose they might have served. The
handles were family heirlooms (Handy 1923, p. 293) and
presumably would have been fit with new fans when the
older ones began to break and wear out. The fans them-
selves were flat at the top and crescent-shaped on the
bottom. They were made of split pandanus leaves that
were skillfully interwoven with sennit fibers so that they
could be attached to the handles. As is frequently the case,
both of these examples have lost their fans, although cat.
no. 92a still has woven sennit around the shaft and the
bases of pandanus leaves. The handles are the most intri-
cately conceived and detailed of all those made in
Polynesia (Mack 1982, pp. 188–93, pls. 80–83).

HANDLES OF WHALE BONE AND WHALE
ivory are not as common as those of wood, and
may signify a higher status for their owners. As
here, they usually show two pairs of *tiki* figures standing
back to back. Rectangular sections decorated with geo-
metric relief designs separate the pairs of figures, and are
also carved at the top and bottom. The hands are typically
placed on the abdomen and the facial features show the
characteristic broad flat noses, open mouths, and large
goggle-shaped eyes of Marquesan figure sculpture.
Although all but the base of the fan itself is now gone,
a good idea of the complexity of Marquesan weaving is
given by the plaited sennit strands at the bottom, and
above them, the braiding of pandanus leaves that show
the method of attachment of the fan to the handle shaft.

Previous collections: Charles Ratton, Paris; Wayne
Heathcote, New York

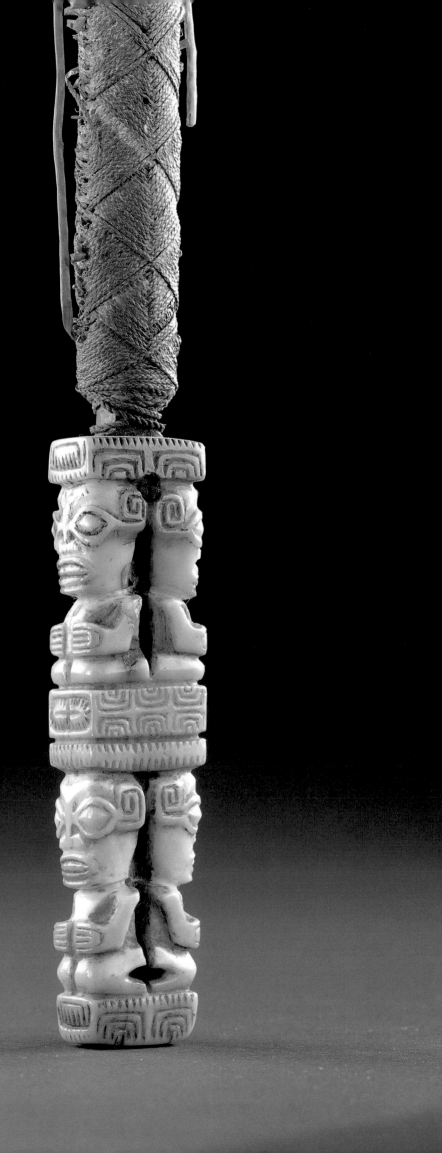

## 92b  Fan Handle

*Wood*
Height: 13 in. (33 cm)

Although made of a more commonly used material than its companion and lacking any traces of weaving, the well-worn and dark patina of this handle suggests that it is earlier in date. It shows the same arrangement of figures but one figure of each pair faces forward, while the other shows the head twisted to look over the back of the figure. The carving style of this wood piece is also freer and less detailed than cat. no. 92a, qualities that are partially dictated by the softer wood medium. On the bottom are two grotesque skull-like heads projecting outwards beyond the *tiki* figures.

Previous collection: Wayne Heathcote, New York

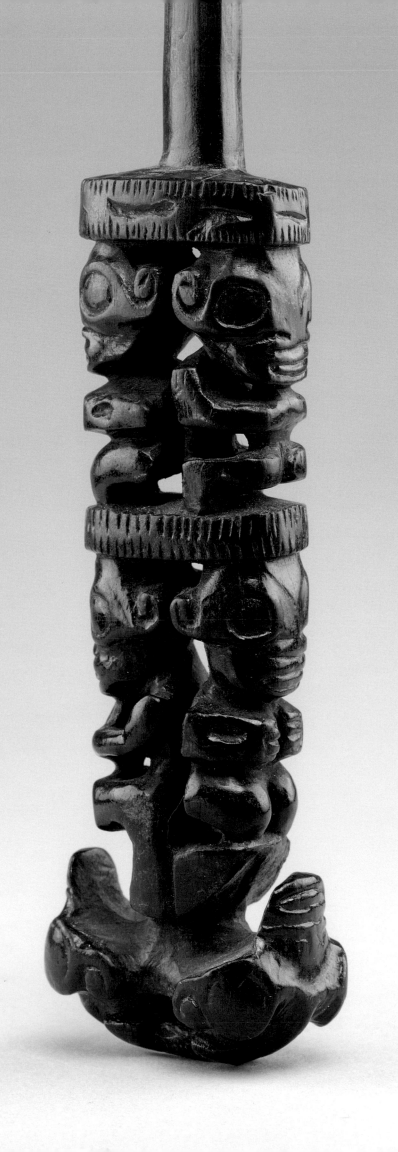

## 93 Stilt Step *(tapuva'e)*
Marquesas Islands
*Wood*
Height: 13 1/2 in. (33.5 cm)

ON THE MARQUESAS, STILT WALKING was practiced during ceremonial occasions, particularly at memorial feasts for the dead. Only men could participate, and among the events held were races and mock battles, with wagers placed on the outcomes. In some displays, contestants sought to knock the stilts out from under their opponents (Linton 1923, p. 387). Remarkable skills were attained, and some of the best performers could even turn somersaults from the stilts (Handy 1923, p. 297).

The stilts were from five to seven feet high, and carved steps such as this one were lashed onto them with fiber cords dyed red and black, two to three feet above the ground. All such steps are carved, usually with a single standing figure underneath the foot rest. Some have the carving of a head under the platform on which the figure stands, as can be seen here. The figures and other parts of the stilt step are additionally ornamented with parallel diagonal relief designs.

This example is unusual from several standpoints. Stilt steps with two figures are considerably less common than those having one, and when two figures do appear, they are usually shown with only one arm raised, the other held to the side with the hand at the abdomen. The caryatid pose of these two figures may well be unique. Their proportions are also considerably more elongated than the compact and stocky conventional ones most often followed in Marquesan figure sculpture.

Previous collections: Charles Ratton, Paris; Wayne Heathcote, New York

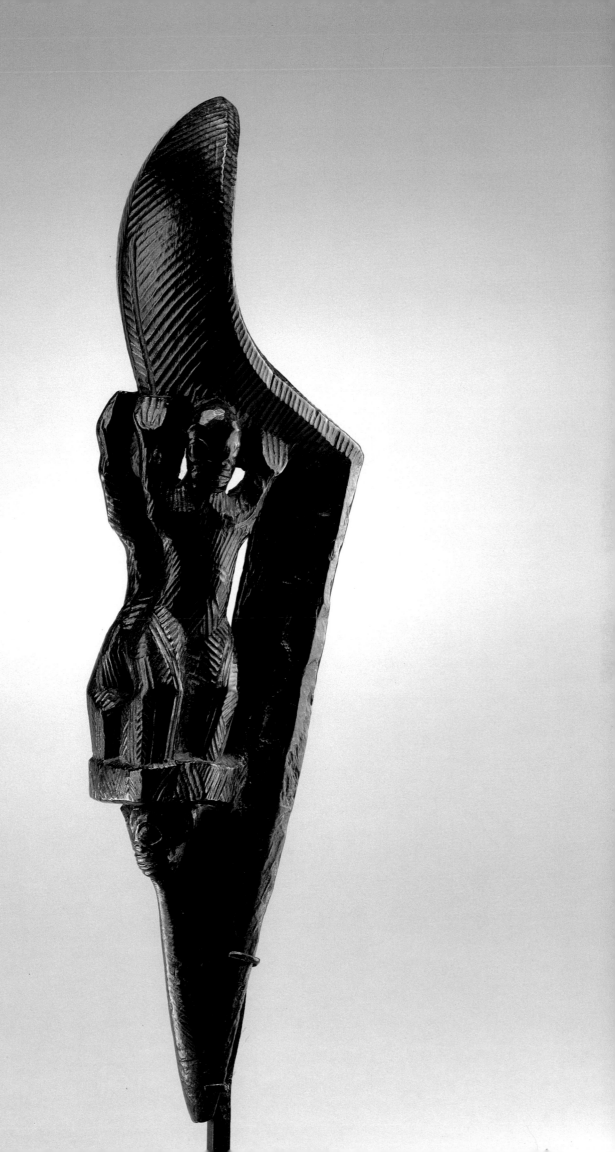

## 94 Headddress (*paekaha*)

Marquesas Islands
*Tortoise-shell, conch shell, fiber*
Length: 9 in. (23 cm)

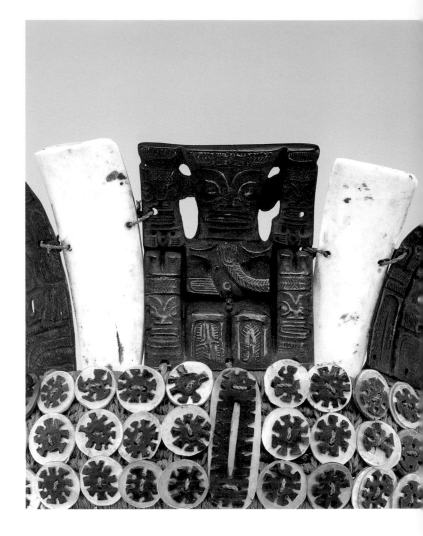

CORONETS OF THIS KIND WERE WORN at ceremonies by Marquesan men and women of the aristocracy. Rather than being individually owned, they were the communal property of families and treated as heirlooms (Handy 1923, p. 283). Apparently the form originated on Fatu Hiva and spread to the other southern Marquesas. Such headdresses are not found on the northern islands (Mack 1982, p. 194). They are composed of a sennit headband to which are affixed relief-carved tortoise-shell plaques showing frontal *tiki* figures alternating with smaller figures on the sides, and undecorated, polished conch shell segments. Both of these elements curve gracefully outward. On the more elaborate examples, of which this is one, the headband is decorated with shell disks overlaid with tortoise-shell rosettes that are somewhat reminiscent of the larger clam- and turtle-shell pendants of Melanesia.

The workmanship of the seven tortoise-shell plaques on this example is particularly fine. They were meticulously carved with tools having points of rat teeth, and each is of a different design. Besides being a unique object type, the *paekaha* is unusual in its use of tortoise-shell. Most ornamentation of this nature in Oceania is made of the more readily available turtle shell.

One recurrent problem concerns the manner in which these crowns were worn. Strangely, all of the early depictions of them show the headband at the top with the plaques facing downward to cover the entire forehead. The relief carvings depicting *tiki* would therefore appear upside down. Such a placement of this important Marquesan motif seems unlikely. Ralph Linton puzzled over this question as long ago as 1923 (p. 436) but reports that one of his informants told him that the coronets were originally worn so that the plates rose above the forehead. In order to show the carvings properly, the detail is displayed upright.

Previous collections: Public Library, Westerly, Rhode Island; Norman Hurst, Boston; Carlo Monzino, Lugano

Publication: Sotheby's, New York, 1987, no. 106

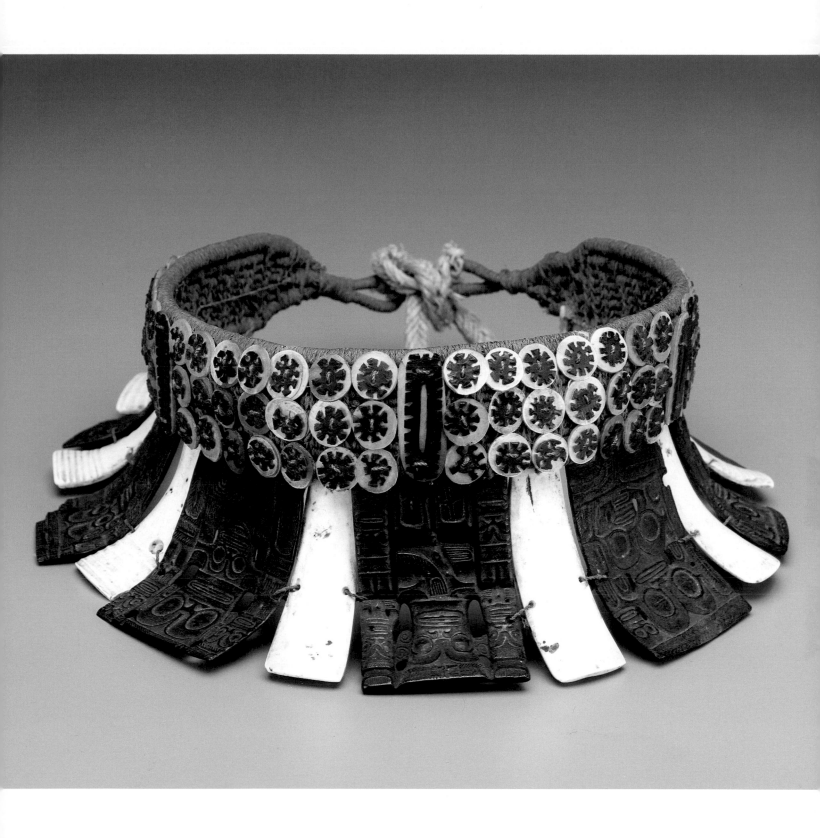

## 95 Club (u'u)

Marquesas Islands
*Wood*
Length: 54 1/2 in. (138 cm)

HUNDREDS OF SUCH CLUBS EXIST IN collections throughout the world, and many of them are undoubtedly of eighteenth-century date. Their form, which is unique to the Marquesas, is of precontact origin as is proven by an example collected on Cook's second voyage in 1774 (Kaeppler 1978, p. 165, fig. 307).

The only area of carving appears on both sides of the top, the upper portion of which is a stylized human face having two small human heads in the pupils of the eyes. Another head appears in bas relief in the center of a plain transverse bar, and below it the club is usually carved in three fields of relief design: a linear geometric band, the eyes and broad nose of a human face, and another area of geometric carving at the bottom. Other human faces in relief sometimes appear in the curved area just below the top. A matting of coconut fibers woven with strands of human hair was originally wrapped around the bottom of the staff just above the butt. As here, this material has worn away from most examples. In a similar manner to that used to make Fijian clubs (see cat. no. 67), the wood attained its dark color from immersion in swamp mud and a final polishing with coconut oil (Barrow 1972, p. 99, no. 159).

The clubs were used for both fighting and prestige display. They were valued heirlooms, and some represented trophies of victorious encounters. The transverse points were the areas that inflicted wounds, and, as unlikely as it may seem, at least one account (Steinen 1925–28, vol. 2, p. 55) claims that they were sometimes thrown. As symbols of status, most early illustrations show them being carried over the shoulder, or being leaned on, the top tucked into the armpit.

At first glance, all of the old examples appear to be virtually the same. With closer study, however, it is revealed that no two are alike. The subtle differences occur in the two geometric relief bands below the transverse bar. These consist of endless variations of parallel lines, rectangles, circles, ovals, and arcs. On the Marquesas, tattooing was as important an art as it was in New Zealand. It is believed that these motifs were the personal property of the individual who owned the club and could be used both for the purpose of tattooing and for the ornamentation of his personal property (Barrow 1972, p. 99, no. 159).

Previous collection, James Hooper, London

Publications: Phelps 1976, p. 107, no. 454; Christie's, London, 1990, no. 112

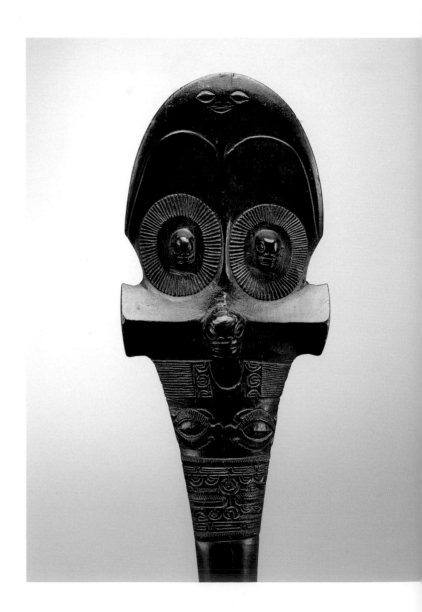

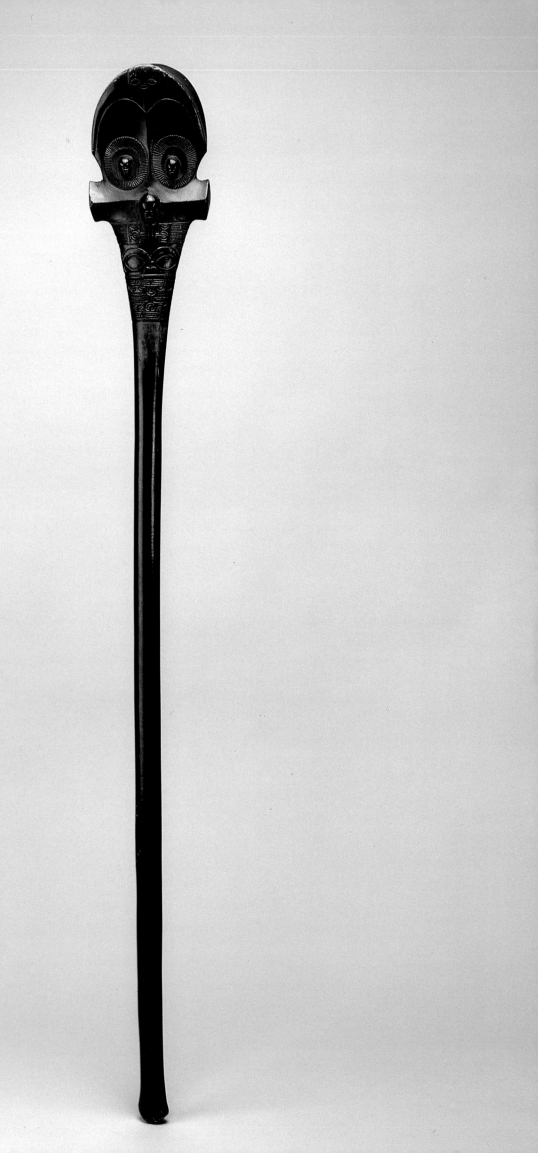

## 96 Figure

Hawaiian Islands, Maui
*Wood*
Height: 25 1/2 in. (65 cm)

O N   T H E   H A W A I I A N   I S L A N D S ,   T H E   Y E A R S
following 1819 when the old gods were over-
thrown saw the disappearance of several
thousand wood sculptures of human form. Many were
simply left to rot, and others were deliberately destroyed
by the Hawaiians themselves. It is possible that some
figures were made for sorcery after this time, but today
fewer than two hundred precontact works have survived.
These have been studied and illustrated by J. Halley Cox
and William Davenport (1988). From what remains, it is
apparent that the sculpture of these islands was rich and
varied. The present-day corpus shows evidence of
regional styles, chronological change, and the hands of
individual carvers. As such, Hawaiian figure sculpture
stands apart from the more homogeneous expressions of
all other Polynesian groups except for New Zealand.

Carvings of humans were made to represent personal
or family deities, craftsmen's spirits, or to be set up on
temples to honor the major Hawaiian gods, Ku, Kanaloa,
Lono, and Kane. Most of those now known have not
come down to us with specific information as to their
original significance. To add to the problem, a single
image "may have been used for multiple purposes and
[taken] on different attributes depending on the occa-
sion and the rank of the person using it" (Kaeppler 1979a,
p. 5).

This particular piece has been classified by Cox and
Davenport (1988, p. 164, A14) as an *aumakua* image, that
is, a personal or family deity that was usually used for pro-
tective purposes, but might sometimes have also been
employed for sorcery. Such figures were owned by families
of high position and kept on altars in houses reserved for
men to eat in. According to Cox and Davenport (ibid., pp.
94–96), *aumakuas* are distinguished by their size, the fact
that they are freestanding, and their display of open,
forward-thrusting mouths and protruding tongues.
Adrienne Kaeppler (1979b), however, feels that so little is
known of the use of undocumented Hawaiian figures
that it is risky to assign specific categories to them. She
therefore simply describes this sculpture as a "free-
standing wooden figure" (ibid., p. 11).

As here, most Hawaiian sculptures assume a dynamic
pose with flexed, forward-leaning legs and protruding
chins, chests, and abdomens. Although these conventions
are often compared to the stances of wrestlers and
boxers, it is more likely, as suggested again by Kaeppler
(1982), that they relate to positions assumed by dancers
or singers.

The Masco figure has lost both of its arms, which were
broken away from the shoulders in ancient times. It
bears some general stylistic similarities to another human
image of undetermined provenance in the Bishop
Museum, Honolulu (Cox and Davenport 1988, p. 164,
A12). It is said to have been found about 1917 in a gulch
at Hamakua Poko, Maui. A report of the discovery was
published in the *Honolulu Advertiser* on February 18 of
that year (Rose 1978, p. 272).

Previous collections: Joseph Star, Honolulu; Hurd,
Honolulu; Werner Muensterberger, New York; Wayne
Heathcote, New York

Publications: Luquiens 1931, p. 29; Sotheby's, New York,
1965, no. 21; Cox 1967, fig. 4A (detail); Teilhet 1973, p. 114;
Kaeppler 1979a, p. 11; Mack 1982, pp. 32–33, pl. 2, no. 2;
Cox and Davenport 1988, p. 164, A14

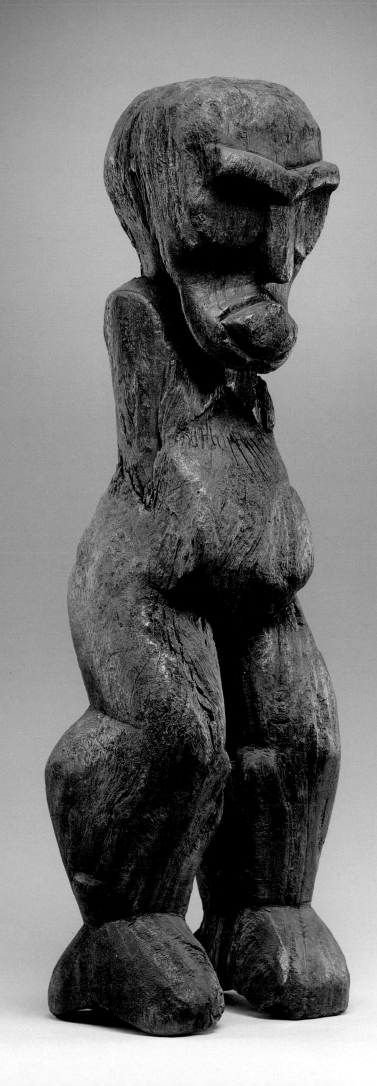

## 97 Drum (*pahu*)

Hawaiian Islands
*Wood, shark skin, fiber*
Height: 20 1/2 in. (52 cm)

ADRIENNE KAEPPLER (1980) HAS WRITten a detailed analysis of these *pahu* drums and their smaller cousins, the *puniu*. According to her, the *pahu* form is said to have originated in eastern Polynesia, perhaps on the Society Islands, and it is also found in the Australs and the Marquesas. It was not used in western Polynesia or Melanesia. On Hawaii in early times, such drums were used both for ceremonies performed at ritual temple platforms and at the somewhat more secular *hula* dances. In the latter context, as still performed today, the sound of the drum was only one part of the event, which combined music, poetry, and the movements of the dance into one exalted expression. At its highest level, the dance was called the *hula pahu,* and it honored the great chiefs and gods.

*Pahus* were associated with Lono, the god of peace and agriculture. Each one had a personal name, and its ownership signified social status. The size of the drum itself suggested the level that had been attained by the player, and only chiefs could use the largest ones. The *pahu* is played with one or both hands, and consists of a sharkskin membrane (restored on this example) stretched over a wood base. Those made in the precontact era have bases carved into a series of openwork crescents joined to one another, which were thought to contain the *mana* of the drum. These forms may well be stylized of human figures with upraised arms such as appear in more recognizable form on some of the drums of the Australs and Tahiti. Kaeppler (ibid., p. 9) suggests that "the images and by extension the crescents, were symbolic of the gods who were responsible for holding up the sky."

This well-known example is of a size that suggests it was played from a sitting position. It was collected by Cook on his third voyage in 1778. The base consists of three rows of beautifully conceived designs. In addition to their symbolic representations of deities supporting the heavens, these interrelated forms may also be a metaphor for the repeated rhythms produced by the drum itself and the movements of the dances that were performed to its accompaniment.

Collected by Captain James Cook in Hawaii on the third voyage in 1778

Previous collections: Leverian Museum, London; Richard Hall Clarke and heirs, Uffcumbe, England; K. J. Hewitt, London; Wayne Heathcote, New York

Publications: Bearnes and Waycotts, Torquay, 1967, no. 587; Kaeppler 1978, p. 102, figs. 159, 160; Kaeppler 1980, p. 13, fig. 4; Mack 1982, pp. 38–39, pl. 5, no. 1

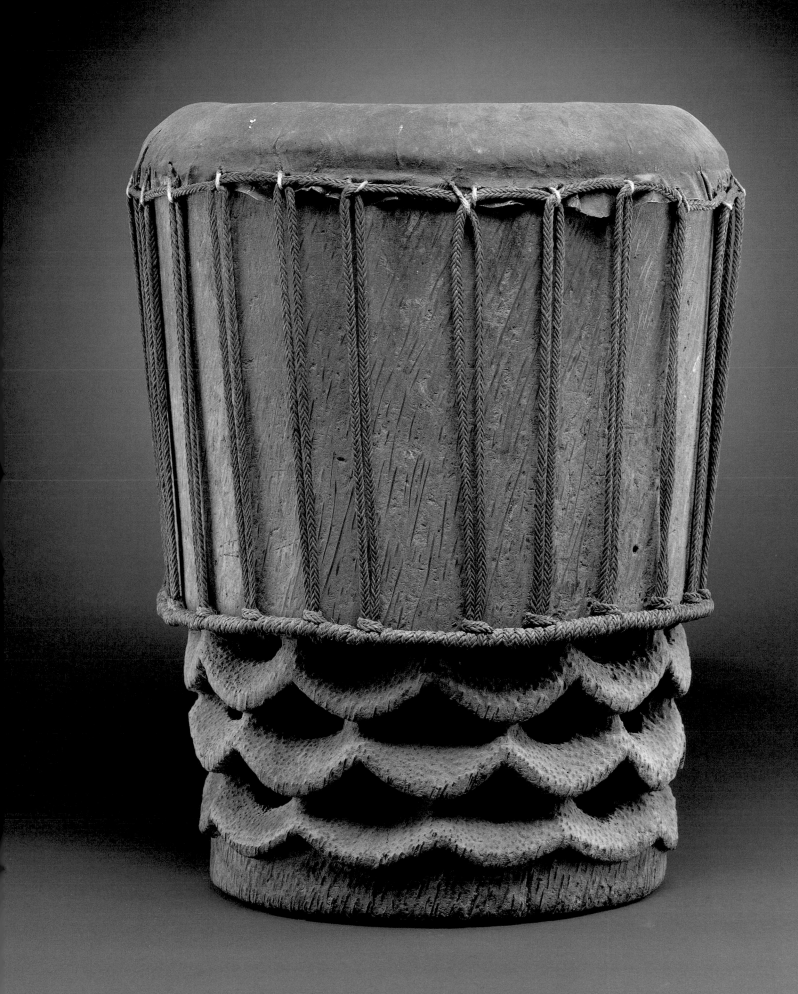

## 98 Pendant Necklace *(lei niho paloa)*

Hawaiian Islands
*Whale tooth, human hair, fiber*
Length: 11 in. (28 cm)

CAPTAIN COOK COLLECTED A NUMBER of such necklaces on his third voyage. The pendants of these and others collected during eighteenth-century visits are quite small in size, averaging about an inch in length. They are also made of a variety of materials besides whale teeth, including calcite, shell, bone, and black coral. Three of the early necklaces have more than one pendant attached. The necklaces themselves are of braided human hair, all of which passes through the pendant, and are not composed of as many strands as are used on later examples such as this one (Kaeppler 1978, pp. 91–93).

Such ornaments were originally worn by members of the chiefly class and their wives, and in early times they were objects of great prestige. Their symbolic value was inferior only to that of the feather capes and cloaks, which were reserved for the aristocracy (Malo 1951, p. 77). By the mid-nineteenth century, however, so many necklaces had been made that it has been suggested they may have been worn by people of lesser status (D'Alleva 1990, p. 56, no. 67). This well-made example is typical of those from the later period.

The significance of the pendant form itself is not known, but it could well have been derived from that of the ceremonial fishhooks worn in parts of Polynesia. J. Halley Cox (1967, pp. 421–24), however, suggests that it may actually represent a highly stylized human head with its tongue extended. Although this may not seem likely, a unique pendant showing a full human figure now in the Metropolitan Museum of Art (Wardwell 1967, p. 69, no. 86) provides some support for an anthropomorphic basis for this unusual shape.

Previous collection: British Railway Pension Trust, London

Publication: Sotheby's, London, 1988, no. 11

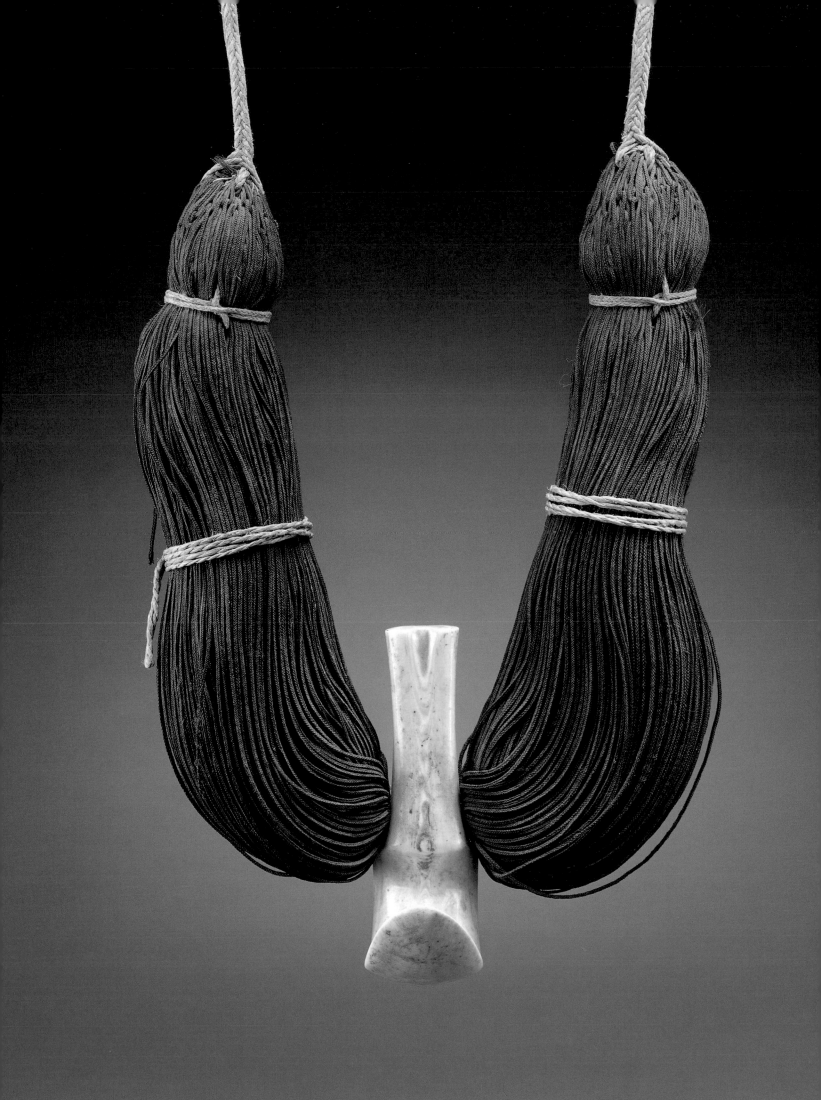

## 99 Six Weapons
Hawaiian Islands

## 99a Shark-tooth Club (*palau papanihomano*)
*Wood, shark teeth, fiber*
Length: 21 3/4 in. (55 cm)

I N HAWAII AS ELSEWHERE IN POLYNESIA, chiefs maintained and added to their *mana* through warfare as well as other means. Although they made and used long spears and clubs, the Hawaiians favored hand-to-hand combat between chiefs themselves or groups of warriors. Small weapons (in the form of thrusting and gouging instruments with shark-tooth edges) and clubs and daggers were therefore predominant (Edler 1990).

David Samwell, one of Cook's surgeon's mates, described the Hawaiian weapons he saw on the third voyage. About the smaller ones, he wrote: "Their arms consist of Spears, Daggers, and short Clubs ... their Daggers are made of fine polished black wood, and of different sizes from a foot & 1/2 to half a foot long, they put a string through the Handles of them which they turn round their Wrists that they may not be wrenched from them. Their Clubs are about a foot long with round heads and strings through the handles of them" (cited in Kaeppler 1978, p. 106). With the coming of Europeans, use of iron was quickly adopted, and the weapons of precontact times such as those shown here were no longer made.

B ASING HIS CATEGORIES ON THE FORM of the handle, the number of teeth, and where they are attached, Peter Buck (1957, p. 443) identifies sixteen different types of Hawaiian shark-tooth weapons. This is typical of the spatulate-ended form, having drilled shark's teeth lashed into place with continuous lacing around the entire perimeter of the handle. Thirty-four teeth have been attached to point downwards on each side. It is the largest example of this type known, and there has been some speculation that it may have been collected by Cook. Although its connection with him remains unproven, it was certainly taken from Hawaii in the eighteenth century as it bears the inscription "Owhyhee," an "archaic spelling [that] was in vogue for only a short time after Cook's discovery" (Mack 1982, p. 58).

Previous collections: William O. Oldman, London; James Hooper, London; Wayne Heathcote, New York

Publications: Phelps 1976, p. 82, no. 369; Christie's, London, 1977, no. 150; Mack 1982, pp. 58–59, pl. 15, no. 2

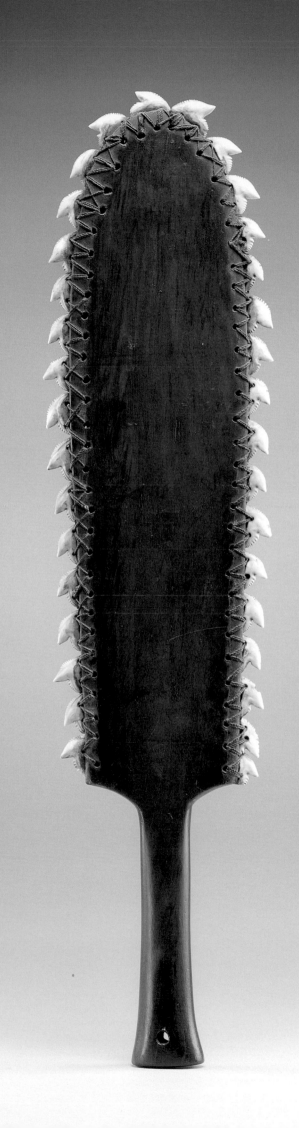

## 99b Shark-tooth Club *(palau papanihomano)*
*Wood, shark teeth, fiber*
Length: 15 1/2 in. (39.5 cm)

THIS WELL-KNOWN AND IMPORTANT specimen is the only example known with a handle that terminates in a pointed end so that it could be used as a dagger as well as a thrusting weapon (Mack 1982, p. 58). A shark-tooth weapon with such a point is illustrated by John Webber in Cook's *Atlas* (1784, pl. 67). Although twenty-three teeth are depicted in the drawing and there are only twenty here, Adrienne Kaeppler believes the illustration to be of the same object (Christie's, London, 1977, p. 46, no. 155).

As with cat. no. 99a, the teeth are arranged to face downward on each side and are affixed by two drill holes with continuous lashings. Although weapons of this form were undoubtedly used for hand-to-hand combat, there is also information that they were used as knives for ritual dissection of the bodies of killed victims. Cook (1784, vol. 2, p. 247) describes such an implement as a "knife or saw . . . with which they dissect the dead bodies." There is also a similar example collected on Cook's third voyage in the National Museum of Ireland, Dublin (Kaeppler 1978, p. 108, fig. 175, p. 109, no. 6), which bears a handwritten label that reads in part, "with a knife of this kind, Capt. Cook was cut to pieces" (Barrow 1972, p. 24, no. 23).

Collected by Captain James Cook in Hawaii on the third voyage in 1778

Previous collections: Leverian Museum, London; Richard Hall Clarke and heirs, Uffcumbe, England; James Hooper, London; Wayne Heathcote, New York

Publications: Cook 1784, pl. 67, no. 1; Moschner 1955, p. 163, no. 20; Buck 1957, p. 434, fig. 279b; Bearnes and Waycotts, Torquay, 1967; Force and Force 1968, p. 85; Teilhet 1973, p. 11; Phelps 1976, p. 418, no. 318; Christie's, London, 1977, no. 155; Kaeppler 1978, p. 109, no. 4; Mack 1982, pp. 58–59, pl. 15, no. 3

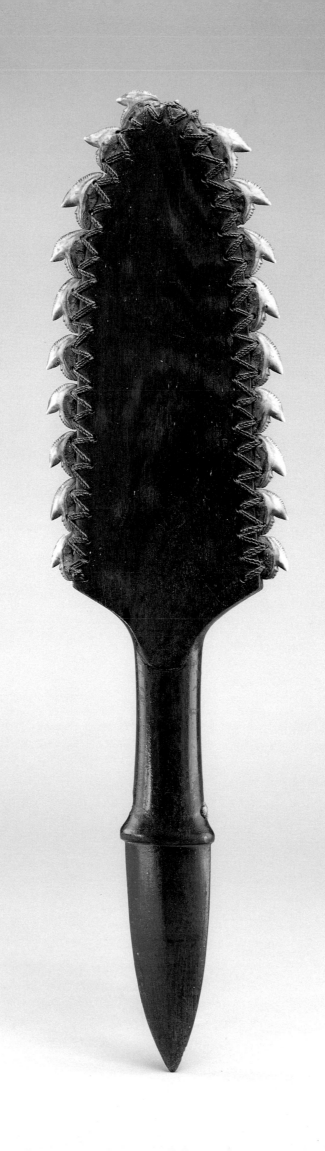

## 99c Shark-tooth Crescent Weapon
### (palau papanihomano)
*Wood, shark teeth*
Length: 4 1/2 in. (11.5 cm)

WEAPONS OF THIS TYPE ARE POPU-larly known as knuckledusters. They were gripped by the hand and used in punching motions in a manner similar to that of brass knuckles. Only two other examples with just one tooth at each end are known: one is in the Museum of Mankind, London, and the other is in the Canterbury Museum, Christchurch, New Zealand (Kaeppler 1978, p. 111, n. 35).

The association of this piece to Captain Cook was made by comparing it to one of the drawings of Cook artifacts made in 1783 by Sarah Stone (Force and Force 1968, p. 85). The comparison between the object and the drawing was made after the time Adrienne Kaeppler had sent the manuscript for *Artificial Curiosities* to the printers and before the opening of the exhibition at the Bishop Museum in Honolulu. The weapon was therefore included in the display, but is only mentioned in the catalogue (p. 111) as having not been located (Sotheby's, New York, 1978, p. 190).

Collected by Captain Cook in Hawaii on the third voyage in 1778

Previous collections: Leverian Museum, London; Jef van der Straete, Brussels; George Ortiz, Geneva; Wayne Heathcote, New York

Publications: Force and Force 1968, p. 85; Kaeppler 1978, p. 111; Sotheby's, New York, 1978, no. 218; Mack 1982, pp. 58–59, pl. 15, no. 5

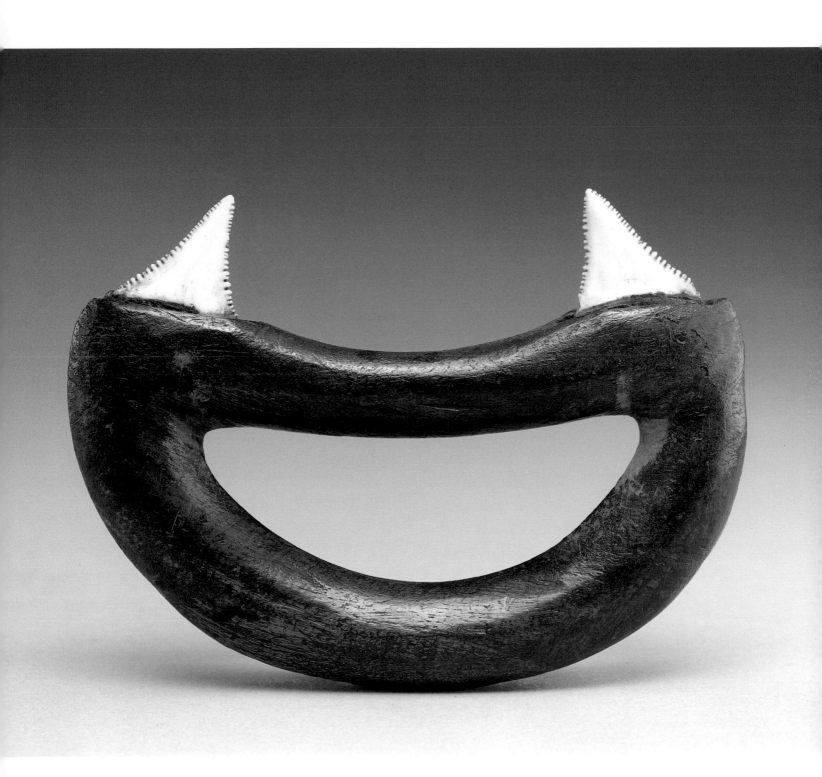

## 99d Shark-tooth Crescent Weapon
### *(palau papanihomano)*
*Wood, shark teeth*
Length: 8 1/4 in. (21 cm)

THIS IS THE MORE COMMON FORM OF knuckleduster, with a row of teeth running around the entire perimeter and pegged into place. All other known examples, however, have the teeth pointing downwards in a manner similar to that seen on the two clubs (cat. nos. 99a and 99b). This is unique in having the teeth facing in one direction (Mack 1982, p. 58). The beveled edges on the outside of the grip are also unusual, as is the large number of sixteen teeth. The six such weapons recorded by Peter Buck (1957, p. 459), for example, have only eight or ten.

Previous collections: Charles Ashby, Staines, England; Curtis Museum, Alton; James Hooper, London; Wayne Heathcote, New York

Publications: Phelps 1976, p. 82, no. 370; Christie's, London, 1977, no. 149; Mack 1982, pp. 58–59, pl. 15, no. 4

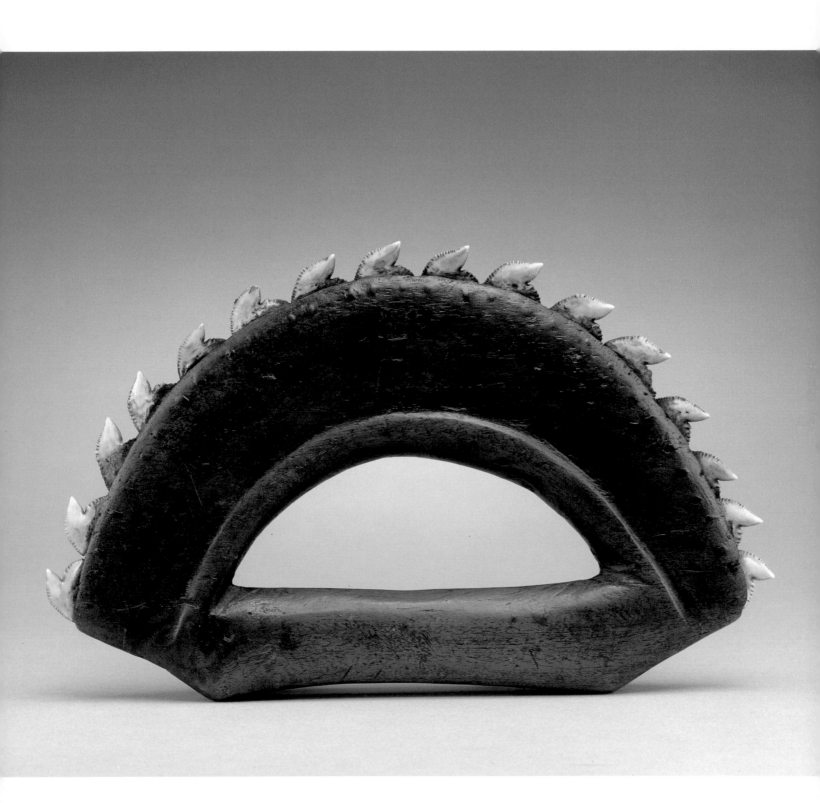

## 99e Dagger

*Wood, stingray spines, fiber*

Length: 14 1/2 in. (37 cm)

THE PRECONTACT WEAPONS OF HAWAII included daggers made of wood with swordfish-bill points (Kaeppler 1978, p. 30, fig. 40). This example is somewhat similar in size and appearance, but it is the only one known with the point made by lashing two stingray spines together. The handle is of the same shape as that of the knuckledusters.

Previous collections: Bedford Museum, Bedford, England; K. J. Hewitt, London; Wayne Heathcote, New York

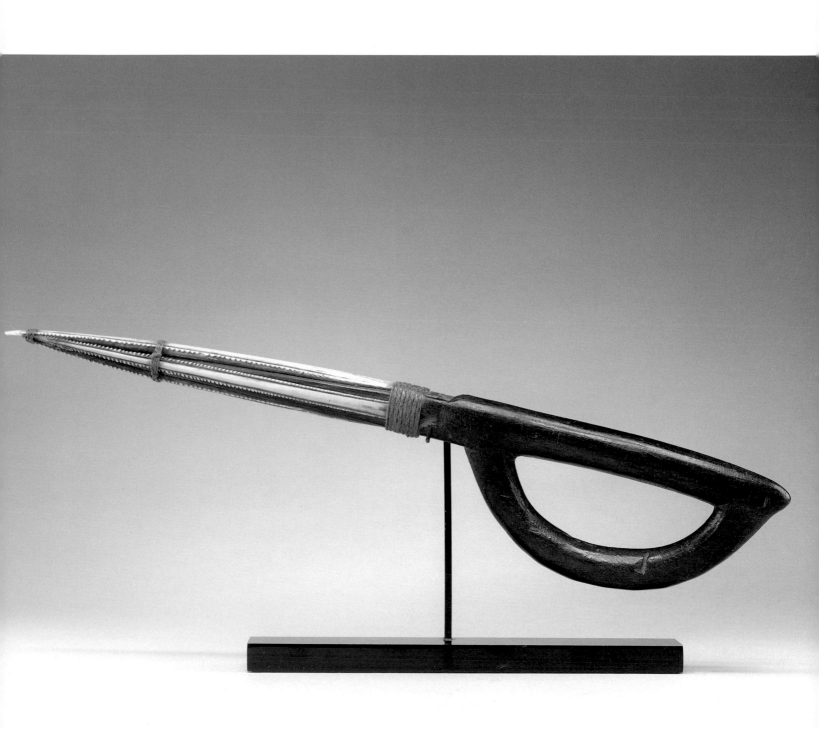

## 99f Club (newa)
*Wood, human teeth*
Length: 10 1/2 in. (26.5 cm)

AVID SAMWELL'S PREVIOUSLY CITED description of Hawaiian clubs (p. 242) applies well to this example. Peter Buck (1957, p. 438) gives the name *newa* to all smooth-headed clubs that are under a yard in length. The use of human teeth inlays in this example may well be unique among Hawaiian weapons, although human teeth were sometimes used to adorn calabashes owned by chiefs. Here their use recalls their appearance among the decorative elements of Fijian clubs (see cat. no. 67b).

Previous collections: Bedford Museum, Bedford, England; K. J. Hewitt, London; Wayne Heathcote, New York

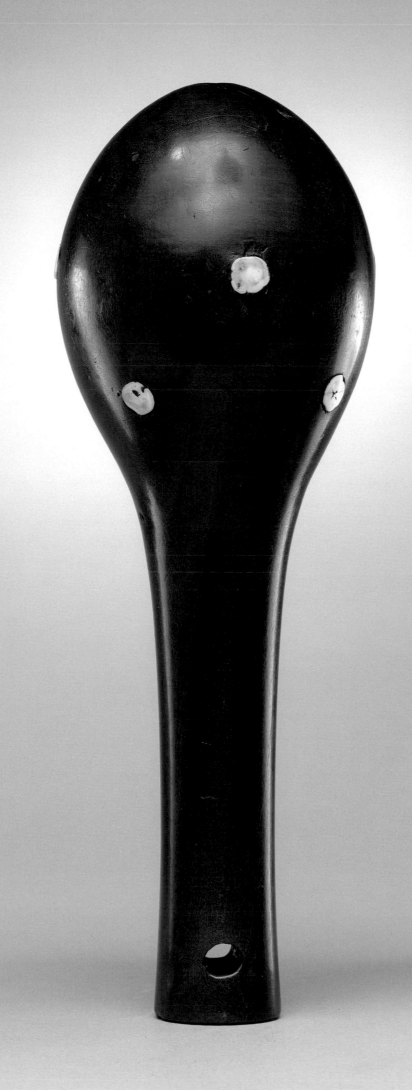

## 100 Poi Bowl *('umeke la'au pakaka)*

Hawaiian Islands
*Wood*
Diameter: 13 in. (33 cm)

THE FORM OF THE BEAUTIFUL AND simple *poi* bowls of Hawaii was originally derived from that of gourds. Cook (1784, vol. 2, pp. 238–39), who collected five examples on his third voyage in 1778 (Kaeppler 1978, p. 85, nos. 1–5), expressed his admiration for their craftsmanship: "Their wooden dishes and bowls . . . [are] as neat as if made on our turning lathe, and perhaps better polished."

Kou wood was the favored material because it was easy to carve, did not readily split, and was not prone to rot and insect damage. In early times, manufacture of these bowls was a meticulous and time-consuming process. It is well described by Irving Jenkins (1989, pp. 89–97), who was at one time the owner of this bowl. Once the proper tree had been carefully selected and felled, large sections were cut into blanks and given their rough outer shapes. Hollowing and thinning then could only be done when the outer surface of the wood was dry. When this was carved away, the bowl had to be set aside for further curing. The craftsman therefore worked on several bowls in different stages of completion during the same period. After months of constant refinement, the sides having been scraped to an even thinness, initial smoothing of the surfaces could begin. Small round abrading tools of stone and coral were used for this purpose.

After this initial shaping had been completed, it was necessary to remove all of the bitterness from the wood so that it would not spoil the taste of the *poi* that was to be served from it. This was done by initially soaking it in sea water for a week, and then placing fermented *poi* in it to leach out the wood flavor. Additional soakings followed, and the bowls were tested by allowing *poi* to stand in them for several days before it was tasted. If any bitterness remained, the process was repeated until no trace could be detected. Some early accounts suggest that the bowls were sometimes soaked in swamp water, but this practice has not been verified.

Final polishing required the progressive use of increasingly softer materials rubbed on the surfaces, beginning with pumice and then charcoal. They were followed by bamboo, the leaves of the breadfruit tree, and at last, tapa. Oil from the kukui nut was then evenly applied, and the bowl was ready for use.

As they dried out, and over long periods of use, some bowls developed cracks and splits, which were exquisitely repaired with round pegs, butterfly joints, wedges, and square and rectangular patches (ibid., pp. 100–5). Many collectors now prefer bowls having such repairs to those that are in pristine condition. The base of this example has fine zigzag joint applications on it.

Each household owned several bowls of different sizes which were used as the occasion demanded. This one is of a larger diameter than those used for individual servings, and probably held *poi* for two or more people. *'Umekes* were valued family possessions and were passed along as heirlooms. Because they were almost always waxed with commercial products when these became available, the original surface of most early examples is obscured under layers of later coatings (Mack 1982, p. 62).

Previous collection: Irving Jenkins, Honolulu

Publication: Bonhams, London, 1990, no. 150

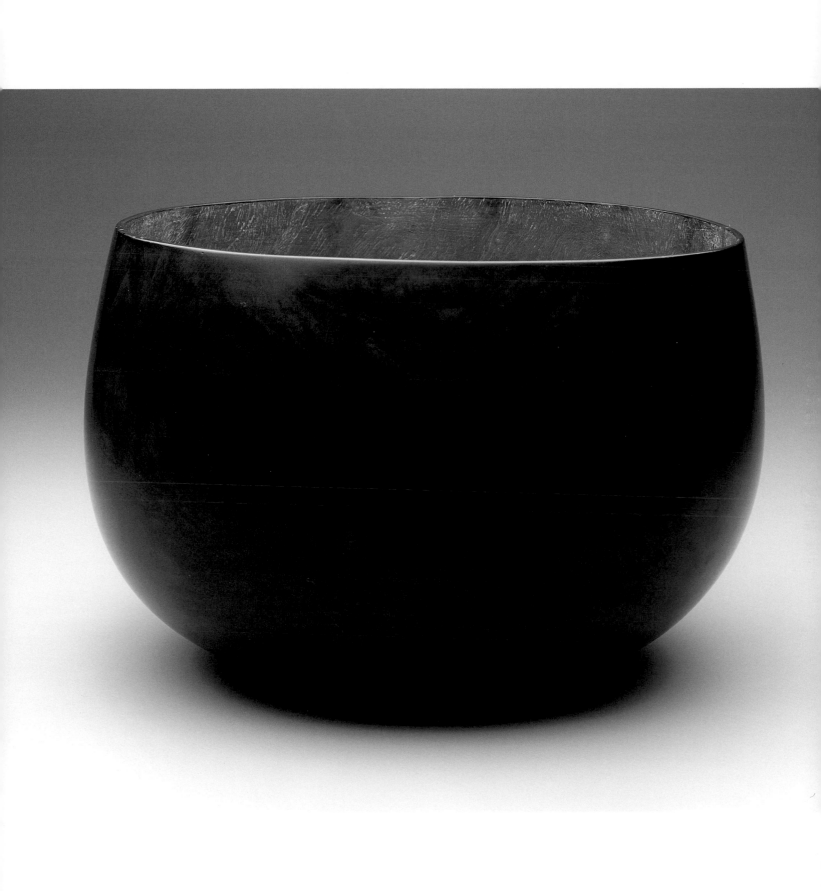

## 101 Male Figure (*moai kavakava*)

Easter Island
*Wood, bird bone, obsidian, traces of red pigment*
Height: 17 3/4 in. (45 cm)

THESE REMARKABLE WOOD SCULPTURES of male figures from Easter Island are among the most extraordinary creations of Polynesia. They stand in a stooped, unbalanced, forward-leaning pose and are meticulously and beautifully carved with fine detailing of such anatomical features as the eyebrows, beard, ears, ribs, and vertebrae. Those that were created during the late eighteenth and early nineteenth centuries, as was this one, were carved from the wood of the indigenous *toro miro* plant, a slow-growing tree that reached a maximum height of about nine feet (Mack 1982, p. 68). Most scholars agree that they are ancestor figures, their hollow, gaunt facial features and emaciated torsos representing the form ancestors took when they reappeared to the living as ghosts (Barrow 1972, p. 139). The beard denotes representation of an elder and further supports their ancestral iconography.

Recently, however, Francina Forment (1990) has postulated that the beaklike treatment of the nose and the recurrent imagery of the frigate bird motif that appears as glyph forms on top of the heads of many examples (ibid., figs. 84–87), including this one, may symbolize the birdman deity who was an important figure in Easter Island mythology. The use of bird bone inlays in the eyes and the strange disk shape in the back above the pelvis, which she compares to the vulvae of birds, provide further connections to a human avian being.

Most such figures have a pierced knob at the base of the skull which indicates that they were suspended and may have been worn on certain occasions. A visit to Easter Island in 1882 by Captain Geiseler of the frigate *Hyena* provides a record of an event at which such figures were displayed (cited in Musées Royaux d'Art et d'Histoire, Brussels, 1990, p. 177). It is reported that during important harvesting, egg gathering, and fishing times, the population gathered together, and leading males brought with them the wood images they had made and owned, showing them suspended from their bodies. A single individual might have had as many as twenty adorning his person, and he gained status both from the numbers in his possession and the quality of their carving (see also Duff 1969, p. 55).

A fair number of early carvings such as this one exist today. By the time of the *Hyena* visit, however, the art of figure carving had declined, and Easter Islanders were engaged in making comparatively crude sculptures for the curio trade. They used softer driftwoods or exotic timbers that were brought by outsiders for this purpose.

The Masco image is one of the finest of its kind. The superb sculptural detailing of the face, with its forward-jutting chin, high cheekbones, protruding nose, and bushy eyebrows, as well as the fine carving of the skeletal components, provide it with a tangible supernatural presence.

Collected by Lieutenant Robert Sayers, HMS *Thetis,* in 1830

Previous collections: by inheritance to Mrs. L. M. Turner; Walter Randel, New York; Francesco Pellizzi, New York; Wayne Heathcote, New York

Publication: Grand Palais, Paris, 1984, no. 306

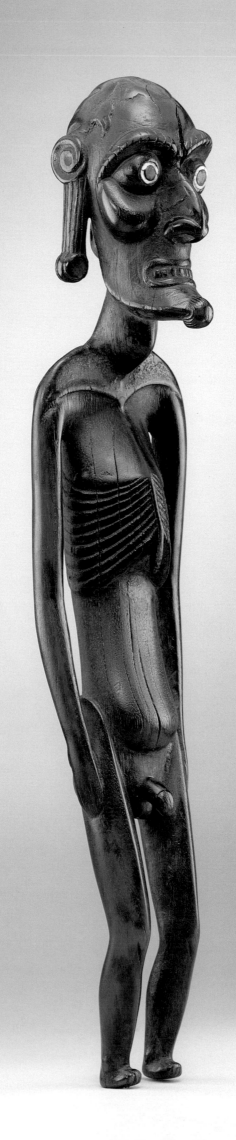

## 102 Club (paoa)

Easter Island
*Wood, obsidian*
Length: 19 in. (48 cm)

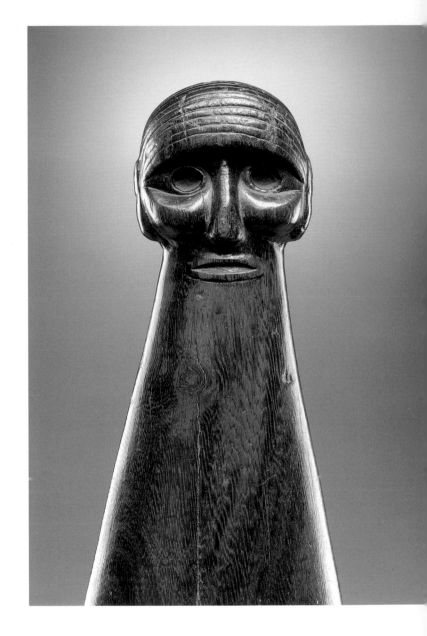

LTHOUGH EASTER ISLANDERS MADE A
type of long staff club for prestige display, these
small hand clubs were used for actual hand-to-
hand encounters. Like certain weapons from New Zealand
(see cat. no. 88), and especially the *patu* form to which
they were compared by Cook in 1774 (Duff 1969, p. 58,
no. 106), *paoas* were used in thrusting and jabbing
motions so that the spatulate end inflicted the wounds.
The high cheekbones and large, deeply inset eyes of the
Janus head at the top, which were originally inlaid with
bird bone and obsidian, are reminiscent of these features
on the wood figures (see cat. no. 101). The patina of this
example indicates considerable use and age, and the piece
probably dates from the early nineteenth century.

Previous collections: James Hooper, London; Wayne
Heathcote, New York

Publications: Phelps 1976, p. 89, no. 394: Christie's,
London, 1979, no. 191; Mack 1982, pp. 84–85, pl. 28, no. 7

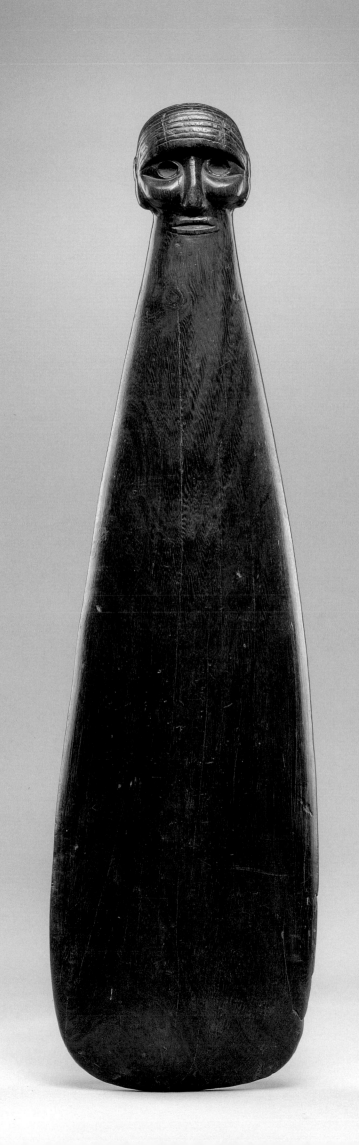

## 103 Dance Paddle (*rapa*)

Easter Island
*Wood*
Length: 33 1/4 in. (84.5 cm)

A NUMBER OF THESE ELEGANT DANCE paddles exist today. They are unique to Easter Island and have been referred to as "among the most beautiful products of Polynesian art" (Barrow 1972, p. 143). One example was collected by Cook in 1774 (Kaeppler 1978, p. 169, no. 3; p. 170, fig. 319), thus establishing their precontact origin.

All of them are almost exactly the same. The top portion represents a highly stylized human face marked by the arching brows, the straight nose ridge, and the elongated ear lobes. There are two distinct interpretations of the lower end. Barrow (ibid.) maintains that it represents an out-thrust tongue, noting that this is a symbol of aggressiveness in parts of Polynesia. Mack (1982, p. 82) and others, including the author, believe it to be an abdomen attached to a long neck, with a penis at the bottom. Like the dance wands of the Trobriands (cat. no. 30), *rapas* were held in the middle of the shaft and twirled in circular motions.

Previous collections: Jay Leff, Uniontown, Pennsylvania; Wayne Heathcote, New York

Publications: Carnegie Institute, Pittsburgh, 1959, no. 192; American Museum of Natural History, New York, 1965, no. 14; Sotheby's, New York, 1975, no. 108

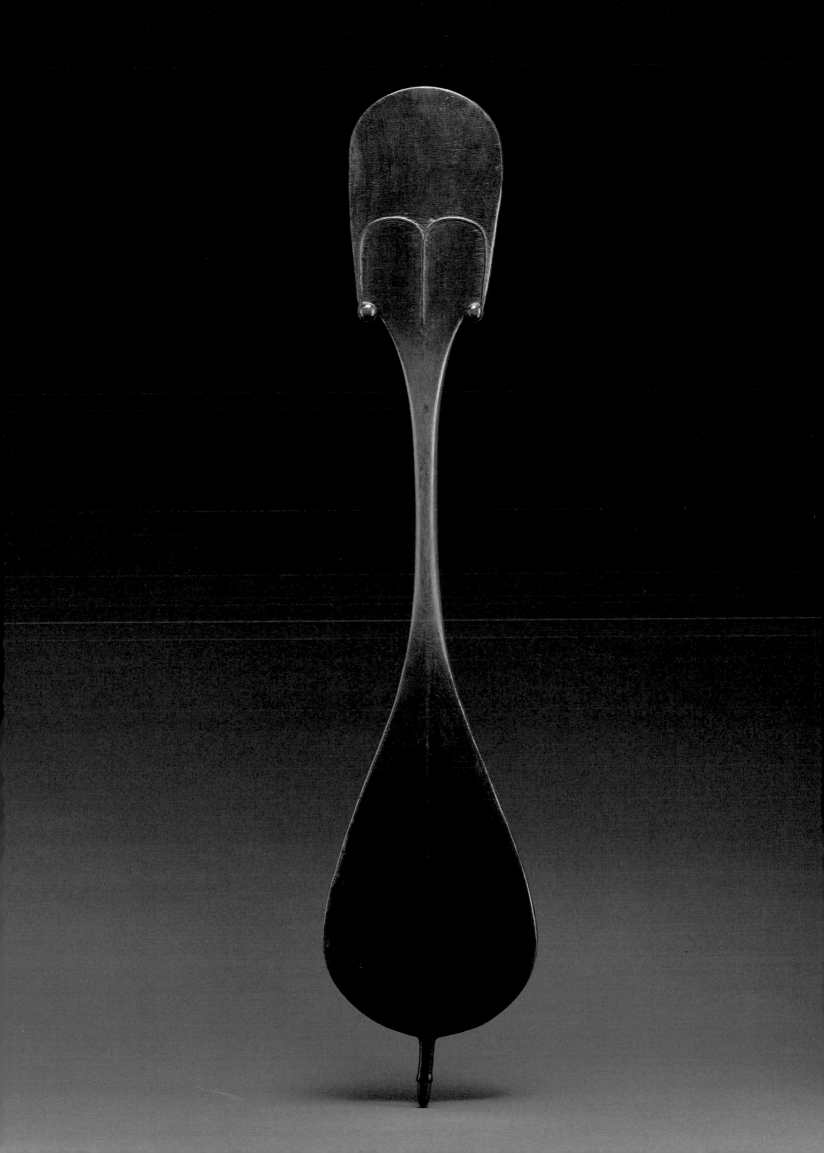

104 **House Mask** *(tapuanu)*
Caroline Islands, Mortlock, Satawan Atoll
*Wood; white, black, and red pigment*
Height: 20 1/2 in. (52 cm)

SUCH MASKS WERE MADE EXCLUSIVELY on the atoll of Satawan in the Mortlock island group of the Carolines. Because they are the only masks that were used throughout all of Micronesia, the form must have been introduced through some unknown contact between Satawan and Melanesia. The name *tapuanu* refers to a sacred ancestor spirit that served to protect the island and its breadfruit crop from the devastation of typhoons.

The masks were made by a secret society called *poutapuanu* which was responsible for the proper observance of rituals and the performance of songs and dances that were held in ceremonial houses every March or April. Although they are often referred to as gable masks, these masks were actually used to decorate the support beams of the house, either carved separately such as this one, or sculpted in relief on the beams themselves. Masks may also have adorned the houseposts of Satawan boat houses (Feldman and Rubinstein 1986, p. 31). There is some information that certain types of masks were made to be worn, but all of the known examples are of this large size and were architectural ornaments.

The Micronesian aesthetic of stark simplicity and minimal form is well represented by this mask. The long straight nose, eyes in the form of thin strips, and a pursed mouth with a small painted area on and underneath the chin are typical. The elegant and sweeping eyebrows represent the wings of a sea bird, a motif that also appears on canoe prows of the Carolines. Only the representation of a single topknot of hair on one side breaks the rigid symmetry of the mask.

Collected in 1887

Previous collections: Museum für Völkerkunde, Leipzig; Carlo Monzino, Lugano

Publications: Sotheby's, New York, 1987, no. 96

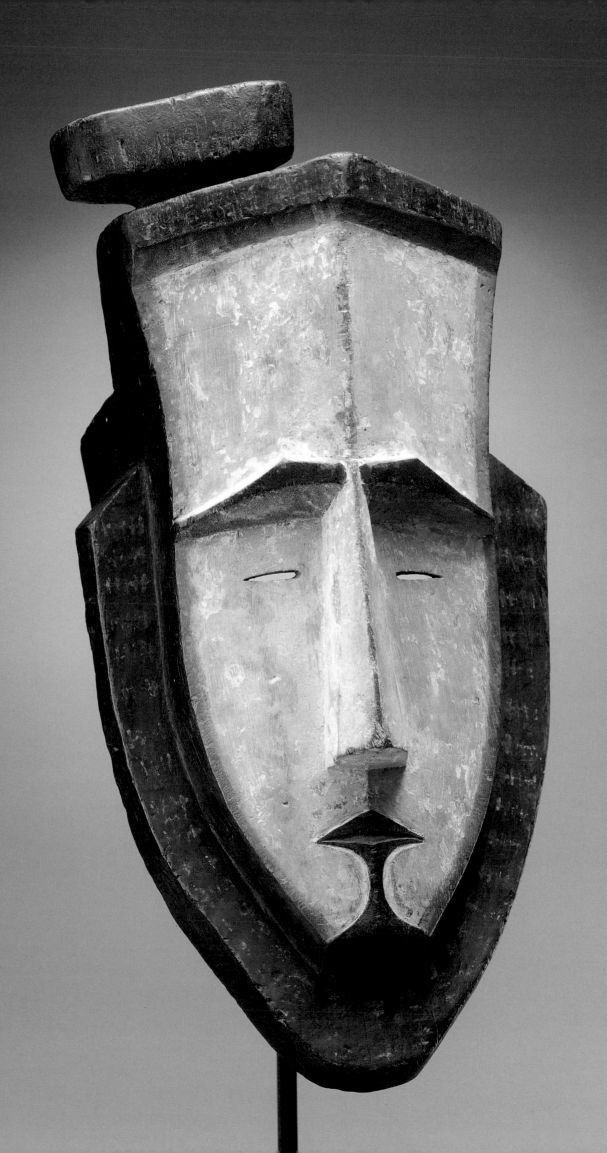

105a **Bark Painting**
*Bark; red, black, and white pigment*
Height: 42 1/2 in. (108 cm)

THE BEST-KNOWN ABORIGINAL BARK paintings were made in north Australia. They decorated the interiors of the lean-to structures in which the people lived and were also made for ritual display. The range of their subject matter is very wide and includes ancestor spirits, features of the landscape, clouds, rain, and representations of totemic animals and plants. Without specific information from their owners, interpretation of the meaning of the scenes shown on them is very difficult. Both of these examples were collected at Oenpelli in central Arnhem Land.

MANY BARK PAINTINGS OF HUMAN figures depict them engaged in sexual exploits. Although this painting is extremely stylized, the exaggeration of the male sexual organs and the representation of what appears to be a pregnant woman indicates the depiction of a scene related to fertility and sexual magic. The bodies of the figures are extremely thin stringlike forms, and they are probably *mimi* spirits, small thin beings that inhabit the cracks of rocks (Sutton 1988, p. 53). Particularly notable is the emphasis given to the body joints, which among the Aborigines were believed to be loci of spirit power. The three branch forms sprouting from the head of the male figure probably represent a plant totem.

Collected before 1920

Previous collection: Wayne Heathcote, New York

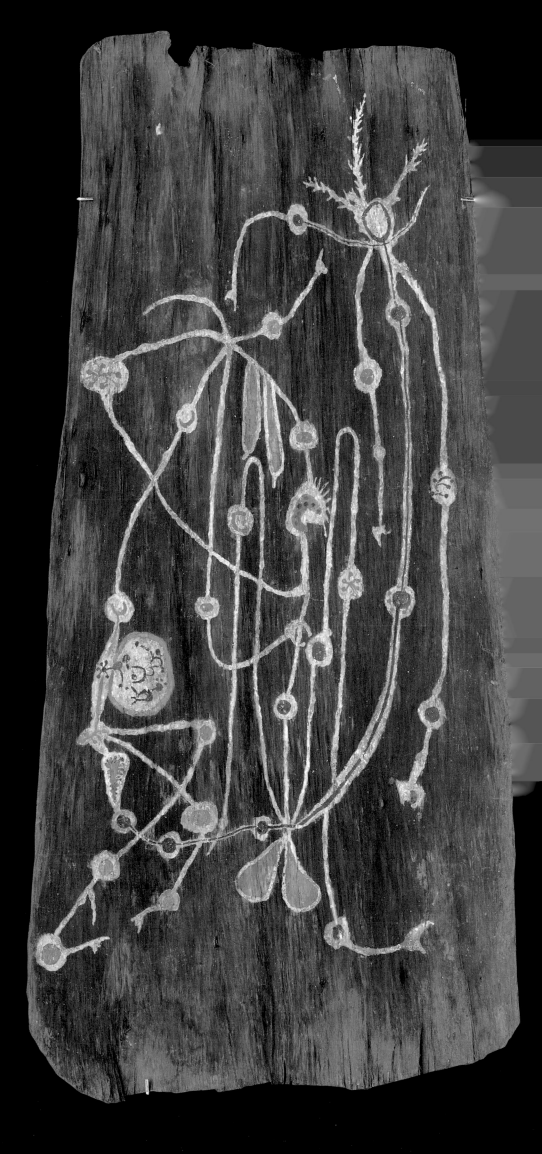

## 105b  Bark Painting

*Bark; brown, orange, and white pigment*

Height: 70 1/2 in. (179 cm)

AS WITH CAT. NO. 105A, THE THEME OF this bark painting is also sexual. The genitalia of both figures are shown in exaggerated size, and the painting probably represents the sexual activities of the Great Ancestors during dream time, when the world was created. The appearance of the vertebrae of each of the figures is an example of the X-ray style by which the internal organs and skeleton are shown. This unusually large example was collected in 1932 by Father Herman Noakes of Berlin University, who went to Arnhem Land with Father Worms, an anthropologist and collector of Aboriginal art.

Previous collections: Father Herman Noakes, Berlin; Wayne Heathcote, New York

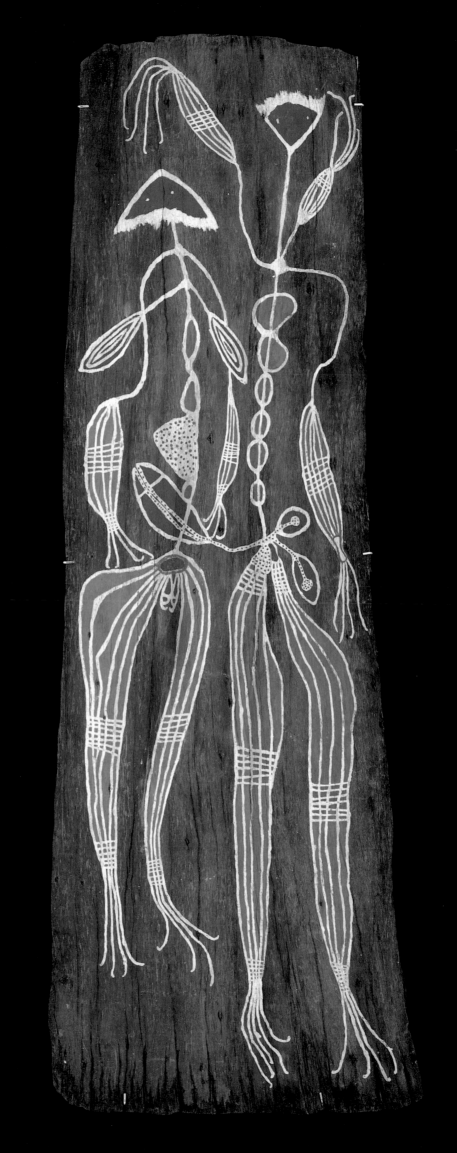

## 106 Sacred Stone (*tjuringa*)

Australia
*Stone*
Length: 34 in. (86.5 cm)

EVERY ADULT MALE OWNED HIS PERSONAL *tjuringa*, and they are therefore among the most common examples of Australian Aboriginal art. They are also among the most sacred. Each one embodied the totemic spirits of its owner as well as those of the creator beings. At the proper times, they provided an abode for these spirits. They were displayed at initiations by elders to explain traditions and legends to novices and during rain-making ceremonies or observances to assure adequate supplies of food. When not in use, they were carefully kept in small storehouses.

*Tjuringas* are usually of elongated oval form such as this one and the three large wood examples also shown here (cat. no. 107). The linear incisions on their surfaces are in the form of concentric circles, squares, ovals, rectangles, diamonds, and arcs as well as spirals, zigzags, and parallel, dotted, and wavy lines. They might refer to any number of beings, myths, parts of the heavens or the landscape, plants, and animals and their tracks. Because any of these motifs can be used to represent many different things, the meaning of a single *tjuringa* is impossible to interpret without information from its owner.

This example, which appears to be of considerable age, has as its principal motif three rayed, concentric circles separated by parallel lines. To give some idea of the complexity of the symbolism of Aboriginal two-dimensional design, citing Baldwin Spencer and P. J. Gillen, Frederick McCarthy (1958, p. 29) writes, "concentric circles usually represent the principal feature of the myth portrayed such as the spiritual ancestor, places where he camped, went into or came out of the ground, distributed spirit children, waged battle with an enemy or rival, and so on. On one *tjuringa* they represent a frog, on others, a tree, a waterhole, or other totem."

Collected before 1935

Previous collections: Völkerkundeliches Mission Museum, Wupperthal; Wayne Heathcote, New York

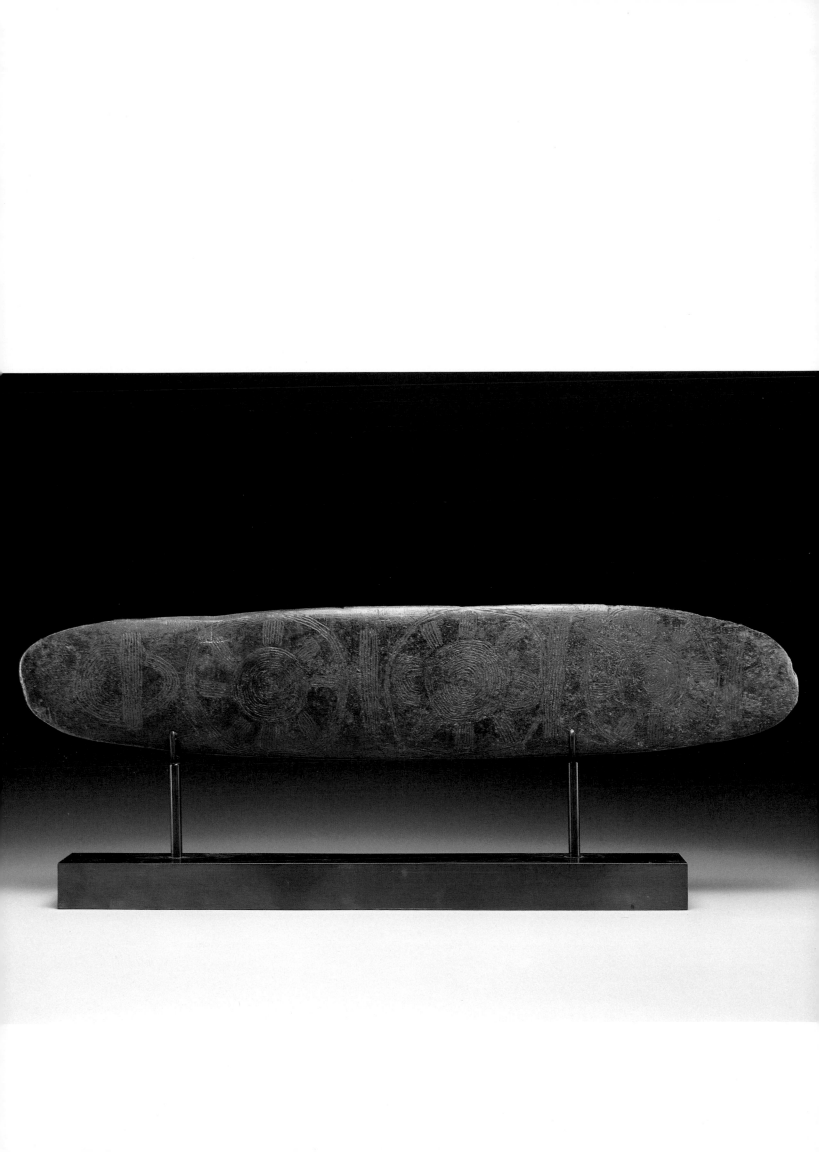

## 107 Three Sacred Boards (*tjuringas*)

Australia
*Wood, ocher pigment*
Length: 77 1/2, 90 1/4, 93 1/2 in. (197, 229, 237.5 cm)

**M**OST *TJURINGAS* WERE MADE TO BE easily carried and stored when not in use. Because of their unusually large size, these three old examples must have been extremely powerful and important ritual objects. Unfortunately, however, nothing is known of their meaning or even of the region of Australia from which they came. The use of *tjuringas* was so widespread throughout the continent, and there is so little stylistic difference between those from one region and another that without collection data they cannot be assigned to a specific place. The designs of these are somewhat related in having as the principal motif the concentric square. Other elements employed are U-shaped forms, concentric circles, and zigzags.

Collected before 1935

Previous collections: Völkerkundeliches Mission Museum, Wupperthal; Wayne Heathcote, New York

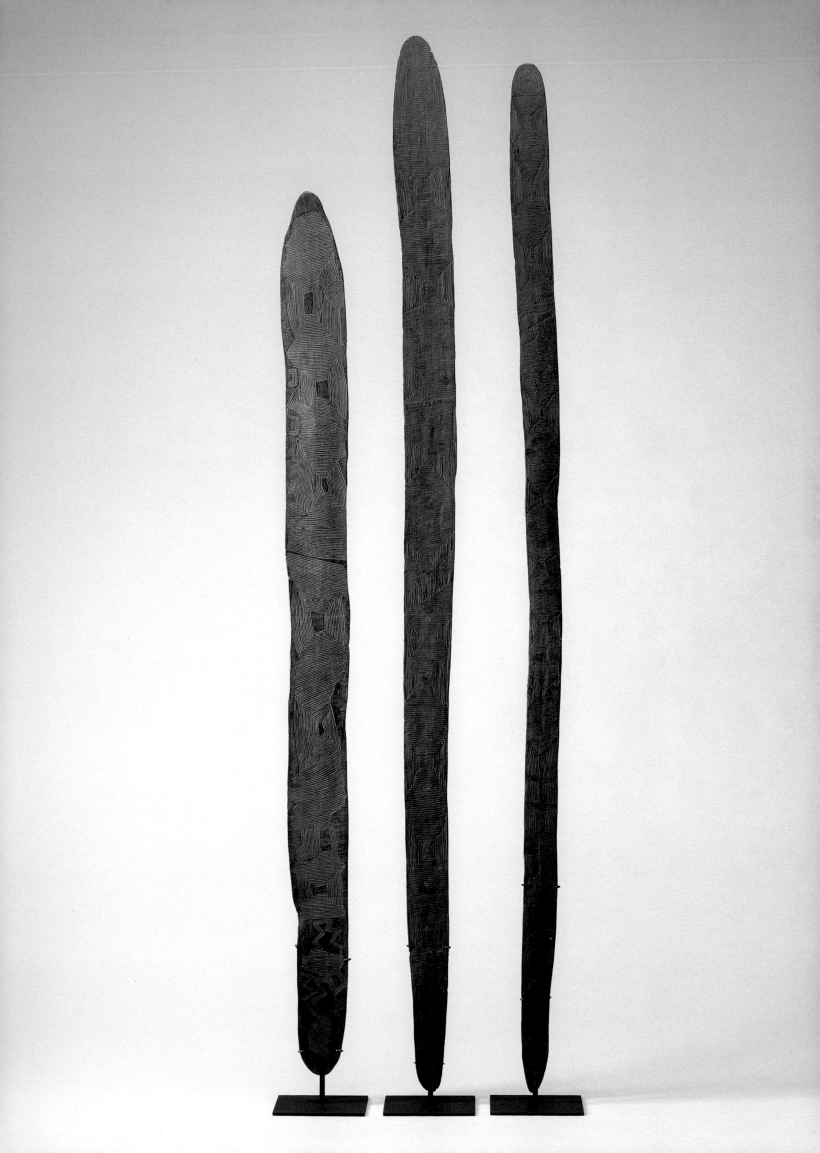

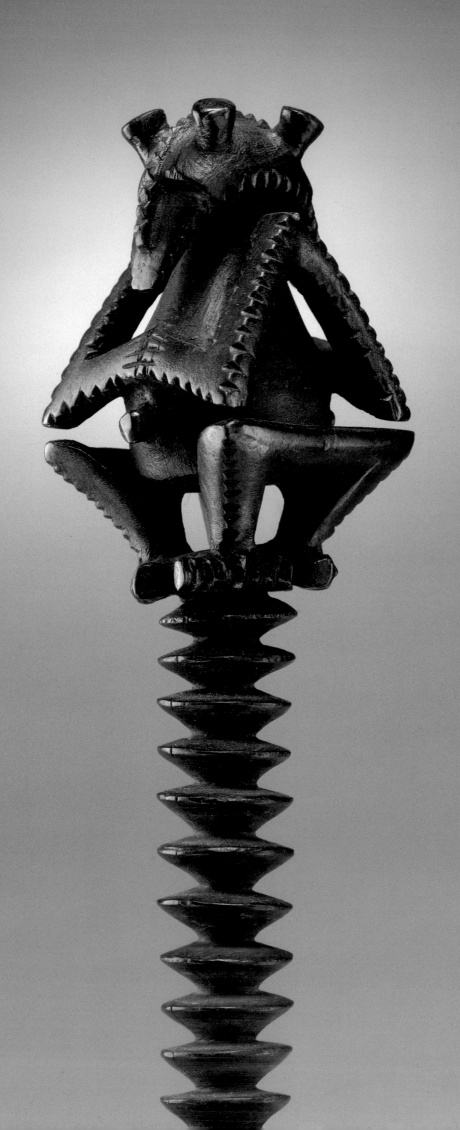

# Bibliography

Ader, Picard and Tajan, Paris. *Afrique, Océanie, Amérique du Nord.* Sale, May 21, 1990.

Alkire, W. H. *An Introduction to the Peoples and Cultures of Micronesia.* Menlo Park, 1977.

American Museum of Natural History. *Faces and Figures: Pacific Island Art from the Collection of Jay C. Leff.* New York, 1965.

Archey, Gilbert. "Art Forms of Polynesia." *Bulletin,* no. 4, Auckland, Auckland Institute and Museum, 1965.

———. *Whaowhia: Maori Art and Its Artists.* Auckland and London, 1977.

Baaren, Theodorus P. van. *Korwars and Korwar Style.* The Hague, 1968.

Badner, Mino. "The Protruding Tongue, and Related Motifs in the Art Styles of the American Northwest Coast, New Zealand, and China." *Wiener Beitrage zur Kulturgeschichte und Linguistik,* Vienna, 1966.

Barbier, Jean Paul. *Indonesie et Melanesie.* Geneva, Musée Barbier-Müller, 1977.

Barrow, Terence. *Arts of the South Sea Islands.* Wellington, 1959.

———. "Material Evidence of the Bird-Man Concept in Polynesia." In Highland et al., *Polynesian Culture History,* pp. 191–214, 1967.

———. *Maori Wood Sculpture of New Zealand.* Wellington, Auckland, Sydney, and Melbourne, 1969.

———. *Art and Life in Polynesia.* Rutland, Vermont, 1972.

———. *The Art of Tahiti.* London, 1979.

———. *An Illustrated Guide to Maori Art.* Honolulu, University of Hawaii Press, 1984.

———. *Notes on the Masco Collection.* Unpublished manuscript, 1990.

Bassani, Ezio, and Malcolm McLeod. *Jacob Epstein, Collector.* Milan, 1989.

Bateson, Gregory. *Naven.* Cambridge, 1936.

Bearnes and Waycotts, Torquay. Sale, December 13, 1967.

Beran, Harry. *Betel-chewing Equipment of East New Guinea.* Aylesbury, England, 1988.

Berndt, Roland M. "Some Methodological Considerations in the Study of Australian Aboriginal Art." *Oceania,* vol. 29, no. 1, pp. 26–43, September 1958.

Bodrogi, Tibor. *Oceanian Art.* Budapest, 1959.

———. *Art in Northeast New Guinea.* Budapest, 1961.

———. "New Ireland Art in Cultural Context." In L. Lincoln, *Assemblage of Spirits: Idea and Image in New Ireland,* pp. 17–32, 1988.

Bonhams and Sons, Ltd., London. *Tribal Art, Asian Art and Antiquities.* Sale, July 3, 1990.

———. *Tribal Art.* Sale, June 17, 1991.

Brake, Brian; James McNeish; and David Simmons. *Art of the Pacific.* Wellington, 1979.

Brower, Kenneth. *Micronesia: The Land, the People and the Sea.* Baton Rouge, 1981.

Brunor, Martin A. *Arts and Crafts of the Austral Islands.* Salem, Mass., Peabody Museum, 1969.

Buck, Peter H. *Arts and Crafts of the Cook Islands.* Bernice P. Bishop Museum Special Publication, no. 179, Honolulu, 1944.

———. *Arts and Crafts of Hawaii.* Bernice P. Bishop Museum Special Publication, no. 45, Honolulu, 1957.

———. *Vikings of the Pacific.* Chicago, 1959.

Buhler, Alfred. *Art of Oceania.* Zurich, 1969.

Buhler, Alfred; Terence Barrow; and Charles P. Mountford. *The Art of the South Sea Islands.* New York, 1962.

*Cahiers d'Art.* Vols. 2 and 3, Paris, 1929.

Campbell, Joseph. *The Way of Animal Powers.* New York, 1983.

Carnegie Institute, Pittsburgh. *Exotic Art from the Collection of Jay C. Leff.* Pittsburgh, 1959.

Chauvet, Stephan. *Les Arts indigènes en Nouvelle-Guinée.* Paris, 1930.

Christie's. *The James Hooper Collection.* Christie, Mansion, and Woods, Ltd., London. Sale, June 21, 1977.

———. *The James Hooper Collection.* Sale, June 19, 1979.

———. *The Meulendijk Collection of Tribal Art.* Sale, October 23, 1980.

———. *Tribal Art.* Sale, June 22, 1981.

———. *Tribal Art.* Sale, June 29, 1983.

———. *Tribal Art.* Sale, June 28, 1988.

———. *Art and Ethnography from Africa, the Pacific and the Americas.* Sale, July 4, 5, 1989.

———. *Art and Ethnography from Africa, the Pacific and the Americas.* Sale, July 3, 4, 1990.

———. *Important Tribal Art.* Sale, June 23, 1992.

Clunie, Fergus. "Fijian Weapons and Warfare." *Bulletin of the Fiji Museum,* no. 2. Suva, 1977.

———. *Yalo i Viti.* Fiji Museum, Suva, 1986.

Codrington, R. H. *The Melanesians.* London, 1891.

Coe, Michael; Douglas Newton; and Roy Sieber. *African, Pacific, and Pre-Columbian Art in the Indiana University Art Museum.* Bloomington, 1986.

Cook, James. *A Voyage to the Pacific . . . in the Resolution and the Discovery, 1776–80.* 3 vols. and Atlas. London, 1784.

Cooper, Douglas. *Great Private Collections.* London, 1963.

Corbin, George A. "The Central Baining Revisited." *Res.,* vols. 7, 8, pp. 44–69, 1984.

———. *Native Arts of North America, Africa, and the South Pacific.* New York, 1988.

Covarrubias, Miguel. *The Eagle, the Serpent, and the Jaguar.* New York, 1954.

Cox, J. Halley. "The Lei Niho Palaoa." In Highland et al., *Polynesian Culture History,* pp. 411–24, 1967.

Cox, J. Halley, and William Davenport. *Hawaiian Sculpture.* 2d ed., Honolulu, 1988.

Cranstone, B. A. L. *Melanesia: A Short Ethnography.* London, The British Museum, 1961.

D'Alleva, Anne. *Art and Artifacts of Polynesia.* Cambridge, Mass., Hurst Gallery, 1990.

Damm, Hans. "Sakrale Holzfiguren von den Nordwest-Polynesischen Radinseln." *Jahrbuch des Museum für Völkerkunde zu Leipzig,* vol. 10, pp. 74–87, 1952.

———. "Bemerkungen zu den Schadelmasken aus Neubritannien (Südsee)." *Jahrbuch des Museum für Völkerkunde zu Leipzig,* vol. 26, pp. 85–116, 1969.

Danielsson, Bengt. *La Découverte de la Polynésie.* Paris, Musée de l'Homme, 1972.

Davenport, William. "Red Feather Money." *Scientific American,* vol. 206, pp. 94–105, 1962.

———. "Sculpture from La Grande Terre." *Expedition,* vol. 7, no. 1, pp. 2–29, 1964.

Deacon, Arthur B. *Malekula: A Vanishing People in the New Hebrides.* London, 1934.

Dodd, Edward. *Polynesian Art.* New York, 1967.

Duff, Roger, ed. *No Sort of Iron: Culture of Cook's Polynesians.* Christchurch, Art Galleries and Museums' Association of New Zealand, 1969.

Edge-Partington, James. *An Album of Weapons, Tools, Ornaments, Articles of Dress, etc., of the Natives of the Pacific Islands Drawn and Described from Examples in Public and Private Collections in England.* Manchester, 1890–98.

Edler, John C. *Art of Polynesia.* Honolulu, 1990.

Fagg, William. *The Epstein Collection.* London, 1960.

Feldman, Jerome, ed. *The Eloquent Dead: Ancestral Sculpture of Indonesia and Southeast Asia.* Los Angeles, 1985.

Feldman, Jerome, and Donald H. Rubinstein. *The Art of Micronesia.* Honolulu, University of Hawaii Art Gallery, 1986.

Finer, Linda Barnard. Personal communication, London, 1992.

Firth, Raymond. *Art and Life in New Guinea.* New York, 1936.

Force, Roland, and Maryanne Force. *Art and Artifacts of the Eighteenth Century: Objects in the Leverian Museum as Painted by Sarah Stone.* Honolulu, Bishop Museum Press, 1968.

———. *The Fuller Collection of Pacific Artifacts.* London, 1971.

Forge, Anthony. "Art and Environment in the Sepik." *Proceedings of the Royal Anthropological Institute of Great Britain and Ireland,* pp. 23–31, 1965.

Forment, Francina. "Le Motif de l'oiseau dans la sculpture en bois traditionelle de l'ile de Pâques," in *Musées Royaux d'Art et d'Histoire,* Brussels, pp. 116–23, 1990.

Friede, John. Personal communication, New York, 1991.

Galerie Pigalle. *Exposition d'art Africaine et d'art Océanien.* Paris, 1930.

Gathercole, Peter; Adrienne Kaeppler; and Douglas Newton. *The Art of the Pacific Islands.* Washington, D. C., The National Gallery of Art, 1979.

Gifford, Edward W. "Tongan Society." *Bernice P. Bishop Museum Bulletin,* no. 61. Honolulu, 1929.

Gifford, Phillip. "Uli Figures." *Connaissance des Arts Tribaux Bulletin,* no. 1. Geneva, Musée Barbier-Müller, 1978.

Gill, William W. *From Darkness to Light in Polynesia.* London, 1894.

Grand Palais. *La Rime et la raison: Les Collections Ménil.* Paris, 1984.

Green, Roger C. "Lapita Pottery and the Origins of Polynesian Culture." *Australian Natural History,* pp. 332–37, June 1973.

———. "New Sites with Lapita Pottery and Their Implications for an Understanding of the Settlement of the Western Pacific." *Working Papers in Anthropology, Archaeology, Linguistics and Maori Studies.* Auckland, University of Auckland, Department of Anthropology, July 1978.

———. "Early Lapita Art from Polynesia and Island Melanesia: Continuities in Ceramics, Barkcloth and Tattoo Decoration," in S. M. Mead, *Exploring the Arts of Oceania,* pp. 13–31, 1979.

Greub, Suzanne, ed. *Authority and Ornament: Art of the Sepik River.* Basel, Tribal Art Center, 1985.

Groves, William. "Secret Beliefs and Practices in New Ireland." *Oceania,* vol. 7, pp. 220–45, 1936.

Guhr, Gunther, and Peter Neumann. *Ethnographische Mosaik aus der Sammlungen des Staatlichen Museums für Völkerkunde, Dresden.* Berlin, Deutscher Verlag der Wissenschaften, 1985.

Guiart, Jean. *Arts of the South Pacific.* New York, 1963.

———. "Nouvelles Hébrides." *Mondes et Cultures.* Auvers-sur-Oise, 1965.

———. "Mythologie des masques en Nouvelle-Caledonie." *Publications de la Société des Océanistes,* no. 18. Paris, Musée de l'Homme, 1966.

Haddon, Alfred C. *The Decorative Art of British New Guinea.* Dublin, 1894.

Haddon, Alfred C., ed. *Reports of the Cambridge Anthropological Expedition to the Torres Strait.* 6 vols. Cambridge, Cambridge University Press, 1901–35.

———. *Sociology, Magic and Religion of the Western Islanders.* Vol. 5 of Reports of the Cambridge Anthropological Expedition to the Torres Straits, ed. A. C. Haddon, 1904.

———. *Arts and Crafts.* Vol. 4 of Reports of the Cambridge Anthropological Expedition to the Torres Straits, ed. A. C. Haddon, 1912.

———. "The Agiba Cult of the Kerewa Culture." *Man,* vol. 18, no. 12, pp. 99–107, December 1918.

Hambly, Wilfred D. "Primitive Hunters of Australia." *Anthropology Leaflet,* no. 32. Chicago, Field Museum of Natural History, 1936.

Hamilton, Augustus. *The Art Workmanship of the Maori.* Wellington, 1896.

Handy, E. S. Craighill. "The Native Culture of the Marquesas." *Bernice P. Bishop Museum Bulletin,* no. 9. Honolulu, 1923.

———. "Marquesan Legends." *Bernice P. Bishop Museum Bulletin,* no. 69. Honolulu, 1930.

Hanson, Allan, and Louise Hanson, eds. *Art and Identity in Oceania.* Honolulu, University of Hawaii Press, 1933.

Heathcote, Wayne. Personal communication, New York, 1991.

Heine-Geldern, Robert von. "L'Art prébouddhique de la Chine et de l'Asie Sud-Est et son influence en Océanie." *Revue des Arts Asiatiques,* vol. 11, part 4, Paris, 1937.

Heintze, Dieter. "On Trying to Understand Some Malagans." In L. Lincoln, *Assemblage of Spirits,* pp. 42–53, 1988.

Helfrich, Klaus. *Malanggan. 1. Bildwerke von Neuirland.* Berlin, Museum für Völkerkunde, 1973.

Highland, Genevieve A.; Roland W. Force; Alan Howard; Marion Kelly; Yoshiko H. Sinoto, eds. *Polynesian Culture History.* Bernice P. Bishop Museum Special Publication, no. 56. Honolulu, 1967.

Honolulu Academy of Arts. *An Exhibition of Oceanic Arts from Collections in Hawaii.* Honolulu, 1967.

Hooper, James T., and Cottie Burland. *The Art of Primitive Peoples.* London, 1953.

Jenkins, Irving. *The Hawaiian Calabash.* Honolulu, 1989.

Joppien, Rudiger, and Bernard Smith. *The Art of Captain Cook's Voyages: The Voyage of the Resolution and Discovery 1776–80.* Vol. 3: *The Catalogue.* New Haven, 1988.

*The Journal of the Polynesian Society.* "A Remarkable Stone Figure from the New Guinea Highlands." Vol. 74, no. 1, frontispiece and pp. 78–79, March 1965.

Kaeppler, Adrienne. *Artificial Curiosities.* Honolulu, Bishop Museum Press, 1978.

———. *Eleven Gods Assembled: An Exhibition of Hawaiian Wooden Images.* Honolulu, Bishop Museum Press, 1979a.

———. "A Survey of Polynesian Art." In S. M. Mead, *Exploring the Arts of Oceania,* pp. 180–91, 1979b.

———. *Pahu and Puniu: An Exhibition of Hawaiian Drums.* Honolulu, Bishop Museum Press, 1980.

———. "Genealogy and Disrespect: A Study of Symbolism in Hawaiian Images." *Res.,* vol. 3 (Spring), pp. 94–95, 1982.

Kaufmann, Christian. *Ethnographische Kostbarkeiten aus der Sammlungen von Alfred Bühler in Basler Museum für Völkerkunde.* Basel, Museum für Völkerkunde, 1970.

———. "Oceania." In *World Cultures, Arts and Crafts.* Basel, 1979.

Kelm, Heinz. *Kunst vom Sepik.* 3 vols. Berlin, Museum für Völkerkunde, 1966.

Kirk, Malcolm. *Man as Art: New Guinea.* New York, 1981.

Kooiman, Simon. *The Art of Lake Sentani.* New York, The Museum of Primitive Art, 1959.

Kramer, Augustine. *Die Malanggane von Tombara.* Munich, 1925.

———. *Inseln um Truk.* Hamburg, 1935.

Kunsthaus Lempertz, Cologne. *Ostasiatische Kunst.* Sale, December 1, 1989.

Lawrence, Peter, and M. J. Meggitt. *Gods, Ghosts and Men in Melanesia.* Melbourne, 1965.

Leenhardt, Maurice. "Le Masque Calédonien." *Bulletin du Musée d'Ethnographie du Trocadéro,* no. 6, July 1933.

———. "Le Masque et le mythe en Nouvelle Calédonie." *Etudes Mélanésiennes,* no. 8, pp. 9–20, 1954.

Lewis, Albert B. "Carved and Painted Designs from New Guinea." *Anthropology Design Series,* no. 5. Chicago, Field Museum of Natural History, 1931.

———. *The Melanesians: People of the South Pacific.* Chicago, Field Museum of Natural History, 1951.

Lincoln, Louise. *Assemblage of Spirits: Idea and Image in New Ireland.* New York, 1988.

Linton, Ralph. "The Material Culture of the Marquesas Islands." *Bernice P. Bishop Museum Memoirs,* vol. 8, no. 5. Honolulu, 1923.

———. *Ethnology of Polynesia and Micronesia.* Chicago, Field Museum of Natural History, 1926.

Linton, Ralph, and Paul Wingert. *Arts of the South Seas.* New York, Museum of Modern Art, 1946.

Losche, Diane. *The Abelam: A People of Papua New Guinea.* Sydney, The Australian Museum, 1982.

Loudmer, Paris. *Arts Primitifs: Collection Tristan Tzara et à divers amateurs.* Sale, November 24, 1988.

Loudmer-Poulain, Paris. *Arts Primitifs.* Sale, December 16, 1978.

Lunsford, John. *Arts of Oceania.* Dallas Museum of Fine Arts, 1970.

Luquet, G. H. *Art Néo-Calédonien.* Paris, 1923.

Luquiens, Huc-Mazlet. *Hawaiian Art.* Bernice P. Bishop Museum Special Publication, no. 18. Honolulu, 1931.

Mack, Charles W. *Polynesian Art at Auction: 1965–1980.* Northboro, Mass., 1982.

Malo, David. *Hawaiian Antiquities.* Bernice P. Bishop Museum Special Publication, no. 2. Honolulu, 1951.

McCarthy, Frederick D. *Australian Aboriginal Decorative Art.* Sydney, The Australian Museum, 1958.

McKesson, John A. "In Search of the Origins of the New Caledonia Mask." In Hanson and Hanson, *Art and Identity in Oceania,* pp. 84–92, 1990.

Mead, Margaret. "Tamberans and Tumbuans in New Guinea." *Natural History,* vol. 34, pp. 234–46, 1934.

Mead, Sidney, M. "Becoming Maori Art." In S. M. Mead, ed., *Te Maori: Maori Art from New Zealand Collections,* pp. 63–75, 1984.

Mead, Sidney M., ed. *Exploring the Arts of Oceania.* Honolulu, 1979.

———. *Te Maori: Maori Art from New Zealand Collections.* New York, 1984.

Mead, Sidney M.; H. Birks; L. Birks; and E. Shaw, eds. "The Lapita Pottery Style of Fiji and Its Associations." *Polynesian Society Memoirs,* no. 38. Wellington, 1973.

Mead, Sidney M., and Bernie Karnot, eds. *Art and Artists of Oceania.* Palmerston North, New Zealand, 1983.

The Metropolitan Museum of Art. *Notable Acquisitions: 1984.* New York, 1984.

Moore, David R. *Arts and Crafts of the Torres Strait.* Aylesbury, England, 1989.

Moschner, Irmgard. "Die Wiener Cook-Sammlung: Südsee-Teil." *Archiv für Völkerkunde,* vol. 10, pp. 136–253, 1955.

Musées Royaux d'Art et d'Histoire. *L'Ile de Pâques: Une Enigme?* Brussels, 1990.

Museum für Völkerkunde. *Führer durch das Museum für Völkerkunde.* Basel, 1931.

———. *Ozeanische Kunst: Meisterwerke.* Basel, 1980.

Nevermann, Hans. *Ergebnisse der Südsee: Expedition 1908–10, Admiralitäts-Inseln.* Hamburg, 1934.

Newton, Douglas. *Art Styles of the Papuan Gulf.* New York, The Museum of Primitive Art, 1961.

———. *New Guinea Art in the Collection of the Museum of Primitive Art.* New York, The Museum of Primitive Art, 1967.

———. *Crocodile and Cassowary.* Greenwich, Conn., 1971.

———. *Massim: Art of the Massim Area, New Guinea.* New York, The Museum of Primitive Art, 1975.

———. "Continuities and Changes in Western Pacific Art." In Gathercole et al., *The Art of the Pacific Islands,* pp. 27–46, 1979a.

———. "Prehistoric and Recent Art Styles in Papua New Guinea." In S. M. Mead, ed., *Exploring the Arts of Oceania,* pp. 32–57, 1979b.

———. "Zoomorphic Figure." In Metropolitan Museum of Art, *Noble Acquisitions,* p. 118, 1984.

———. "Visual Arts in the Pacific." In Coe et al., *African, Pacific, and Pre-Columbian Art in the Indiana University Art Museum,* pp. 49–97, 1986.

———. "Mother Cassowary's Bones: Daggers of the East Sepik Province, Papua New Guinea." *Metropolitan Museum Journal,* vol. 24, pp. 303–25, 1989.

———. Personal communication, New York, 1991.

———. Personal communication, New York, 1992.

Oldman, William O. "The Oldman Collection of Polynesian Artifacts." *Memoirs of the Polynesian Society,* vol. 15, 1943.

———. "Skilled Handiwork of the Maori." *Memoirs of the Polynesian Society,* vol. 14, 1946.

Parsons, Lee. *Ritual Arts of the South Seas.* St. Louis, 1975.

Pfeiffer, Marian M. "Monumental Ancestor Figures of the Sawos: Identification of the Yamok Style Group, Middle Sepik River, Papua New Guinea." Master's thesis, Meadows School of the Arts, Southern Methodist University, Dallas, 1983.

Phelps, Stephen. *Art and Artifacts of the Pacific, Africa, and the Americas: The James Hooper Collection.* London, 1976.

Phillips, Son and Neal, London. *Antiquities and Tribal Art.* Sale, Oct. 25, 1983.

Poignant, Roslyn. *Oceanic Mythology.* London, 1967.

Portier, A., and F. Poncetton. *Les Arts sauvages: Océanie.* Paris, 1930.

Powell, A. W. B. "The Canoes of Geelvinck Bay." *Auckland Institute Museum Records,* vol. 5, nos. 1 and 2, 1958.

Rawson, Philip. *Primitive Erotic Art.* New York, 1973.

Reichard, Gladys A. *Melanesian Design: A Study in Wood and Tortoise Shell Carving.* New York, 1933.

Rijksmuseum. *Papuan Art in the Rijksmuseum.* Amsterdam, 1966.

Rollin, Louis. *Les Iles Marquises.* Paris, 1929.

Rose, Roger C. "Reconstructing the Art and Religion of Hawaii." *Journal of the Polynesian Society,* vol. 87, no. 3, pp. 267–78, 1978.

———. "On the Origin and Diversity of the 'Tahitian' Janiform Fly Whisks." In S. M. Mead, *Exploring the Arts of Oceania,* pp. 202–23, 1979.

Rubin, William, ed. *"Primitivism" in Twentieth-Century Art.* New York, The Museum of Modern Art, 1984.

Salisbury, R. F. "The Siane of the Eastern Highlands." In Lawrence and Meggitt, *Gods, Ghosts and Men in Melanesia,* pp. 50–77, 1965.

Sarasin, Fritz. *Atlas zur Ethnologie der Neu-Caledonier und Loyalty-Insulaner.* Berlin, 1929.

Schmid, Christin K. "Catalogue." In S. Greub, *Authority and Ornament,* pp. 177–210, 1985.

Schmitz, Carl A. *Oceanic Sculpture: Sculpture of Melanesia.* New York, 1962.

———. *Oceanic Art: Myth, Man, and Image in the South Seas.* New York, 1969.

Schmitz, Carl A., and F. L. Kenett. *Ozeanische Kunst.* Munich, 1962.

Schuster, Carl. "Joint-Marks, a Possible Index of Cultural Contact between Latin America, Oceania, and the Far East." Med. XCLV, *Afdeling Culturele en Physische Antropologie,* no. 39, Koninklijl Instituut voor de Tropen, Amsterdam, 1951.

Seligmann, Charles G. *The Melanesians of British New Guinea.* Cambridge, England, 1910.

Simmons, David R. "Catalogue." In S. M. Mead, *Te Maori,* pp. 176–235, 1984.

Skinner, H. D. *The Maori Hei-Tiki*. Dunedin, New Zealand, The Otago Museum, 1966.

Smidt, Dirk. *The Seized Collections of the Papua New Guinea Museum*. Port Moresby, Papua New Guinea, 1975.

Solheim, Wilhelm G. "Korwar of the Biak." In J. Feldman, *The Eloquent Dead*, pp. 147–60, 1985.

Sotheby's, London
———. *Primitive Art*. Sale, Sotheby & Co., London, July 8, 1974.
———. *Pinto Collection*. Sale, Sotheby & Co., London, May 9, 1977.
———. *George Ortiz Collection*. Sale, Sotheby & Co., London, July 10, 1978a.
———. *Pre-Columbian, American Indian, Oceanic and African Art*. Sale, Sotheby & Co., London, December 11, 1978b.
———. *Primitive Works of Art*. Sale, Sotheby & Co., London, June 21, 1979.
———. *Primitive Works of Art*. Sale, Sotheby & Co., London, June 16, 1980a.
———. *Primitive Works of Art*. Sale, Sotheby & Co., London, December 2, 1980b.
———. *Primitive Works of Art*. Sale, Sotheby & Co., London, June 6, 1983.
———. *British Railway Pension Trust Collection*. Sale, Sotheby & Co., London, July 11, 1988.

Sotheby's, New York
———. *Important African, Oceanic, and Indian Sculpture*. Sale, Sotheby & Co., New York, November 15, 1965.
———. *African, Oceanic, and Pre-Columbian Art*. Sale, Sotheby & Co., New York, October 11, 1974.
———. *The Jay C. Leff Collection*. Sale, Sotheby & Co., New York, October 10, 1975.
———. *The George Ortiz Collection*. Sale, Sotheby & Co., New York, June 29, 1978.
———. *The Ben Heller Collection*. Sale, Sotheby & Co., New York, December 1, 1983a.
———. *Important Tribal Art*. Sale, Sotheby & Co., New York, December 2, 1983b.
———. *Important Tribal Art*. Sale, Sotheby & Co., New York, November 29, 30, 1984.
———. *Important Tribal Art*. Sale, Sotheby & Co., New York, November 10, 1987.
———. *Important Tribal Art*. Sale, Sotheby & Co., New York, May 15, 1991.

Sowell, Teri. *Treasures from Polynesia: Selections from the Raymond and Laura Wielgus Collection*. Bloomington, Indiana University Art Museum, n. d. [1988?]

Speiser, Felix. *Ethnographische Materialien aus den Neuen Hebriden und den Banks Inseln*. Berlin, 1923.
———. "Über Kunstile in Melanesien." *Zeitschrift für Ethnologie*, vol. 68, pp. 304–69, 1936.
———. "Kunstile in der Südsee." *Führer durch das Museum für Völkerkunde*. Basel, 1941.

Starzecka, Dorota C., and B. A. L. Cranstone. *The Solomon Islanders*. London, The British Museum, 1974.

Steinen, Karl von den. *Die Marquesaner und Ihre Kunst*. 3 vols. Berlin, 1925–28.

Stöhr, Waldemar. *Melanesien: Schwarze Inseln der Südsee*. Cologne, Kunsthalle, 1971.
———. *Kunst und Kultur aus der Südsee*. Cologne, Rautenstrauch Joest Museum für Völkerkunde, 1987.

Sutton, Peter, ed. *Dreamings: The Art of Aboriginal Australia*. New York, 1988.

Teilhet, Johanne H., ed. *Dimensions of Polynesia*. San Diego, 1973.

Tischner, Herbert. *Oceanic Art*. New York, 1954.
———. *Kulturen der Südsee*. Hamburg, Museum für Völkerkunde und Vorgeschichte, 1958.

Valluet, Christine. "Uli, la grande cérémonie." *Primitifs*, no. 6, pp. 36–50, 1991.

van Baaren. *See* Baaren, Theodorus P. van.

Waite, Deborah. *Art of the Solomon Islands*. Geneva, Musée Barbier-Müller, 1983a.
———. "Shell Inlaid Shields from the Solomon Islands." In Mead and Karnot, eds., *Art and Artists of Oceania*, pp. 114–36, 1983b.
———. "Mon Canoes of the Western Solomon Islands." In Hanson and Hanson, *Art and Identity in Oceania*, pp. 44–66, 1990.

Wardwell, Allen. *The Sculpture of Polynesia*. Chicago, The Art Institute of Chicago, 1967.
———. *The Art of the Sepik River*. Chicago, The Art Institute of Chicago, 1971.

Webster, W. D. *Catalogue of the Ethnographical Specimens . . .*, Catalogue no. 31, London, November 1901.

Wingert, Paul. *Outline Guide to the Art of the South Pacific*. New York, 1946.
———. "Human Forms in the Art of Melanesia." *Records of the Auckland Institute and Museum*, vol. 4, no. 3, pp. 145–52, 1952.
———. *Art of the South Pacific Islands*. New York, 1953.

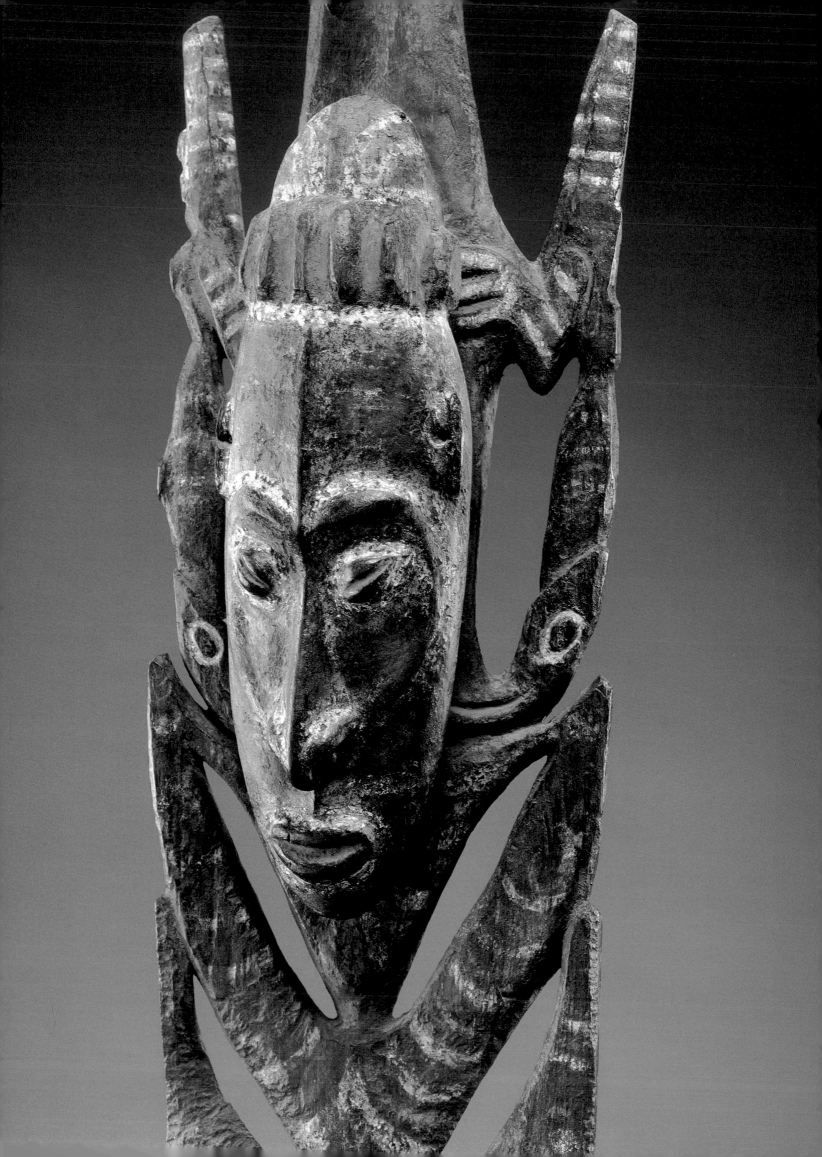

# Index

Bold numbers refer to pages with illustrations